The Contingent Object of Contemporary Art

The Contingent Object of Contemporary Art

MARTHA BUSKIRK

THE MIT PRESS ❚ CAMBRIDGE, MASSACHUSETTS ❚ LONDON, ENGLAND

This book was set in Minion, Syntax, and Scala Sans by Graphic Composition, Inc., Athens, Georgia, and was printed and bound in the United States of America.

Library of Congress Cataloging-in-Publication Data

Buskirk, Martha.
 The contingent object of contemporary art / Martha Buskirk.
 p. cm.
 Includes bibliographical references and index.
 ISBN 0-262-02539-6 (hc. : alk. paper)
 1. Art—Reproduction. 2. Art—Attribution. 3. Art, Modern—20th century. 4. Aesthetics, Modern—20th century. I. Title.

N8580 .B87 2003
709'.04'5—dc21

2002038061

Contents

ACKNOWLEDGMENTS vii

INTRODUCTION 1

1 AUTHORSHIP AND AUTHORITY 19

2 ORIGINAL COPIES 59

3 MEDIUM AND MATERIALITY 107

4 CONTEXT AS SUBJECT 161

5 CONTINGENT OBJECTS 211

NOTES 261

SELECTED BIBLIOGRAPHY 287

INDEX 297

ACKNOWLEDGMENTS

This book would not have happened without the time afforded by a Bunting Fellowship at the Radcliffe Institute for Advanced Study during 2000–2001. My first thanks therefore go to the people whose advice and assistance were crucial as I was pursuing this fellowship, specifically Carol Armstrong, Laura Hoptman, Rosalind Krauss, Kathy O'Dell, and Laura Tonelli. I also benefited from a sabbatical leave from my teaching duties, which was supported by Kate Bodin, John Raimo, and the many colleagues at Montserrat College of Art who took over my responsibilities while I was away. Rita Nakashima Brock, Director of the Bunting Fellowship Program, provided important support for the research that I undertook during the Bunting year. Nor would this book be possible without a publisher, which it found with the encouragement and support of Roger Conover at the MIT Press.

It is difficult to imagine researching a contemporary topic without the excellent resources and knowledgeable librarians at the Museum of Modern Art Library. The Research Library of the Getty Research Institute, particularly the Special Collections staff, provided access to important firsthand documents in the collection. The Fine Arts Library at Harvard University has been indispensable on an ongoing basis, and Abby Smith in particular has helped with many urgent requests. I would also like to thank the artists whose work I discuss, particularly those who have taken the time to talk about aspects of their work with me over the years that I have been considering these issues. In addition, the images for this book came from many places, and the book in its present form would not have been possible without the help of many artists, artists' assistants, galleries, museums, and others who provided images or helped direct me to their source.

Three people in particular, Linda Norden, Kim Sichel, and Ronnie Wright, volunteered to read the entire manuscript, which has benefited enormously from their generosity. The early stages of the writing process took place in the context of a works-in-progress group at the Bunting. Denise Buell, Alison Crocetta, Colleen Kiely, Sue Miller, Angelica Nuzzo, and Daryl Tress all helped shape the initial formulation of these ideas. At the MIT Press, Matthew Abbate's thoughtful attention to the text and Erin Hasley's elegant design gave the book its final form. Many others have read sections of this project at different stages or have provided other important support during the research and writing: Bill Arning, Barbara Bosworth, Judy Brown, Michelle Brown, Alan Colby, Susan Edwards, Jane Farver, Ana Guerra, Blyth Hazen, Patricia Johnston, Caroline Jones, Masako Kamiya, Therese Lichtenstein, Sarah Lowe, Joanne Lukitsh, Roxana Marcoci, Siobhan McDonald-Stowell, Terry and Sam Moriber, Christopher Phillips, Lisa Reeve, Robin Reisenfeld, Virginia Rutledge, Sandy Schleinz, Vernon Shetley, Elisabeth Smith, Beatrice St. Laurent, Liselot van der Heyden, and Lawrence Waung. I also thank my parents, Mary and Fred Buskirk, and my sister, Janet Buskirk, for all their encouragement. Finally, and most of all, I would like to thank Scott Hadfield, who read every word, often more than once, and provided his enthusiastic support along every step of the way.

The Contingent Object of Contemporary Art

Robert Morris, *Statement of Esthetic Withdrawal*, 1963. Typed and notarized statement on paper and sheet of lead over wood mounted in imitation leather mat, overall 17⅝" x 23¼". The Museum of Modern Art, New York, Gift of Philip Johnson. © 2002 Robert Morris / Artists Rights Society (ARS), New York. Photo © 2001 The Museum of Modern Art, New York.

INTRODUCTION

Consider two examples. One is a notarized statement incorporated into a metal, wood, and imitation leather construction, and the other is an ad published in a major art magazine. Both were authored by artists, employ the written word to make a statement about authorship, and relate to works in which the artist's hand or touch has been displaced to varying degrees by the use of manufactured components or techniques of industrial fabrication. But there the similarities end, because the first, Robert Morris's 1963 *Statement of Esthetic Withdrawal*, plays ironically on the power of the artist to author a work through an act of designation by presenting a legalistic inversion of such an act, whereas the second, a 1990 ad taken out by Donald Judd in *Art in America*, is an utterly serious repudiation of a work that Judd did not want presented under his name.

Morris's *Statement* refers to his 1963 *Litanies,* a construction in which a hanging ring holds 27 keys. Each key is inscribed with a word taken from a translation of one of the notes that comprise Marcel Duchamp's *Green Box,* a text consisting of a series of litanies ascribed by Duchamp to the chariot or sleigh component of his *Large Glass.* Morris exhibited *Litanies* in his first solo exhibition, where it was bought by Philip Johnson. *Statement* came six months later, when Morris still had not received payment and responded with the following declaration, duly signed and notarized: "The undersigned, ROBERT MORRIS, being the maker of the metal construction entitled LITANIES, described in the annexed Exhibit A, hereby withdraws from said construction all esthetic quality and content and declares that from the date hereof said construction has no such quality and content." The play with legal rhetoric continues in the relief presented as Exhibit A, which portrays front and profile views of *Litanies* incised in lead, the same material used in *Litanies* itself.

Advertisement placed by Donald Judd, *Art in America,* March 1990.

One issue raised by Morris's statement is the question of what power an artist continues to have over a work of art after it has left the artist's possession; in particular, to what degree the artist can change the status of the work without physically altering the object itself. If it is the aesthetic of the piece that is at issue, as the wording of the statement suggests, one then has to ask by what aesthetic criteria we judge a work such as *Litanies:* a construction consisting of a ready-made ring, individually worked keys, and, set into the lead surface above the hook from which the ring hangs, a brass lock. What is the content of a work that makes textual reference to another artist, with those references inscribed on keys that will never unlock the actual lock below which they are suspended? If a legal declaration can purport to remove aesthetic quality and content from a work, the statement also forces us to consider how these qualities might have entered the work in the first place. The familiar form of keys on a ring continues the challenge presented by Duchamp in the beginning of the twentieth century, when he invented the concept of the readymade to describe works of art he made simply by selecting and so designating a series of everyday objects chosen precisely because of their familiarity. Although both *Litanies* and *Statement of Esthetic Withdrawal* are constructions rather than readymades, the readymade certainly lies behind *Statement,* since the linguistic withdrawal of aesthetic attributes (even if ironic) implies a preceding possibility, the radical act of designation rather than making through which the readymade is produced. The ultimate irony of *Statement* lies in the fact that, far from subtracting content from *Litanies,* it adds to the subtle paradox already contained in the juxtaposition of textual keys and an actual, if nonfunctional, lock. Furthermore, the act of adding a retroactive overlay of interest to the initial construction suggestively echoes the role that the notes published in Duchamp's *Green Box* played in relation to his *Large Glass.*

The second statement, Judd's quarter-page advertisement in the March 1990 *Art in America,* consists of black text surrounded by a simple black outline: "The Fall 1989 show of sculpture at Ace Gallery in Los Angeles exhibited an installation wrongly attributed to Donald Judd. Fabrication of the piece was authorized by Giuseppe Panza without the approval or permission of Donald Judd." The ad therefore announces a much more comprehensive withdrawal, one that encompasses not just aesthetic quality and content but authorship in its entirety. The dispute concerned a 1974 work owned by Giuseppe Panza and installed in his villa in Varese, Italy, which consists of an uninterrupted row of largely identical five-foot-high galvanized iron plates affixed via hidden brackets so that they stand eight inches in front of the wall along three sides of a room. The piece establishes a second wall that, despite the weight of the materials involved, appears to float inside the architecture of the room. In 1989 the Ace Gallery in Los Angeles wanted to borrow this work by Judd, along with Carl Andre's 1968 *Fall,* also owned by Panza, for an exhibition devoted to

minimal art. Rather than shipping the two large-scale works from Italy, Panza authorized the gallery to refabricate the pieces in Los Angeles. Neither artist was consulted, and both publicly disavowed the copies exhibited under their names once they found out about the Los Angeles versions. Besides the paradoxes that can arise from the authorizing language of contracts or certificates (to be considered in later chapters of this book), there are important issues that need to be raised at the outset.

First, why would it have seemed plausible to a collector and a major art gallery that an unauthorized copy could be substituted for an absent work of art? Or, to ask the question another way, was there anything about the work itself that would have suggested that the copy could be a suitable stand-in for the original object? The contested work by Judd relied on qualities identified with minimalism: industrial materials, simple, geometric forms, the repetition of identical units, and the activation of the surrounding or contained space. By employing methods of industrial fabrication, Judd was able to remove a typical mark of artistic authorship, the evidence of the artist's hand. This could also be seen as the elimination of a significant component of aesthetic quality and content for a more traditional work of art. In that sense, Judd and other artists associated with minimalism participated in an undermining of one traditional measure of authorship which, not coincidentally, also provided an inherent limit on production. Even the use of the term "original" is fraught in relation to works already structured around the act of copying inherent in serial forms. However, as I will argue throughout this book, the removal of the artist's hand, rather than lessening the importance of artistic authorship, makes the sure connection between work and artist that much more significant.

While the shapes involved may seem simple, the issues they raise are complex. The designation of a work made through instructions for industrial fabrication or through the act of selecting an already manufactured object (the readymade paradigm that carries through in minimalism in the use of prefabricated components like bricks or fluorescent fixtures) requires a fully elaborated external structure of support, which includes the framework of explanation, both by the artists themselves and by critics, the adherence to external conventions that limit and control the reproduction of otherwise inherently reproducible works (the assignment of authorship and the use of the limited edition being the most important constraints), and a clear understanding of what, exactly, is being purchased by the collector of such a work. When works of this type were first shown, critics both favorably and unfavorably disposed focused on how these objectlike forms occupy the same space as the viewer. The lack of a pedestal or other barrier separating such simple, often hollow works from their surroundings forces the viewer to be aware of her or his experience unfolding in space and time. Furthermore, this emphasis on the surrounding space has a

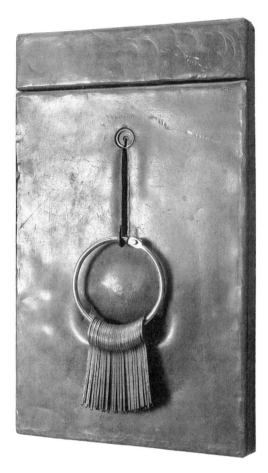

Robert Morris, *Litanies,* 1963. Lead over wood with steel key ring, twenty-seven keys, and brass lock, 12" x 7⅛" x 2½". The Museum of Modern Art, New York, Gift of Philip Johnson. © 2002 Robert Morris / Artists Rights Society (ARS), New York. Photo © 2001 The Museum of Modern Art, New York.

corollary in another form of exteriority, and that is the externalization of the evidence of authorship.

Adherence to external conventions that limit and control the production of otherwise inherently reproducible works is essential in order for such works to be collected in the context of a system based on the importance of originality and rarity. The mechanisms by which such authorship is regulated can range from assumed understandings to detailed written instructions, certificates, and even contractual arrangements. Recent artistic practices involving objects that do not carry inherent evidence of artistic authorship have necessitated new conventions for designating and maintaining their categorization as works of art. However, there is a precedent in the importance of a sound provenance that con-

Donald Judd, *Untitled* (galvanized iron wall), 1974. ¼"-thick galvanized iron plates, 60" high, along three existing walls, 8" in front of wall. Installation at the Villa Menafoglio Litta Panza, Varese, Italy. Solomon R. Guggenheim Museum.
Art © Donald Judd Foundation / licensed by VAGA, New York. Photo © Giorgio Colombo, Milan.

firms the assessment of connoisseurship by demonstrating a historical chain of connections to the time and place of a work's production. Such histories help authenticate and therefore secure market value, even as conservation labs have continued to search for ever more precise tools to study and evaluate the material or intrinsic traces of authorship. Evidence that is externalized, however, also makes clear the degree to which the construction of authorship depends on divisions that are fundamentally arbitrary, in the sense that such authorship is based on a whole series of specific, separable, and sometimes even negotiated decisions.

Returning to the Morris and Judd examples, while both are statements, and both are authored by artists, they are not both works of art. The difference in their classification is based on the structure of authorship as a system that addresses itself not just to the question of who is speaking but to the discourse or framework within which a work, as opposed to other types of objects or utterances, will be received and interpreted. Part of this interpretive context is provided by the artist's other works. Another framework is provided by the critical discourse surrounding the artist, a critical discourse in which both Judd and

Morris were active participants. For Morris's *Statement,* it is the history of the readymade, and specifically the speech act through which an everyday object is so designated, that establishes the interpretive context for the work. It is, however, equally telling that part of the conflict between Judd and Panza was based on Panza's understanding of Judd through his interest in the conceptual plan or project.

The emphasis on idea or concept makes explicit the possibility that the work of art will not be synonymous with an object, but could consist of a proposition that might be conveyed in many different forms. Judd's presentation of his work, along with his written statements about art, made it clear that he had no interest in having such conventions an evident part of his work. However, they lie in a very practical way behind the physical object, since a number of the works by Judd in Panza's collection were purchased on the basis of plans rather than already realized objects. While some forms of conceptual art explicitly delegate the realization of the plan to the individual or institution acquiring the work, Judd wanted to retain final authority to approve or disapprove of works presented under his name. Yet it could be argued that any work made through an act of designation or the fabrication of an object on the basis of instructions raises the question of what aspects of authorship are transferred with the purchase of the work of art.

Who has the authority to realize a work on the basis of plans? Is the power to delegate the realization of plans itself a one-time option, or is the transfer of that power part of the transfer of the work of art? Once the readymade is established as a model that allows the artist to take an object and designate it a work of authorship, to what extent is that authority, as well as the object itself, transferable? In fact, depending on the artist, these questions have been answered in many different ways, particularly in the wake of conceptual art's explicit reorientation of the status of the idea in relation to the object. Even for Judd, however, with his insistent focus on the physical presence of the object, the use of fabrication opens up an important temporal gap between plan and realization. While this delay may not appear significant for works that he had built while in close communication with his fabricators, the consequences become considerable as the gap between conception and realization widens. Thus the statements by Judd and Morris speak in different ways about the issue of authorship and how it is invested in certain objects and not in others. Their contrasting objectives also point to how inherent tensions in the authorization to make decisions about a work's realization and presentation can open onto contested terrain.

The exploration of points of intersection between minimalism and conceptual art—approaches often sharply differentiated in their early articulations—is part of a process of looking back at movements now firmly inscribed in the history of modern and contemporary art. Evidence of the thorough process of historicization already under way appears in

the many highly focused studies of artists and movements associated with the 1960s and 1970s. But the tendency of specialized examinations to emphasize distinct qualities as part of the process of setting their subjects off from other practices, even if consistent with the artists' own delineation of their positions, does not account for the ways successive generations of artists have drawn upon the precedents established since the 1950s, often bringing together multiple and, in their initial articulations, distinct approaches and procedures.

Consider another example. The two large cubes, one of chocolate and one of lard, in Janine Antoni's 1992 *Gnaw* refer unquestionably to minimalism in the use of simple, three-dimensional geometric forms that take command of their surrounding space. Yet Antoni moves in a different direction, employing not industrial but organic materials that carry a whole range of cultural associations as well as varying degrees of physical stability. Furthermore, these are works that assert the artist's physical presence in the act of making, particularly in the traces of her obsessively repeated action: Antoni has altered the strict geometry of each cube through a process of biting off the chocolate and lard, turning the ninety-degree angles of the edges and corners into surfaces roughly marked by a record of the artist's physical progress across the material. Through her choice of materials and method, this female artist has taken abstract geometric forms identified with the largely male realm of minimalism and shaped a work that speaks both viscerally and quite specifically to our associations with the materials. These are not simply substances that can be consumed, but ones that carry anxious connections between body image and the pleasure that can turn into disgust with their overconsumption. Such associations are further supported by what Antoni has done with the chocolate and lard bitten off from the cubes. Shown in conjunction with the two gnawed cubes is a mirror-and-glass case displaying lipstick forms made from the bitten-off lard mixed with wax and pigment, and, from the bitten chocolate, not candies themselves but heart-shaped versions of the segmented containers used in chocolate boxes.

One could argue that Antoni, in her use of a version of touch, has simply reestablished the mark-making excluded from the minimalist object. In contrast to the unconscious mark assumed by connoisseurship, however, this is a very specific and culturally loaded use of the body to shape the material. The touch or mark is not simply a vehicle for creating an aesthetic effect; rather, recognition of the mark itself and its relation to the body of the artist is central to the message of the work. Yet for all that this work is about a visceral trace that suggests direct evidence of the artist's touch, it also depends on repetition in the form of the cast copy for its continued existence. In the case of the chocolate cube, the appearance will gradually change over time as the chocolate ages. Lard, however, tends to lose its form more catastrophically, in total collapse. Retaining basic characteristics of her materials

is more important to Antoni than the preservation of appearance, to the extent that she would not want to alter the nature of either the lard or the chocolate for the sake of conservation. The lard component is therefore recast each time it is exhibited, using a mold taken from the bitten cube to duplicate its original contours. Thus the work combines a specific and limited authorization to recreate or copy with otherwise direct traces of the artist's actions.

Gnaw is a work that speaks on many levels to issues of temporality. Its making required repetition and endurance, with Antoni biting off the chocolate and lard over many days, until her mouth was covered with blisters. The work then began to unmake itself as soon as it was complete, with the chocolate and lard components both showing evidence of aging, if at different rates. The changes in the work mark both the long duration of collecting and the short duration of individual exhibitions, since the chocolate cube and the objects in the case have shown signs of aging between exhibition appearances, whereas the lard ranges from newness to decay during each exhibition cycle. The lard cube could be said to have internalized the established rhythms of the temporary exhibition. Thus the experience of the work, including the relationship of its components to one another, changes depending on when and in what part of the cycle one sees it, and also diverges from photographic records of its appearance.

Chocolate and lard are only two of a variety of materials employed by Antoni in works that range from impermanent to relatively enduring objects and have encompassed various combinations of sculpture, performance, video, photography, and installation. Recurring themes include her exploration of endurance and the power of repetitive actions, her interest in gender, particularly as articulated through the female body, her use of materials with strong cultural associations, and her continued and varied assertion of the artist's presence in the work. It is interesting to ask by what criteria one can assess a body of work based on such heterogeneous forms and media. The question increases in urgency when one considers the degree to which her work shares its heterogeneous approach both with the work of many other artists taken individually, and with the field of contemporary art considered as a whole.

The designation of authorship according to internal evidence was based on the perception of unity and stylistic consistency. Historically the establishment of museums led to the organization of works of art according to period as well as individual style, the goal of these divisions being the education of the museum-going public. However, with classification of works according to authorship secure, this system of divisions and hierarchies now forms the basis for a very different model of artistic production. Authorship thus becomes the vehicle for the reintroduction of a degree of heterogeneity banished from the art

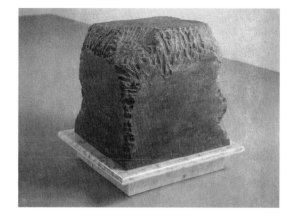

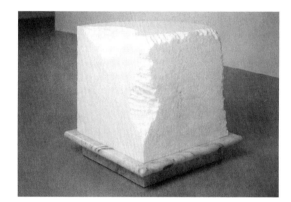

Janine Antoni, *Gnaw*, 1992 (details). 600-pound cube of chocolate gnawed by the artist, 24" × 24" × 24", 600-pound cube of lard gnawed by the artist, 24" × 24" × 24", and display case with 45 heart-shaped packaging trays for chocolate made from chewed chocolate removed from the chocolate cube and 400 lipsticks made with pigment, beeswax, and chewed lard removed from the lard cube. Collection the Museum of Modern Art, New York. Courtesy the artist and Luhring Augustine, New York. Photos: Brian Forrest.

museum when it was separated from other types of collecting institutions, such that a division based on an idea of authorial integrity or stylistic unity has been transformed into a framework for interpreting artistic practices based on heterogeneity and a lack of stylistic consistency. Presentation under an artist's name ensures not only that a range of different forms of expression will be read as works, but that heterogeneity within that series of works will be read as a decision that itself carries meaning as a play on the very idea of authorship as a form of unity or internal consistency.

Clearly there has also been a dramatic redefinition of the museum and its mission, evident in the commitment made by the Museum of Modern Art, in acquiring *Gnaw,* both to meet the preservation challenges and to continually remake this work of art. It is again the readymade, one could argue, that opened the door for a seemingly limitless variety of manifestations to enter the art museum. The readymade derives from a multiple gesture involving the act of selection (choosing an object from among many), designation (as a work of art as well as designation of authorship), and recontextualization. Whereas many of the objects included in the collections of historical survey museums were recontextualized by their entry into the museum, for contemporary art the museum or gallery space now dominates as the presumed context, both as a type of physical space and with respect to institutional conventions. For contemporary works of art that assume the museum or gallery as a natural context, recontextualization is not something that happens to the work as a result of the collecting process, but a technique that artists often choose to employ as a key element of the artistic process.

If the readymade is based on objects redesignated and recontextualized, another variation is the use of unexpected materials, particularly ones that carry cultural associations that extend beyond the museum's walls. Perhaps chocolate is one such material. But in what context, exactly, might one expect to find a 24-inch cube fashioned from 600 pounds of chocolate and replete with human bite marks? Perhaps it is exactly the modern art museum in which one might not be completely surprised by such an unanticipated object, and might, in that setting, have a context in which to consider its relationship both to the history of art and to contemporary culture, because of, not despite, the fact that it is presented under the authority of the name Antoni.

In one recent appearance, Antoni's *Gnaw* was shown in the Museum of Modern Art's 2000 "Open Ends" exhibition, devoted to works in the museum collection from 1960 to 2000. This was the third in a series of collection exhibitions mounted before the midtown building was to be closed for renovation, and all three were organized according to a group of broad but not necessarily comprehensive thematic topics. As a group they announced a concerted break with MoMA's earlier arrangement of modern art according to a series of chronologically sequential rooms devoted to different periods and movements. The exhi-

bitions could therefore be read as an institutional response to critiques of linear histories of style and influence; but another reason for this new arrangement of the history of the twentieth century can certainly be found in its new culmination not in modernism but in postmodernism. Furthermore, the individual groupings within "Open Ends" suggested how difficult, if not impossible, interpreting art according to divisions based on style or movement has become since 1960. *Gnaw* was included in the section "Minimalism and After," which, along with "Pop and After," nodded to the earlier habit of periodization. But Antoni's work might just as easily have been included in "Actual Size," "Matter," or "One Thing after Another," which were also among the exhibition's eleven arbitrary and often overlapping categories.

In calling these divisions arbitrary, however, I am not trying to suggest that the museum capriciously ignored a more coherent or logical model for presenting the art of the last four decades. One might have begun with pop art, minimalism, earthworks, conceptual art, and performance, which are only the more prominent among the movements identified with little more than a decade in the 1960s and early 1970s. Yet the absurdity of isolating these tendencies and identifying each with the brief period of its initial formulation and success becomes apparent in the slippage of artists from one designation to another and, even more significantly, in the ongoing production over many decades by artists identified with these categories. Furthermore, the overturn of the sequential model is already implied in the museum project itself. The chronological organization, physically embodied in the layout of most survey museums and present in disembodied form in art history textbooks, is a structure that contains within itself the potential undoing of its logic. Despite all attempts to guide the visitor or reader through a sequential unfolding, the possibility of skipping backward or forward in the succession of rooms or chapters yields a different message, that message being the simultaneous availability of all periods and styles. And with the increasing number of museums devoted to collecting and exhibiting art of the present moment, the circularity of reference has further tightened, with art that incorporates a response to museum presentation subject to immediate assimilation into that very context. Moreover, whereas the history of period styles once provided the framework within which authorship designated the ultimate stylistic unity, now authorship has become the most significant category even as stylistic unity is no longer one of its requirements.

The daunting situation faced by the artist of the early twenty-first century is one in which all choices seem possible. If art from the early phase of postmodernism in the 1960s and 1970s could still be understood according to certain movements or categories, a second phase predominant in the 1980s and 1990s has been characterized by artists who have felt free to pick and choose among the entire range of possibilities established since the late 1950s, pulling apart and recombining elements associated with many different movements.

In *Gnaw* alone, for example, Antoni has evoked minimalism in her use of geometric forms, pop art as well as the earlier readymade with the display case filled with versions of everyday objects, process art through the emphasis on repetitive action, and various forms of feminist and body or performance art through the issues raised by the materials and her action on them. Undoubtedly there are other precedents that could also be identified, though such a catalogue would hardly suffice to account for the impact of the work.

The freedom to draw from multiple sources can also be seen as a form of pressure, however, since under these circumstances no artist can escape the obligation of having to make a series of self-conscious decisions about issues that include format, medium, context, content, appearance, duration, and relationship to precedents, with each read as a conscious choice and no decision that can be taken as assumed or given. The complexity of such positioning becomes even more evident when one considers the shifting status of apparent opposites running through many forms of contemporary art. These linked pairs include original/copy, performance/document, object/context, high/low, representation/abstraction, or permanence/transience, with each subject to subtle combinations and overlays as well as a continuing process of redefinition.

One example of the overlay of apparent opposites is evident in the degree to which mechanical reproduction is at the core of many artists' production during the last four decades, with original works of art made increasingly through processes in which duplication of the work is controlled not through inherent limits on production (most commonly, the skill or touch of the artist) but by external limits. The avid collecting of such works raises the further issue of how art that incorporates a questioning of originality, uniqueness, artistic skill, touch, longevity, or even materiality can and has been enfolded into a system of collecting and valuation founded on those very qualities. While the notion of a postmodern rupture with earlier practices is seductive as a way of describing the turn away from the unity of medium and form associated with modernism, it does not (even if accepted) explain the embrace of contemporary art by collecting institutions focused on the care and preservation of unique works of art. There are also telling parallels between such art world conventions as the limited edition and broader efforts to limit the proliferation and thereby insure the value of inherently reproducible forms through legal controls, particularly copyright legislation, such that some of the changes in the museum's relationship to inherently reproducible forms can be connected to larger cultural transformations.

The suspension of presumed contradictions takes place at many levels, with some only becoming significant in the transition from a work of art's initial appearance to its extended life as an object to be preserved, collected, and contextualized as part of a historical narrative. For at this point a complex process of negotiation begins, as questions arise

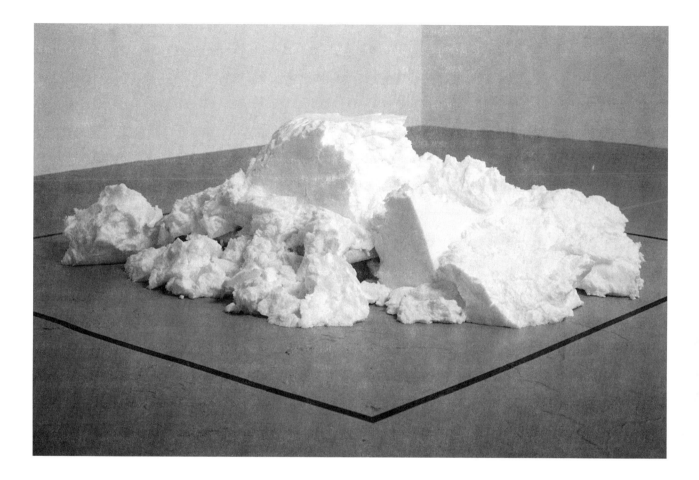

Janine Antoni, *Gnaw,* 1992: lard
cube after collapse.

about the relationship between documentation and the work itself, for ephemeral works that range from performances to site-specific installations; about the issue of preservation, for works made from fragile or unstable materials; and about the definition of what exactly constitutes the original object, for works that employ forms of reproduction or mass-produced elements.

So, too, the multiplicity of media employed by artists as well as the prevalence of quotation not only of images but also of effects associated with one medium in another make clear the absolute impossibility of continuing to categorize according to medium in any meaningful sense. For example, in the case of paintings that are based on photographs and other forms of reproduction, or photographs that refer to the conventions of painting, one can see how the conventions associated with a medium are separable from the medium itself. But the fact that the conventions that these artists refer to are in many cases divorced from the original medium with which they are associated does not mean that such associations are effaced; rather, they retain traces of their previous histories even as they are reinscribed and dissolved into new contexts as part of a complex overlay of conventions. In the process, the method and materials that the artist selects for creating the work are transformed, so that rather than functioning just as the raw matter or vehicle for the artist's aesthetic expression, the materials themselves generate associations that, together with the forms into which they are shaped, establish the subject or content of the work of art.

Underlying these various forms of interruption is the issue of temporal discontinuity. An earlier ideal of unity between form and content presupposed a process of creation in which decisions about form were inseparable from the act of making the work, with the work emerging from the studio fully realized and self-sustaining. While retrospective assessments of modernism have found this to be a somewhat illusory unity, it is nonetheless important to note how multifaceted and varied the repudiation of this ideal has been. For many works produced in the last four decades, temporal gaps open up at the level of production. For others they begin to appear later in the work's life, as it has to be adjusted or even remade for a new context. This rift may appear in the very places where spatial and temporal experiences are the most important, as objects that depend on an unmarked uniformity are marked with the signs of age, as performances are known through partial documents or accounts, and as works initially installed or arranged with the artist's direct participation are increasingly interpreted by others.

For works that are completed not in the studio but only at the point of their realization in an exhibition or performance space, the existence of the work is linked to its public presentation. Attempts to extend the life of such works will give rise to spatial and temporal shifts for viewers, who may have radically different experiences depending on when and

where the work is encountered. If the physicality of many minimalist works is only completed by the activation of the surrounding space, then this is a contingent physicality that ceases to exist when the elements of the work are disassembled for storage, and can be profoundly compromised by a careless or imprecise arrangement of elements. Other gaps can open up between the work and its documentation, particularly for works that change over time because of how they are installed or the types of materials used. For site-specific, performance, and a variety of ephemeral works, the documentation provides a limited access to otherwise distant or inaccessible manifestations. And still other issues of temporality are raised by the realities of conservation, especially the need to replace decaying elements or to update works that rely on obsolete technologies. For such works, decision-making becomes increasingly nonsynchronous with initial production.

Another key discontinuity arises from the interaction with context, particularly as artists play with materials, forms, and methods that are closely related to corresponding examples from nonart realms. However, recontextualization is ultimately more an act of authorship than of physical transportation. For all the importance of museums and galleries as the spaces in which contemporary art is displayed, the first two of the maneuvers associated with the readymade—selection and designation—can take place without requiring the third—physical recontextualization—as works executed outside the institutional spaces appear as objects or actions that might be scarcely distinguishable from their surroundings but are still accepted by those who are aware of their designation as art. The readymade in particular and recontextualization more generally are possible because of the play on long-held assumptions about artistic authorship. There is even a body of law, known generally as moral rights, that speaks to the integrity of the work of art based on the idea of authorship and the belief that the work of art is more than simply another commodity. However, when works of art are made using forms close to or identical with the realm of objects not defined as art, the designation of authorship may in fact be the only feature that distinguishes the work of art from any other object.

An earlier approach to the work of art looked to the object itself for evidence about its aesthetic. For many contemporary forms, however, understanding how a work of art was realized includes far more than a knowledge of artistic materials and their properties. It is again the readymade that calls into question both judgment based on aesthetic criteria and the possibility of assessing a work of art on the basis of internal evidence. Of equal importance, however, is the widespread acceptance of the plan, derived from conceptual art, that has facilitated recent developments, with instructions of one kind or another behind many forms of art produced in the last four decades. In fact, the use of certificates and other essentially administrative procedures for defining the nature and boundaries of the work of

art has been effective both in the establishment of a market for potentially ephemeral works and in giving artists a certain freedom from the idea of art-making as the production of lasting objects. As such documentation is externalized, the physical object may remain mute in the absence of instructions about how it is meant to address its audience.

Herein lies yet another paradox: on the one hand, the category of authorship for contemporary art is one that allows for processes based on administration and delegation of making; but on the other hand, although the artist's touch may be less evident in the physical process of making, the artist's ongoing presence and decision-making have become more important for contingent works where the physical boundaries of the piece have to be reconceived each time it is exhibited. Thus, even if artistic intent has been repudiated as the basis for critical assessment, it reappears as a determinant of the work's very form. In circumstances where the tangible form in which an artist's expression is communicated to the viewer may not entirely coincide with the artist's definition of what constitutes the work of art, attention to the object itself has to be supplemented or even supplanted by information about the artist's conception.

This book takes as both interesting and strange the fact that almost anything can be and has been called art during the last four decades and addresses the question of how it is possible to assess this plurality of methods. Given the tremendous heterogeneity of artistic practices that greeted the beginning of the twenty-first century, it is important to consider how the definition of a work of art is established, how it is administered over time, and by what criteria assessments are made in the face of widely divergent forms. Furthermore, the conflicts that have arisen as works of art have been collected or presented to the public point to the nonsynchronous evolution of ideas about how the work of art is defined or constituted. The goal is therefore not a comprehensive history, proceeding in orderly fashion through movements and decades. Instead, the examples have been chosen to draw out connections across different artistic practices of the last four decades, with particular attention to how characteristics and methods associated with movements that originated in the 1960s and 1970s have subsequently become part of a far less sharply differentiated series of options taken up and recombined by succeeding generations of artists. This book explores the situation by focusing on the intersecting issues of authorship, reproduction, context, and temporality as they reverberate through artistic practices of the last four decades of the twentieth century.

AUTHORSHIP AND AUTHORITY

I remember very clearly the drama of my third visit to the Dia Center exhibition of Richard Serra's *Torqued Ellipses*. The space was completely taken over by three large volumes formed from curved sheets of steel that tilted both inward and outward to varying degrees and according to different rhythms. On two earlier occasions, once by myself and once with a group of students, I had walked around the exterior and interior of each of the three forms in turn. The constantly shifting incline of their twelve- or thirteen-foot-high walls of steel induced a feeling close to vertigo, and in the *Double Torqued Ellipse* the sense of being kept off balance was even more pronounced within the narrow passageway established between the exterior and the second set of plates that formed an inner enclosure. In the strong light pouring down from above, the unfolding experience of the different spaces was completely linked to the materiality and varying tonalities of the rusting surfaces of the steel, surfaces that were unavoidable as they closed in around anyone willing to enter the quiet menace of the heavy forms.

It was with the anticipation of a repeat encounter that I stopped in at the end of a subsequent trip to Chelsea. Since my previous visits had taken place in the middle of the day, I had not noted the absence of artificial lights in the space. But my perception of the work changed dramatically when the illumination from the skylights faded. As the room dimmed, surface, color, and detail were taken out of the equation, to be replaced by the overall apprehension of masses, darkly silhouetted in the remaining light, enclosing ambiguous interior spaces. So dramatic was this transformation that the *Torqued Ellipses* I was experiencing could have been a different work.

No work of art is immune to the circumstances of its presentation. Nor is it an uncommon experience to find some new quality or detail in a work of art that one has seen many times. Part of the power of works of art that bring one back time and again is that

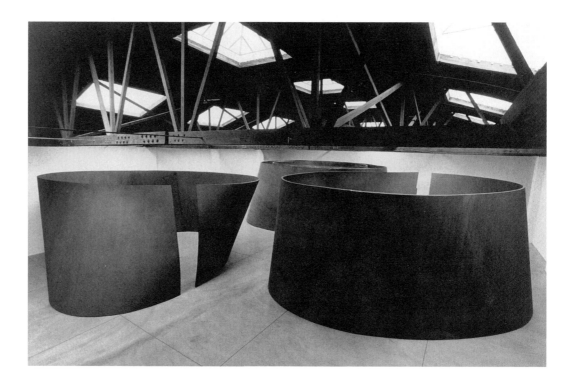

Richard Serra, *Torqued Ellipse I,*
Torqued Ellipse II, both 1996, and
Double Torqued Ellipse, 1997.
Weatherproof steel, overall dimen-
sions 12' × 29' × 20' 5", 13' 1" × 29' 11"
× 20' 7", and 13' 1" × 33' 6" × 27' 1".
Installation at the Dia Center for the
Arts, New York. Courtesy the artist.

surprise in the midst of the familiar. But the degree to which the surrounding environment frames this work establishes a form of contingency that can have a profound impact on how the work is understood. Nor is it just the object and the surrounding space that are in play, because the other actor is the viewer, mobile and experiencing the work as a series of unfolding encounters. The body is thus present, not as sculptural representation, but rather in the person of the spectator whose movement through space is framed and marked by abstract form.[1]

Although Serra's emphasis on materials and process as well as the complexity of his forms move his work away from some of the characteristics identified with minimalism, both frame an experience of space and time in which one's visual perception of the work cannot be separated from one's bodily understanding of its presence. The focus on the entire experience generated by the work was critically articulated in response to the relatively simple shapes that one finds in the work of Donald Judd, Carl Andre, and, for a period, Robert Morris, or the arrangements of standardized fluorescent fixtures by Dan Flavin. The literal shape of the minimalist object depended on the use of industrial means of production, the creation of objects based on simple geometric forms conceived in advance of their realization, the incorporation of the copy in the creation of work based on repetition or serial forms, and the use of prefabricated units like bricks or fluorescent fixtures. This use of standardized industrial materials and forms contributed to the nonart look that Michael Fried aptly described in his classic condemnation of minimalism's theatricality, while many of the same qualities were read by Rosalind Krauss as a powerful activation of exteriority and the phenomenological unfolding of the viewer's experience in time and space.[2]

One reason why every nuance of the intersection between object, surrounding space, and viewer's experience takes on such importance is that so much has been excluded from the work. The "cool" quality that early critics found in minimalism came from the smooth, untouched surfaces of these simple shapes. The deceptive simplicity that inspired the label of minimalism—which stuck over the objections of the artists—led some to focus on ideal form at the expense of the specific material realization. What the work excludes is evidence of the artist, of an author's touch in its formation. In his retrospective assessment of this tendency, however, Hal Foster has argued against readings of minimalism as ideal form, insisting on the importance of distinguishing between "the purity of conception" and "the contingency of perception."[3] Foster, citing Roland Barthes, links this death of the author to the birth of the viewer.[4] Douglas Crimp makes a similar argument, attributing the importance of the spectator to minimalism's "attack on the prestige of both artist and artwork."[5] The degree to which traditional markers of the artist's presence have been removed from the minimalist work can be connected to significant features of authorship

described by Michel Foucault as a system of classification based on the use of the author's name to designate and differentiate among works.[6]

However, it is around the function of authorship that the issues become more complicated. On the one hand there is the removal of evidence of authorship in minimalism's seemingly untouched surfaces; and this withdrawal of touch was not just an effect, given the widespread use of fabricators and ready-made components. Yet the long-term history of this work tells another story about authorship, one concerning the artist's ongoing connection to the work, expressed in efforts to control context and placement. This history includes an often built-in legal requirement for collectors and institutions to consult the artists on issues ranging from placement to replacement of parts, and one of its expressions is the use of written contracts, certificates, and other forms of instruction to accompany the work. Read in this light, minimalism's history subsequent to its initial appearance— the story of its success with collectors and institutions—requires an analysis of the intersection of authorship and ownership.

Over a work's history, decisions about how it will be presented necessarily determine the spectator's experiential understanding of it. In the case of work made from unfixed or changeable elements, interpretation is not simply a matter of a possibly varied response to an essentially stable physical object; instead, a prior stage of interpretation can have dramatic implications for the configuration of the object to be perceived. Furthermore, the process of interpretation that shapes decisions about display as well as long-term care and preservation is frequently presented as a reading of artistic intent—a reading based on assumptions about the artist's common practice as well as written statements and related documentation. Over the life of a work, questions about display and preservation require an interpretation of exactly what constitutes the work and who is authorized to make decisions that will shape how it is received. The answers are not necessarily obvious for works that depend on establishing a specific relationship to ever-changing conditions.

My third experience of *Torqued Ellipses* constituted a dramatic change. Though neither the materiality of the work nor its placement within the surrounding physical space were altered, the shift in lighting created radically different viewing conditions. But what happens if the object itself is also contingent, subject to shifts in material or configuration over time? "A beam on its end is not the same as the same beam on its side," wrote Morris in his "Notes on Sculpture."[7] Morris explored this idea in the mid-sixties with simple straight or L-shaped beams shown simultaneously in different orientations, and in several exhibitions where he introduced daily change as part of his plan for groupings of rectangular and wedge-shaped forms or, slightly later, a room piled with thread waste. At other times, the materials will alter over time, whether such change is desired or not, and the experience of

the work will be transformed by differences in the work's appearance. While the dramatic yellowing of Eva Hesse's works in fiberglass and the brittle discoloration or complete decay of those made from latex may have been predictable, the consequences have been extreme for the ongoing appreciation of the work. Yet even these examples involve demonstrable changes to the physical object. An object that is not self-contained but depends on its relation to the surrounding space can be subject to more ambiguous changes from shifts in the relationship of components to one another or to their environment.

Judd's famous description of composition based on "one thing after another" found its articulation in serial progressions that are sometimes physically linked, and at other times are made up of independent units that only come together in the moment of their exhibition and essentially cease to function as a work of art when not arranged for display.[8] While it may be difficult to see and therefore appreciate a painting when it has been badly lit, one doesn't tend to think that the object itself has changed, whereas works involving components arrayed on the floor or walls of a room depend on their arrangement for their impact on a viewer. How much compromise or deviation is allowed, then, before the result is a failure of the work, or of authorship? The rearrangement of components could constitute a new work, or simply no work, when their layout diverges from the one established by the artist.

Work that is dependent on its context is in a certain sense not finished until it is actually on exhibition. Nor is it definitively set just because it has been exhibited and even sold. The issues surrounding the future of a work of art may not be of much concern the first time the work is exhibited, particularly if the artist is only just becoming known and collected. It is only with the establishment of a market for their work that artists are forced to concern themselves with the life of the work over time, as it enters situations that the artist did not select and may not be able to control. Given the degree of interconnection between the minimal object and its physical space, perhaps it should not be surprising that minimal art has seen some of the more vigorously argued confrontations between artists and other individuals or institutions over the collecting and display of their work. The embrace of such works by collectors and museums brings up not only the importance of placement in relation to a space, but also conservation issues involving the possible exchange or replacement of elements. The sale of works on the basis of plans raises even more fundamental issues about the extent to which the artist is willing to delegate decisions about the work's realization. The potential malleability of the relationship between object and environment, or, at a more basic level, the question of who is authorized to realize a work, forces consideration of how much long-term control artists can continue to exercise over the conditions of display for their works, and by what means they retain that control. The

absence of the artist's hand or touch also has a corollary in a greater emphasis on exterior evidence of the work's authenticity. The externalization of evidence both of artistic intent and of authenticity gives rise to a somewhat paradoxical situation, in which the long-term existence of this physically commanding work turns on issues of language.

The deployment of language is not necessarily surprising, given the degree to which the artists associated with minimalism were active in the critical discourse of the period. In fact, Fried opened his attack on minimalism's theatricality by declaring the work "largely ideological," an enterprise that "seeks to declare and occupy a position—one that can be formulated in words, and in fact has been formulated by some of its leading practitioners."[9] Somewhat later, Craig Owens ascribed a less secondary role to statements that used language not as description, but in ways that paralleled the constructed aspect of the work.[10] Language is also implied in the connection to the enunciative statement "this is art" that Thierry de Duve has posited as a condition of the readymade.[11]

Many of the significant documents, however, lack the visibility of the artists' published statements, necessitating a consideration of the institutional conventions through which claims of authorship for serially fabricated works are secured and administered. The language of instructions, certificates, and contracts may seem to have little relevance for the experience of a work of art; yet the passage of time only increases the importance of this interpretation that generally takes place out of sight. Seemingly, a certificate of authenticity issued by an artist would be secondary to the object being so described. In fact, such conventions became central to conceptual art, with an early example in Mel Bochner's "Working Drawings and Other Visible Things on Paper Not Necessarily Meant to Be Viewed as Art," a 1966 exhibition he curated for the School of Visual Arts Gallery in New York. The installation consisted of four binders filled with photocopies of preparatory drawings, plans, proposals, and even receipts solicited from artists, architects, composers, and others. Although Bochner's title left the status of these documents open, his inclusion of drawings and other material from artists who made use of outside fabricators in the production of their work was an early indication of a point of intersection between issues of production for artists associated with minimalism and questions concerning the nature of the work that would be raised by conceptual artists.[12] It was precisely an "aesthetic of linguistic conventions and legalistic arrangements," Benjamin Buchloh has argued, that distinguished conceptual art from the "aesthetic of production and consumption" he identifies as characteristic of pop art and minimalism.[13] The question that has to be examined, then, is what the implications are when these conventions also function as underlying conditions in the production and marketability of minimal art.

To what extent is the idea separable from its specific material expression, and how much latitude can there be in the material object for it to constitute an expression of that

idea? Does the work of authorship lie in the material object, or in the plans and instructions for its realization? If the artist has the power to declare an object to be a work of art, to what extent does the artist have the power to revise that declaration, and to what extent is that power of declaration transferred with the sale of the work? These considerations are typically the province of conceptual rather than minimal art. Nonetheless the relatively disembodied realms of written words and diagrams are enmeshed with work that is about a particular kind of physical experience. No single answer can be given to the question of where the "work" resides, since the answers vary, even within the approach taken by individual artists. One way to start to consider the nature of this form of authorship, however, is in the moments when it has become contested.

The withdrawal of authorship as a form of protest was Andre's response to a series of decisions by the Whitney Museum following the museum's request to borrow Andre's 1975 *Twelfth Copper Corner* for its 1976 exhibition "200 Years of American Sculpture." The piece, at the time still owned by Andre, was one of a series consisting of 50 cm x 50 cm copper plates set into the corner of a room in descending rows such that the overall shape is a right triangle with a jagged-edge hypotenuse. Because the plates extend only 0.5 cm above the height of the floor, the work is sculptural due to its orientation rather than its actual volume. It is a work that requires a particular kind of space as well as arrangement, and in relation to the verticality of the spectator the work takes control not only of the floor, but also of the column of space that extends above the array of plates. For the exhibition at the Whitney, Andre initially participated in the selection of a space within the galleries. Later, however, the work was moved from the location he had chosen to a corner where it had to compete with a window and an emergency exit door, and Andre withdrew the loan. The Whitney then replaced the withdrawn piece with a work from the permanent collection, Andre's 1975 *Twenty-Ninth Copper Cardinal*, which also consisted of an arrangement of plates, in this case a row of units determined by a cardinal number extending out from a wall. The museum, however, decided to install the work with a rubber mat underneath in order to compensate for the uneven flagstone floor on which it was placed.[14]

For most works of art, the placement of a work that an artist no longer owns is generally assumed to be outside the artist's control. However, the arrangement of elements is an integral part of Andre's work. Presumably the collectors and institutions that own his work also understand that the effect of the work depends on its placement within the space of the room, with no pedestal or platform separating the work from the viewer. But for Andre, to interpose any material between the work and the floor was also a transgression. Andre's response was to offer to buy back the Whitney's work for $26,000, one thousand more than the purchase price. After this tender was rejected, he reduced his offer to 70 cents per pound for the scrap metal, and he mounted a counterexhibition at 355 West Broadway in

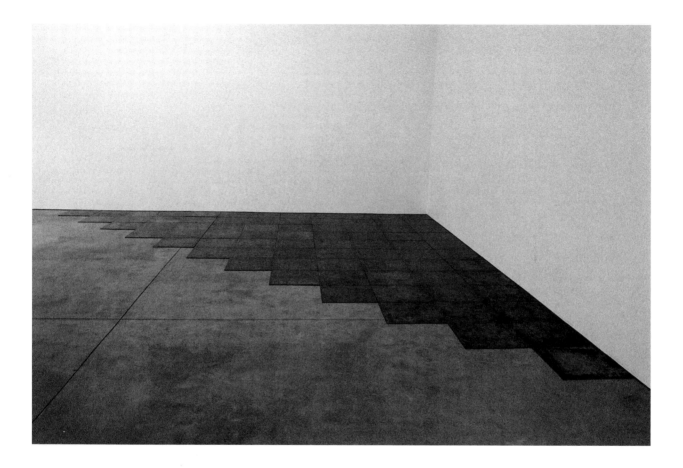

Carl Andre, *Twelfth Copper Corner*,
1975. Copper, 78 units, ⅟₁₆" × 19⅛" ×
19⅛" each, ¾₆" × 19' 8" × 19' 8" over-
all. Courtesy Paula Cooper Gallery,
New York.

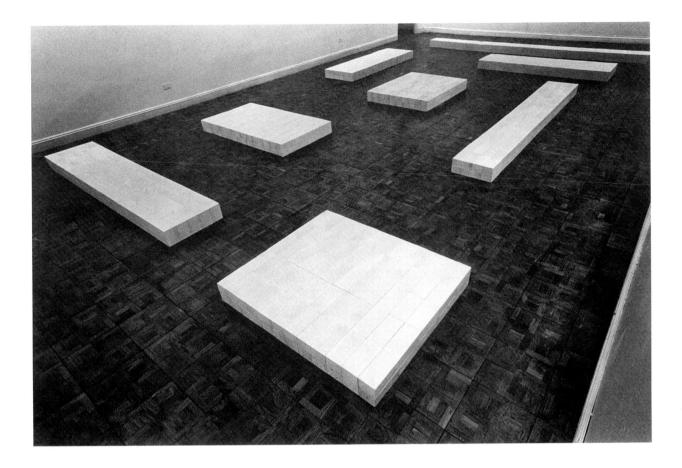

Carl Andre, *Equivalents I–VIII*, 1966.
Sand-lime brick. Installation at
Tibor de Nagy Gallery, New York,
1966. Courtesy Paula Cooper
Gallery, New York.

which he displayed not only the *Twelfth Copper Corner* but also a competing version of the *Twenty-Ninth Copper Cardinal* that he designated as the original, "liberated," as the invitation declared, "from property bondage."[15]

The Whitney embraced Andre's initial designation and arrangement of the industrially produced elements, but resolutely ignored his redesignation of authorship to another physical object. Apparently not doubting the permanence of its title to the work, the museum continues to list the work as part of the collection. Perhaps the curators simply did not doubt the work's continuous material existence. Yet the piece is also included, without any obvious irony, in a subsequent catalogue of collection works entitled *Immaterial Objects*. While the catalogue does not make any reference to the controversy, it does reproduce the certificate Andre provided with the work.[16] These sheets, standardized by Andre, record basic factual information about a work's specifications and history that could be misconstrued as a kind of recipe were they not clearly secondary to the object. In this sense, the Whitney has used one statement by the artist, a piece of paper by which he confirmed this particular group of metal plates to be the work, in order to refute other subsequent declarations by Andre. The publication of the certificate alongside the installation photographs suggests that it is the museum's possession of the original sheet of paper, as much as the original metal plates, through which they affirm their ownership of a work of art rather than a pile of scrap metal.

In 1976 a controversy also erupted in England when the press found out about the Tate Gallery's purchase of Andre's *Equivalent VIII*. The work that the Tate had acquired in 1972 was one of eight rectangular configurations made from 120 bricks layered two deep. The original group of *Equivalents* comprised Andre's second solo show in New York in 1966, and their arrangement, dispersed across the space of the gallery with room to walk in between, was an early example of Andre's use of relatively horizontal forms to take control of an environment. What drew the attention of the British press, however, was the fact that the Tate had spent a large sum of money on an arrangement of bricks and, additionally, that the bricks which constituted the work when it was sold to the Tate were not the same bricks that Andre had used when he first made the work.[17] While the logic of the piece was based on a standardized unit that could be readily replaced, such lack of concern for the specific physical object nonetheless goes against long-held assumptions about the work of art. It is therefore telling that catalogues of Andre's work give two dates for *Equivalents I–VI* and *VIII:* "New York 1966 (destroyed) / New York 1969 (remade)," putting into art-historical language the fact that replacement bricks were used for all but *Equivalent VII*.[18]

A rather different impulse seems to have motivated the creation of yet another version of *Equivalents*. In 1995 the Gagosian Gallery exhibited a re-creation of the work under the

title *Sand-Lime Instar,* and the 1969 date dropped away in the listing "destroyed 1966 / re-made 1995." The gallery provided several justifications for yet another remake of a work that had already been made, remade, and sold. One reason was the dispersal of the earlier elements, and another, surprisingly, was the fact that the second version had actually not been made from the right bricks, since Andre had bought firebricks in 1969 rather than the sand-lime bricks used in the original: "All but one of the original *Equivalents* were destroyed; the others were remade in firebrick in 1969. These works have been dispersed. *Sand-Lime Instar* is thus the final *Equivalent,* the ninth 'work': the installation itself."[19] Where the bricks were initially treated as interchangeable, arguments for the later version invoke claims of strict historical accuracy. But the wrong bricks also have a certain priority, since they were authorized by the artist at a time close to the work's inception. Perhaps the more important issue was the difficulty that the scattering of elements would have presented to organizers of a 1996 retrospective where the work was exhibited. Hesse regretted a similar decision to disperse the units that made up her 1968 *Sans II,* a fiberglass relief made from double rows of shallow boxes that presents a purposely eccentric version of minimal repetition. In Hesse's case, not only was her largest work separated, but because of its dispersal the fiberglass units have subsequently yellowed at varying rates—with the differences in their relative condition all too evident when they appeared reunited in the 2002 retrospective of Hesse's work.[20] The inconsistency in the bricks used for the eight dispersed *Equivalents* would have meant that their reunion would be marred by a conceptual inconsistency in some respects more acute than differences in condition. Regardless of its accuracy, however, the recent re-creation would be no more than a replica were it not for the artist's renewed assertion of authorship.

The history of art is filled with examples of artists who return to and reinterpret their earlier ideas. The question, then, is what constitutes the difference between a reinterpretation and a simple repetition. Art world customs driven by a market based on rarity insist on the distinction between a unique work and work produced in an edition. The convention of the limited edition developed in response to the inherent multiplicity of mechanical reproduction, as opposed to the assumed uniqueness of the hand-painted original. For works that could, seemingly, be duplicated, the artist's authorization provides the most significant differentiation or limit on production. Given the market imperative to control multiple copies, the existence of more than one authorized version of a work can have significant consequences.

In an unusual instance involving a hand-painted original that was also a copy, Frank Stella was taken to court by collectors Donald and Lynn Factor when they learned of another version of Stella's 1960 *Marquis de Portago.* The work was part of Stella's first series

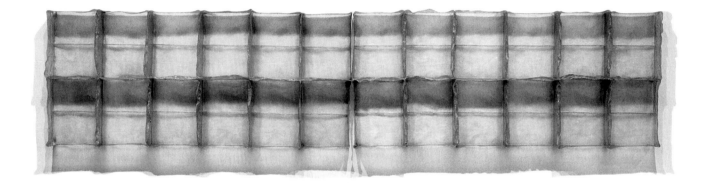

Eva Hesse, *Sans II,* 1968 (two
units). Polyester resin and fiber-
glass, 38" x 170" x 6⅛". Whitney
Museum of American Art, New
York. Reproduced with the permis-
sion of the Estate of Eva Hesse,
Galerie Hauser & Wirth, Zurich.

of shaped canvases, painted with aluminum paint on notched rectangular supports. The combined effect of their shaped surfaces, relatively deep stretchers, and the industrial aluminum paint used for their parallel stripes is the elimination of traces of illusionism in the work.[21] Furthermore, the paintings are necessarily conceived in advance of their execution, and this absolute unity of composition and support contributed to Judd's inclusion of Stella in his description of "Specific Objects" that he praised for being "neither painting nor sculpture."[22]

It was the existence of another version of *Marquis de Portago* that the Factors blamed when the reserve on the painting was lowered from $35,000 to $15,000 when it was put up for auction in 1970 (where it sold for $17,000). The painting that the Factors purchased was actually the second version of the work, done in a lighter aluminum paint. Stella painted two versions each of his first three aluminum paintings, using an identical format but changing from a darker to the slightly lighter shade that he then used for the remainder of the eight configurations in the series. But the history of the Factors' painting was still more complicated. Their work was damaged in 1964, and Stella agreed to repaint it, which he did in 1965 using a third type of paint. Caroline Jones quotes Stella to the effect that "people in California are only interested in perfection" as the reason why he completely repainted the work.[23] The Factors returned the damaged work to Stella, and they believed that it was their work, subsequently restored, that was in the collection of Carter Burden. Although Stella did eventually restore and sell the second version of the painting, the work in Burden's collection was the first version. In deciding the Stella case, the court found that "an artist has a duty to a purchaser of his work to inform the purchaser of the existence of a duplicate work which would materially affect the value or marketability of the purchased work." The other complications, however, led the judge to conclude that there was no evidence that the value of the work had been compromised, and therefore to decide in favor of Stella on the question of damages.[24]

Stella obviously painted the copy of his own work without intending to emphasize the paradox that Robert Rauschenberg made the subject of his play on the repetition of the apparently spontaneous gesture in his 1957 *Factum I* and *Factum II,* but what is interesting is that they were perceived by the collectors as being sufficiently similar in plan that the different versions were merely repetitions of one another rather than different interpretations by the artist. In response to a question posed by Bruce Glaser, Stella addressed the process of interpretation involved in moving from a plan to a painting: "A diagram is not a painting; it's as simple as that. I can make a painting from a diagram, but can you?"[25] The repainted version that became the source of contention does look quite different from the first version. The fact that the third version of the work was painted with the type of metallic

Frank Stella, *Marquis de Portago* (second version), 1960. Aluminum oil paint on canvas, 7' 9½" × 5' 11½". © 2002 Frank Stella / Artists Rights Society (ARS), New York.

paint that Stella was using in 1965 also shows how his own interpretation of the diagram changed over time, so that rather than being a duplicate of a work based on the same composition, it was a new interpretation of that idea based on the artist's shifting aesthetic concerns. These questions about how much one interpretation of a composition might differ from the next, and the potential separation between plan and execution, took yet another peculiar twist when Stella's work became the subject of a pseudonymous parody article entitled "The Fake as More," included in Gregory Battcock's 1973 *Idea Art,* concerning copies of Stella's work by the imaginary artist Hank Herron described as identical to Stella's originals in appearance, yet entirely different in content.[26]

Works produced by methods that employ rather than simply suggest industrial manufacture may be accompanied by written confirmation of the work's authenticity and uniqueness. The history of a work—its provenance—has long provided important evidence of authenticity, even for works that bear marks of the artist's hand. As internal or material evidence of a work's history is lessened, however, external measures are increasingly important. For Giuseppe Panza, the Italian collector who amassed a significant collection of postwar American art particularly notable for the minimal and conceptual works that he purchased early and often in great depth, issues of documentation were especially crucial. The importance of these documents was later highlighted both by his public disagreements with several artists represented in his collection and by questions about the status of some of the works included in the sale of his extensive collection of minimal and conceptual art to the Guggenheim Museum. It was not just a matter of having certificates to substantiate the authenticity of objects that did not carry evident traces of authorship; in a number of instances the piece of paper was the only evidence of Panza's possession of the work.

Panza's collecting habits give new meaning to the description "works on paper," since many of the works in his collection were acquired on the basis of plans rather than extant physical objects. Panza's archives, now housed in the Special Collections division of the library of the Getty Research Institute, are filled with various examples of certificates and agreements and with the traces of his efforts to secure such documentation. While such certificates and other forms of authentication are increasingly used, they are much more rarely reproduced. The publications and documents surrounding Panza's collection provide the most revealing window onto such practices. In addition to charting Panza's own growing concern for this documentation, his archives also reveal some of the steps taken by artists in his collection to organize and regularize their own use of such documents.

Panza's resolve to have documentation certifying the works in his collection was clearly strengthened by an early incident involving Bruce Nauman's projects for various

types of installations. In a 1971 letter, Douglas Christmas of Ace Gallery made passing reference to plans for two versions of Nauman's installations, one for the North American market and one for Europe. Panza responded to this information with urgent letters to Nauman's galleries and Nauman himself expressing alarm at the idea that he did not have exclusive rights in the works he had purchased in the form of plans. The result was a decision by Nauman's dealers not to pursue the sale of multiple versions, and assurances from Leo Castelli that all of the works Panza had purchased would remain unique. The Castelli Gallery also provided Panza with certificates for several works in the form of photographic documentation signed on the back by the artist.[27]

Starting in 1974, however, Nauman also signed a series of typed certificates for the installations that Panza had already purchased in plan, with the main provisions contained in three sentences that declare Panza to be the owner of the work, that entitle him to realize and to assign the right to realize the work, and that guarantee the following: "I certify that the above work is my original and unique creation, and I undertake not to do, realize, sell, or authorize the same work." (In fact Nauman canceled out the last five words of the statement, which originally called on the artist to make a remarkably broad promise to Panza: "I certify that the above work is my original and unique creation, and I undertake not to do, realize, sell, or authorize the same work *and or of similar work.*")[28] The language of the certificate would therefore ensure that Nauman would not authorize competing versions of works that Panza had bought as the right to realize a particular constructed configuration. Nauman generally added provisions requiring his approval for reconstructions, and specifying that the original drawing had to accompany the work. There are also important distinctions within Nauman's work regarding what can and cannot be replicated. The installations sold as plans allow for a certain amount of latitude with respect to exterior support in situations where the significant experience is the interior space. For the neon pieces, an actual object does change hands, but the fragile originals can be represented by exhibition copies as long as those duplicates are then destroyed. Many of his other works exist as unique objects that cannot be replicated.[29]

The vicissitudes of the Panza collection provide a telling demonstration of what can happen in the gap between plan and execution when the collector's conception of the work is shaped by conceptual practices. If, as Buchloh has suggested, many developments in conceptual art can be traced to the minimalist artists chosen as reference points, it is also important to consider how readings of minimalism have been subtly shifted by the subsequent intervention of conceptual practices. Part of the tension inherent in Panza's approach emanated from his insistence on relying on linguistic and legal conventions to frame his understanding of works while the artist remained committed to the material

object. A collector who takes over the production of the work may shape the work in strange and unexpected ways, as Panza's conflicts with Judd, Andre, and Flavin demonstrate. Flavin protested when a number of his large-scale works were reconstructed without his knowledge or participation for a 1988 exhibition of the Panza collection at the Centro de Arte Reina Sofía in Madrid. The most publicized, however, were Andre's and especially Judd's denunciations of the 1989 Ace Gallery reconstructions, with which I opened this book.

What could have made Panza think it was acceptable for him to authorize these reconstructions? While it does indeed seem unusual that he should have taken such a liberty, an examination of his collection archives reveals the equally extraordinary fact that Judd signed a series of certificates that did grant Panza remarkably broad authority over the works by Judd in his collection—far greater authority than he was given by Nauman's agreements or those of many other artists in his collection. The emphasis on plan also highlights a form of temporality different from the kind described by the experiential reading of minimalism: namely, the temporal gap between idea and realization. The delay between the drawing of a diagram and the execution of an object by industrial fabricators, in the case of Judd, or the acquisition of specific fluorescent fixtures, in the case of Flavin, was initially not a significant consideration. Judd was forced to spread out the production of many of his early works simply because he could not afford to have all his ideas fabricated at once. But Panza's acquisition of plans that he did not immediately have realized became the source of increasing tensions.

Pieces that Panza collected in his version of works on paper included installations that had already been realized for temporary exhibitions and then disassembled or destroyed, and planned works that had yet to be realized. Shipping the idea rather than the object was in many cases a convenience that saved Panza transportation and storage costs as well as the import taxes assessed for physically extant works of art. Purchasing what he termed projects also allowed him to acquire larger-scale examples than would otherwise have been practical to collect, including installations that would have to be adjusted for their particular site when realized. Throughout the time he was collecting minimal and conceptual art Panza was constantly thinking in terms of finding a museum for his collection, so that he was buying not just for his own villa at Varese but with the idea of a much larger-scale museum project that was continually deferred. For this reason, Panza was in no particular hurry to realize many of the works he had purchased in the form of plans, particularly those that would need to be specific to the dimension of their site.

The ad that Judd took out in *Art in America* to disclaim authorship in the re-creation Panza authorized at Ace Gallery was the public eruption of tensions that had been sim-

mering between the artist and the collector for much of the 1980s. Their origins can be traced back even further, to two large purchases comprising a total of fourteen large-scale works by Judd that Panza made in 1974–1975 through the Castelli Gallery. A number of the works had already been exhibited, and two are noted as existing in other versions. Nonetheless, the letters of agreement covering the works, drawn up in 1974 and signed by Judd in May of 1975, indicate that all were sold to Panza in the form of plans for works to be fabricated at Panza's expense. The purchase included three rows of boxes, two to be made from wood and one from steel, one galvanized iron and one brass wall of boxes, two aluminum tubes, and a number of room installations. These installations were described as two plywood wall pieces that had first been shown at the Lisson Gallery, London, in 1974, a galvanized iron wall, a double steel wall open, another steel wall, a double copper wall closed, and a single steel wall bent. All of the large-scale works would incorporate the walls of the spaces in which they were realized, and in fact Panza built only one such work, the untitled installation catalogued by Panza as *Galvanized Iron Wall* that became the subject of the controversial Ace Gallery exhibition.

It was around the time of this major purchase that Panza was increasing his efforts to get certificates and other documentation for the work in his collection. In 1975 and 1976 Judd signed a series of certificates that were remarkably broad in the latitude granted to Panza. These certificates covered not only works sold as plans, but Panza's earlier purchases of realized works by Judd that had been shipped to Italy in the traditional fashion. For Judd's works that already existed, key provisions included assigning Panza and his successors the right to reconstruct the work in the event that it was dismantled, destroyed, stolen, or lost, as long as instructions and documentation provided by Judd were followed and either he or his estate was notified; provisions for temporary exhibition copies, as long as the temporary copy was destroyed after the exhibition; and, most astonishingly, the right to recreate the work to save expense and difficulty in transportation as long as the *original* was then destroyed. Further conditions included the owner's right to request the artist's approval for such reconstructions (though with the further proviso that such approval was not necessary as long as the work was realized according to specifications) and the artist's declaration that the work was original and unique. On the majority of the certificates for extant works, the sole exception noted by Judd was the limitation that the pieces should be remade only by Bernstein Brothers (Judd's usual fabricator for works in metal). Many of the files for extant works also contain blueprints prepared in Italy at Panza's behest, and some of these are also signed by Judd, again with the Bernstein limitation noted. The certificates for not yet constructed works are equally inclusive in the rights

granted to Panza to make and remake the works, with relatively limited exceptions noted by Judd for certain of the pieces.[30]

"Panza is not a very good artist" was Judd's angry condemnation in a multipart manifesto he published in 1990 denouncing the works that Panza had fabricated.[31] But in the mid-1970s it apparently did not occur to Judd that in selling works not yet realized he could in effect be assigning his right as an artist to author his own work. The language of the certificates is at the heart of the subsequent dispute. Rather than establishing an understanding between artist and collector, they laid the groundwork for future misunderstandings when Panza began to exercise the substantial authority over the work that they granted. Perhaps it was precisely because he did not think of his work in conceptual terms that Judd did not consider the implications of the language in the contractlike certificates he endorsed. Robert Morris signed similar agreements, but for Morris the provisions had a certain logic, since the remaking of the works for different exhibitions had been part of his process for a number of the works Panza purchased. Other artists were more cautious about the language of the certificates or agreements they provided.

Panza's extensive records for the works in his collection are filled with the traces of an ongoing series of negotiations and requests between 1975 and 1980. Some of the requests were from Panza, asking for further clarification about works or requesting permission to make substitutions. Other correspondence from Judd or his representatives concerned specific questions about fabrication and suggests some degree of flexibility during the first few years after the purchase of the planned works. Panza apparently asked Judd about substituting wood for a piece bought as an aluminum tube with a parallelogram inside, since Judd, in a November 1976 letter, told Panza that it had to be metal and asked whether he was sure that the required aluminum sheets were not available as a special order. Further correspondence indicates that Judd eventually agreed to substitute hot-rolled steel for this and another work described as a straight single tube. A 1979 purchase order prepared for Panza and signed by Dudley Del Balso, Judd's assistant, appears to confirm the substitution of hot-rolled steel for the tube with the parallelogram inside; and the file for the single straight tube, a work that was fabricated by Panza, contains copies of drawings by Judd specifying construction details for both the aluminum and the hot-rolled steel versions.[32]

The works fabricated by Panza demonstrate the importance of subtle shifts in materials and methods as well as the degree to which Judd's conception of an accurate rendition of the work differed from Panza's. Variations on different themes appear throughout Judd's career, with the cantilevered stacks, rows of boxes, and horizontal progressions shifting scale and changing color and material. Judd considered each of these variants a different work (as opposed to those works that he created in identical editions). Furthermore, a

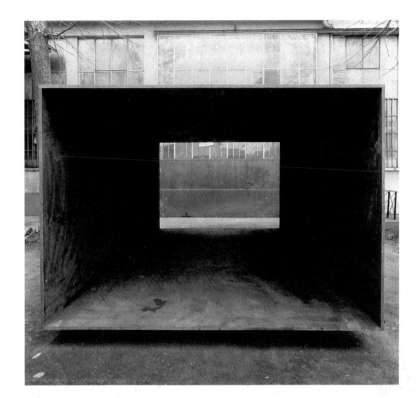

number of the works Panza purchased were very open-ended indeed, with the dimensions or number of units not yet set at the time of their purchase, so they could not be realized until Judd finished conceiving the work. Panza's request to change materials is in one sense consistent with Judd's own production of variants, but in another sense is highly unusual, since for Judd these variations constitute different works. Panza's collection included, for example, a 1971 row of eight 48 x 48 x 48-inch boxes made from cold-rolled steel and painted with orange enamel that was identical in material, scale, and configuration to a 1967 work painted in burnt sienna enamel in another collection.[33]

In a 1971 interview, Judd described the form of his work as "given in advance."[34] There is a suggestive echo of the process Sol LeWitt outlined in his 1967 "Paragraphs on Conceptual Art": "When an artist uses a conceptual form of art, it means that all of the planning and decisions are made beforehand and the execution is a perfunctory affair. The idea becomes the machine that makes the art."[35] LeWitt's use of simple, modular forms and the relative neutrality of white or sometimes black paint for his cube constructions reflected his desire to allow the viewer to apprehend the idea that generated the construction. The

Donald Judd, *Untitled* (straight single tube), 1974. Hot-rolled steel, 60" × 144" × 84". Solomon R. Guggenheim Museum, New York, Panza Collection, 1991. Art © Donald Judd Foundation / licensed by VAGA, New York. Photo © The Solomon R. Guggenheim Museum Foundation, New York.

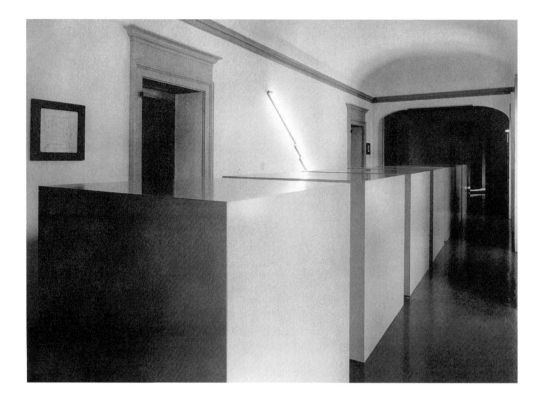

Donald Judd, *Untitled*, 1971. Orange enamel on cold-rolled steel, eight units 48" × 48" × 48" each, 468" long overall. Solomon R. Guggenheim Museum, New York, Panza Collection, 1991. Art © Donald Judd Foundation / licensed by VAGA, New York. Photo © The Solomon R. Guggenheim Museum Foundation, New York.

ideas for Judd's works tended to be even more basic than those of LeWitt, consisting of the repetition of identical forms or simple mathematical progressions that he realized in a variety of materials and sizes. But Judd's motivation for advance planning was not an emphasis on concept or idea; rather, his goal was to achieve a sense of unity, so that "it doesn't look as if it is just done part by part visually."[36] For all that he was farming out production, he still assumed that he would be involved with decision-making over its course and would give final approval only on the basis of the realized work. "Even if you plan the thing completely ahead of time, you still don't know what it looks like until it's right there," Judd told Glaser in 1964. "You may turn out to be totally wrong once you have gone to all the trouble of building this thing."[37] The initial sketch was simply that, to be followed by a more detailed plan for realization, sometimes in consultation with his fabricators.

Judd had the opportunity to see the examples of his work fabricated under Panza's direction during a visit to Varese in the summer of 1980, and the result was an extensive letter written on Judd's behalf by James Dearing, another of his assistants, outlining Judd's concerns. The letter contains instructions to change the overly shiny screws in the plywood pieces and expresses concern about the roughness of the metal in a steel tube and a group of

eight steel boxes. It also addresses the only large-scale installation realized by Panza, the wall made from galvanized iron, which was installed in a room with an uneven, sloping floor that Judd reportedly felt detracted from the piece. The suggested solutions include adding a second wall, thereby transforming the work into a new piece, or removing it entirely and exchanging it for a completely different piece to be made for the room—a trade that would involve no new purchase price, but would require Panza to pay for fabrication of the new work. Dearing also reiterated the importance of Judd's final approval for all installations.[38]

Judd was also concerned about questions of permanence for his site-specific works. The issue came up even before the Ace Gallery incident, when Panza loaned one of the works he had not yet realized to the Los Angeles Museum of Contemporary Art's 1983 "First Show." Judd insisted that Peter Ballantine, his usual carpenter for works in plywood, be hired to realize the MOCA installation, and was then disturbed when Panza wanted the piece to be unrealized at the end of the show: "We wrote to Panza that the work at MOCA existed, finally, and that if it was destroyed, it was destroyed. Panza thought, as always, that the work could be made over again for another space of different dimensions. Forever and forever."[39] Apparently Panza had not expected his purchase to be depleted by a single realization for a temporary exhibition. Yet it is also not clear how Judd went about deciding the exact number of times a piece could be realized, since the plywood piece installed at MOCA was already a repeat from Judd's 1974 Lisson Gallery exhibition. Judd was equally adamant about the galvanized iron wall, even though it, too, was a second version of a work that had been shown at the Castelli Gallery in 1970 and the Pasadena Museum in 1971: "Since in some works the dimensions could be altered according to the space available, Panza assumed that he could do this as well as me. And then destroy the work and do it again differently, forever. But these alterations in some works involving whole spaces are mine to decide, not anyone's. And, if a work is installed permanently, that's it."[40] Judd's suspicion was that Panza wanted to make sure that the works would remain portable, and therefore salable: "I can only guess that Panza had second thoughts about the permanency of the work in Varese and realized that by putting it in the shop window he had removed it from sale."[41] In Judd's view, the installations at Varese were a marketing tool for Panza's collection but, paradoxically, the installation of the site-specific works meant that they were no longer available to be loaned or sold.

Panza would later claim that Judd's fabricators were too expensive, the works in question being "geometrical cubes or parallelograms, which could be easily made by any factory with good machinery and material."[42] And where Judd did not specify a particular fabricator, his agreements with Panza only required construction in the designated materials with a general provision for good workmanship. Although Panza drew some distinctions between minimal and conceptual art, he nonetheless assigned a great deal of authority to

the collector: "Minimal art is closely connected to the project, and the collector has the right to produce it, but his freedom of interpretation is very limited. He must simply see to it that the fabrication conforms to the project."[43] In response to an interviewer's question about his conflict with Judd, Panza stated: "The artist cannot control what goes on outside his studio. When a work changes owners, it starts on another life."[44] While this may be largely true for an easel painting, which has traditionally been assumed to be essentially self-contained and transportable, the issues are far more complex for works that depend on establishing a relationship to their surrounding space. Panza assumed substantial authority for his own realizations even as he was intent on precluding the possibility that the artists might authorize additional versions of works he had purchased.

Subsequent to these conflicts, Panza proposed that future disagreements about the realization of Judd's work should be decided by an independent expert appointed by the lawyers representing Judd and Panza. According to Judd, "to even begin to argue" against this proposal "makes me feel already within the door of the insane asylum."[45] Certainly Panza's suggestion that he and Judd should settle a dispute about artistic authorship with the help of their lawyers has an unreal quality. However, the language of the certificates Judd signed contributed to the circumstances in which Panza could think of authorship as a legally defined and transferable power rather than a gesture innate to the artist, and could therefore propose relying on the authority of contract law rather than on the expertise of the artist to make decisions about how to realize the artist's work.

Judd's general level of indignation also extended to Panza's publication of what he saw as private agreements in *Art of the Sixties and Seventies,* the 1988 catalogue of his collection. The catalogue does present a rather strange record if one asks just what exactly is being documented. Intermixed with the installation photographs and certificates are purchase orders signed by Judd's assistant that describe changes in materials or even complete exchanges of works for the unrealized pieces. Many of the photographs also date from previous exhibitions of works that Panza bought as plans and never himself realized. The 1988 catalogue and the slightly revised 1999 edition make a tacit argument for the connection between minimal and conceptual art by presenting both through an intermix of photographs of objects and installations and reproductions of plans, diagrams, certificates, and other documentation.

For Flavin it turned out that the photographic records of his early installations became the basis for Panza's later reconstructions. One advantage of selling plans not only for future works but for works that had existed and were then destroyed was the creation of a retroactive market for works that had not sold, or were perhaps barely considered salable at the time of their initial appearance. Flavin experienced his own frustrations, however, with the partial and long-delayed realization of the works from the group of large-scale installa-

tions Panza bought through the Heiner Friedrich Gallery in 1973. The seven works consisted mainly of installations that had previously been realized and then destroyed after being exhibited, along with one to be made specifically for Panza's villa in Varese. Flavin's contract included a three-year deadline (counting from 1974) for the completion of the installation.

Flavin supervised the realization of two of the works in Varese, including the 1976 *Varese Corridor* that he designed for the site. According to the letter of the agreement, Panza's right to have the other works built expired in 1977, though Flavin did continue to express interest in their implementation and in 1983 helped reconstruct a barrier installation, the 1968 *Untitled (to Flavin Starbuck Judd)* for MOCA's "First Show." Flavin was therefore surprised to find out that the 1988 exhibition of Panza's collection at the Reina Sofía included a version of the Varese corridor as well as a number of works like the 1966 *Greens Crossing Greens (to Piet Mondrian who lacked green)* that Flavin had never rebuilt. "You purchased *finite* installations of fluorescent light from me," Flavin wrote to Panza. "You have no right whatsoever to recreate, to interpret, to adapt, to extend, to reduce them."[46] As far as Flavin could tell, Panza had reconstructed *Greens Crossing Greens* from a monochrome photograph of its initial installation.[47] Panza had the expired agreement, for which he had paid in full, but he otherwise had little evidence to support his ownership of the unrealized works that he had bought. Although he had repeatedly requested certificates, Flavin adamantly refused to issue them for works that did not exist. Whereas Panza wanted the certificates to ensure his future rights to realize the works, Flavin would only issue certificates to validate those that existed. Their difference over this administrative procedure points to a deeper divergence about the priority that the rhetoric of the certificate has over the work.

What happens when language is used to communicate the artist's intent and the artist misspeaks? One drawback to depending on descriptions rather than the evidence contained in a material object is the problem of ambiguity or even error. In a couple of cases Panza was actually confused about exactly which work he had bought. Correspondence between Panza and Castelli records Panza's uncertainty about whether he had bought the version of Nauman's 1972 *Floating Room* that was lit from inside, or the one that was light outside and dark inside. The source of the problem is evident in the catalogue of Panza's collection, where the title line in the standard typewritten certificate reproduced for *Floating Room (Light Outside, Dark Inside)* has been filled out in Nauman's hand as *Floating Room (light inside, dark outside)*.[48] It is also noteworthy how remarkably inadequate many of the pieces of paper in Panza's archives are as guidelines for the creation of physical objects and, by extension, as statements of artistic intent. In the case of Nauman's 1973 *Yellow Room (Triangular)*, the lack of information has led to markedly different versions even

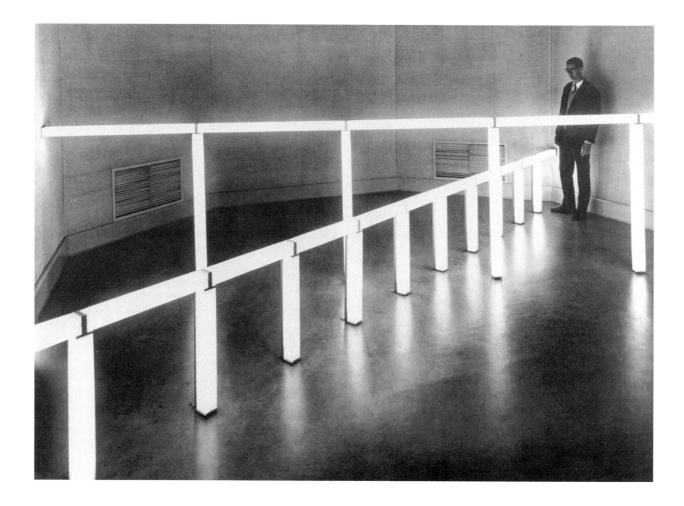

Dan Flavin, *Greens Crossing Greens
(to Piet Mondrian who lacked green)*,
1966, installed in "Kunst Licht
Kunst," Stedelijk van Abbemuseum,
Eindhoven, 1966. © 2002 Estate
of Dan Flavin / Artists Rights Soci-
ety (ARS), New York. Photo courtesy
the Research Library, Getty
Research Institute, Los Angeles.

though the work had been realized once before being sold. Early photographs of the work clearly show a white interior. However, Konrad Fischer apparently sold the work to Panza with limited documentation, and a copy of a drawing by Nauman in the files indicates overall shape rather than construction specifics. While the room was reconstructed for the 1994 Nauman retrospective with a white interior, Panza's version had bare wood inside, and it was in this form that the work appeared in a 1999 MASS MoCA exhibition drawn extensively from the Panza collection now at the Guggenheim. Needless to say, the jarring effect of the unrelentingly bright yellow light reverberating in the glare of the triangular white space made for a very different experience from the one afforded by the color and varied grain of the wood in the competing interpretation of the work. Panza also had questions about which work he owned from Andre's 1968 *Slope* series, made up of rows of plates extending out from a wall at an angle determined by the dimensions of the plate next to the wall, since Panza had a certificate labeled *Slope 2002*, but catalogue listings indicated that he owned *Slope 2001*.[49]

If the certificate had, for Andre, constituted the primary evidence of the work, then its definition of the work would logically have to be correct. However, Andre's emphasis, in this case, on the importance of the work's physical existence, together with the fact that he had already refused another suggestion that one of his works be refabricated rather than shipped for MOCA's "First Show," make Panza's decision to have Andre's 1968 *Fall* refabricated for the 1989 Ace exhibition that much more remarkable. Nor did Panza succeed in authorizing a convincing replica of the work. *Fall* is made from one-inch-thick hot-rolled steel, bent at a right angle to form twenty-one 72 x 28 x 72-inch units arranged along the base of a wall in a 49-foot row. But photographs of the Ace version show that the bend in the steel was far less sharp than in the original. After finding out about the refabrication from a review, Andre insisted in a letter to *Art in America* that "No such 'refabrication' of my work has been authorized by me and any such 'refabrication' is a gross falsification of my work."[50]

If Panza's attitude toward the work in his collection was shaped by conceptual practices, the model could well have been the wall drawings that LeWitt began producing in 1968. For these works, the only object that is actually transferred is a certificate, accompanied by a diagram with instructions for the realization of the drawing. The wall drawings can even exist for a limited period of time in more than one place if a drawing that is already installed is loaned to a temporary exhibition. LeWitt specifically connects the wall drawings to "a musical score that could be redone by any or some people."[51] Furthermore, he has stipulated that they should not be maintained as artifacts: "I would hope that wall drawings would be periodically redrawn if necessary. As the wall becomes older it may

Bruce Nauman, *Yellow Room (Triangular)*, 1973. Wallboard, plywood, yellow fluorescent lights, dimensions variable; 120" x 177" x 157" as installed at Galerie Konrad Fischer, Düsseldorf, 1974. Collection of the Solomon R. Guggenheim Museum, New York, Panza Collection, 1991. © 2002 Bruce Nauman / Artists Rights Society (ARS), New York. Photo courtesy Sperone Westwater, New York.

crack, have water damage, etc. Also the wall drawings may become soiled, colors change, etc. The new site may be different, as long as the plan is followed."[52] And in fact Panza amassed an extensive collection of LeWitt's wall drawings, many of which are reproduced in the collection catalogue in the form of the certificates and diagrams issued by LeWitt to purchasers of these works. But even though LeWitt wanted to have the instructions exhibited together with the realized wall drawings, he has insisted that they are insufficient in themselves: "The plan exists as an idea but needs to be put into its optimum form. Ideas of wall drawings alone are contradictions of the idea of wall drawings."[53] For the wall drawings, as for the other works he had amassed, Panza was able to display only a limited part of his collection, though the storage requirements for the wall drawings not on display were markedly negligible.

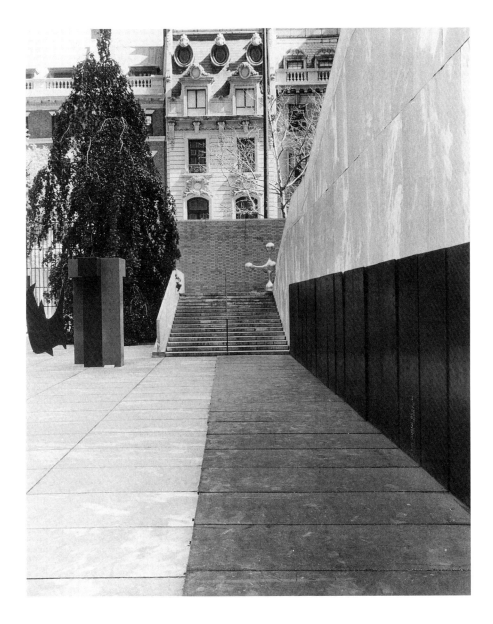

Carl Andre, *Fall*, 1968. Hot-rolled
steel, 21 sections, each 28" wide,
overall 6' high x 49' long x 6' deep.
Installation at the Museum of Mod-
ern Art, New York, 1968. Courtesy
Paula Cooper Gallery, New York.

Panza is not the only collector or institution to have grasped that there can be advantages in the dematerialization of the object—or to have tried to apply those principles broadly. Even for LeWitt, the emphasis on plan rather than object can turn into a convenience against which he has to guard his work, since he makes a distinction between different types of works within his production. LeWitt therefore vetoed a request from the Wadsworth Atheneum to avoid shipping costs by having his 1965 *Standing Open Structure, Black* refabricated for an exhibition in Europe. In answer to the question about refabricating the sculpture, LeWitt asked, rhetorically, "Would you repaint a Mondrian?" According to LeWitt, "A wall drawing may be duplicated in another site while an object (a work of art in this case) can be physically transported and should be."[54]

What is the work? Where is the work? When is the work? The answers to these questions have become increasingly complex and interwoven. For site-specific installations, where and when may be inseparable, since removal of the material that has been used to make the work at a particular site may equal the destruction rather than the transfer of the work. Panza's attitude toward the site-specific installations at Varese was the root of some of his disagreements with the artists represented in his collection, but by far the most famous contest for control over the future of a site-specific sculpture was the battle waged between Serra and the United States General Services Administration.

The legal battle that Serra waged in an attempt to prevent the GSA from removing and thereby destroying *Tilted Arc* showed the limits of the artist's ability to control the fate of the work in the face of a transfer of ownership. Serra determined the nature and placement of the work for Federal Plaza in lower Manhattan after extensive study of both the site and the pedestrian traffic patterns in the plaza. The 12-foot-high, 120-foot-long arc framed the experience of moving across the space as one walked the outside of the curve or along the side where the inward lean added to the sense of enclosure established both by the wall itself and by its relation to its surroundings. The strategic redefinition of this site-specific work was an important issue in the conflict over *Tilted Arc,* since the GSA continued to insist throughout the dispute that its intention was simply to "relocate" the sculpture to another site. In that instance, the denial of the work's site-specificity was a strategic maneuver by a government agency intent on removing Serra's work. Serra's failure to prevent the destruction of the work also highlighted the fact that the United States lagged far behind many other countries in the legal recognition of integrity or moral rights in works of art that supersede ownership rights.

As it was, the court decisions turned on questions of contractual language as well as issues of ownership over expression. When the GSA commissioned *Tilted Arc,* Serra had signed the Art-in-Architecture Program's standard contract, which included the stipulation

that the work "may be conveyed . . . to the National Collection of Fine Arts—Smithsonian Institution for exhibiting purposes and permanent safekeeping." Though Serra had received verbal assurance from a representative of the GSA that it intended to install the work permanently, agents of the GSA subsequently used the language of the contract to support its campaign to remove *Tilted Arc* from the plaza.[55] Both the district court and the court of appeals decided against Serra, denying his arguments based on the freedom of speech guaranteed by the First Amendment to the US Constitution on the grounds that Serra had sold his speech (the *Tilted Arc*) to the government and had therefore relinquished any further right to control its configuration. The decision by appeals court judge Jon O. Newman is particularly revealing: "While we agree that artwork, like other nonverbal forms of expression, may under some circumstances constitute speech for First Amendment purposes, we believe that the First Amendment has only limited application in a case like the present one where the artistic expression belongs to the government rather than a private individual. . . . In this case, the speaker is the United States Government. Serra relinquished his own speech rights in the sculpture when he voluntarily sold it to GSA."[56]

The idea that the work of art should not be altered or destroyed derives from a belief that it should remain true to the vision of the artist. Although such rights only became part of United States law with the passage of the 1990 Visual Artists Rights Act, many precedents exist, particularly in French law, where the early articulation of *droit moral* was part of an attempt to wrest control over artistic production from the hands of the sovereign at the time of the French Revolution. Moral or integrity rights are also sometimes known as personality rights, presupposing an intimate connection between the artist's self and the work of art he or she creates. It is on this basis that the right of artists to prevent alteration or destruction of their work has been articulated as one that supersedes property rights. Interestingly, these "personality" rights have, if anything, gained in significance for works from which traditional markers of touch or presence have been excluded. However, if there is no agreement about what constitutes the work, then it may be difficult to determine whether a work has been compromised or destroyed. Work that depends on a relationship to a particular site presents a special challenge, but it is not the only type of work that raises questions about what degree of alteration is possible, and under what circumstances slight changes can lead to a catastrophic failure of the work, or of authorship.

To see the divergent possibilities that emerge from these moments of contested authorship, one has only to ask: What happened to the scrap metal? For the Whitney there was no scrap metal, since the museum never accepted Andre's redesignation of the *Twenty-Ninth Copper Cardinal* and continued to proceed on the assumption that the group of metal squares they had purchased as a sculpture remained a sculpture. For the museum,

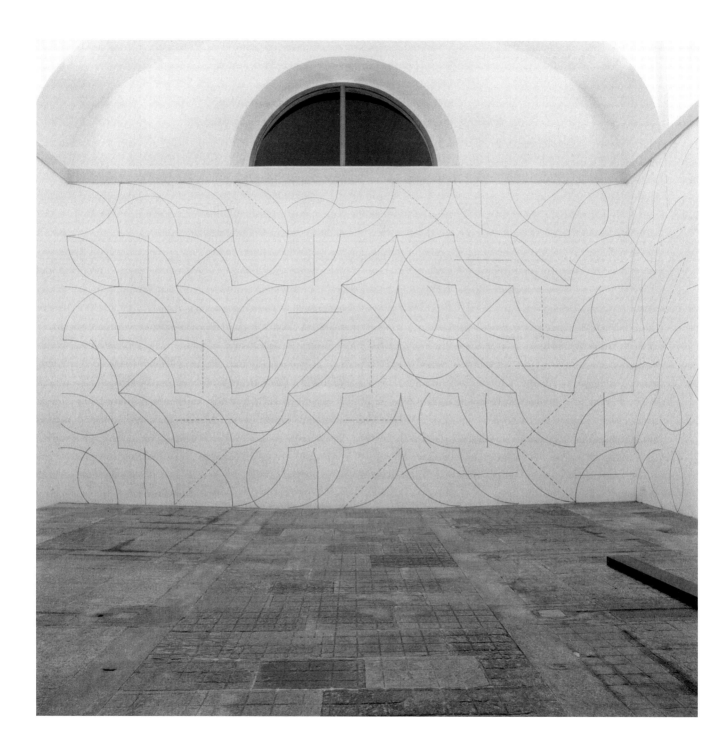

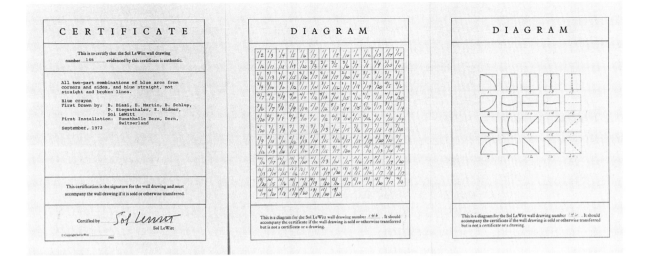

the work that had existed continued to exist. Judd insisted that the work Panza authorized for the Ace Gallery be immediately disassembled, and in order to make sure of its eradication he took the metal away with him after paying the gallery its price as scrap.[57] For Judd the Ace Gallery version was never a work. With respect to *Tilted Arc*, the GSA insisted that it only wanted to relocate a work that it did not accept as site-specific. To support that assertion it had to hold on to the residue of the work, so for a number of years the plates that had been cut out from the plaza sat in a heap in a GSA parking lot. For Serra it was a work that had existed but was then irrevocably destroyed.

In the aftermath of *Tilted Arc*'s destruction, Serra developed his own contracts for his sculptures that are designed to prevent changes not only in site-specific works, but also in the relationship among the individual parts that constitute a piece or in the relationship between a work and the type of site for which it is made. Nor is Serra alone in his use of contracts to control the long-term disposition of the work. The exercise of such mechanisms has reflected increasing activism on the part of artists over how their work might be used. The impetus in 1969 for the establishment of the Art Workers Coalition, which provided a forum for some of these discussions, was an artistic protest about the inclusion of a work by Takis Vassilakis in MoMA's "The Machine at the End of the Mechanical Age" that the artist did not feel properly represented his development.[58] In the context of activism often linked to a broader political agenda, the AWC articulated a series of demands regarding museum governance, exhibition policies, and artists' control over the disposition of their work even after its sale—with this last provision expressed in one of its

Above: Sol LeWitt, certificate and diagrams for *Wall Drawing no. 146.* Reproduced courtesy the artist. © Sol LeWitt. Photo © Giorgio Colombo, Milan.

Facing page: Sol LeWitt, *Wall Drawing no. 146 (all two-part combinations of blue arcs from corners and sides and blue straight, not straight and broken lines),* 1972. Detail of the installation, Villa Menafoglio Litta Panza, Varese, Italy. Collection of the Solomon R. Guggenheim Museum, Panza Collection Gift, 1992. © 2002 Sol LeWitt / Artists Rights Society (ARS), New York. Photo © The Solomon R. Guggenheim Foundation, New York.

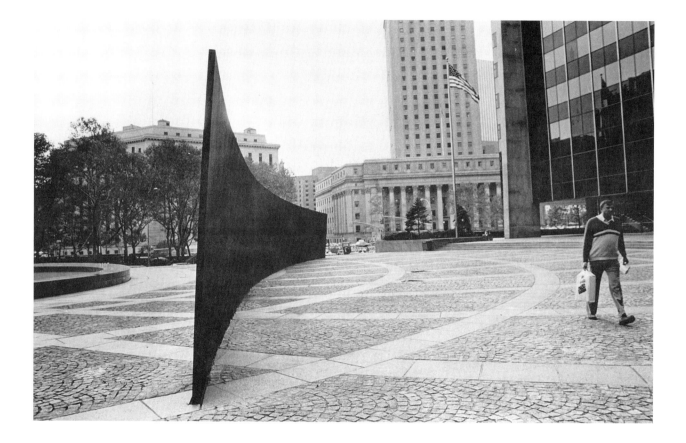

Richard Serra, *Tilted Arc*, 1981.
Weatherproof steel, 12' × 120' × 2½".
Installation at Federal Plaza, New
York; destroyed March 15, 1989.
Courtesy the artist. Photo: David
Aschkenas.

more extreme forms in LeWitt's 1969 declaration that the artist "should have the right to change or destroy any work of his as long as he lives."[59]

Both Jackie Winsor and Hans Haacke have long used contracts to control the placement as well as the transfer and dissemination of their work, with Haacke's agreement based on a contract developed by Robert Projansky and Seth Siegelaub that was circulated in the early 1970s.[60] One of the more remarkable contracts, however, resulted from Panza's attempts to purchase a work by Michael Asher. Both Heiner Friedrich and Nicholas Longsdail of the Lisson Gallery offered to sell Panza installations Asher had realized for the Heiner Friedrich Gallery in Cologne, the Lisson Gallery in London, and the Toselli Gallery in Milan. It was not clear, however, how they expected to effect the transfer and reconstruction of these highly situation-specific works, each of which incorporated a response to the particular conditions of the gallery in which it was realized. Asher and Panza eventually began negotiations for a work that would be planned specifically for Panza. Although that sale, too, was ultimately never completed, the challenge of trying to purchase a work generated by Asher's extremely site- and situation-specific working method was articulated in an eight-page contract that included provisions tightly limiting and controlling the circumstances under which the work could be reconceived for another site, a requirement for consent from Asher for assignment or transfer of the work, ownership by the artist of any drawings or documents relating to the work, and even a paragraph outlining the degree to which Asher's other work might or might not resemble the commissioned work.[61]

How does a work come to exist in the first place? And what are the circumstances of its continuity? Morris's *Statement of Esthetic Withdrawal*, with its declaration witnessed by a notary public, presented a playful intersection of legal and artistic authority. In fact, Buchloh found in *Statement* an early instance of linguistic and legalistic conventions that were to become a key strategy for conceptual art. Ultimately Lawrence Weiner extended this idea to include registering ownership of the linguistic statements that formed the basis of his work with Jerald Ordover, his lawyer, who maintained a record similar to a centralized copyright or trademark registry. Yet the legal rhetoric so prominent in conceptual art also makes an appearance in the graph paper certificates that Flavin issued for realized works, including many in Panza's collection, which validated the authenticity of the work with both the artist's signature and the imprint of a New York corporate seal in the name of Dan Flavin, Ltd. and the date of 1969.

A certificate covers a wide range of purposes. It can simply provide added assurance about the authenticity of a physical object that has a continuous existence; it can represent the continuous existence of an idea that does not have an ongoing physical presence; and it can describe a work not yet made that can be realized on the basis of the certificate. In the

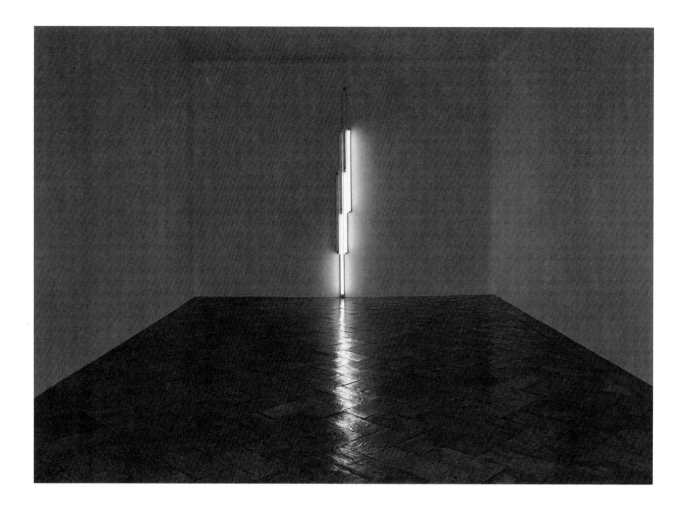

Dan Flavin, *Untitled 6B*, 1968. Red
and green fluorescent light, 120"
high. Installation at the Villa
Menafoglio Litta Panza, Varese,
Italy. Collection of the Solomon R.
Guggenheim Foundation (Panza
Gift) on permanent loan to Fondo
per l'Ambiente Italiano. © 2002
Estate of Dan Flavin / Artists Rights
Society (ARS), New York. Photo ©
Giorgio Colombo, Milan.

4' red

6B/ untitled

from the exposition
"two primary series and
one secondary"
May - July 1968
Galerie Heiner Friedrich
München

4' red 4' green

4' red 4' green

4' green

fluorescent light
10' high

Dan Flavin

a certificate only

Certificate for Dan Flavin, *Untitled 6B*. © 2002 Estate of Dan Flavin / Artists Rights Society (ARS), New York. Photo © Giorgio Colombo, Milan.

case of Dan Flavin, Ltd., certificates played an important role in the marketability of pieces where the physical object was made from off-the-shelf elements, some of which require periodic replacement. Such declarations constitute a form of control over the work that the artist can take advantage of or even play with. However, their significance as a form of proof-of-purchase is corroborated in correspondence from galleries in Panza's files assuring him that the bill of sale will double as an authentication document until such time as the artist can be prevailed upon to produce a certificate. The language of authorization is a double-edged sword. When the work enters the marketplace, the question of what happens to the artist's power of designation opens up an array of possibilities, some anticipated and some both unexpected and unwelcome.

Critical or descriptive language, declarative language, the language of instructions, the language of agreements and contracts—all of these are relevant because they shape the form in which the work of art will arrive at the viewer. The point is not to conflate minimal and conceptual art, as Panza was wont to do at times. Instead, the important issue is that similar mechanisms were being used by artists to very different ends. Sometimes they were an explicit part of the work, contributing to its dematerialization, but at other times they were employed behind the scenes to control the configuration of a work still defined as a specific physical object. Other important challenges presented by minimalism that continue to resonate include the problem of maintaining eternal newness for pristine industrial finishes or ready-made components, and the significance of work that is essentially incomplete until it is actually on display.

Once the question of whether authenticity may or may not reside in a specific material object is raised, the answer can only be found through a process of interpretation encompassing expressions of intent that include written statements by the artist and a more nebulous set of assumptions about the artist's customary practice. Even works by the same artist may have widely varying requirements when it comes to arrangement, placement, or the substitution of elements. The complex history of the work after it leaves the control of the artist speaks to the importance of later understandings. The reading of any work will be influenced by the context of its presentation. For works that are not fixed as physical entities, however, interpretation also shapes how the work is constituted. There is a subtle but important shift between the impact of context on subsequent readings and a process of interpretation that operates in advance to shape the nature of the work so that it will conform to expectations. As artists have exercised the authority to delegate aspects of production or realization, the very possibility of such fragmentation necessitates constant reinterpretation of the nature of artistic authorship.

ORIGINAL COPIES

Sherrie Levine, *Fountain (after Marcel Duchamp)*, 1991. Cast bronze, 15" × 25" × 15". Courtesy Paula Cooper Gallery, New York.

This is a story that ends with a cast bronze urinal. It is an unexpectedly beautiful object, presented on a narrow pedestal, with its smooth, curvilinear surfaces polished to a highly reflective finish. Under different circumstances it might be read as a fragment from an astonishingly ostentatious interior. Yet it was never intended and is totally unsuitable for use. Moreover, in the context of its display the viewer is forbidden physical contact with its luxurious surface. The sensuality of the material as well as the position of the urinal, rotated so that it is lying on its back rather than upright, draw attention to the potentially abstract qualities of the form. Though its shape is based on a common utilitarian item, this particular example was made for a particular and highly specialized function, that being its display as a work of art.

Sherrie Levine made this object in 1991. Or to be more precise, she had it cast for her, using an actual porcelain urinal as a model. What might be its meaning? Certainly the transformation of materials is unmistakable. Levine has taken a standard plumbing fixture and had it remade using material and production methods that connect the work to a long sculptural tradition. She has, as a female artist, chosen an article designed specifically for the male anatomy. Nor is Levine the only artist to have taken up the urinal during the 1980s and 1990s. One perspective from which to consider Levine's interest in the urinal is therefore her relationship to her contemporaries and some of their uses not only of everyday objects in general, but of this one in particular.

David Hammons affixed a series of urinals to trees to create his 1990 *Public Toilets* for the exhibition "Ponton Temse" at the Museum van Hedendaagse Kunst in Ghent, Belgium. In the natural wooded setting, their nonfunctional presence suggested an ironic comment on the social conventions that remove a natural bodily function to the confines of a specific kind of constructed space, at the same time as they played off of the territorial marking that

David Hammons, *Public Toilets,*
1990. Installation at "Ponton Temse,"
Museum van Hedendaagse Kunst,
Ghent, Belgium. Courtesy Jack
Tilton Gallery, New York.

does take place in a forest. They are also connected to Hammons's broader interest in the unexpected deployment of found objects both in traditional gallery settings and in more urban public spaces, where his references to avant-garde traditions are often combined with materials and forms specifically associated with aspects of contemporary African-American life.

Robert Gober first turned to the urinal as a subject in 1984, and the works that followed were closely related to the more extensive series of sinks begun the year before. In his hand-made sinks the familiar form became the basis for a subtle play between object and body. The circular openings on the back, where the faucets would be installed on an actual sink, contribute to the suggestion of a truncated torso. On the other hand, the backs of sinks, presented as partially submerged, resemble tombstones. Gober's urinals, also made by hand and closely related to the sinks in appearance, were less conspicuously transformed or ambiguous. When the urinals were shown in groups, lined up in a row, their presenta-

Robert Gober, *Three Urinals*, 1988. Wood, wire lath, plaster, and enamel paint, each 21¼" × 15¼" × 15", overall installation 73¼" long. Courtesy the artist. Photo: D. James Dee.

tion on white gallery walls closely approximated actual urinals' typical arrangement when positioned for use. In relation to the context established by Gober's other work, this suggestion of a community of male bodies was understood as a reference to gay identity and, more obliquely, to the deepening AIDS crisis of the 1980s.[1]

In each of these cases the artist has performed an act of recontextualization, taking a familiar object and transforming it by changing where it is found or how it is made. In the process, each artist has accomplished the paradoxical feat of claiming authorship over the urinal. However, as any student of twentieth-century art knows, this particular bathroom fixture comes ready-made with yet another proper name attached. Marcel Duchamp's thorough assimilation into museum collections and art-historical discourse has insured that any use of such objects as a bicycle wheel, snow shovel, and especially a urinal will be read as a reference to Duchamp, not just a use of the object itself. Levine's remake presents the most pointed reference to Duchamp's peculiar hold over authorship. Her title, *Fountain*

(after Marcel Duchamp), acknowledges the unmistakable reference of the work. So, too, does its presentation on a narrow pedestal that closely mimics the presentation of Duchamp's *Fountain* in a photograph taken by Alfred Stieglitz shortly after the rejection of the work from the 1917 exhibition of the American Society of Independent Artists. Although Levine was not able to find the exact model used by Duchamp, she strove for historical accuracy by tracking down a urinal from the same manufacturer and year. Even the catalogue produced for the 1991 exhibition featuring Levine's *Fountain* follows the format of a catalogue by William Camfield produced for a 1989 exhibition at the Menil Collection devoted to Duchamp's *Fountain.* Nor did Levine's search for the correct urinal end in 1991, because when she found another historic example even closer to the one Duchamp initially selected, she made a new edition in 1996 with the title *Buddha.* Yet these are not slavish replicas, because Levine's referencing of Duchamp does not include duplicating the signature of the pseudonymous R. Mutt scrawled on the 1917 original. The material and finish further complicate matters by pointing in a different direction, toward Constantin Brancusi, another early twentieth-century master. Though this association was more fortuitous than planned, it shows how an artist can become associated with a particular material or technique as well as with a type of subject matter.[2] Thus Duchamp's original readymade has been both copied and transformed as a result of Levine's decision to have it cast in highly polished bronze.

But what might it mean to speak of an original readymade? Duchamp's assault on artistic tradition was based specifically on the fact that the objects he selected and so designated were neither original nor rare. They were also not selected for their artistic qualities. Rather than "esthetic delectation," Duchamp insisted, his choice "was based on a reaction of visual indifference with at the same time a total absence of good or bad taste . . . in fact a complete anesthesia."[3] As manufactured objects they were inherently multiple, fabricated according to principles of mass production with their form determined prior to Duchamp's attention. Their startling originality emanates not from their physical form but from the unexpected act or gesture through which they were plucked from the everyday and designated as works of art.

The readymade provides the starting point for a broader consideration of how inherently multiple forms and methods have been assimilated into a realm predicated on sharply limited production. One achievement of manufacturing has been the potential to create theoretically limitless numbers of identical and therefore relatively inexpensive products. With this potential comes the need to prevent unauthorized duplication of certain types of commodities, largely through external limits like copyright, trademark, and patent legislation. When materials or techniques derived from mass production are taken

up by artists, the demands of the art market mean that inherent multiplicity has to be re-aligned in accordance with conventions that restrict production, the most common of which is the limited edition. The various ways in which contemporary artists have taken up and refashioned the readymade, however, also speak to the complex layering of reference and quotation that characterizes contemporary art. The designation of authorship gives a tenuous and riven unity to multiple references that can include other works of art as well as the means by which they are disseminated in reproduction, the contexts of their reception, and the much larger realm of nonart sources. The copy is therefore the basis for a conception of art-making in which artists incorporate increasingly subtle and layered references to the history of art as well as other sources without necessarily relying on their techniques or materials.

One of the striking features of the urinals of Gober, Hammons, and Levine is how differently each artist deployed this common object, and how each use emerged from concerns articulated in the artist's other works, as part of their markedly different approaches to the use of found objects or forms. Levine was aware of Gober's use, but her interest derived from a different agenda. "I always thought of the sinks as being very feminine," Levine told an interviewer in an exchange about Gober's work. "I think my urinals had more to do with Gober's sinks than his urinals."[4] Levine was already thinking about issues of gender in her series of early appropriations focused on historical avant-garde and modernist male artists. In the context of the late 1970s and early 1980s art world that, according to Levine, "only wanted images of male desire," her response was "a sort of bad girl attitude: you want it, I'll give it to you. But of course, because I'm a woman, those images became a woman's work."[5] Levine's use of Duchamp was therefore part of a larger critique of originality inspired by her contemporary context as well as historical precedents.

Levine announced her assault on originality in several early series where she simply cut out and mounted reproductions from books in a radically streamlined version of collage, or presented rephotographed images of modernist paintings and photographs. The works by Atget, Evans, Weston, Cézanne, Monet, or Van Gogh that Levine has rephotographed are, of course, firmly entrenched as established masterpieces and are widely dispersed across different collections. Because she photographed published reproductions rather than the actual objects, however, Levine has been able to rely on the mobility of the reproduction to assemble physically remote works of art. The photos after photographic reproductions therefore comment on the importance of reproductions as intermediaries that mediate and structure our understanding of works of art, and they play off an aspect of reproduction described by Walter Benjamin: the use of the reproduction to allow "the original to meet the beholder halfway" by putting "the copy of the original into situations

which would be out of reach for the original itself."[6] Yet she also revokes that mobility when she returns her own images of these works to the gallery or museum spaces that the works themselves would normally inhabit. And her mechanical reproductions of mechanical reproductions bring up still other paradoxes when they are returned to books or magazines, contexts in which they are materially indistinguishable from images of the originals they reproduce.

Running through Levine's photographs and her subsequent exploration of sculptural forms, including those based on Duchamp, is her interest in the "almost-same."[7] Her concerted critique might seem to affirm, by means of contrast, the quality of originality in the works to which she has responded. But exactly the opposite is the case, since she succeeds in highlighting inherent tensions and contradictions that preceded her forays into the terrain of artistic originality. Her subtle but precise positioning of the work speaks to the relationship between the work and a highly elaborated context for its reception. The "almost-same" becomes the radically different when slight or even negligible shifts in form or image accompany dramatic changes in the context of the work's reception. Caught in the space between Duchamp's first readymades early in the twentieth century and Levine's return at the century's end is a whole series of intervening shifts, as definitions of authorship and originality have been continually adjusted in their application to works that incorporated elements of copying, mechanical production, or other forms of inherent multiplicity.

The steps by which Duchamp's work began to resonate tell a larger story about postwar art through the significance of the artists chosen as precursors. Thus the first wave of renewed attention to Duchamp during the 1950s and 1960s marked a turn away from conventional Greenbergian modernism—articulated in the fascination with the layering of references as well as the incorporation of objects, images, and methods drawn from the realm of mass production—that eventually gained the label of postmodernism. In his 1960 *Painted Bronze,* Jasper Johns unmistakably announced the importance of Duchamp as well as a break with modernist ideals when he used traditional materials and methods of the fine arts to recreate a familiar, everyday object. In this case the object was a pair of Ballantine Ale cans, which Johns duplicated in the form of cast bronze with painted labels. The origin story for the work also links it to tensions among adherents of abstract expressionism about the notice that neo-dada work was beginning to command. The immediate inspiration was a complaint voiced by Willem de Kooning about Leo Castelli, retold by Johns as: "That son of a bitch, you could give him two beer cans and he could sell them." According to Johns, "I heard this and thought, 'What a sculpture—two beer cans.' It seemed to me to fit in perfectly with what I was doing, so I did them—and Leo sold them."[8]

Johns's version of the readymade came at the idea from a different direction than Duchamp's initial gesture. Where Duchamp selected objects for their unremarkable qual-

Jasper Johns, *Painted Bronze,* 1960.
Painted bronze, 5½" × 8" × 4¾".
© Jasper Johns / Licensed by
VAGA, New York. Photo courtesy
Leo Castelli, New York.

ities in an act that mounted a challenge to fine-art traditions from the realm of mass production, Johns was undermining from within, using time-honored materials and methods but disguising those means so that the work would masquerade as an object from outside that tradition. Johns was also invoking a particular type of object, not just any beer but a specific brand, known through its trademarked name as well as the design of its packaging. While Duchamp incorporated a play on manufacturers' names in some of the readymades, packaging and brand identification were a more significant part of the postwar landscape. In that respect, Johns's *Painted Bronze* made an early reference to the commodity image that became an important focus of pop art. Levine's interest in Duchamp came in the midst of a new wave of interest in forms of copying and simulation during the 1980s that was eventually given the label of appropriation art. What Levine's *Fountain* and Johns's *Painted Bronze* have in common is the remake of the readymade using fine-arts materials and methods, thus inverting, perhaps even subverting, the transgressive power of Duchamp's simple act of selecting a mass-produced object.

The significance of renewed postwar interest in strategies associated with early twentieth-century avant-garde activity is itself a hotly debated topic. In his *Theory of the Avant-Garde,* Peter Bürger dismissed the postwar or neo-avant-garde as a repetition that destroyed the

critique of artistic autonomy ascribed to the earlier or historic avant-garde movements. Yet even as Bürger found that "the neo-avant-garde institutionalizes the *avant-garde as art* and thus negates genuinely avant-gardiste intentions," he had already acknowledged that "the *objet trouvé* . . . loses its character as antiart and becomes, in the museum, an autonomous work among others."[9] Certainly one irony of postwar avant-garde activity is the backdrop provided by the assimilation of earlier markers of rebellion into museums and art-historical canons, but the responsibility for that state of affairs cannot be ascribed simply to the renewed postwar artistic interest in the early twentieth-century avant-garde. Indeed, by means of a telling inversion of this aspect of Bürger's critique, Hal Foster has argued against attempts to dismiss later avant-garde activities as mere repetition, positing, instead, their return as a means of working through contradictions inherent in the earlier avant-garde movements.[10]

The appearance of the remade readymade in the work of Johns and, more than three decades later, of Levine might seem like a long-delayed reaction, as well as a significant shift away from Duchamp's selection of mass-produced objects. But it also encourages a retrospective view of Duchamp's own readymades and the process of remaking that was still ongoing at the time of Johns's *Painted Bronze.* The history of the readymades subsequent to their first appearance is far more complex than the straightforward simplicity of the initial gesture would seem to suggest. One mark of how effectively Duchamp challenged traditional definitions of art is apparent in the fact that his objects did not, in many cases, retain their status, slipping back into the world of the everyday where they were used and discarded. Most of the original objects Duchamp selected as readymades were lost and not replaced until decades later, so a retroactive process of recontextualization and remaking was by necessity part of Duchamp's production, and also subject to numerous delays. Through the publication of reproductions and facsimiles of his works as well as related notes, Duchamp was able to ensure the continued existence of the readymades as concepts, even when the specific physical object had not been retained. One step that Duchamp took to consolidate and provide a context for his work was his production of the *Box in a Valise,* which made its first appearance in 1941. This facsimile edition functioned as a miniature museum that used small-scale replicas to unite works dispersed in various private collections and readymades that did not, at least at that time, even have a physical existence.[11] Robert Lebel's influential 1959 monograph on Duchamp relied heavily on the reproductions used for the *Box in a Valise,* so it introduced Duchamp's work to a new audience through a similar conflation of extant and, at least in their physical form, lost works.

The dating of Duchamp's readymades to the moment of their first appearance masks the significance of the intervening steps and what they have to say about the reception and

Marcel Duchamp, *Box in a Valise*,
1941. Leather valise containing
miniature replicas, photographs,
and color reproductions, 16" × 15"
× 4" closed. Philadelphia Museum
of Art, The Louise and Walter
Arensberg Collection. © 2002
Artists Rights Society (ARS), New
York / ADAGP, Paris / Estate of
Marcel Duchamp.

assimilation of early twentieth-century avant-garde practices into art-historical accounts and museum collections devoted to the twentieth century. For a number of the readymades, the objects needed to represent the work were repeatedly procured, sometimes by Duchamp and sometimes by others, and often discarded after their immediate use. As Duchamp's stature rose in the 1950s and 1960s, curators eager to display his work contributed to the remaking of the readymades. Chronologies of their replication indicate that the works materialized as needed: the *Fountain* reappeared in 1950 and the *Bicycle Wheel* in 1951, so that Sidney Janis could include them in exhibitions at his gallery; and subsequent versions of these and other readymades turned up in various exhibitions during the early 1960s. In addition to authorizing most of these duplications, sometimes after the fact, Duchamp gave them credibility with his 1961 statement that an important aspect of the readymade "is its lack of uniqueness . . . the replica of a 'readymade' delivering the same message."[12]

Duchamp's professed lack of concern for uniqueness did not prevent him from participating with Arturo Schwarz in the production of a series of specially fabricated readymades that appeared in 1964 in editions of eight. In fact, Francis Naumann chronicles how Duchamp's willingness to sign readymades found by others was brought to an end by his agreement with Schwarz.[13] When Schwarz embarked upon these limited-edition replicas, he attempted to duplicate as closely as possible the contours of the first, "original" readymades. For this he had to rely extensively on documentary evidence, much of it from photographs that had also been included in the *Box in a Valise.* As a gallery owner who was also involved in publishing editions, Schwarz had an active role in the making of work by Duchamp that he would then sell. This double role as both producer and intermediary is not uncommon in the art world. To these two roles, however, Schwarz added a third, that of author of its history, most significantly in his catalogue raisonné of Duchamp's work. The intersection of Schwarz's interests is readily apparent in the histories of the readymades in the successive versions of *The Complete Works of Marcel Duchamp,* where Schwarz distinguishes his editions from other contenders for the status of the true readymade. In the 1969 edition of the catalogue, the listings of the succeeding versions of each readymade culminate in the 1964 entry, which is generally accompanied by one or another variant on the sentence "1964, Milan: First full-scale replicas issued under the direct supervision of Duchamp on the basis of a blueprint derived from photos of the lost original."[14] This reference to the blueprint is used not to show the limited-edition readymade's continuity with mass production but to differentiate these editions from other contenders by showing them to be more accurate to the initial found objects. By the 1997 third revised version of the catalogue, the rhetoric had shifted from blueprint to documentary photograph, but to the same end, namely the validation of the 1964 editions.

If Duchamp's initial gesture of choosing the readymade referred to mass production, the later forms of reproduction through which the readymades cycled secured their status as art. The 1964 readymades incorporate a less conspicuous version of the dissonance suggested by remaking an everyday object according to fine-art traditions. By colluding with the rhetoric of the limited edition—a rhetoric of rarity and authenticity—Duchamp endorsed the creation of readymades closer in appearance to their first versions than were many of the intervening found objects. But that similarity of form masks their dramatic transformation. The look of a seamless unity, of an ostensible continuity with the first instance of each readymade, was facilitated by the reproduction in the *Box in a Valise* as well as the later limited editions produced by Schwarz, both of which were involved in a doubling process that helped hide the interim steps that constructed a context for the initial gesture. Given that the readymade's gesture depended on the juxtaposition of an everyday item that would retain its familiar aspect and a context usually reserved for a different order of objects, it is therefore ironic that the majority of Duchamp readymades one is likely to see in museums today are replicas made specifically for the art market. In their careful remanufacture according to art world conventions of the limited edition, these readymades are far closer than they seem to the transformation effected by Levine's cast bronze urinal.

What does Duchamp's use of reproductions say about the larger significance of the reproduction for the original? For one thing, the role played by Duchamp's *Box in a Valise* in bringing his work together in facsimile has parallels to the power that André Malraux ascribes to photographic reproduction generally. The photographically illustrated art history book accomplishes what no individual museum can, bringing together as a single body, without the impediment of differences in material and scale or geographical separation, the far-flung examples that comprise the work of a particular artist or artistic style, or the diverse examples assembled with the goal of providing a comprehensive survey. Even with the widespread establishment of museums in the nineteenth century, Malraux has argued, knowledge about art history still tended to be fragmentary and localized. Though the major museums increasingly provided a synoptic view of Western art, the strengths and lacunae of particular collections had a tremendous impact on one's view of art as a whole. "What, until 1900, had been seen by all those whose views on art still impress us as revealing and important; whom we take to be speaking of the same works, referring to the same sources, as those we know ourselves?" To this opening question in *Museum without Walls,* Malraux answered, "Two or three of the great museums, and photographs, engravings, or copies of a handful of the masterpieces of European art. Most of their readers had seen even less. In the art knowledge of those days there existed an area of ambiguity: comparison of a picture in the Louvre with another in Madrid, in Florence, or in Rome was comparison

of a present vision with a memory." By contrast, the work represented in Malraux's imaginary museum would "carry infinitely farther that limited revelation of the world of art which the real museums offer us within their walls."[15]

The actual collection is always incomplete in relation to the elusive totality suggested by compilations of reproductions. Yet the ability of the photograph to facilitate comparisons among scattered works has also played a crucial role in assessing the authenticity of the unique originals that remain bound in time and place. Early art historians were avid collectors of photographs, which could convey information about texture and materiality that far surpassed the descriptive value of the reproductive prints they supplanted. At the same time, the comparative study of the physical object known as connoisseurship depends upon having available a body of secure examples, preferably in publicly accessible collections, and is closely tied to the ethos of the museum, where attention is traditionally isolated and focused on formal qualities. The functional, often market-driven determinations of authenticity achieved through connoisseurship stand in sharp contrast, however, to Benjamin's description of a quality compromised by both reproductions and collecting practices. For Benjamin, authenticity emanates from the experience of the original, with the work's presence, or aura, diminished by the reach of the reproduction as well as by the shift from cult value to exhibition value, whereby works have been wrested from the fabric of tradition in order to be recontextualized as objects of contemplation.[16]

When is a copy a replica, and under what circumstances does it become an original? The impact of clearly secondary reproductions on the work of art is part of a larger process of reciprocal definition between the original and copy. Nor was it always clear that the copy could not coexist with the original. At the time Duchamp mounted his challenge to the original with his first readymades, the copy had only just been banished from the art museum. In France a culmination and turning point in the status of painted copies was the museum of copies that opened, and quickly closed, in 1872–1873.[17] Alan Wallach charts an equally sudden shift around 1900 in the attitude of United States museums toward plaster casts. In the late nineteenth century, casts were valued because they allowed museums to amass a relatively complete collection of the canonical antique works. Plaster copies allowed for a three-dimensional version of the completeness later ascribed to the virtual or imaginary museum made possible by photographic reproductions. In the early twentieth century, however, classical casts were quickly banished from museum collections in favor of originals, an emphasis that served both artistic ideals and the sense of prestige attached to ownership of the unique or rare.[18] But even after plaster casts lost their appeal, not all casts were expelled from the museum. Bronze statues, coins, and many other works made

through such inherently multiple processes as casting or printing were allowed to stay because of their historic as well as artistic value.

For more recent multiples, the significant issue is authorship. Thus the specter of the copy appears in a different guise in the analysis of Rodin with which Rosalind Krauss introduces her essay "The Originality of the Avant-Garde." After describing the experience of watching a film documenting the 1978 cast of *The Gates of Hell,* she concludes that "to some—though hardly all—of the people sitting in that theater watching the casting of *The Gates of Hell,* it must have occurred that they were witnessing the making of a fake."[19] Her answer to the question she poses about whether one can consider original a work produced so long after the artist's death in 1917, and based on a plaster that had never been fixed in a final arrangement, is a provocative neither-yes-nor-no. The cast had the legal authority of Rodin's bequest to the French state of both the works in his possession and reproduction rights, but the lack of a lifetime cast or even a definitive arrangement of the plaster suggests that "*all* the casts of *The Gates of Hell* are examples of multiple copies that exist in the absence of an original."[20] The situation is made only more complex by the multiplicity inherent throughout Rodin's production. But the convention of the limited edition established the condition under which reproduction rights could themselves be sold or included in a bequest, thus continuing, even after the death of the artist, the artist's authority to apply arbitrary limits to the production of the inherently reproducible.

The limited edition also played an important role in the process of defining prints as works of authorship, particularly as photographs took over from prints the utilitarian function of reproduction. Though long practiced in the form referred to as prints of invention, the "original print" only developed as a clearly defined category in the nineteenth century. It was also during the nineteenth century that the artist's signature on prints, which had the practical function of conveying the artist's approval of the impression, began to be used within the print trade as a way of increasing the value of prints—a practice Whistler is particularly well known for having exploited.[21] Ongoing attempts to find a balance between inherent reproducibility and originality are evident in conventions that emphasize the artist's direct involvement in the process, most significantly those articulated by the Third International Congress of Artists (Vienna, 1960), which defined originals as only those prints "for which the artist made the original plate, cut the wood block, worked on the stone or any other material."[22] Yet it is telling that this definition, with its attempt to retain some version of the artist's hand, was established at the very moment when it was destined for obsolescence. The following decade was marked by a vast increase in the production of multiples, evident particularly in the context of pop art, where the functional definition of originality articulated in the requirement for the artist's physical presence in

the making of a multiple gave way to techniques and strategies that removed traces of the hand even as the artist's signature and process of selection or designation remained vital.

The increasingly central role played by techniques of mechanical reproduction in the creation of works of art also subjected the museum to a further redefinition. At issue was not just the means by which the work had been produced, but the eclectic assembly of forms and images enabled by the copy. It was the paradox inherent in the photograph's dual role as both reproduction used to document works of art and a form of art in itself that Douglas Crimp pointed to when he suggested that Malraux made a "fatal error" in bringing the photograph into his imaginary museum not just as vehicle but also as object. The resulting heterogeneity is, for Crimp, embodied in Robert Rauschenberg's use of photo silkscreens to juxtapose a range of images that are held together but not unified by their tenuous connection as reproductions.[23] It was, however, Andy Warhol's use of photo silkscreens that presented the most concerted challenge to traditional definitions of originality. In the silkscreen paintings that he began to produce in 1962, Warhol pursued inherent multiplicity in the repeated use of screens to produce series of works and in the serial repetition of an image within the space of a single work. The incorporation of mechanical transfer, particularly photo silkscreen processes, removed the hand not only from prints but also from works made by the application of those same techniques to canvas and then received in the context of painting.

One of the remarkable features of the Warhol enterprise is the degree to which he was able to incorporate a delegation not only of production but even of decision-making into his stance as an artist. Warhol already had practice in subcontracting the work that he did as a commercial illustrator, using others to help him provide an apparently personal touch in his hand-colored lithographs, and relying on his mother to produce the extravagant script and signature that was part of the style for which he was known. His technique of blotting gave the ink line in his drawings the appearance of a personal touch even as the method also lent itself to replicating variants of the image through a process of repeated tracing that could be partially farmed out to his assistants. And even the fake signature was not always genuine, because when Warhol's mother was tired of providing the writing, Warhol's assistant Nathan Gluck would imitate her script.[24] In the commercial work, however, the production assistance and mechanical interventions were downplayed, so that Warhol was known for the playful and seemingly personal line that characterized his illustrations of shoes and other fashion-oriented subjects. Warhol's fame as a fine artist, by contrast, rests on the way he excised traces of his touch and evidence of what would be thought of as individuality.[25] A particularly striking example is immortalized in Emile de Antonio's film *Painters Painting* when Warhol, sitting next to Brigid Berlin, claims that

Robert Rauschenberg, *Tracer*, 1963.
Oil and silkscreen on canvas, 84⅛"
× 60". The Nelson Atkins Museum
of Art, Kansas City, Missouri (Pur-
chase) F84-70. © Robert Rauschen-
berg / Licensed by VAGA, New York.
Photo: Jamison Miller.

Berlin has been doing all his paintings, and even deflects interview questions to Berlin so that she can provide his answers.

Warhol's discovery of his blank, seemingly unworked presentation was a several-stage process, usually retold as having been driven by suggestions from others. De Antonio has taken credit for encouraging Warhol's move away from a painterly approach to pop subjects more akin to that of Johns. In this anecdote, Warhol showed de Antonio two paintings of Coke bottles. One "was just a big black-and-white Coke bottle. The other was the same thing except that it was surrounded by Abstract Expressionist hatches and crosses." For de Antonio, the gestural painting was "kind of ridiculous," whereas the one with little evidence of touch, he told Warhol, "is so clearly your own."[26] Similarly for the selection of one of his most famous subjects, Campbell's Soup: as Warhol assistant Ted Carey told the story, Warhol asked his friend Muriel Latow for an idea, which she supplied after demanding and receiving a check for fifty dollars in payment. In fact he got two ideas for the price of one, her first being money, the thing she said he liked more than anything else, and the second that he do something widely recognized, like Campbell's Soup.[27] Another origin myth for the images of money, specifically the two-dollar bills, appears in the story of Eleanor Ward's visit to Warhol's studio, where she reportedly told him that she would give him a show at her Stable Gallery, his first in New York, but only if he made her a painting of a two-dollar bill like the one she carried for luck.[28] And Warhol's own answer to the question of why he did the soup cans was that Campbell's Soup was what he always had for lunch, "the same thing over and over again" for twenty years.[29] Henry Geldzahler assumes credit for another breakthrough, the *129 Die in Jet (Plane Crash)* of 1962, which reportedly came about when he showed Warhol the June 4, 1962 *New York Mirror* with banner headlines about the airplane disaster and told him that he should be doing works about death rather than just glorifying consumerism. Warhol took the suggestion even more literally, producing one of his last hand-painted works in a direct copy of the tabloid front page.[30] David Bourdon points out, however, that Warhol was constantly soliciting ideas, only a few of which he used, so that he was involved in a process of selection even if it masqueraded as a blank responsiveness to suggestion.[31] He thus made sure that decisions he did make were deflected onto others, even if he ultimately backed away from his more extreme claims about having others make all his work for him.

Warhol explored various strategies to remove the evidence of his hand or touch from the work that he was beginning to produce for the fine-art context. The dance diagrams or the thirty-two Campbell's Soup paintings, which comprised his first major show at the Ferus Gallery in Los Angeles in 1962, were produced through projected enlargements, though he may also have used a rubbed transfer of a pencil tracing to maintain the uniformity of the soup can images.[32] The soup can paintings were also an early example of his use

of serial production with slight variation, in this case based on the selections available in the Campbell's product line that was their subject. The important development in the early Coca-Cola works was his incorporation of serial repetition into the space of a single canvas together with the use of forms of mechanical reproduction to duplicate the images. An early method was stamping, quickly replaced by hand-cut silkscreen images, and then by the photo silkscreens that provided Warhol with the perfect medium in which to perform the withdrawal of authorship.

Ironically, the incorporation of silkscreens into his production became the basis for Warhol's fame as a *painter*. The relatively brief period from 1962, when Warhol began using the photo silkscreens, to 1965, when he renounced painting in favor of filmmaking, was a period of amazing output, during which Warhol produced the various series of celebrity images, name-brand products, and representations of death and disaster that have been the basis for his enduring reputation as an artist. According to Rainer Crone, in roughly two years, from August 1962 to the end of 1964, Warhol and his assistants created approximately 2,000 works, including silkscreen paintings and the various box replicas. In addition, Crone reports the production of more than 900 *Flowers* in various sizes.[33] These were also the works that established Warhol as a celebrity. By the end of this period of intense production, the 1965 opening for Warhol's exhibition at the Institute of Contemporary Art in Philadelphia was so mobbed that all of the art work had to be taken down to prevent it from getting crushed by the crowds. Warhol's response: "It was fabulous: an art opening with no art!"[34] Appropriately, by that time he had already announced his retirement from painting while in Paris for the 1965 exhibition of the *Flowers* paintings at the Galerie Ileana Sonnabend.

The paintings of this period are perfect examples of multiple copies without an original. Warhol's deployment of silkscreen allowed plenty of room for the chance or accident that introduces variations even if the works are not about touch. Differences are endemic in the inking and registration of the screens, and the application of the images to unstretched, sometimes even uncut lengths of canvas introduced other variables when they were mounted. Warhol kept the screens for future use, but the disparate applications meant that the paintings were not produced in editions; rather, the differences in background color, number of repetitions, overlapping, or how they were printed tended to result in open-ended sets of variants rather than identical repetitions. Warhol employed assistants in the context of a studio famously known as the Factory to produce works generated using mechanical means to capture and transfer found images that he did not always even select himself. But the works are nonetheless understood as Warhol's because his particular form of authorship, one could even say his original contribution, encompassed this systematic evacuation of evident participation.

Thus as Warhol made familiar, name-brand products as well as celebrity images the subject of his work, he made the empty, market-driven sign into the basis of his signature style. The ultimate impact of Warhol's process can be felt in the degree to which he succeeded in creating a fine-art product line, replete with various forms of outsourcing and, as he became more successful, celebrity endorsements and licensing agreements. He even found ways to make sure that reflections on art and on himself, presented as his, were produced through a form of collective authorship. Colacello describes what he termed "a literary assembly line" for the writing of *The Philosophy of Andy Warhol:* "When I finished the chapter, I handed it to Andy. . . . He took it home that night and read it over the phone to Brigid Berlin, taping her reaction. Then he gave the tape to Pat Hackett, telling her to 'make it better.' So now the ghostwriter had a ghostwriter, Factory-style."[35] It was Warhol's own idea, Colacello says, to lift the opening description of what he saw when he looked at himself in the mirror each morning from accounts that had appeared in newspaper and magazine articles over the years. The twist that Warhol gave to this collective authorship was the corporate twist—with the combined efforts presented under his brand name.

Echoes of the readymade reverberate in Warhol's removal of the hand of the artist in favor of the power of designation. Warhol's specific connections to Duchamp included the purchase of a *Box in a Valise* during the early 1960s, his attending the opening of Duchamp's 1963 show at the Pasadena Art Museum during a visit to Los Angeles, the silkscreened Mona Lisa paintings from 1963, with their echo of Duchamp's *L.H.O.O.Q.*, his filming of Duchamp in 1966, and his purchase of a *Fountain* from the Schwarz edition. Warhol even produced an actual readymade for the 1964 "American Supermarket" exhibition at the Bianchini Gallery, a stack of signed Campbell's Soup cans, sold at the price of three for $18.[36] However, this genuine readymade was more of a novelty item and relatively peripheral to Warhol's work. According to Colacello, "When he got bored in a restaurant, or wanted to charm potential clients, he did what he called 'my Duchamp number'—and signed the spoons, forks, knives, plates, cups, ashtrays, and gave them away. Except Andy never used the word *signature*—it was always *autograph*."[37] In this context Warhol's signature took on an added layer of quotation, with Warhol playing the role of the celebrity acknowledging his fans.

The remade readymade played a more central role for Warhol, with its most specific appearance in the Brillo boxes and other cartons (Heinz ketchup, Kellogg's corn flakes, Del Monte peach halves, Campbell's tomato juice) made to duplicate the appearance of their prototypes. Their selection echoes Duchamp's declared indifference, since Warhol had to impose his own will in order to come up with boxes that were sufficiently artless. Warhol first sent Gluck to pick them out. But Gluck came back with boxes that appealed to him

because of ornate imagery, remembered as "grapefruit with maybe palm trees or crazy flamingos," and the like—kitsch, in other words.[38] By contrast, the cartons Warhol selected conveyed a utilitarian familiarity. To make the replicas, Warhol employed silkscreen on wood boxes that were made to appear identical to each other and to the cartons that they reproduced. One form of mechanical reproduction was therefore used to duplicate another form of printed surface, but the shift of materials added subtle change to the more dramatic transformation that resulted from their recontextualization. The deployment of serial repetition also suggests one of the most obvious parallels with strategies later associated with minimalism, both in the repetition of identical, preplanned units and the activation of the gallery space when the boxes were arranged in a grid across the floor.

Andy Warhol, various box sculptures, 1964. Synthetic polymer paint and silkscreen ink on wood. © 2002 The Andy Warhol Foundation for the Visual Arts / ARS, New York. Photo © The Andy Warhol Foundation, Inc. / Art Resource, NY.

What happens when a work of art that plays with everyday forms leaves the protective confines of the gallery or museum? It is now remarkably common to find Warhol's boxes protectively encased in a Plexiglas vitrine when they appear on display. But at the time they were first being shown, the transformation in a work that so closely mimicked its prototype sometimes failed to register, particularly when the work was on the road. Questions of definition arose in a 1965 incident when Warhol's works based on the Brillo and Campbell's tomato juice cartons were denied status as works of art and would have been subject to duty when a Canadian gallery attempted to include them in an exhibition.[39] Here there are further parallels to Duchamp, since the Pasadena Museum of Art had had similar problems only two years before with U.S. customs around readymades that were shipped from Sweden for the 1963 Duchamp retrospective. In that case the museum was assessed increased duties based on the fact that they were not "original works of art"—a decision that Walter Hopps protested in a letter that described the "unique aesthetic innovation" of the readymades and compared the different versions to the multiples produced by traditional bronze casting.[40] And Duchamp himself had been involved in a much earlier customs problem involving a group of Brancusi's sculptures that Duchamp brought over from Paris in 1926 for an exhibition in New York. In this case the sculptures were assessed the forty percent tariff applied to miscellaneous goods rather than being allowed the exemption for original works of art because, according to the customs official, Brancusi "left too much to the imagination." Brancusi's supporters were, however, able to line up enough testimony during the ensuing lawsuit to convince a judge that, even if the work did not meet a contemporary dictionary definition centered on the imitation of nature, it was at least "the original production of a professional sculptor."[41] The sticking point in the earlier incident was abstraction, whereas in the later it was verisimilitude. But the verisimilitude was itself of a specialized type—with objects close or even identical in appearance and material to manufactured instead of natural forms.

One of Warhol's most striking contributions was the incisive critique of the lure of the commodity in a media-driven culture, achieved through his seemingly blank reflection of appearances as well as the strategy of numbing repetition. The appeal of the products Warhol selected for his treatment, however, is based on design as well as promotion, so an anonymous author (the designer) whose work helped promote the product is replaced by the artist whose recontextualization serves as a comment on the product's cultural familiarity. In an ironic twist, the Brillo box that Warhol appropriated had been created by an abstract expressionist painter, James Harvey, whose day job was industrial design. A review of Warhol's 1964 show at the Stable Gallery quotes a press release from the design firm where Harvey worked: "this makes Jim scream, 'Andy is running away with my box.'"[42]

Andy Warhol, *Flowers,* c. 1965. Synthetic polymer paint and silkscreen ink on canvas, 48" × 48". © 2002 The Andy Warhol Foundation for the Visual Arts / ARS, New York. Photo © The Andy Warhol Foundation, Inc. / Art Resource, NY.

However, Irving Sandler's recollection of the incident, recounted to Smith, indicates that this might have been more of a publicity stunt than actual outrage, since Harvey purportedly disclaimed any involvement in the press release. Sandler suggested to Harvey that he should counter Warhol's show by signing the actual boxes himself, and Harvey followed up by sending Sandler a signed box. "Warhol found out about it and called Harvey and offered to trade, but shortly after, before anything happened, Harvey died." So, according to Sandler, "the trade never took place, and I have the only *real Brillo Box,* the original."[43]

Images based on other images raise complex issues about ownership as well as authorship. The *Flowers,* which coincided with Warhol's announced retirement from painting, were less immediately recognizable as a specific reference to a media or commodity source. Writing in 1970, Rainer Crone described the *Flowers* paintings as "unique in Warhol's production by virtue of their meaningless image content," a dubious honor he ascribed to "strictly decorative" qualities shared only by the *Cow Wallpaper* and the *Silver Clouds.*[44] The *Flowers* were also produced in such tremendous volume that they virtually filled the walls for the exhibitions at the Castelli Gallery in New York in 1964 and the Sonnabend in

Sturtevant, *Warhol Flowers,* 1964/1965. Silkscreen on canvas, 22" × 22". Courtesy the artist and Galerie Thaddaeus Ropac, Paris.

Paris in 1965. It was, of course, extensive studio assistance that allowed Warhol to produce the *Flowers* paintings, with their sheer numbers suggesting at least the partial fulfillment of a desire he had earlier expressed to G. R. Swenson: "I think somebody should be able to do all my paintings for me. . . . I think it would be great if more people took up silk screens so that no one would know whether my picture was mine or somebody else's."[45] Yet the full implications of the statement were destined to be realized in a different quarter.

A group of closely related paintings of flowers was exhibited at the Bianchini Gallery in New York in 1965. They were identical in the method of production, format, and the use of color variations to differentiate individual paintings. Only these paintings, rather than being titled simply *Flowers,* went by the title *Warhol Flowers,* and their author was an artist by the name of Sturtevant. She made them using screens given to her by Warhol, so there is little to distinguish them from Warhol's own flower paintings, made under his supervision from the same screens. According to Sturtevant, Warhol first gave her the silk screens for the flowers and then, when she wanted to do the Marilyn, let her come to his studio and look through all of his silk screens.[46] While it is certainly possible to identify methods and

conventions characteristic of Warhol's work, there nonetheless might be little discernible difference between a silkscreened work produced with the help of his studio assistants and the work that Sturtevant produced after Warhol using the screens that he gave her. The originality of Sturtevant's work therefore derives from a further act of recontextualization. Included in the same exhibition were other examples where the expected author was likewise displaced into the title: *Johns Flag, Oldenburg Shirt, Stella Concentric Painting,* and so on, such that these relatively disparate works achieved a new if tenuous unity under Sturtevant's authorship.

Sturtevant has described her work in terms that suggest not so much a process of copying as an apprenticeship in the ideas and methods of the artists whose work she has remade. The difference between her remakes of Warhol's works, using the same screens that were deployed for him by assistants, and her versions of Johns's paintings of flags, targets, or numbers points to the difference of touch in those works. Nonetheless, when a flag painting by Johns was stolen from Rauschenberg's 1955 *Short Circuit,* it was replaced by a Sturtevant replica, adding a further layer of irony to the already complex layering of authorship in this ensemble of objects and images that included an oil painting by Susan Weil (visible, like the flag, only when the hinged doors are in their open position) and a collage by Ray Johnson in the lower register.[47] And the works after Stella that Sturtevant produced during the 1960s may or may not have inspired a parody article entitled "The Fake as More," presented as the work of Cheryl Bernstein in Gregory Battcock's 1973 anthology *Idea Art*—an essay Carol Duncan subsequently acknowledged as her own, composed in collaboration with Andrew Duncan in response to the theoretical discourse appearing in *Artforum* around the time of its writing in 1970.[48] In turn, Thomas Crow brought renewed attention to the article in a 1986 essay that pointed to its precedent for 1980s appropriation, though it was only in a subsequent revision that Crow introduced Sturtevant as a central figure for his argument, bringing her in with the suggestion that it was "curious, in fact, how much the fictitious replicater for a time came to overshadow the genuine prototype in Elaine Sturtevant."[49]

While there is a tendency to view Sturtevant in light of later forms of appropriation associated with the 1980s, many of her works served to highlight the degree to which her sources were already using forms and images that raised questions about originality or uniqueness. Thus paintings after Stella's work that Sturtevant produced in 1989 and 1990 have included her own multiple renderings of paintings from the 1960 aluminum series that Stella himself made in more than one version. Sturtevant has described 1980s appropriation as a movement that "allowed entry into my work" and also "made me into a precursor—not a bad place to be."[50] Yet there are clear differences between Sturtevant's concerns

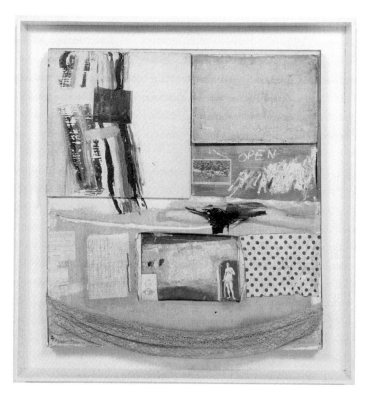

Robert Rauschenberg, *Short Circuit,* 1955 (closed position). Combine painting, 40¼" × 37½". Collection Robert Rauschenberg. © Robert Rauschenberg / Licensed by VAGA, New York. Photo: David Heald.

and those of the subsequent generation to which she has been linked. In response to Bill Arning's questions about the significance of her decision to appropriate exclusively male artists, she claimed that it was coincidental, insisting, "My choices are made on another level."[51] The refusal to consider the significance of a female artist choosing to replicate the work of an all-male group of artists is one important distinction between Sturtevant and Levine. Sturtevant was also working in historical proximity to many of the artists she took up, with attendant perils suggested by Claes Oldenburg's shift from supporter to antagonist when she recreated his 1961 installation, *The Store,* in 1967. The temporal closeness between source and copy characteristic of Sturtevant's early work therefore stands in contrast to the approach taken by Levine, where the delay, sometimes more than a century, opens up different readings of the return.

Sturtevant's silkscreen flower paintings raise key issues about the layering of authorship claims as images based on other images are appropriated and recontextualized. But the original photograph used in Warhol's screens was the work of yet another author, Patricia Caulfield, who instituted a lawsuit against Warhol for infringing on her copyright in the photograph, which he had taken from a magazine. Caulfield discovered the use of

Patricia Caulfield, photograph of
hibiscus flowers, published in
Modern Photography, June 1964.
© Patricia Caulfield. Courtesy the
artist.

her photograph in 1965, not long after Warhol began the series, when she saw a poster of
Warhol's work in the window of a New York bookstore. While Warhol may have estab-
lished himself as the author of the tremendously successful series of silkscreen paintings
entitled *Flowers,* Caulfield could claim legal authorship, and therefore ownership, of the
underlying photograph. Ultimately the case was settled out of court, with Warhol agreeing
to give Caulfield and her attorney two of the *Flowers* paintings, and also to give Caulfield a
royalty for future use of the image.[52]

A comparison between Caulfield's photograph and Warhol's silkscreen paintings
shows his adjustments to the image. Her close-up of multiple hibiscus flowers in a hori-
zontal format has been cropped to square in Warhol's image of four flowers, and the flower
furthest in the corner of the square has been rotated and moved slightly closer to the oth-
ers in order to fit that format. The image has also been further flattened by the removal
of detail, with the flowers printed first as silhouetted areas of color. Only the center of
each flower has been retained (simplified and made smaller than in the original photo) and
overprinted on the flower as part of the same screen with the surrounding foliage. Though
the shapes of the silhouetted flowers were based on the original image, it is only in the

adjacent areas that much of the photographic detail has been retained. Warhol produced the paintings in different sizes and orientations, with some examples further cropped to only two flowers, and variety was also maintained, particularly in the tremendous number of small paintings made using the same screens, by changes in the color combinations. The changes in medium, scale, and color certainly transformed the image, but not so much that Caulfield failed to recognize its source.

Ivan Karp, who was working at the Castelli Gallery at the time of Warhol's 1964 exhibition, remembers the copyright problems with the *Flowers* as "some legal hassle, which is really unfortunate, because he had to pay off with some very valuable pictures." According to Karp, Warhol "was very innocent of doing a disservice to this photographer because this photograph was *not* what you might call a 'remarkable photograph.' It was not an earth-shaking photograph, but Warhol made a *remarkable* series of paintings out of it . . . they were totally successful, and *we sold them all!*"[53] Crone was equally certain about who should get the credit for the success of the work. "Warhol had found the original photo in a woman's magazine; it had won second prize in a contest for the best snapshot taken by a housewife," was his dismissive summation.[54] Both Karp and Crone defended Warhol's claim over the image by insisting that he was more capable of putting it to interesting use than was the woman who happened, perhaps even accidentally, to click the shutter. But the description of Caulfield as an amateur, which has persisted, following Crone, in the Warhol literature, has little to do with her actual status. In fact the image was published in the magazine *Modern Photography* as part of an article about color processors.[55] The photograph is clearly attributed in a caption to Executive Editor Patricia Caulfield, which is also how her name appears on the magazine's masthead, immediately below that of the publisher. And the image would have been hard to miss, since it appears both on the cover and in a two-sided glossy color foldout, where Warhol's multiple use is already suggested in the repetition and variation used to show shifts in the color relations from different processing decisions. In fact its composition was the result of a succession of highly conscious decisions. Caulfield came across the vase of hibiscus flowers in a restaurant in Barbados, where it was set off by a play of light so striking that she interrupted her lunch, got her camera and tripod, and recorded the subject in multiple photographs. The image published in the magazine was further composed through cropping to create the tight arrangement of flowers and foliage that obviously appealed to Warhol.[56]

In the case of the *Flowers* there are at least three contenders for authorship: Caulfield for the original photograph, Warhol for its reinterpretation as a series of silkscreened images, and Sturtevant for the recontextualization of the reinterpretation. Other lesser claimants include Geldzahler, sometimes credited with coming across the photo while

paging through magazines and suggesting its use to Warhol, and the various assistants who helped produce the works using some of the same screens later used by Sturtevant, but under the umbrella of Warhol's Factory production and authorship. Warhol's better-known authorship claim over the *Flowers* paintings is thus bracketed by the work of two female authors, one disparaged by Warhol's supporters, and another uninterested in considering the significance of gender in the assertion of authorial power. The inaccuracy in Crone's account of the *Flowers* series is telling for how he used both amateur status and the negative stereotypes ascribed to women's magazines to assert the priority of Warhol's appropriation. Asked some years later about the whole business, Caulfield responded, "What's irritating is to have someone like an image enough to use it, but then denigrate the original talent."[57] Caulfield went on to have a substantial career in the field of nature photography. And there are other reasons why this example of appropriation cannot be made to fit the cliché of high-minded artistic interest coming in conflict with the banal world of commercial image production. Karp's complaint about the unfairness of Warhol having to pay out for the photo used in *Flowers* with valuable art work assumed a greater artistic merit as the basis for the greater importance of Warhol's version. But he also emphasized, in the same breath, how salable Warhol's paintings were—their success, in fact, as artistic commodities.

In his early work Warhol had an unerring eye for resonant images that could be made to speak of the culture from which they were plucked simply as a result of the way they were transferred, blown up, or reiterated. Crow, in particular, has contested the reading of Warhol's imagery (following Warhol's own pronouncements) as passive and impersonal, arguing the significance of subjects associated with death or suffering in Warhol's early work.[58] Many of the photographs Warhol selected were so telling that they seemed to belong to the culture at large. But for the original photographers, the familiarity or historic significance of a particular image did not make it anonymous, an authorless image waiting for Warhol to fill the void. Warhol's use of images published in *Life* magazine therefore sparked protests from Charles Moore, whose photographs from a 1963 story in *Life* were the basis for the 1963–1964 *Race Riot* series, and Fred Ward, whose photograph of Jacqueline Kennedy that appeared on the cover of *Life* not long after the assassination of John F. Kennedy became part of Warhol's 1963–1964 *Jackie* series. In both of these cases Warhol again used works of art to settle out of court, with Ward receiving a painting from the *Jackie* series and Moore, in an ironic twist, winding up with prints from the *Flowers* portfolio.[59] Warhol's legal problems led him to change his methods in his later work, relying more on photographs produced by assistants or going through the process of getting copyright permission when he used cartoon characters in his 1981 *Myths* series.[60] And the Warhol Foundation has taken out insurance against future copyright claims, a fact brought to light by a

lawsuit between the foundation and the insurance company about paying a claim from a 1996 copyright infringement case brought by yet another photographer whose work for *Life* was incorporated by Warhol into his *Jackie* series, in this case Henri Dauman's photographs of Jacqueline Kennedy at the funeral of the president. Nor was Warhol the only artist to face such problems. Rauschenberg was also sued by photographer Morton Beebe over his incorporation of Beebe's photograph of a diver in his 1974 *Pull*. One reason Beebe was annoyed when he discovered the use of his work was his knowledge of Rauschenberg's active support for artists' rights. Though the case was settled out of court for less than Beebe initially demanded, authorship was to a degree restored by the promise that, when reproduced, the print would be accompanied by the statement that "the image of the Diver in *Pull* is after a photograph by Morton Beebe."[61]

Although Rauschenberg and Warhol used the medium of photo silkscreen to largely different ends, both employed this form of mechanical reproduction in ways that made the act of copying an explicit part of the work and helped distinguish this postmodern copying from earlier traditions. The borrowed motifs that appear in Renaissance and baroque art, though aided by mechanical reproduction in the reliance on prints, assimilated the source material into the subsequent work. Similarly, the classical models or prototypes used as the basis for academic training were supposed to become integral to the artist's formal vocabulary.[62] In postmodern forms of borrowing based on mechanical reproduction, the obvious copy effects a different kind of critique of originality articulated in the layering of quotation and reference. Equally important is how the suspended process of assimilation serves to demonstrate that meaning is contingent and mutable, based on the relationship between a given element and the context of its presentation.

The economic importance of the images that pervade contemporary culture can present difficulties for artists whose work is based on an evident process of borrowing and quotation. Yet the idea that the meaning of a work may be transformed as a result of fragmentation and recontextualization did receive a degree of legal support in a case concerning the plucking of a fragment from its role within an ensemble of images. In 1990 David Wojnarowicz sued Donald Wildmon and the American Family Association over a pamphlet that reproduced fragments of Wojnarowicz's work, many of them explicit images of gay sex, in an envelope marked "Caution—Contains Extremely Offensive Material." The fragments were taken from works illustrated in the catalogue for Wojnarowicz's 1990 "Tongues of Flame" exhibition, partially funded by the National Endowment for the Arts. In the original works, however, the more explicit vignettes were part of larger ensembles of images that drew their critical power from the sometimes pointed and at other times more ambiguously open-ended juxtapositions of many different types of imagery.

Andy Warhol, *Mustard Race Riot*, 1963. Synthetic polymer paint and silkscreen ink on canvas, two panels, each 114" × 82". © 2002 The Andy Warhol Foundation for the Visual Arts / ARS, New York. Photo © The Andy Warhol Foundation, Inc. / Art Resource, NY.

The case against Wildmon was based in part on the fact that there are certain situations in which artistic authorship does enjoy special status and protection. Wojnarowicz was able to show that Wildmon's pamphlet violated the provisions of the New York Artists' Authorship Rights Act against displaying or publishing without permission a work of art "in an altered, defaced, mutilated or modified form" as the work of the artist if "damage to the artist's reputation is reasonably likely to result therefrom." In his decision, Judge William Conner found that, "By excising and reproducing only small portions of plaintiff's work, defendants have largely reduced plaintiff's multi-imaged works of art to solely sexual images, devoid of any political and artistic content."[63] The decision required Wildmon to mail a court-approved correction to the hundreds of recipients of the original pamphlet, but because he could not show any canceled exhibitions or lost sales resulting from the pamphlet, Wojnarowicz was awarded only a token $1.00 for damages. And Wildmon's lawyers relied successfully on the fair use provision in the copyright code to argue against Wojnarowicz's claim of infringement. It is this exception that allows for the use, in certain circumstances, of material that is protected by copyright, with the fair use factors to be taken into consideration articulated in the 1976 revision of the copyright code as: "(1) the purpose and character of the use, including whether such use is of a commercial nature or is for nonprofit purposes; (2) the nature of the copyrighted work; (3) the amount and substantiality of the portion used in relation to the copyrighted work as a whole; and (4) the effect of the use on the potential market for or value of the copyrighted work." Although the judge noted that the pamphlet was part of a fundraising effort, which would argue for its commercial rather than nonprofit use, he found that its main objective was an argument against federal arts funding, and that it was therefore a form of criticism and comment recognized as fair use.

For a time it seemed possible that fair use might also apply to works of art based on strategies of quotation and recontextualization. The question was whether criticism and commentary of a work could, following precedents established for parody, include works of art that deploy the copy as a form of critique. A crucial distinction for parody cases, however, concerns the amount needed to evoke the original, whereas postmodern appropriation is likely to involve a more wholesale copying. For Fredric Jameson, one of the key markers of the postmodern attitude was the deployment of a form of blank parody or pastiche. Parody plays on individual stylistic eccentricities and in doing so assumes a norm from which the object of the parody is shown to diverge. But pastiche, "parody that has lost its sense of humor" as Jameson describes it, skims the surface of a decentered heterogeneity.[64] In the visual arts, evidence of this attitude appears in contemporary forms in which individual style in the traditional sense has been supplanted by authorship identified with a

particular set of interests, selections, or processes where the end results are more likely to be linked conceptually than through stylistic unity. Warhol's early silkscreen paintings are the outcome of a process of selection (whether Warhol's own or not) and mechanical translation in which the impact of the work depended both on Warhol's treatment and the simultaneously undisguised impact of the underlying image. Jeff Koons, following in Warhol's footsteps as a prominent representative of a later wave of appropriation, also drew from the realm of mass production, recontextualizing but leaving the appeal of the basic commodity intact. Given how legal arguments in support of Koons's appropriation fared, however, it seems that Warhol may have been wise to settle his earlier cases out of court.

Fair use was the basis for Koons's defense in a series of copyright infringement suits arising from works in his 1988 "Banality Show." And unlike most copyright cases that have been decided out of court, the decisions in the lawsuits against Koons set precedents with broad implications for image use by artists employing strategies of appropriation. Photographer Art Rogers brought suit against Koons for copyright infringement in 1989 after a friend drew his attention to a reproduction of Koons's *String of Puppies* sculpture on the front page of the calendar section of the *Los Angeles Times. String of Puppies* was based on a black-and-white greeting card photograph of a couple holding eight German shepherd puppies that Koons had purchased in a gift shop. Like many of the other works in the "Banality Show" produced from photographic sources, *String of Puppies* involved both direct copying and significant transformation, with the oddly amputated legs of the couple, similar to the disturbing truncation of the head in *Woman in Tub,* representing a three-dimensional translation of the type of cropping found in the two-dimensional images that served as prototypes. Koons nevertheless did indicate a number of changes—including the colors used throughout, the flowers that he added in the hair of the man and woman, and the exaggerated noses on the puppies based on a cartoon character—before handing the photo over to the studio he used in Italy to be fabricated in an edition of three life-sized painted wood sculptures plus one artist's proof.

Once again the case highlights the collision of two types of authors. Koons's better-known work incorporated various forms of selection and extensive use of assistants and outside fabricators in the production of the object. Rogers was directly involved in taking the photograph, but he licensed its reproduction in a format where its connection to a specific author would be secondary to its appeal as an image. Koons used the photograph because, to him, it represented generic kitsch, and it is certainly the same qualities read straight—the cuteness and familial warmth of the image—that would have attracted less cynical purchasers of the card. But according to the legal definition, Rogers is very much an author, regardless of how he chose to license his image. Nor was Koons's defense helped

Jeff Koons, *String of Puppies*, 1988.
Polychromed wood, 42" × 62" × 37".
Courtesy the artist and Gagosian
Gallery, New York.

by his eager embrace of forms associated with the commodity, including his decision to take the money that could have been spent on a catalogue for the "Banality Show" and use it for the purposely kitsch full-color, full-page exhibition ads that appeared in *Artforum, Art in America, Flash Art,* and *Arts Magazine.*[65] In the legal realm such deliberate provocations contributed to a judgment that found in Koons's work not consummate irony, but rather the creation of a set of valuable limited-edition commodities that relied on the creative work expressed in the underlying images.

The district court that heard the copyright lawsuit brought by Rogers against Koons refused to give Koons's high-priced, limited-edition sculptures priority over the inexpensive, mass-produced note card edition of Rogers's photograph, and the lower court ruling was subsequently affirmed in an appeals court decision that found Koons's copying "so deliberate as to suggest that defendants resolved so long as they were significant players in the art business, and the copies they produced bettered the prices of the copied work by a thousand to one, their piracy of a less well-known artist's work would escape being sullied by an accusation of plagiarism." The appeals court also drew a distinction between creating a parody of modern society in general and a parody directed at a specific work, finding that the obscurity of the original meant that the Koons's work was unlikely, even if less directly copied, to read as a parody of a specific source.[66]

Nor was the suit brought by Rogers the only case concerning works in the "Banality Show." A second one, brought by United Feature Syndicate, concerned Koons's sculpture *Wild Boy and Puppy.* There, however, rather than using a relatively obscure photograph as a model, Koons had adapted the copyrighted cartoon character of Odie from the Garfield comics. Because *Wild Boy and Puppy* was based on a well-known character, the use seemed to raise a somewhat different set of issues. Some commentators have attempted to draw a distinction between using a less well-known image taken from the world of popular culture and a cartoon character that has become part of a shared cultural vocabulary.[67] The counterargument, however, is to ask why the more successful author should be penalized by having his or her creation subject to appropriation simply because it has become well known.[68] With respect to the characters used for *Wild Boy and Puppy,* the district court concluded that they had not lost copyright protection simply because they had become part of American culture. In the wake of this second setback, Koons settled all four cases that arose out of the "Banality Show," including two other pending lawsuits, one by MGM, brought in response to Koons's use of the Pink Panther character in his sculpture of the same name, and the other by photographer Barbara Campbell concerning a greeting card picture used as the basis for his *Ushering in Banality.*

While the Koons decisions sent a message that there is no automatic artistic immunity for the appropriation of copyrighted images, the lack of visibility as long as the appropriating work remains within the art world means that most such uses are likely to remain undetected. Koons's success helped spark his legal problems, since it was only after his work was reproduced in mass-media channels that Rogers became aware of his act of appropriation. Similarly, Caulfield discovered Warhol's *Flowers* by seeing a poster based on the work, Moore found out about *Red Race Riot* after it was reproduced in a *Time* magazine profile on Warhol, and Dauman only noticed Warhol's image use when *Sixteen Jackies* made news because of its sale price at a 1992 auction. Such was also the case with a lawsuit that Thomas Hoepker filed against Barbara Kruger in 2000 over the photograph she incorporated in her 1990 work *Untitled (It's a small world but not if you have to clean it)*, since the publicity surrounding Kruger's 2000 retrospective at the Whitney brought the work to Hoepker's attention, particularly its use in billboards advertising the exhibition as well as merchandise like T-shirts, notepads, and magnets available at the museum gift shop.

At certain moments, and in the hands of specific artists, the discordant effect of bringing unexpected objects or imagery into galleries or museums has produced a sharply critical edge. But as art institutions and even some artists have become involved in licensing agreements and the sale of reproductions themselves, works of art that incorporate versions of the readymade have returned to the realm of mass production as a kind of designer commodity. In particular, the volume of licensed Warhol merchandise shows the intersection of Warhol the artist, whose incisive challenge to artistic conventions included the incorporation of imagery and strategies from mass production, and Warhol the name brand, whose persona and imagery became the basis for a successful marketing strategy that endures long after his death in 1987.

In an early and often-cited case involving circus posters, Supreme Court Justice Oliver Wendell Holmes addressed the issue of artistic copying, stating: "Others are free to copy the original. They are not free to copy the copy. . . . The copy is the personal reaction of an individual upon nature."[69] The same case also established that copyright protection does not depend on the artistic merit of the work in question. Yet the environment of the image has changed dramatically in the century since this decision. In an economy based on promoting consumer identification with products, the reaction of the individual upon the commodity can be an equally pressing subject for the artist. The iconic nature of the images that Warhol used as the basis for his early 1960s silkscreen work speaks clearly to their broader cultural power. Copies based explicitly on preexisting images point to the importance of images that are broadly reproduced and therefore part of a familiar landscape. The crucial difference for artists between the use of mass-media images and trademark designs

rather than the natural landscape as subject matter is that the already-encoded is likely to be the already-commodified.

If ownership is based on originality, the question of what and how much may be owned has become increasingly complex in the face of images based on other images, as well as the way strategies associated with postmodernism have problematized the very notion of an original. Indeed, it is the paradox of an ever-receding original that Levine highlights in her photographs after Edward Weston's pictures of his son Neil. On the one hand the works seem to fit the paradigm of the difference between the copy after nature and the copy after the copy. Yet Crimp has pointed out how much the figure in Weston's image recalls the contrapposto pose familiar from classical sculpture.[70] Levine's appropriation, situated at one extreme in a succession that includes many different modes of copying or assimilation of precedents, thus draws attention to how and where originality may be assigned in the context of mechanical reproduction.

A consideration of the act of copying framed primarily as a theoretical argument about issues of originality and authorship does not, however, account for its extensive and pervasive reach in recent practices. The types of copies that appear in contemporary art are as varied as the materials artists have employed, with the copy's manifold appearances serving to indicate its importance as an increasingly significant technique for the making of what are received as original works. The changes performed by the direct copy can involve explicit shifts from one medium to another, or the far more subtle recontextualization that connects appropriation to the readymade. The tremendous power of this process of transformation is evident in works based on layers of mediation, as images, forms, and textures are subject to multiple processes of translation. In such instances the copy also functions as a wedge, contributing to the fracturing of the idea of medium in the translation from one material to another. Photography's central role in the context of contemporary art can be ascribed in part to the mediation inherent in the process, even as it is only one of many forms of copying deployed by contemporary artists. Thus works as different as James Welling's small gelatin silver photographs of crumpled foil, and Rachel Whiteread's resin casts of the undersides of tables and chairs, show how the process of capture or transmission itself is crucial even in situations where the artist may be largely responsible for establishing the form that is thus transformed.

"What I do appropriate is a classic photographic style and the institutional presentation that goes along with 'straight' photography."[71] This was how Welling characterized the difference between his approach and other forms of photographic appropriation with which he was often grouped during the 1980s. Yet the early series based on his adaptation of straight photography to images of draped fabrics or crumpled foil incorporate a double

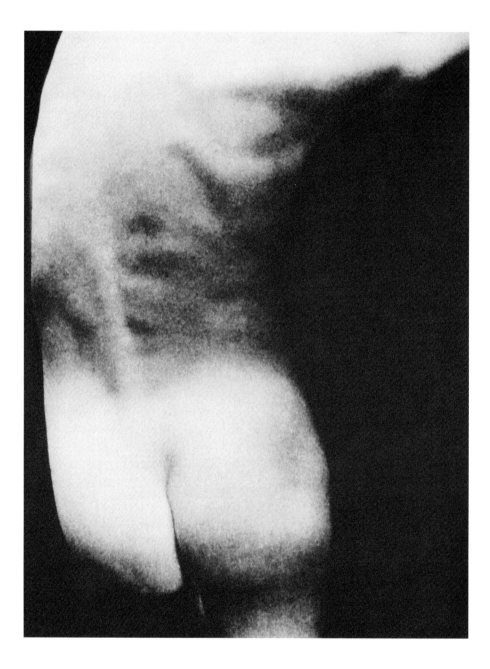

Sherrie Levine, *Untitled (After Edward Weston #5)*, 1980. Black-and-white photograph, 10" × 8". Courtesy Paula Cooper Gallery, New York.

process, first the manipulation of the material that will be the subject of the image, and second the taking of the photograph itself. In the intimately detailed close-ups of foil, their precision only serves to heighten the attention to the photographic transformation itself in the creation of images that are at once highly detailed and yet abstract. "They are about something which happens to be very difficult to describe," was Welling's own evaluation. "Everyone sees landscapes—so do I—but the point is, what kind of landscapes are these? What interests me is this primitive desire to look at shiny, glittering objects of incoherent beauty."[72] As part of an engagement with photography that has since encompassed classically detailed black-and-white photographs of railroads or the architecture of H. H. Richardson, digitally printed images of light sources, and different forms of cameraless abstraction in black-and-white photograms of geometrical arrangements or nearly monochromatic fields of color, they suggest an interest in photographic processes as a form of mediation that can be deployed to a profusion of different ends.

The three-dimensional mode of capturing nuances of texture and form constituted by the casting process can also be employed so that the translation itself is part of the subject of the work. The defamiliarized yet particular quality of Whiteread's sculpture depends on the simultaneous recording and negation of material specificity—whether it is the three-story cement interior of her most famous work, the 1993 *House,* or the more intimate series of resin casts of the undersides of chairs and tables. Scale as well as composition are functions of the objects selected, though the impact of the work is equally dependent on the material used to create the new form. And the materialization of what had been void further contributes to a transformation that renders the familiar simultaneously abstract. The 1995 *Untitled (One Hundred Spaces),* a series of rectangular resin blocks cast from the undersides of chairs and arrayed across the gallery space, suggests the serial repetition of minimalism through the copying process, but with the added specificity of the cast, based on the scale of an object already associated with the habits of the body, and therefore adding another layer of significance to the relationship established with the viewer. The fact that the configurations Whiteread copies have ranged from entirely found forms to ones that she has to varying degrees established herself (forming what will then be transformed) only serves to emphasize the importance of the copy as a technique for making.

In a sense, however, the most powerful testimony to the ability of the copy to transform occurs in situations where the exact copy is unrecognizable as such simply because of the way the underlying visual information has been mediated or transcribed. Under certain circumstances the process of selecting, isolating, and moving between different scales or materials can even result in a literal record that has the appearance of a total abstraction. Moreover, the application of a predetermined system to the selection or combination of

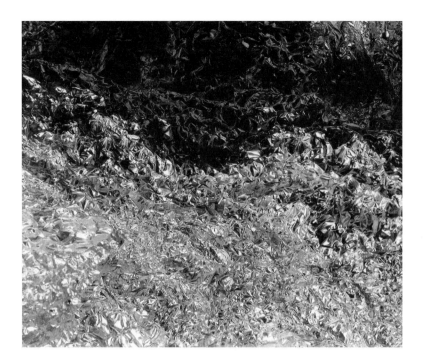

James Welling, *Untitled 2-291-80*,
1980. Gelatin silver print, 3⅛" × 4".
Courtesy the artist.

found objects or images indicates the important link between certain forms of copying and strategies significant for conceptual art. All of these considerations are decisive for an understanding of Allan McCollum's series of *Perpetual Photos,* pursued from 1982 to 1989, where the mechanically recorded image has been transformed to near or total abstraction simply as a function of cycling through enough different media. The procedure was remarkably simple: "A snapshot is taken from the television screen when a framed artwork is seen on the wall behind the dramatic action. The *Perpetual Photos* are these artworks enlarged again to a normal scale and reframed by the artist for re-presentation in a tangible setting."[73] However, the process involves a number of transformations. The works of art are frequently part of the background of a scene, and therefore relatively small and not necessarily in focus. They have also been transformed by the graininess of the television picture, and further homogenized by the conversion to black-and-white photographs. Once these elements are enlarged, the blurry images present both literal records of what has been mechanically recorded and compositions that appear largely abstract.

Recourse to a system for generating the work is one way that contemporary artists, drawing upon conceptual art, have participated in a critique of originality while at the same time looking for ways to take such procedures in new and unexpected directions. It is

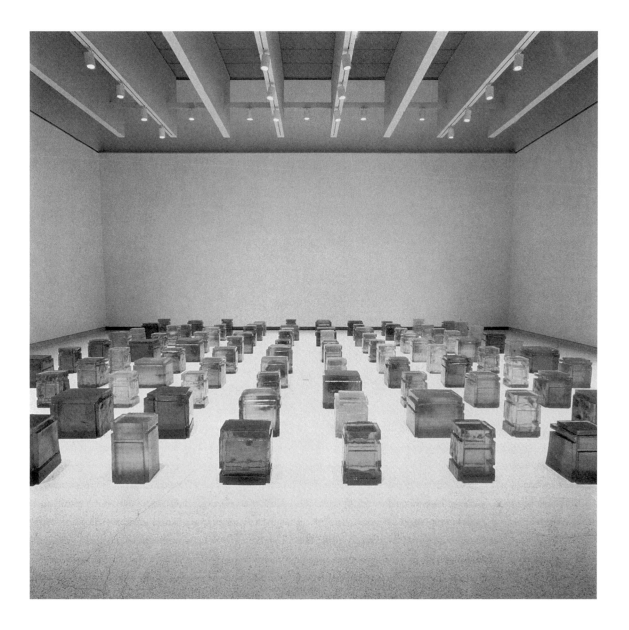

Rachel Whiteread, *Untitled (One Hundred Spaces)*, 1995. 100 units of 9 sizes. Installation at the Carnegie International. Courtesy Luhring Augustine, New York.

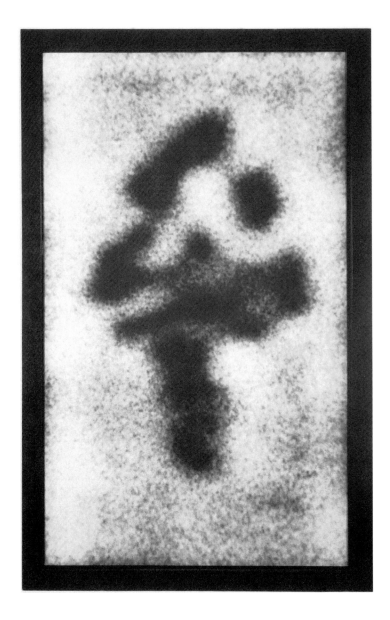

Allan McCollum, *Perpetual Photo
(No. 119)*, 1982/1986. Gelatin silver
print, sepia-toned, 62½" × 39".
Courtesy the artist and Friedrich
Petzel Gallery, New York.

therefore not surprising that Levine's self-conscious search for models or precedents has also led her to explore ways of using the copy as part of the process for generating abstractions. Her *Melt Down* paintings respond to the history of the monochrome very specifically. Levine's first set of monochromes was inspired by a kind of chance, when a computer consultant who was helping her generate printouts based on dividing up paintings into grids and averaging out the color for each section also produced an overall reading of each work—a monochrome, in other words. But because the overall averaging of colors tended to produce varying shades of gray, Levine turned to the work of Yves Klein. By feeding monochrome works into a computer programmed to produce monochromes, she was able to create monochromes with the same saturated colors that Klein had used, though they are also transformed by being painted on wood. Their apparent abstraction derives from both the process used for the copy and the objects subjected to that process. Questions of origin or originality are fraught in regard to a form with the radical simplicity of a monochrome painting, although it is also true that the impact of Klein's work depends on a materiality of surface lost in the generations of mechanical reproduction separating his monochromes and Levine's. And in asserting the monochrome, Klein was taking up a form that Rodchenko had already established thirty years earlier.[74] Levine's incorporation, however, avoids any possible accusation of naive duplication by addressing the weight of history directly, in a way that has so foregrounded the element of mediation that repetition itself becomes part of the subject of the work.

Levine's monochromes came about during the process of making another series, presented under the similar title of *Meltdown*—a portfolio of prints from 1989 based on a computer-generated grid structure. The twelve colored rectangles that made up each grid were based on computer readings of works by Mondrian, Kirchner, Monet, and Duchamp, using a program designed to average the color in each of the sections of the grid. The images fed into the computer were not the paintings themselves, of course, but reproductions, specifically Levine's own 1983 photographs, which were photographs of already-reproduced images. The computer output was then translated into the more traditional medium of woodblock printing. Yet even though the computer-generated grids used for the *Meltdown* prints may not look like photographs of paintings, the works do still retain an indexical relation, however attenuated, to their source. Collapsed within the final print are all of the earlier stages in the move from art work to photograph to printed reproduction to photograph to computer-generated grid and, finally, to woodblock print. Each representation of the painting functions as a screen (or grid) through which visual information is relayed, with the abstraction of the final work produced by the decision to simplify radically the grid through which previously detailed information was transmitted.

Given how central the fact of mediation is to the experience of these prints, it seemed a bit incongruous to come across Levine's *Meltdown* after Duchamp hanging in a 2001 MoMA print exhibition devoted to portraits from the permanent collection. The original work that Levine subjected to her much-mediated replication was none other than Duchamp's *L.H.O.O.Q.,* the work he made in 1919 by amending the Mona Lisa with the addition of a mustache, goatee, and the vulgar description that can be gleaned from the letters when spoken aloud in French, *elle a chaud au cul,* or "she has a hot ass." Duchamp's assisted readymade got its power from the dada gesture of applying this irreverent graffito to a masterpiece of Italian Renaissance painting with a long history of veneration that includes Vasari's high praise in his sixteenth-century *Lives of the Artists,* Walter Pater's late nineteenth-century reveries, and Sigmund Freud's early twentieth-century psychoanalytic interpretation. The Mona Lisa had also made headlines in Paris not long before Duchamp's addendum when it was stolen from the Louvre in 1911, and again two years later when it was recovered and restored to the museum.[75] It is also true that the painting is a portrait, though the identification of the sitter is less than certain, and its fame is more closely tied to the identity of its author, Leonardo da Vinci.

But it was not Leonardo's painting itself that was subject to Duchamp's gesture. Rather it was a small color reproduction, a mass-produced chromolithograph less than eight inches high. It was a harbinger of what would become a sea of copies such that the experience of this painting in the museum, like that of so many other famous works, is an encounter with an original made numbingly familiar through its many iterations. Thus Duchamp was responding not just to the work itself but to a whole history of the work's popularization as cultural icon. Duchamp's gesture was made famous in turn through published images of the altered version, including Duchamp's own meticulous reproduction for the 1941 *Box in a Valise,* giving Duchamp a kind of priority over appropriations of the Mona Lisa. So even though Warhol's 1963 series of Mona Lisa silkscreen paintings may allude to the fame of the original, it can hardly avoid the subsequent associations that have attached to the painting. While Leonardo may have maintained his position as author of the original, Duchamp's hold over its reproduction was only further affirmed by his 1965 *L.H.O.O.Q. Shaved.* For this later version of his own gesture, which served as an invitation to an exhibition preview, Duchamp presented a series of Mona Lisa reproductions from a pack of playing cards simply mounted on paper without any intervention in the image, obviously confident that his earlier appropriation would be securely inscribed in the pointedly unaltered version.

Authorship isolates, frames, and provides the context within which the copy or even the found object can be designated an honorary original. While categorizing works of art

Sherrie Levine, *Meltdown*, 1989
(from the portfolio of four prints
published by Peter Blum Editions).
Color woodcut, 36½" × 25¾".
Courtesy Peter Blum, New York.

Marcel Duchamp, *L.H.O.O.Q.*, 1919 (replica from the *Box in a Valise*, 1941). Collotype, 7⅛" × 4¹³⁄₁₆". Philadelphia Museum of Art, The Louise and Walter Arensberg Collection. © 2002 Artists Rights Society (ARS), New York / ADAGP, Paris / Estate of Marcel Duchamp. Photo: Lynn Rosenthal.

according to author is a mode of organization particularly associated with the rise of the museum, recent trends allow the artist's act of making to be replaced by a process of designation, such that selecting and categorizing can become the act of authorship itself. Under these circumstances, the artist's designation may alter what is found or copied little or not at all. What changes is its significance, read in relation to works by the same artist and the history of related acts by other artists. As the designation of authorship reframes the image or object, it is removed from a former purpose, becoming simultaneously a comment on that previous function as well as part of a new category of works by the artist. The reference to an everyday object that has a history of use by artists addresses, by implication, not just the intersection of art and mass production, but also the entire history of such uses. In situations where traditional skills are supplanted by the incorporation of ready-made elements, mechanical reproduction, or the use of outside fabricators, the sense of history internalized by the mastery of traditional skills is replaced by a more explicit and self-conscious structure of reference and quotation. Nor is the association of authorship, once established for a specific type of work, readily surrendered. Examples of the hold that an artist can gain over a particular image include Johns and the American flag, or Warhol's claim over Campbell's Soup, such that any subsequent play with the image will be read as a reference to the artist as well as to the original object. Thus the old apprenticeship in skill and technique turns into a new apprenticeship in ideas. Multilayered references point not just to other objects and images, but also to the history of their assimilation into art-historical and critical traditions.

In deciding to make a cast bronze urinal, Levine chose an object with such a significant avant-garde history that the focus on the idea of her recontextualization can make it hard to appreciate the tremendous sensuality of materials and surface in the object that has resulted. Yet when Levine took up the urinal, she did so fully aware of how Duchamp had succeeded in laying claim to this object to such a degree that any further use will be read in relation to Duchamp's earlier assertion of authorship. The reference to Duchamp was obvious, although, in another sense, Levine's *Fountain* is not a copy at all, because she did not have to go to a museum original in order to create the replica. For her bronze cast, Levine went to the same source as Duchamp, the realm of mass production, albeit with a historic delay. The work activates a whole history of references to earlier readymades and copies of everyday objects. Such traces are not literally inscribed in the work, but appear in the intersection of the work and its presentation in critical or interpretive contexts where it will be read in relation to, and become part of, this history.

MEDIUM AND MATERIALITY

Wolfgang Laib, *Milkstone*, 1988.
Marble and milk, 2½" × 23½" × 30½".
Courtesy Sperone Westwater, New
York.

What might it mean for an exhibition devoted to the twentieth-century still life to end with Wolfgang Laib's 1988 *Milkstone*? The exhibition was the Museum of Modern Art's 1997 "Objects of Desire," and the sculpture was, according to curator Margit Rowell, "a 'still life' unlike any we have seen before."[1] The example at MoMA was one of multiple versions of the work, each made from a relatively low rectangular block of white marble carved with a slightly concave surface that constitutes the permanent part of the work. The sculpture is completed by the addition of a thin layer of milk that extends exactly to the edges of the flat surface and duplicates the white of the marble so precisely that the difference between the solid stone and the glistening liquid surface is almost imperceptible. The precision and elegance of the spare, white rectangle is matched by equally exacting requirements for exhibition, including a meticulously level floor and daily milk replacement. For Laib the pouring of the milk that replenishes the pristine surface of each *Milkstone* is part of a participatory ritual handed on to future exhibitors or owners of the work.[2] There, as in Laib's other work, the use of specific substances reflects a commitment to nature and to ritual as a form of spiritual purification, evident for example in those made from pollen that he spends months harvesting each spring—with the significant difference that the pollen is carefully retained between appearances, whereas the milk only becomes part of the work when it is spread in a thin layer on the marble base that it completes. The only obvious connection to the history of the still life is the presence of milk, creating a tenuous link to the provisions likely to populate traditional paintings of such subjects. But "Objects of Desire" was an exhibition that dealt head-on with the paradox of trying to apply a traditional genre category like still life to recent forms of art.

The exhibition opened as one might expect, with modernist paintings by Cézanne, Picasso, and Matisse that used still life motifs as the basis for each artist's exploration of

painted form. This work had already announced the end of an earlier era, when still life occupied a position as one category of painting within a set that also included landscapes, portraits, history painting, and the images of daily life dubbed genre paintings. Such categories played a central role in the French Academy where, as Thomas Crow has shown, history painting was the most prestigious form, even if not always the most financially lucrative for painters, based on the narrative complexity of the religious and historical subjects as well as the status associated with state and church commissions.[3] The lesser orders within that hierarchical system, landscape, still life, and portraiture, did not require the long study of anatomy, classical form, and composition needed to build complex, multifigure narratives. The absence of narrative combined with the use of familiar, often directly observed motifs, however, constituted the very qualities that attracted the advanced painters of the nineteenth century to the lower genres.

By the beginning of the twentieth century the genre categories continued to exist as a kind of artifact, but their function of organizing the traditional subject matter, so that one painted particular people, objects, or places, was giving way to their role as vehicles for the development of modernism. For Clement Greenberg, who complained that illusionistic painting "dissembled the medium, using art to conceal art," the important distinctions could be found not in the subject of a painting, but in the exploration of the medium itself. The lower genres were little more than stepping stones in Greenberg's genealogy of abstraction. The sequence of discovery in his essay "Modernist Painting" takes the reader from Manet's flattening of the picture plane to the explicitness of impressionist paint, Cézanne's move away from verisimilitude, and onward through cubism in the march toward abstract expressionism. What was important was the exploration of "the characteristic methods of a discipline," which, for painting, resided in abstraction and a near but not absolute flatness, "in order to entrench it more firmly in its area of competence."[4]

The attempt to retain the vestigial category of still life for the twentieth century as a whole is therefore fraught with paradox. One approach might have been to follow the thread of the painted still life through its many and various twentieth-century permutations before, after, and in many cases contrary to high modernist abstraction. But the MoMA exhibition announced a different direction by the inclusion of actual objects, with early readymades and surreal assemblages pointing forward to the nearly exclusive focus on found objects or pop facsimiles in the sections devoted to the 1950s and 1960s. The inclusion of the readymade announced the exhibition's allegiance to an alternate historical trajectory, leading not to modernist purity but to the postmodern play with reference and quotation from a range of art as well as nonart sources. Since this narrative deflection re-

quires the embrace of a fractured and wide-ranging field of possibilities, what should be included in such an exhibition is far from obvious.

For the periods after the 1960s the selections in "Objects of Desire" could only be described as eclectic, with the 1970s largely ignored and the decade of the 1980s represented by everything from neoexpressionist painting to Charles Ray's 1989 *Tabletop,* which consisted of a wooden table populated by a plate, bowl, and other objects that prolonged contemplation reveals are not sitting still, but slowly spinning with the assistance of hidden motors. Gerhard Richter's oil painting of a skull and candle, one of a series showing various configurations of these still life elements, and Cindy Sherman's color photograph of a table encrusted with wax dripped from burnt-down candles and the remains of a seemingly bizarre meal, suggested a return to the *vanitas* theme pervasive in seventeenth-century Dutch still life traditions. In both cases, however, the sense of quotation is an essential part of the work. Richter's 1983 *Skull with Candle* (shown at MoMA) and the closely related *Two Candles* are clearly based on photographic sources, and Sherman's 1987 *Untitled #172,* in addition to referencing the tradition of still life painting, employs cheap and exaggerated props to draw attention to the artifice of the simulated setting. Yet both of these works, with their layered reference and quotation, were made within a few years of Laib's use of pure and unadulterated milk in the context of a work that seems to owe far more to minimalism than to pop art precedents.

How to compare the incommensurate? Certainly that is one of the most significant challenges posed by the explosion of possibilities that, by the end of the twentieth century, left few limits to what could be defined as art. The genre hierarchies of the academic tradition, with divisions based on subject, or the modernist division of art into broad categories according to medium, held out the promise that comparison and judgment could take place within the boundaries set out by each classification system. But the straight line that Greenberg attempted to draw from the nineteenth to the middle of the twentieth century was only possible because he dispensed with the many forms of avant-garde activity that did not fit his push toward purity and specificity. Looking back at this same period, Thierry de Duve has located in the acceptance of Duchamp's readymades, with their proposition that a work of art might be designated rather than made, the establishment of "art in general" as a category that trumps previous distinctions. In the wake of the readymade, "you can now be an artist without being either a painter, or a sculptor, or a composer, or a writer, or an architect—an artist at large."[5] Yet the existence of work that can only be categorized according to the widest generic term "art" does not lead de Duve to conclude that the generic and the particular, the readymade and early twentieth-century modernist painting,

Gerhard Richter, *Two Candles,* 1983. Oil on canvas, 55⅛" × 55⅛". Courtesy Marian Goodman Gallery, New York.

can be assessed by the same criteria, or that the readymade eradicated painting as a specific arena of artistic exploration.

The question, then, is whether or according to what terms the concept of medium remains relevant. By the twentieth century's end, categories like painting, sculpture, or photography had not been effaced; but they did, over the course of the century, lose both their exclusivity and their status as markers of a self-evident connection between medium and material support. Traces of these earlier modes of production abound in contemporary art. Yet the increasingly complex play of reference involving both subject matter and medium conventions has created a set of possibilities characterized by simultaneously dispersed and overlapping activity. In the place of medium divisions used to designate specific qualities, it is increasingly necessary to speak of painting, photography, and a range of other forms in terms of a series of conventions that may or may not be divorced from the

Cindy Sherman, *Untitled #172*, 1987.
Color photograph, 71½" × 47½".
Courtesy Metro Pictures, New York.

medium itself. An earlier conception of medium has fractured into, on the one hand, a se-
ries of conventions that may or may not appear in conjunction with their traditional sup-
port, and an abundance of highly specific materials drawn from a multitude of sources.
It is in this context that the copy appears in its many guises, as a mode of art production,
as part of a process of remaking that allows the continuation of otherwise impermanent
works, and in the quotations of both imagery and effects that appear in many contexts.
Even the determination of what, exactly, constitutes the work of art is less and less self-
evident. Once it is accepted that a work of art can consist of nothing more tangible than a
linguistic declaration or an ephemeral action, the establishment of a physical configuration
constitutes a specific and significant decision that must then be followed by many more,
including the determination of form, materials, context, and even duration. And as the
physical object has become increasingly unstable as a marker of what constitutes the work,

the now all-important category that frames and gives meaning to this play of reference is artistic authorship. An analysis of some of the ways contemporary artists have incorporated references to the traditional genre divisions is thus an important first step in addressing the implications of this far more heterogeneous field.

While the works by Sherman and Richter in the show at MoMA were in some respects more closely linked to earlier still life paintings, these artists could not be further from the category of specialists in the genre. Nor does still life function in their work as it did at the turn of the twentieth century—as a vehicle or armature for the exploration and reinvention of painting itself. Instead, still life appears as one of a multitude of quotations or references drawn from art-historical sources as well as the wider field of late twentieth-century visual culture. The two works also share a play across different media. But to overemphasize the neat parallel between a photograph that refers to traditional painted forms and a painting clearly based on a photographic source would be to ignore equally significant distinctions that include not only the specific contrast between Richter's origins in a divided Germany and Sherman's in the northeastern United States, but also the broader difference between a generation whose establishment of a range of procedures involving reference and quotation during the 1960s was in many cases marked by a dialogue with or against painting, and a subsequent generation associated with the late 1970s and 1980s whose play with reference and simulation tended to be centered in photographic activity.

What is the importance of the medium of photography for Sherman's work? The black-and-white *Untitled Film Stills* that established Sherman's reputation vary greatly both in the composition of the staged scenes and in such photographic qualities as the degree of graininess and contrast. Sherman shot many of the images herself, using a shutter release (with the bulb and cord sometimes evident) or a timer, and she relied on help from friends and family to take some of the pictures, particularly those with exterior settings.[6] She has also distanced herself from part of the production process by using commercial darkrooms for her printing. Authorship is therefore not a matter of who did the printing or even who shot the picture. Then there is Peter Bunnell's rather paradoxical claim that Sherman is "interesting as an artist but uninteresting as a photographer" due to her limited engagement with "the nature of the medium through which she derives her expression."[7] Given the fact that Sherman's exhibited work has consisted almost exclusively of photographs, this is an undeniably narrow view of what an engagement with the medium might entail. But her success has provided the final proof of how the conventions established to separate and elevate artistic versions of photography from other utilitarian or amateur forms have been irrevocably shattered by a variety of postmodern uses and, in particular, by the role of the document, often deliberately unaestheticized, in the context of certain forms of conceptual and performance art.

It is therefore not surprising to learn that, as a student, Sherman's breakthrough came not in courses devoted to technical processes but from her introduction to conceptual art and related performance practices. In talking about the derivation of her work, she has described a version of open-ended performance that involved donning various costumes and simply going about daily life, which came to an end after she moved to New York City.[8] Although this play with identity was redirected into the setups for her photographs, there is a suggestive echo of Adrian Piper's confrontation with everyday life in a series of public performances from the early and mid-1970s that are, not coincidentally, documented through photographs that purport to record a small fragment of these ongoing activities. Sherman has in fact identified Piper and Eleanor Antin as both "true influences" and "real pioneers" during a period of the 1970s "considered a 'dead zone' for women artists."[9]

Sherman has removed herself from the work in one sense, in that she has not concerned herself with the production of the final print. But she is famously present in her work in other ways, in the forms of masquerade announced by the film stills in the late 1970s as well as the numerous guises taken up in subsequent work. In the film stills, the nostalgic evocation of fragments from familiar film narratives—revolving around suburban decadence, *noir* foreboding, the young career girl in the city, or her departure from the farm—depends on the viewer's ability to recognize cinematic conventions. Sherman's impersonation of different characters might further suggest a reading of the film stills as performance documents. However, recognizing that these fragments are staged forces an awareness of the conventions themselves, as visual cues that suggest narrative conventions drawn from film are reinscribed in the still photograph.

The elaborate period costumes and drapery, fake breasts, and assorted props that Sherman turned to in the late 1980s made the act of staging even more obvious. In the series of color photographs that take paintings as their reference points, the suggestions include specific images by Caravaggio or Raphael as well as generalized types ranging from portrait subjects to religious icons. History painting is also evoked, as in her version of Judith with the head of Holofernes in her *Untitled #228* from 1990, a subject made famous by both Caravaggio and Artemisia Gentileschi. But because she is using only herself as a model, she has done without Judith's maid, presenting a stripped-down version of history painting's narrative complexity. Furthermore, the obvious costuming and props—particularly the head of Holofernes in the form of a rubber Halloween fright mask—are as likely to suggest another series of associations with the anachronistic details characteristic of the type of low-budget movie destined to become a cult classic.

Viewed in relation to the history portraits, Sherman's *Untitled #172* might indeed be seen as a play on another painting tradition, that of the still life—which is the role it was asked to play in the "Objects of Desire" exhibition. However, the obviously plastic worms

Cindy Sherman, *Untitled #228*,
1990. Color photograph, 82" × 48".
Courtesy Metro Pictures, New York.

or parasites in a plate of viscous liquid at the foreground of *Untitled #172* present one of
the more restrained examples of imagery from another group of works from the same pe-
riod as the history portraits. By the late 1980s Sherman had heightened the disturbing
and macabre qualities that began to appear in the fairy tale images from the middle of the
decade in works characterized by fragmented or distorted body parts, chaotic piles of de-
bris, and strangely glistening substances. Nor does the obvious staging diminish the power
of their visceral suggestions of violence or decay. It hardly matters that the substances
Sherman has used to suggest blood, vomit, or excrement appear at times to be little more
than familiar condiments like catsup or mustard and perhaps some sort of canned stew. A
double transformation remains evident in the final work, first as Sherman combines var-
ious props or substances to stage the tableau, and then when the scene is recorded and
presented as a color photograph. The medium of presentation is hardly incidental to the

process. The large color photographs convey information that enables the recognition of the materiality of the tableau to operate simultaneously with a response to the transformation of those materials into an image capable of provoking undeniable feelings of fascination and repulsion.

In Richter's case there can be little doubt that he is indeed a painter. Even so, his engagement with the medium has been extensively mediated by models from other sources, particularly photography, and one of the most evident features of his work as a whole is the refusal of stylistic coherence. The paintings based on mass-media sources that he began in the 1960s, and a subsequent succession that has included hard-edged color paintings of grids, far more gestural gray monochromes, and his ongoing oscillation between photorealism and abstraction, speak to a combination of mastery and denial. A significant key to this stylistic heterogeneity is located in a source external to the paintings themselves, in Richter's *Atlas*. The source material gathered in this vast compendium is predominantly, though not exclusively, photographic—the most prominent exception being the small color paint samples that formed the basis for his large-scale color grid paintings. What the paintings based on found images, paint samples, and his own color snapshots share is the elimination of the need for invention through the use of ready-made compositions.

Landscape, still life, and portraiture make their appearances in paintings based on photographic sources, meaning that it is through the use of photographs that Richter has engaged in a dialogue with the genre traditions of painting. Then there are the photo-realist brushstrokes, where Richter's precise renditions of photographically enlarged details from his own works constitute minutely representational abstract paintings. The play between different styles argues against the inevitability of any one given form, as does the use of ready-made models for their composition. The challenge to postmodern readings that have emphasized the use of such models comes from the abstractions where Richter has not relied on photographic mediation. It was in 1976, as he told Sabine Schütz in an interview, that he began to paint abstract paintings in which "arbitrary choice and chance play an important part." Asked by the same interviewer whether they are "something like a painted commentary on painting," his response was negative: "in the end that would mean that it means nothing and says nothing," and, he continued, "What counts is always the seeing." [10]

As his contribution to the 1992 Documenta 9, Richter created a cabinet with a small floral still life hung high in a space dominated by his abstract paintings. For Crow, Richter's juxtaposition of the large-scale painterly abstractions and small photo-realist still life paintings evoked the hierarchy of the salon, where history painting dominated both in scale and importance. The connection is part of a general argument Crow makes about history painting's twentieth-century successors. Crow finds one descendant of history

painting in the postwar abstract expressionists, arguing that "they extinguished explicit figuration the better to retain the formal characteristics of heroicizing art from the past: large scale, expansiveness of effect, the rhetoric of action and risk," to create work that was, in this sense, "old-fashioned in its ambition."[11] Crow's argument involves the displacement of the lower genres into realms denigrated as kitsch, a category in which he includes forms like the paint-by-numbers kits that Warhol made the basis for his series of *Do It Yourself* paintings in 1962, or amateur versions of representational painting based on photographs.[12] According to this scheme, the obviously photographic realism that enjoyed a vogue during the 1970s, as well as Richter's manifold versions of the practice, entered the art tradition through the back door of kitsch, regardless of the mastery exhibited by the artists who took up this approach.

But the lineage of history painting has produced more than a single set of offspring, even within Richter's own work. History painting makes an appearance of a different kind in Richter's *October 18, 1977*, the series of paintings from 1988 based on individuals and events connected with Germany's Baader-Meinhof group. Although Richter had shifted from the use of images found in printed sources to a reliance on his own photographs by the early 1970s, he returned to the use of photographs culled from various media and archival sources to create his response to contemporary history in the fifteen paintings that together comprise the *October* work. By using photographic models for this series of monochrome paintings, Richter succeeded in creating history paintings that acknowledge the degree to which the photograph has taken over the dominant role in giving visual form to contemporary events, as well as the succession of photographs through which any given situation is likely to be conveyed. It is therefore significant that this version of history is presented not as a single multifigure narrative painting, but in a fractured as well as overlapping sequence of events and individuals, some of which could, viewed in isolation, even be read in terms of portraiture. The provocative nature of their subject also distinguishes them from classic history paintings, commissioned by and designed to glorify the state. Exhibited shortly after their completion in Germany, they reminded viewers of a still recent wave of terrorist acts and also of suspicions about the circumstances surrounding the reported suicide of the three prisoners who were found dead or dying in their cells in Germany's Stannheim prison on the morning of October 18, 1977.[13]

Benjamin Buchloh makes a connection to earlier painting traditions, drawing a comparison between *Funeral* and the three versions of *Dead* in the *October* series and "two of the central images from the complex prehistory of the destruction of history painting in the nineteenth century," specifically Courbet's *Burial at Ornans* and Manet's *Dead Toreador*. But Buchloh goes on to argue that "the history of history painting is itself a history of the

Gerhard Richter, *October 18, 1977: Confrontation (3)*, 1988. Oil on canvas, 44" × 40¼". Courtesy Marian Goodman Gallery, New York.

withdrawal of a subject from painting's ability to represent, a withdrawal that ultimately generated the modernist notion of aesthetic autonomy."[14] In this way he alludes to the same process of transformation described by Crow while suggesting a return, via the photograph, to a category of production subsumed by modernism. Thus Richter is described in these two accounts as exploring, separately, two different extensions of history painting, one in his version of modernist abstraction, another in the use of photographs to establish references to specific events. Yet these hand-painted renditions of photographs, which draw attention simultaneously to Richter's response to photographic effects and to the subjects captured by the image so rendered, also suggest another body of work centered around contemporary events far more recent than nineteenth-century history painting, specifically Warhol's mechanically reproduced images of death and disaster. There, too, the effect of the silkscreen transfer and its repetition force attention to the surface of the work while simultaneously allowing access to subjects both compelling and historically significant, particularly the photographs of civil rights protests that he used for his *Race Riot* series. In using photographs as the basis for paintings, in Richter's case, or in the space of painting (photo silkscreen on canvas, painting's traditional support) in Warhol's, both artists have reintroduced a form of representation that simultaneously insists, through the sense of quotation, that the rendering of the representation is itself part of the subject of the work.

Given this fracturing of the category of history painting, what are some of the other places where its attributes may have come to reside? Crow himself finds another contender in the way Jeff Wall's photographs, presented as large-scale color transparencies in commercial-style light boxes, suggest history painting's narrative traditions. If, however, it is large scale and high seriousness rather than narrative that makes abstract expressionism the heir to history painting, then perhaps the category could be extended to photographic play with those qualities in Andreas Gursky's large-scale color photographs, the dispersed activity of which very often echoes the all-over compositional flatness of modernist painting. To further complicate matters, Gursky, like Wall, has turned to digital techniques to compose images where extensive alteration or assembly of photographic information destroys the indexical relationship to the object often assumed to be one of photography's defining features. For Gursky, the decision to alter the photographic source for the image that became his 1996 *Rhein* was motivated by his desire to convey a contemporary rather than picturesque image of the river. According to him, the image he was after implied a view that "cannot be obtained *in situ;* a fictitious construction was required to provide an accurate image of a modern river."[15]

The use of photographic information that has been digitally redrawn and then presented on a scale previously associated with painting is just one of the ways that effects identified with the medium of photography have been detached and reassembled. The turn

Andreas Gursky, *Rhein*, 1996.
C-print, 72⅞" × 86⅛". Courtesy
Matthew Marks Gallery, New York.

to digital imaging can be understood both as a pivotal development in the history of photography and as merely the final destabilization of a category already called into question by the myriad ways photographic forms have been incorporated into artistic practices of the last four decades. The possibility that a digitally produced composition might be extensively manipulated or even assembled from multiple elements while still appearing photographic connects this version of photography to a far more extensive fracturing of medium specificity. This version of the hand-made photograph may appear photographic simply because of how the final image has been printed, but in other respects the essentially arbitrary decisions about what type of visual information to emulate connects this rift between medium and effect to the internal fracturing of the image into separable conventions already evident in the imitation of photographic and other graphic effects in photo-realist paintings. Such internal fracturing also makes it clear why it is difficult to chart a direct line from earlier modes of production into recent practices.

Chuck Close's large-scale paintings of the human face present a case in point. They continue the large scale associated with the abstract expressionist canvas, they are composed with an all-over approach to that field, and a retrospective view of his work presents compelling evidence of his ongoing engagement with the exploration of his medium. He

does so using recognizably photographic images as the basis for paintings, drawings, prints, and a number of more hybrid forms, yet the idea that these works might constitute portraits is countered by the function they so clearly serve as simply the starting point for another series of investigations. Indeed one could say that the real focus of Close's work as a whole is an exploration of the qualities of the medium, using the recognizable image only as a vehicle, were it not for the fact that this leaves open the key question of which medium, or what combination of media, is under investigation.

Close's engagement with mechanical reproduction encompasses far more than just the use of a photographic source. Given the underlying grid in the early black-and-white paintings, it is not surprising to hear him speak of the impact of learning about art from black-and-white reproductions, examined with a magnifying glass.[16] His use of paint therefore refers not just to photographs, but to the offshoot of photography in the line screens and color separations used to reproduce images in print. Indeed Close does not identify himself as a painter of portraits, despite a remarkably consistent focus on the human face in paintings, drawings, prints, and photographs that would, in another era, have identified him firmly as a specialist in the genre. As Robert Storr points out, few of the paintings Close terms simply "heads" are owned by the subject of the image, and his only commissioned portrait was a 1996 photograph of President Bill Clinton.[17] The true subject of his portraitlike paintings and drawings might better be described as the process of depiction, mediated by the photograph and other forms of graphic information. Close himself has stated that he turned to the heads because they provided an all-over focus inspired by Stella's stripe paintings.[18]

"The photograph is the source, a well to which you can go and from which you can keep bringing back bucketsful," was how he described its role in a 1984 interview. At that point it was the same group of fifteen or twenty photographs to which he kept returning, a situation he described as "the opposite of the story of Dorian Gray. The person ages, I have something that stays constant."[19] That, one might be tempted to point out, is the traditional relationship of the portrait to the sitter. But Close is describing the photograph as a constant in relation to an open-ended series of works based on those images, meaning that both the person and the series of paintings and drawings depart from this record of a specific moment, each according to a different course. The 1978 *Robert/Fingerprint*, part of his exploration of an unexpectedly literal version of touch using his finger to apply the ink from a stamp pad to create varying shades of gray dots within a penciled grid, was one of these departures, and one that demonstrates his play with an evident grid of information through which the image has been both copied and transformed. The source was the same photograph that had provided the model for his 1973–1974 *Robert/104,072*, a nine-

by-seven-foot monochrome painting divided into the far more detailed grid indicated by the number of divisions recorded in the title.

Echoes of the printed page also appear in his use of the technique of color separation as the basis for color paintings of the 1970s created by means of successive applications of each component color. In paintings since the mid-1980s, the cyan, magenta, and yellow of the printer have given way to a myriad of individual hues, as the technique of color separation has become the basis for increasingly evident brushed marks within large-scale grids. But even as the subjects are now often other well-known artists, with their identity confirmed by the first names given in the titles, the exploration in the work is that much more evidently the play between the painted gesture and the underlying photographic information. In referencing the tradition of portraiture without incorporating its function, Close stands in contrast to Warhol, who played a complex double game with his commissioned portraits of the 1970s and 1980s—his earlier play with quotation and reference giving a postmodern gloss to his return to portraiture as a functional category, as part of his self-described turn to business art. The more apropos comparison would be to Roy Lichtenstein's laborious reenactment in painting of effects associated with the bargain basement printing techniques used for comic books (black lines, flat color, benday dots): "the style of industrialization, but not necessarily the fact."[20] In works by both Lichtenstein and Close, stylization enlarged from the printed page is part of the subject of the work, slowing down access to the rendered image as much as conveying it.

This play across painting, photography, and related graphic qualities involves at least two sets of choices—the choice of medium, and the choice of the conventions traditionally associated with any given medium—that may increasingly fail to coincide. An artist may also choose to use recognizable imagery, begging the further question of what connection may exist between the means of representation and the subject thus represented. Though the subjects or conventions to which the artist refers may be divorced from the original genre or medium category with which they were associated, this does not mean that such associations are lost or effaced; rather they retain traces of their original contexts even as they are reinscribed into a complex overlay of traits and effects. Nor is it no longer possible for an artist to explore the qualities of a traditional medium such as painting or photography. What has changed is that the selection of both medium and the qualities within that form will be seen as explicit choices rather than the reestablishment of previous givens.

Thus Hiroshi Sugimoto's consummate mastery is evident in the gelatin silver prints that he produces from large-format negatives. Carol Armstrong points to the importance of the medium, "self-reflexively signified in the sublime *Seascapes* series, with its dramatization

Chuck Close, *Robert/Fingerprint,*
1978. Pencil and stamp pad ink on
paper, 29½" × 22½". © Chuck Close.
Courtesy PaceWildenstein, New
York. Photo: Albert Mozell.

of the gray scale of photography, and the silver constitution of its images."[21] Yet in his 1999 *Portraits* series, Sugimoto has turned this medium-specific approach to the painted portrait, making this genre the subject of a series of photographs that record the lifelike figures that populate wax museums. Their absolute precision and detail produce an uncanny combination of familiarity and dissonance. Further layers of mediation ensue from the fact that the wax representations of contemporary and historic figures are themselves not one but several stages removed from their subjects, since they are in turn generally based on photographic or painted prototypes.

The combination of closeness and distance to the painted prototype is most apparent in one of the few images from the series that does not confine itself to a single figure. *The Music Lesson* is a photograph of an interior tableau based on the painting by Jan Vermeer of the same name. In this case Sugimoto positioned his tripod so that its legs would be reflected in the mirror at the back of the room, just as the legs of Vermeer's easel are in the painting, and chose a lens that would approximate the effect of the camera obscura Vermeer is presumed to have used. Sugimoto's photograph of this wax museum tableau, itself based on a painting that may have been produced with the aid of an optical instrument, alludes to the art-historical debate about the extent to which Vermeer simply copied mechanically produced effects.[22] Yet Sugimoto, by attempting to reproduce the spatial arrangement of Vermeer's painting for his own camera, introduced a paradoxical proof of Vermeer's invention. When Sugimoto set out to photograph the wax museum tableau, he planned to rectify the absence of the bass viol and chair partially visible behind the draped table in the painting's foreground. But when he attempted to restore these elements he found that "there was no space to place the instrument and the chair. It couldn't have existed in that area."[23] The unsuccessful attempt to place these elements in an actual (even if staged) space indicates that they were specific to the two-dimensional space of the painted composition. This key difference between the photograph and the painting that served as prototype is an effect of Sugimoto's adherence to analog techniques, so that even if what appears in front of the lens has been arranged or manufactured, the photographs provide an indexical record of the staged scene, not a digital composition based on photographic source material.

The materials used for the different renditions of these figures—oil paint, wax modeling, and the tonal detail of the gelatin silver print—all carry associations with qualities and conventions specific to the role each plays as a medium of expression or depiction. Sugimoto has described his close study of portrait paintings—the positioning of the sitters, lighting, approach to detail—in preparation for his *Portraits* series.[24] That study is evident in his photographs of the wax figures of Henry VIII and three of his wives, figures based on painted portraits Hans Holbein the Younger made while he was Henry VIII's

Hiroshi Sugimoto, *The Music Lesson,* 1999. Gelatin silver print, 58 ¼" × 47". Courtesy Sonnabend Gallery, New York.

court painter, even as part of the power of Sugimoto's images comes from the subtle but unmistakable sense of dissonance created by the intervening presence of the three-dimensional wax interpretations of the paintings. The realism of the wax effigies creates the unexpected sensation of somehow finally having the opportunity to see photographs of historic figures who lived long before such documents were possible. Because of the kind of detailed information about materials and surfaces specific to the photographic image, however, it is possible to distinguish as modern facsimiles the relatively crude workmanship in the costume jewelry worn by the wax figure of Jane Seymour, or the recent machine stitching in the embroidery decorating the clothing of Anne of Cleves or Henry VIII.

Sugimoto's presentation of the photographs further encourages multiple associations. The initial presentation of the portraits as a group in an exhibition organized by the Guggenheim Museum, printed almost five feet high and mounted on rectangular supports floated in the frame in a manner that suggests the depth of stretcher bars, created an uncanny resemblance to the arrangement of paintings in a traditional portrait gallery. Yet the fact that these portraits are not portraits is signaled both by internal evidence and by the context of their appearance in a solo exhibition devoted to works by Sugimoto. In this respect they allude to the general process of reclassification associated with the entry of the work into the art museum, in which earlier portraits, created when this was still a genre devoted to commemorating specific individuals, were realigned into a structure based on authorship. But they could also be understood in conjunction with many recent references to portraiture that were never part of a program to fulfill the traditional function of the portrait.

Transformations in the function and contexts of reception for art have established the conditions under which both the exploration of new forms and the reappearance of traditional conventions must necessarily be read as conscious decisions. The painted portrait of the ruler is a case in point. This once common form has become so anachronistic that a simple revival attempt would be doomed to carry a whiff of kitsch. The exception is when those means are used as a comment on the tradition, and in that case the closeness of the return will only make the comment more precisely calibrated. The degree to which the earlier commemorative function of the painted portrait has been overturned is particularly evident in Hans Haacke's simultaneous use of and comment on ceremonial representation in his 1982 *Oelgemaelde, Hommage à Marcel Broodthaers*. The allusions to divergent traditions are clear from the title itself: literally "oil painting," followed by a reference to an artist known for his fictional museum constructions. Speaking of the gilt-framed portrait of Ronald Reagan in *Oelgemaelde* and his 1983–1984 representation of Margaret Thatcher in *Taking Stock (unfinished)*, Haacke stated, "I chose to paint because the medium as such has a particular meaning. It is almost synonymous with what is popularly viewed as Art—art

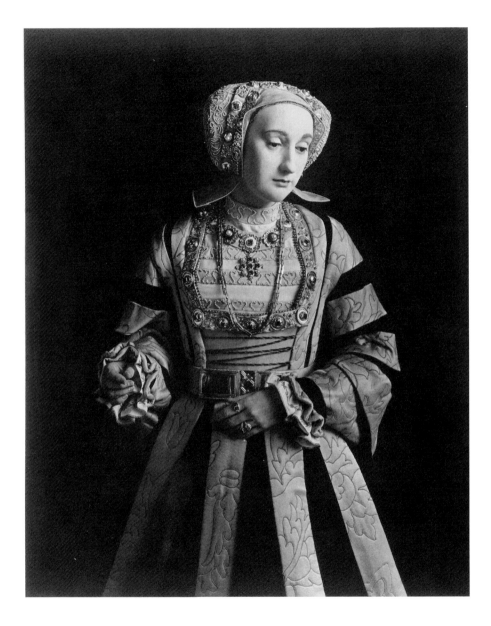

Hiroshi Sugimoto, *Anne of Cleves*,
1999. Gelatin silver print, 58¼" ×
47". Courtesy Sonnabend Gallery,
New York.

with a capital A—with all the glory, the piety, and the authority that it commands."[25] *Oel-gemaelde* presented the portrait of Reagan as part of an installation, facing a blown-up black-and-white photograph of a march protesting nuclear proliferation, with the two linked by a red carpet stretching between them and the portrait further set off by stanchions and a velvet rope positioned in front of the image. For the work's first appearance at Documenta 7, Haacke used a photograph that he took the week before the opening, of an antinuclear demonstration in Bonn occasioned by Reagan's visit and speech to the Bundestag; for subsequent exhibitions in New York, London, and Bern, Haacke replaced this image with photographs others had taken of antinuclear demonstrations from those cities or regions.[26] The photographic status of the image of the protest was emphasized by the black border with sprocket holes and frame numbers across the top and bottom, an inclusion that suggests the immediacy of a print from a contact sheet though the photograph is enlarged to fill the entire wall.

The tremendous range of Haacke's work demonstrates a particular kind of authorship—what might be described as authorship in general, as a corollary of de Duve's art in general. Historically it was a very different conception of authorship, based on an appreciation of stylistic unity and an emphasis on handling rather than subject matter, that formed the basis for the construction of the artist's oeuvre and, by extension, a reorganization of the collection that retroactively wrested portraiture and the other lower genres out of their respective subject categories. Yet the degree to which, once established, authorship could provide the framework for the extreme heterogeneity of contemporary art is clearly demonstrated by Haacke's work. Within his production, the fact that he does not adhere to any single style or medium also means that no such choices can be understood as neutral or given. In works from the 1960s and 1970s Haacke employed materials as various as water evaporating and condensing in an acrylic cube, suspended fabric blown by air currents from a fan, chickens hatching on a farm in New Jersey, turtles set free in the south of France, and many versions of information systems. So perhaps the only real surprise could come from the reappearance of a traditional artistic medium. His turn to the painted portrait, then, implies a selection from a multitude of possibilities rather than the reinstatement of a traditional category. In this context the use of oil paint is a self-conscious rather than given choice; the fact that it will be read as a quotation allows him to use the conventions of the medium to make a comment on it. The frame of authorship that encompasses readymades and conceptual practices allows the entire range of forms drawn into its domain to be read as conscious references rather than simply a return to the practices themselves. If oil paint is understood as a particular medium—one among many, rather than the dominant vehicle for artistic expression—even its selection is transformed into a choice filled with significance.

Hans Haacke, *Oelgemaelde, Hommage à Marcel Broodthaers*, 1982 (details). Installation at Documenta 7, Kassel, Germany. © 2002 Artists Rights Society (ARS), New York / VG Bild-Kunst, Bonn. Photos: Udo Reuschling.

How exactly was it that painting, after centuries of preeminence, could have been transformed into one medium or, even more startling, simply one material among many? The seeds were there in Harold Rosenberg's emphasis on the act of painting, with the canvas recording "not a picture but an event." But when Rosenberg spoke of "extinguishing the object," he was referring to painted representation, not the painting itself.[27] Yet that was exactly the conclusion that Allan Kaprow reached in his reading of Jackson Pollock as a basis for his early articulation of happenings. "He created some magnificent paintings," Kaprow wrote in 1958, two years after Pollock's death. "But he also destroyed painting." The oscillation between appreciating the marks on the canvas and the tendency to identify with Pollock's physical act of painting established, for Kaprow, a form of instability that opened onto the world of the everyday. His articulation of the breakdown of distinctions between different types of art, and between art and life, concluded with a call to discover "out of ordinary things the meaning of ordinariness."[28]

For Robert Rauschenberg, painting provided a repeated point of departure rather than a form to be rejected outright. In his well-known declaration of intent from 1959 "to act in that gap" between art and life, he had proposed "a pair of socks" as "no less suitable to make a painting than wood, nails, turpentine, oil, and fabric."[29] In an interview seven years later Rauschenberg again emphasized material properties, describing how he was "unable to divorce paint, as it was traditionally, from the fact that it was just another material. Paint has a character, a quality, it has a physical, recognizable body and I just couldn't cultivate in myself that other kind of illusionary quality that I would have had to have believed in in order to have gone in a different direction." By then his materials list had expanded exponentially, and he concluded that "after you recognize that the canvas you're painting on is simply another rag then it doesn't matter whether you use stuffed chickens or electric light bulbs or pure forms."[30]

Robert Morris's "Anti Form," published ten years after Kaprow's essay, returned to Pollock's process for what it said about the materiality of paint itself, with the dripping an expression of its fluidity.[31] Some of those same concerns were evident in the works Morris included in "Nine at Leo Castelli," the 1968 exhibition he organized at Castelli's warehouse. There the works, whether dispersed across the floor or arrayed along the walls, pointed to the importance of sculpture as the arena for a linked exploration of material qualities and site-specific forms, while at the same time confirming the dissolution of sculpture as a category that could delimit a consistent set of practices or strategies, much less a clearly defined medium.

In some respects the show organized by Morris anticipated several major exhibitions in 1969, including "Anti-Illusion: Procedures/Materials" at the Whitney Museum in New

York, "When Attitudes Become Form: Works—Concepts—Processes—Situations—Information: Live in Your Head" at the Kunsthalle, Bern, and "Op losse schroeven: Situaties en cryptostructuren" at the Stedelijk Museum in Amsterdam. These exhibitions also featured the exploration of materials, process, and site, but the traditional medium divisions gave way to an even greater extent in a diverse amalgam that included conceptual projects, temporary works outside the exhibition space, and an extension of the engagement with process into video. An equally important feature of these exhibitions was the now familiar procedure of inviting artists to work with the specific circumstances of the site, rather than organizing the exhibition by bringing together a group of already extant objects. "We discovered that the normal curatorial procedures of seeing and then selecting or rejecting works to be included could not be followed," wrote James Monte of the approach he and Marcia Tucker had to take to what he deemed the risky enterprise of presenting works completed only at the moment of their exhibition, on the basis of the artist's actions not in the studio but in the space of the gallery.[32] "Post-studio artists" was Scott Burton's phrase to describe the relationship to location that he saw as one of the few features shared by the disparate works in the exhibition "When Attitudes Become Form." Expanding upon its initial application to the use of outside fabricators in the context of minimalism, Burton used the idea of post-studio production to draw connections to site-specific actions and far more disembodied conceptual propositions.[33]

It was around this time that Richard Serra provided his own concise articulation of the possibility that the work might emerge from an encounter between the artist's actions and the particular qualities of materials in his "Verb List" of 1967–1968, a string of 108 entries, mostly transitive verbs, beginning with "to roll, to crease, to fold, to store, to bend, to shorten, to twist, to dapple, to crumple, to shave, to tear, to chip, to split, to cut," and including other terms that refer to forces, "of tension, of gravity, of entropy."[34] Evidence of one such encounter took the form of the 1968 film *Hand Catching Lead,* which presented the repeated action of a single hand attempting to grasp a piece of lead as it falls through the frame. And Serra used the opportunity afforded by the new procedure of issuing invitations to artists to create works for a specific occasion, producing a series of work in lead, each made in the space and each destroyed at the end of the exhibition. For the Castelli warehouse show in 1968 Serra created *Splashing* by flinging molten lead into the angle formed by the wall and the floor, where it adhered to the interior of the angle created by the architecture and hardened into an uneven line that, despite the weight of the metal itself, managed to defeat sculpture's traditional solidity and mass. *Casting,* for the 1969 Whitney exhibition, manifested an equally specific relationship between action, site, and material, as Serra again used molten lead but this time pulled the lead out of the angle

between the wall and the floor after it had hardened, twelve times in succession, filling the floor with rows of the hardened metal, and demonstrating in the process how the architecture gave form to the lead in this variant on the traditional sculptural process of casting. Serra's *One Ton Prop (House of Cards)*, which stood nearby in the center of the gallery, could, in contrast, be assembled elsewhere, though it demonstrated another kind of contingency in the way the form was created through an arrangement of plates dependent on a combination of balance and gravity.

The complex intersection of materials, process, and form was equally evident in the works that Eva Hesse showed in the two New York exhibitions, with their demonstration of the tremendous power of her use of new or unexpected materials to transform the established geometries of minimalism into a playfully absurd repetition. In her 1968 *Augment* and *Aught* at the Castelli warehouse, the layered pile of latex-covered canvas on the floor, or the row of four vaguely pillowlike rectangles made from sheets of latex stuffed with polyethylene on the wall, showed clearly how the geometry of the rectangle could be transformed into irregular shapes absurdly subjected to the forces of gravity. And at the Whitney, Hesse's 1969 *Expanded Expansion* relied on the same wall that gave form to Serra's lead to support the leaning row of fiberglass verticals connecting sheets of rubberized cheesecloth that could be altered to fit the different circumstances in which it might appear. Photographs that show the pale expanses of draped material in *Expanded Expansion* give hints of its provocative pliability in this early appearance—even if, in the decades since, dramatic transformations in this and many other of Hesse's works caused by the yellowing of the fiberglass and the increasing fragility or decay of latex and rubber elements show the paradox of work that derived its power from the use of materials that will alter over time.[35]

A review of the "Anti-Illusion" exhibition provided a telling list of materials for the works in it, enumerating "flour dust, hay and grease, steel, poured latex, neon and glass, lead, styrofoam blocks, ice and dry leaves, invested money, dog food, rock, rubberized cheesecloth, and the human body."[36] The reference to the body was not to its representation but to the viewer's body, as framed by Bruce Nauman's *Performance Corridor,* or to Nauman's own body appearing in videos and a performance. The invested money was Morris's work, evident in the exhibition through the display of correspondence and the document of an agreement between Morris and the museum outlining an investment plan set up for the duration of the exhibition. And missing from this list was air, which Michael Asher deployed, blowing in an invisible plane within a doorway, with the velocity reduced to a minimum to underscore the contrast between the physicality of a work like Serra's *One Ton Prop* and the conceptual dimension that Asher wanted to emphasize.[37]

Richard Serra, *Splashing*, 1968
(installation at Castelli warehouse).
Lead, 18" × 26'. Courtesy the artist.
Photo: Peter Moore.

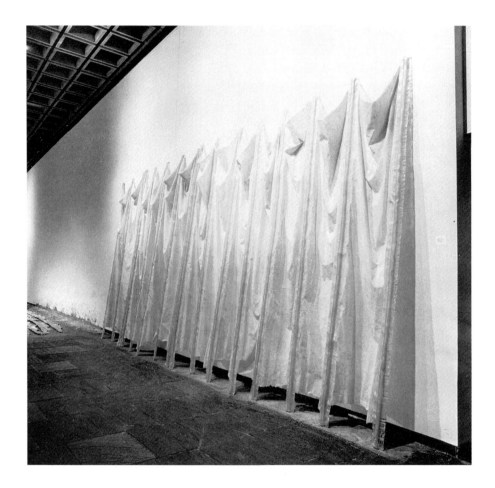

Installation view of "Anti-Illusion: Procedures/Materials," May 19–June 22, 1969, Whitney Museum of American Art. Eva Hesse, *Expanded Expansion,* 1969, reproduced with the permission of the Estate of Eva Hesse, Galerie Hauser & Wirth, Zurich. Photo courtesy the Whitney Museum. Photo by Peter Moore © Estate of Peter Moore / VAGA, New York.

Why does this discussion of expanding material possibilities follow upon a consideration of the quotation of traditional genre categories and the general dissolution of medium divisions? In fact the incorporation of a range of new materials, along with the layering of reference and quotation evident in the interplay between painting and photography, are both aspects of an increasingly complex intersection of material and form in contemporary practices. Paint is indeed only one material among many that may be chosen because of formal qualities, cultural associations, or a variety of other reasons. It is also intriguing to look back at the convergence of works emerging from specific material qualities with far more dematerialized conceptual projects presented as part of "Anti-Illusion" and "When Attitudes Become Form." The different types of works in these early exhibitions have since been sharply distinguished from one another; but from the standpoint of recent artistic

practices it is the points of intersection that seem particularly significant. Questions raised by conceptual practices about the definition of art are now established as part of a larger discourse that takes as given the idea that the work need not be understood as identical with a permanent physical object or configuration. At the same time, the possibility that a work's physical manifestation might be of limited duration, or that it might come and go as needed, has also helped facilitate the multitude of highly particular materials now commonly found in the context of the work of art.

One striking feature in the work of several younger generations of artists who came to prominence in the 1980s and 1990s, and whose work incorporates allusions to art of the preceding decades, has been a careful attention to formal and material decisions not as an end in themselves, but as a means of addressing a wide range of cultural as well as personal references. If Janine Antoni were to produce her own verb list, it might start "to gnaw, to lick, to lather," all actions that she has performed in the creation of a series of works made from chocolate, lard, and soap. She has also painted the floor with her hair dipped in hair dye, made drawings by repeatedly fluttering her mascara-coated lashes against a sheet of paper, and spent years intermittently walking in a circle to grind two rocks against each other in order to achieve an interdependent form. Some of her materials could be found in a drugstore, under brand names like Cover Girl Thicklash mascara or Loving Care Natural Black hair dye. Others are generic but equally familiar substances like chocolate or soap that both retain their original associations and gain new significance as they assume unexpected forms. And just as the actions and materials vary, so too does the mode of presentation. Subsequent to its first realization in 1992, *Loving Care* was a public performance that also established a temporary installation in a room marked by the sight and smell of the floor painted with hair dye. Many other works bear evident traces of actions performed elsewhere, either in the form given to objects or in actions captured by a camera.

For Antoni the use of highly specific materials is part of an intense and often extended encounter between her own body and a particular set of circumstances. Thus the creation of her 1992 *Gnaw* was based on Antoni's decision to transform the everyday activity of biting into a tenaciously repeated gesture that changed the appearance of the 600-pound cubes of chocolate and lard as well as removing material that she then reprocessed to create other objects. Obviously the cube was no neutral abstract geometrical form by the early 1990s. Its use establishes a reference to minimalism as surely as a sculpted head establishes a reference to the whole history of the portrait bust. Yet *Gnaw* also demonstrates how minimalism can be transformed into both a historical reference and, simultaneously, a model for a certain kind of objecthood. Even though their pure geometry has been insistently abolished, the chocolate and lard cubes assert their physical presence in the same real space

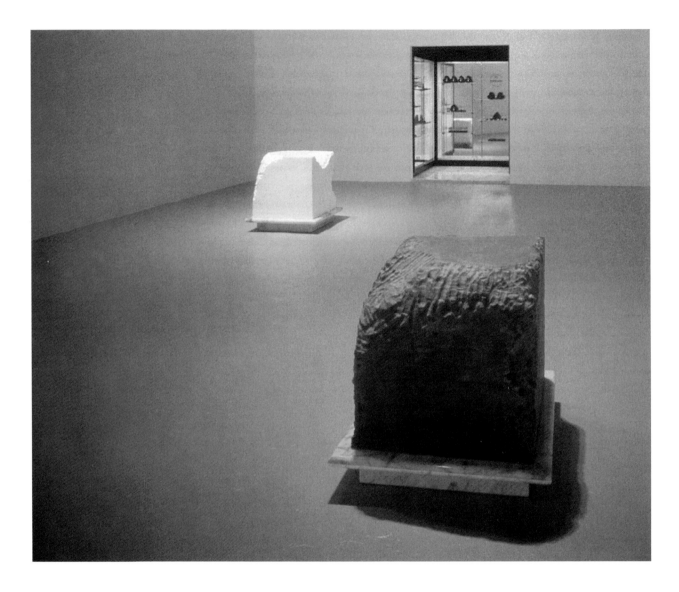

Janine Antoni, *Gnaw,* 1992
(installation and detail). Chocolate,
lard, lipstick, and display case,
installation dimensions variable.
Collection the Museum of Modern
Art, New York. Courtesy the artist
and Luhring Augustine, New York.

occupied by the viewer. The collapse of the lard cube might even be read as a dramatic reenactment of the historic transition from hard-edged minimalism to more pliable materials, were it not for the intervening bites, with the profusion of psychological and cultural associations they suggest.

To the classic reading of minimalism as an activation of the viewer's space and unfolding experience, Antoni adds another layer in the traces of her performance. What the viewer encounters is not the action itself but forms that carry evidence of Antoni's bodily presence. "I can only bite the cube in a certain way because of the relationship of my body to that form," says Antoni of the specific configuration of bite marks that move up and across the edges of the cube.[38] Yet these traces add to rather than undo the minimalist sense of objecthood because they are also external to the object, having clearly taken place in the space now occupied by the viewer, from which Antoni has absented herself once she has completed her part of the experiential process. "I'm convinced the viewer won't have an experience unless I've had an experience," Antoni insists. Yet there is also careful consideration of the formal means through which the signs of her experience might be conveyed once she has relinquished the space to the viewer. "By removing myself, I allow the viewer to have a relationship to the object. Inevitably, through the traces, the viewer is brought back to the process I went through to make the work. The viewer is left to fill in the story within that gap—the space between process and object. Thus, I create a space for the viewer to exist, to participate in the work. If I'm performing, it is much more difficult to create that circumstance because the focus is on me."[39] Through their continued activation of the viewer's experiential reading, the objects that carry this evidence of performance thus extend and redirect the more abstract theatricality associated with minimalism. That minimalism is only one reference point for *Gnaw* is also demonstrated by the objects made from the bitten chocolate and lard—the heart-shaped candy containers and lipsticks on display in the mirrored glass case that constitutes the third component of the work. There the connection to the artist appears in another guise, as a self-referential play on the idea of brand identity, since both the glass display case and labels on individual lipsticks carry, as a circular logo, "JANINE ANTONI / 92 LIPSLICK / NET WT 3.4g."

Antoni articulates a complex relationship to an artistic heritage that, by her own description, "defines me as an artist and . . . excludes me as a woman."[40] It is a heritage that encompasses sculptural forms as well as materials. One of the remarkable features of Antoni's use of chocolate and of lard is that these materials were hardly new to the art world when she used them during the 1990s, so that while her particular deployment may have been unexpected, the materials themselves were not without a tradition. It would not be possible for an artist to use lard without bringing to mind Joseph Beuys and the role it

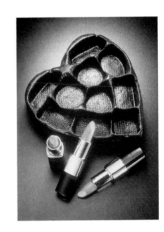

played as a part of his myth of rebirth, as a substance vital to sustaining life, and as a highly malleable solid. Chocolate has also made numerous appearances, perhaps most notably in the work of Dieter Roth, who was adamant that the organic substances in his work not be subject to preservation steps that would slow decay or prevent infestation. It is also significant that Hannah Wilke's bodily investigation of female beauty included, in addition to her provocative chewing-gum forms, the casting of herself in chocolate. Antoni cites feminist work of the 1970s, including that of Wilke and Ana Mendieta, for the central importance of the body as well as "the humor, the process, the emphasis on performance, the intensely visceral quality of their work."[41]

Such visceral qualities are readily apparent in Antoni's *Lick and Lather,* where the complex interplay of presence and absence, trace and reference, shares much with *Gnaw. Lick and Lather* began, however, not with minimalist cubes but with fourteen life-sized busts of Antoni herself, seven cast of chocolate, the other seven of soap. She then proceeded to lick away the features of the chocolate busts and to lather away those of the ones made from soap during prolonged bathing, resulting in a subtly disconcerting array of partially effaced portrait sculptures, each transformed in a different and disconcerting fashion. In an essay that explores Antoni's connections to earlier feminist practices, Ewa Lajer-Burcharth posits the use of the body and of self-representation in *Lick and Lather* as a conscious adoption of narcissism, once an accusation leveled at women artists of the 1970s who made their bodies central to their work, as a strategy that "appropriates it as one of the mechanisms of aesthetic self-generation."[42] Yet a striking feature of the work is how Antoni has employed her body to transform what was formed from the same. "Narcissism is often discussed with respect to *Lick and Lather,* but I also think of Pygmalion," says Antoni in reference to this oddly intimate yet externalized process of self-fashioning.[43]

Presented atop cylindrical pedestals arranged in a circle for their initial appearance in Venice, or in facing rows of chocolate and soap for their subsequent installation in New York, they suggested a reworked version of the proverbial portrait gallery. It was, in fact, a work that she conceived in response to the classical tradition in sculpture that she knew would be much in evidence in the context of the 1993 Venice Biennale, where *Lick and Lather* was first shown, and an even more specific association was suggested by the erosion evident in outdoor sculpture.[44] Her use of chocolate and soap further shares a reliance on the potential for transformation from liquid to solid with the process of casting used for any of the traditional metals. But, as she told an interviewer, the mold was made as a direct cast from her body, "so there is no sculpting in the initial form except for the imitation of the classical stand. The only sculpting was the licking and the washing."[45] These materials are also formed into their familiar guises as consumer goods by a version of casting, just as her actions upon them are similar to what commonly happens to those consumer goods,

Janine Antoni, *Lick and Lather,*
1993–1994. Seven soap and seven
chocolate self-portrait busts,
installation dimensions variable.
Courtesy the artist and Luhring
Augustine, New York. Photo: John
Bessler.

but exaggerated and arrested before the process of consumption is complete. Antoni has acted out a process of compulsive repetition in a manner that redirects the actions, forcing consideration of the uncomfortable boundaries between gratification and pathology.

"The aging of the material is conceptually part of the work," Antoni insists with respect to *Lick and Lather*.[46] Yet Antoni has had to remake parts of *Lick and Lather* in response to unexpected changes to the work caused both by the aging of the soap and more unusual forms of damage. On three separate occasions, in three different countries, audience members have bitten off the nose from one of the chocolate busts. "I made a piece about desire and somebody actually lived it out. I guess I could take it as a compliment," says Antoni. But the sense of aggression contrasted sharply to Antoni's "loving act" of licking, "so to have somebody's bites in there shifted the meaning of the sculpture."[47] Whereas the lard elements in other works are remade by casting the components to the shape created by the original process, Antoni remade the chocolate busts for *Lick and Lather* the same way she made the first version, by licking away the features of the face.

Recasting the lard components of her works as part of a planned strategy is a decision that has allowed Antoni to reclaim the qualities of the material at the time of her initial interaction. To make *Eureka* in 1993, she filled a tub with lard and had herself lowered into the tub, leaving an indent of her body. She then took the lard that she had displaced and added lye to create soap, which she formed into a large cube. The use of the displaced lard to make the soap posits the soap as an abstract equivalent for the absent body. And that reference was both reinforced and partially erased when Antoni bathed with the soap, since this further bodily action reduced the volume and thereby the symbolic equivalence derived from the initial displacement. The soap cube, which retains traces of the bathing in the smoothed edges of its geometry, remains constant and is allowed to age. The lard present in the tub in *Eureka,* like the lard component of *Gnaw,* is replenished each time it is exhibited, with the lard cast in the form created by Antoni's original actions upon the material. According to Antoni, "It is important to me that the viewer can make out that a body has been dipped in the tub because I used the displaced lard to make the soap. If I just let the piece be a tub with some dirty lard it would be about the aura of this material that came in contact with my body."[48] Her concern is thus not with mystifying the materials as historical relics of actions, but with maintaining a material presence capable of conveying the process by which the works were made.

What should be clear is that it is not just the particular materials Antoni uses that give her work this resonance, but the precise nature of their use. It was important in each of these cases that the material in use was indeed chocolate or soap or lard and not something fashioned to resemble that material. The presence of these materials is itself significant, even as they also carry the potential to be molded into shapes that suggest a series of other

references. Under Antoni's command, chocolate does not dissemble its medium, even as it is made to assume shapes that bring multiple additional associations. Yet it is an open question whether chocolate can be described as a medium at all, given its obdurate materiality. Antoni's use of these materials opens onto a series of intersecting concerns, with process and the traces of actions, with gender identification, and with the process of representation itself. Antoni's medium could more appropriately be identified with her insistent return to the body and to the traces left by repeated actions or patterns of use.

"I am always taken with the experience of sitting on a seat in the subway and feeling the body heat of someone who sat there before me," Antoni comments. "Maybe I never saw them, but I feel very close. One body recognizes the warmth of another. I seek that recognition in my work."[49] What this statement leaves open, however, is the way the feeling might be realized. It is not through description but through the form of the work that she wants to convey it. Thus the use of many different materials and traditions shows not a lack of concern for the qualities and conventions associated with each, but a desire to redirect the intense formal engagement with issues of structure, material, and context that characterized the work of an earlier generation of artists so that they become the starting point for the articulation of her own concerns. Nor does the incorporation of multiple references, which Antoni's work shares with that of many of her contemporaries, mean that the various materials, forms, and effects are subsumed into a unified whole. The process of recontextualization remains as materials and formal references retain a connection to their original context or use even as they gain new significance in their new combinations.

Linked to the proliferation of once unusual materials is a constant process of delineation, whereby assumptions that might once have held regarding the givens of a particular medium have been supplanted by an open-ended series of considerations regarding both the initial and the ongoing disposition of the work. It is from this vantage point that one has to consider how decisions about the long-term existence of the work inflect the way Zoe Leonard's 1992–1997 *Strange Fruit (for David)* or Robert Gober's 1989 *Bag of Donuts* refer to the tradition of the still life, using organic materials associated with the objects themselves rather than with their representation. In both works the artist has made very specific choices about what materials to employ and also about what constitutes the definition of the work over the long term. And in each the issue of quotation, when one medium or material is made to mimic effects associated with another, appears not in the initial making of the work, but in subsequent decisions about how or whether to preserve the appearance of a potentially perishable object by employing conservation techniques that change its material nature.

The individual elements that make up Leonard's *Strange Fruit* consist of peels from almost three hundred oranges, grapefruits, and bananas that Leonard has sewn back

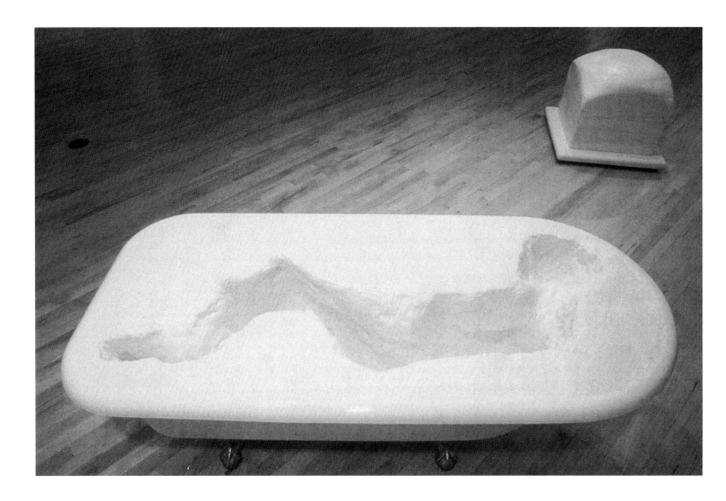

Janine Antoni, *Eureka*, 1993. Bath-
tub, lard, and soap; soap 22" × 26"
× 26", tub 30" × 70" × 25". Courtesy
the artist and Luhring Augustine,
New York.

together after consuming the fruit, sometimes incorporating buttons and zippers as well as stitching. The display of Leonard's work, with the objects scattered across the floor of the gallery, certainly evokes the random arrangement of individual components that sometimes appears in the work of Hesse and others of her generation, and Leonard's decision to use perishable material suggests another connection. But the fact that these objects were once pieces of fruit, and the process that has transformed their character without altering their essential organic nature, adds an abundance of specific associations. The multiple references of the title—to the Billie Holiday song, with its powerful image of lynched bodies, to Leonard's friend David Wojnarowicz, who died of AIDS in 1992, and to the pejorative use of the term "fruit" as slang for gay—suggest specific associations that support a general sense of loss. Thus their presentation, dispersed across the floor of the gallery, serves to emphasize the isolation of each of these paradoxical objects.

Having made this series of objects from perishable materials, Leonard then had to decide whether to employ the heroic preservation steps that have become a surprisingly common response to unusual artistic materials. Christian Scheidemann, a conservator of contemporary art who specializes in just this type of challenge, arrived at a solution that arrested the decay of the organic components without destroying the other elements. Yet eventually Leonard decided against taking such steps, which, surprisingly enough, did not deter the Philadelphia Museum of Art from acquiring the work.[50] Twenty-five pieces are preserved, but these examples constitute a representation of the work rather than the work itself. These preserved elements, Leonard told Anna Blume, "serve almost as photographs of the piece. In ten years, when the rest of the fruit have turned to dust the preserved ones will be the remnants of the larger piece."[51] The description of the preserved objects as photographs or documents is particularly significant coming from an artist whose work has involved many different forms of photography, some of which she connects specifically to the process of memory.[52] In the case of *Strange Fruit,* the decay of the objects, even after the futile repairs made by stitching the skins back together, implied an interconnected process of recollection and loss: "The very essence of the piece is to decompose. The absurdity, irony, pain and humor of it is that we attempt to hang on to memory, but we forget."[53]

The decision to arrest disintegration, though more in keeping with the traditional imperative to preserve works of art, can be equally provocative when it follows an initial decision to use an organic material. When Gober set about to create his *Bag of Donuts,* a life-sized sculpture consisting of a dozen donuts in a specially made paper bag, he made the pastry components in the traditional fashion, by frying dough. But their decay was not part of his plan. In fact, he told an interviewer, "I want those donuts to exist forever."[54] So he shipped the donuts off to Germany to receive extensive treatment from Scheidemann, the

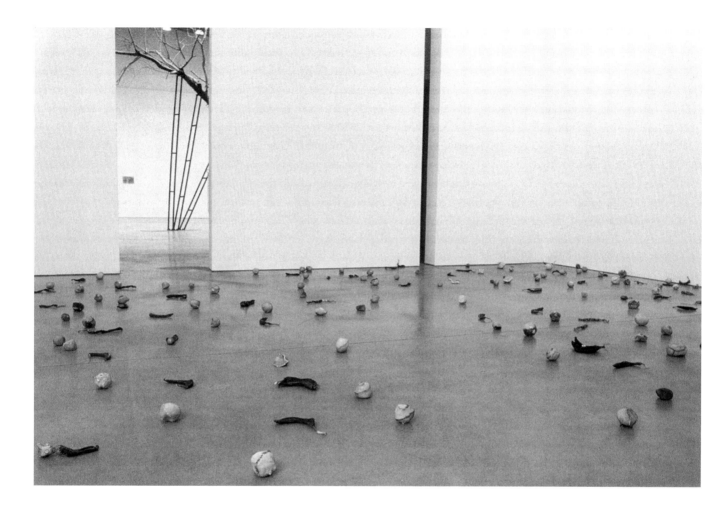

Zoe Leonard, *Strange Fruit (for David)*, 1992–1997. 295 banana, orange, grapefruit, lemon, and avocado peels, thread, zippers, buttons, sinew, needles, plastic, wire, stickers, fabric, and trim wax; dimensions variable. Courtesy Paula Cooper Gallery, New York. Photo of detail: Vivien Bittencourt.

same conservator who later worked on Leonard's fruit. The multistage process to which they were subjected included degreasing through repeated acetone baths and a final coating with a synthetic resin for preservation, followed by cinnamon for aroma and appearance.[55] While some artists and even conservators would rather allow changes to appearance than completely transform the material itself, Gober's response came down firmly on the side of appearance. The result was so convincing that one person at the exhibition opening who was not attuned to the subtleties of Gober's play with familiar objects and forms decided to help himself, with the "ensuing scramble" leading Richard Flood to wonder "if they were trying to protect the art or him."[56]

 Though their ingredients and initial making connected the donuts to the familiar foodstuff, the conservation treatment could be argued to have transformed them into bizarre representations, raising the question of why not simply simulate the actual object in the first place. In another respect, however, they were entirely consistent, in their transformed state, with Gober's play with hand-made readymades, such as the painted plaster versions of subtly altered sinks, urinals, and bags of kitty litter, or the surreal objectlike body fragments made with beeswax and human hair. Nor can the role of conservation be thought of as simply an afterthought, since decisions about whether or not to try to arrest changes often go to the heart of why the materials may have been used in the first place. In the same interview in which he spoke of preserving the donuts, he indicated that the

Robert Gober, *Bag of Donuts,* 1989.
Acid-free hand-cut paper, dough,
and synthetic resin, 11" × 6½" × 6".
Courtesy the artist. Photo: Geoffrey
Clements.

bag, also specially made, could potentially be replaced, and he even suggested that his sinks could be repainted with the same type of white enamel paint should they yellow over time.[57] The donuts, in their peculiar permanence, remind viewers of the transience that would usually be their fate. In this respect they evoke the *vanitas* theme of Dutch still life painting, where mortality was suggested in representations of abundance arrested just at the onset of the decay.

If extravagant preservation steps or planned decay represent two extremes in the face of perishable materials, another alternative, following conceptual art's challenge to a definition of art based on the physical object, relies on a process of remaking to ensure the work's long-term existence. Nayland Blake has cited Lawrence Weiner's work in particular for having established procedures for dealing with works that are in one way or another ephemeral in nature. Yet it is equally significant that he made this connection in the context of a discussion of his 1998 *Feeder 2*, a large-scale gingerbread house that made concrete the very familiar but nonetheless abstract image from the story of Hansel and Gretel.[58] The command that this seven-foot-high structure exerted over its physical environment contained suggestions of the minimalist object, but with the significant difference that it was simultaneously both abstract (because based on a fanciful image from a fairy tale) and recognizable (as a highly unlikely house), and part of its activation of the viewer's space was due to the powerful aroma of the gingerbread used in its construction. The conceptual precedents came into play not for the work's initial fabrication, for which Blake relied on a collaboration with a New York bakery, but in the process of defining what would constitute the work over the long term. A strategy of remaking that would allow the cookies to be replaced as needed was dictated both by the inherent instability of the gingerbread and because the panels that constituted the house as shown in the gallery had been extensively damaged by audience members who apparently could not resist breaking off bits of the aromatic confection.

"I see myself as a very radical formalist," Blake told an interviewer in a discussion of how a larger set of concerns may be articulated in the work that he produces as an artist.[59] Blake had already used edible substances in his art, specifically chocolate Easter bunnies that incorporated various substances including strychnine in an evocation of African bowli (and which were also connected to the rabbit characters that often turn up in Blake's sculptures, videos, and performances).[60] While the incorporation of foodstuffs in a work of art has the power to evoke a wide range of associations for viewers, it also arose from specific preoccupations of the artist. Temptation was part of the gingerbread house, but Blake showed it together with another work called *Gorge* that he hoped would give the audience a different feeling about wanting to consume his realized fairy tale. The hour-long video,

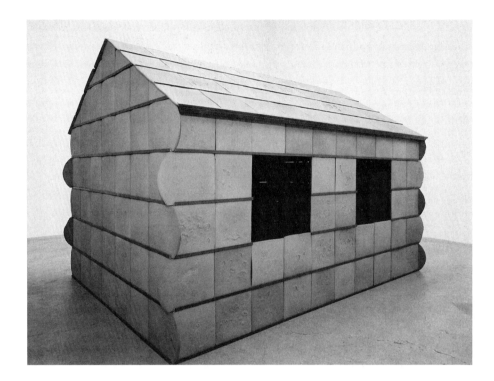

Nayland Blake, *Feeder 2,* 1998. Steel and gingerbread, 7' × 10' × 7'. Courtesy Matthew Marks Gallery, New York.

which shows Blake sitting passively as he consumes food that he is fed by a man partially visible behind him, points to Blake's complex relationship to issues of identity. Blake's background as the son of biracial couple who could by his own description "pass" as white is suggested by the fact that he is being fed by a man who is more obviously black. Furthermore, Blake has described the video as an exploration of his interest in a specific gay subculture focused on weight gain and its encouragement that he connects to a process of infantile regression.[61]

It might be possible to characterize *Feeder 2* as a form of still life, not because of any resemblance to earlier still life paintings in appearance, or even just because he has used food to make the work, but because of the linked associations with abundance and consumption. Yet it is equally important that these associations are produced as a result of a series of precise decisions about form and materials, with the impact of the work dependent on how a somewhat austere-looking grid takes on additional significance, first as the planes are arranged to suggest the walls and peaked roof of a house, and then as the unexpected material gives the construction a still more explicit association. What emerges is a

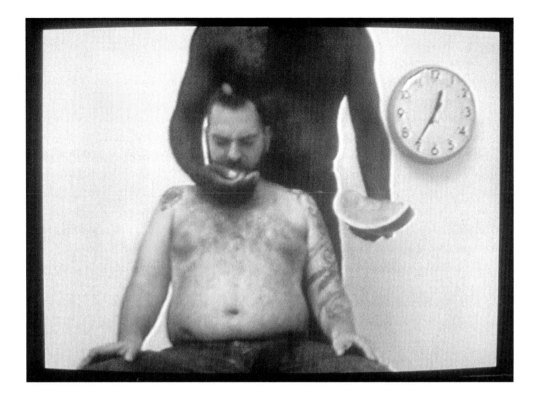

Nayland Blake, still from *Gorge*, 1998. 60-minute videotape (color, stereo). Courtesy Matthew Marks Gallery, New York.

particular version of truth to materials; having established the premise that he wants to re-alize a material version of a fantastic image, he has done so using the material itself rather than a stand-in or representation, and has turned to a process of remaking to retain that purity. It is therefore somewhat paradoxical that one effect of the precise consideration that Blake, like many of his contemporaries, gives to decisions about materials and form is evident in works that derive their power from a series of precise decisions that are difficult to identify with broader medium divisions or characteristics.

What might constitute a medium? To what extent does the term remain relevant? To what extent can it be connected to specific materials? Rosalind Krauss's answer, provoked by the role of photography in conceptual practices, has been to redefine the idea of medium "as a set of conventions derived from (but not identical with) the material condi-tions of a given technical support." Her essay "Reinventing the Medium" presents a frac-tured and highly localized conception of medium that operates not in terms of general categories, but with respect to such qualities as the "collision between stillness and move-ment" central to works by James Coleman that consist of sequences of projected slides, in

a use of the obsolete commercial form of the slide tape as a means of presenting images that Krauss further connects to the narrative rhetoric of another medium, that of the comic book–like photo-novel.[62]

Might arrangement then be described as a medium? That arrangement is central to the definition of certain works is supported by examples of the potential failure or destruction of a work that relies on the particular placement of elements if that placement is not respected. Witness Donald Judd's protests over the display of his modular works with uneven or incorrect intervals. And witness, too, the controversy that greeted the proposal to transport the installation known as the Beuys Block at the Darmstadt Landesmuseum, which Beuys had arranged over many years, to Berlin for a 1988 exhibition at the Martin-Gropius-Bau. Since the objects that make up the block would presumably have been carefully catalogued and documented before their removal, they could theoretically have been returned to their original positions. If, however, arrangement is defined as part of the making of this installation, then their rearrangement, even in order to restore them to their original configuration, could be seen as a form of remaking.[63]

"Installation seems to be a material as much as anything else is," Jim Hodges has asserted.[64] The incredibly light touch that Hodges employs to create arrangements along a wall or out into a space is evident in the cobweblike forms made from thin silver chains that appear in the angles or corner of a room, or the hanging screens of artificial flowers stitched together to form a partially transparent barrier. The deceptive simplicity of his work is particularly apparent in the works that Hodges has created from silk flowers and leaves pinned across a wall; the lack of obvious embellishment belies the time-consuming process required to affix the dozens of individual components in his 1994 *Not Here,* or the hundreds of elements in larger works based on this process. Not only is the arrangement of the components key to the work, but procedures adapted from conceptual art are apparent in the ways Hodges has developed of recording or mapping such work, which would cease to exist if the components were randomly removed. Demands for extensive remaking or detailed installation procedures could be seen as onerous for the collector; but they can also lead to a different kind of engagement between the work and the owner or exhibiting institution. "There's an opportunity for the artist to share a very intimate kind of experiential component of one's process," says Hodges of the demands that reinstalling his work can place on subsequent owners or exhibitors. "The idea of instructions can be very cold and analytical, and it can also be very quiet, personal, and intimate."[65]

Might participation or even ephemerality thus constitute a medium? Perhaps permanence might also be described as a medium? Or scale? Or newness? Or deterioration? In a sense all of these possibilities stretch the term "medium" to the breaking point. Yet these

Jim Hodges, *Not Here,* 1994. Silk, plastic, wire, and pins, 36" × 27". Courtesy CRG Gallery, New York. Photo: Zindman/Fremont Photography.

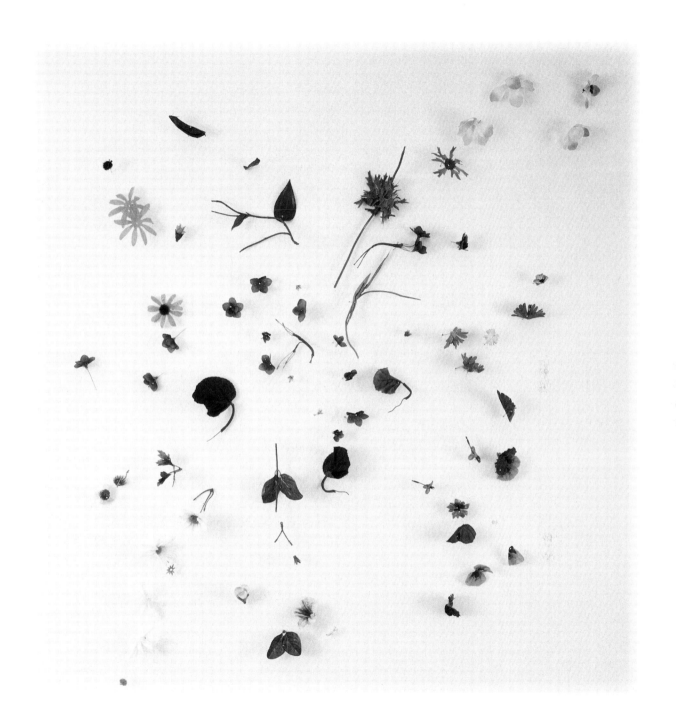

are qualities central to the definition of a great many works of art, where to ignore their implications would not just alter but destroy the work. Thus they go to the heart of questions about where the work actually resides along a continuum of possibilities.

In fact ephemerality is intrinsic to works by Felix Gonzalez-Torres where viewers are encouraged to take away individual pieces of candy from piles or sheets of printed paper from stacks. "Without a public these works are nothing, nothing," Gonzalez-Torres insisted. "I need the public to complete the work."[66] Another form of collaboration appears in the requirement that the exhibitor then remake the work, with the need to replenish the piece linked to the invitation to viewers to take away the elements in an ongoing cycle of disappearance and reappearance.

Gonzalez-Torres's work shows with particular clarity how a mode of authorship rooted in the procedures established by conceptual art can be linked both to very specific formal considerations and to a multitude of other interests. His thoroughgoing critique not only of authorship but of the role played by context in the shaping of the work is readily apparent in the series of twenty-four works consisting of strings of electric lights which are simultaneously the same and each unique, both because he declared them so through the separate titles given to each and because their installation or arrangement is left entirely to each owner or curator who exhibits them.[67] David Deitcher has described how the instructions recorded in the artist's certificates, not shown as part of the work but generating its configuration, are often quite poignant. For those works that need to be remade from store-bought components, Deitcher cites instructions that are both specific and flexible, telling the owner where to go to buy the components but also allowing for substitutions: "Fortune cookies of other producers may be used provided that the messages they contain are optimistic."[68] Thus the work is about an ongoing process of collaboration planned by the artist but then handed on to others as part of the transfer of the work.

Equally compelling is the formal elegance of the paper stacks, presenting themselves as minimalist cubes but otherwise varied in scale and in the nature of what is printed on the assembled sheets of paper. "What is this thing? A two or three-dimensional object? Is the work the certificate of authenticity or the piece itself?"[69] Gonzalez-Torres posed these questions regarding his stacks, leaving the answers open. But as his statement suggests, even the definition of what actually constitutes the work is open to question when the work consists of sheets of paper that viewers are invited to take away. While ownership is based on a certificate that also provides instructions for the remaking of the work, it is only when the work is realized for an exhibition that the encounter with the viewer can take place.

"This type of work (the stacks) has this image of authority, especially after so many years of conceptual art and minimal art," Gonzalez-Torres told Tim Rollins. "They look so powerful, they look so clean, they look so historical already. But in my case, when you get

close to them you realize that they have been 'contaminated' with something social."[70] That "something social" included the issue of identity, and how the powerful rhetoric of minimal and conceptual art might also be made to reflect the concerns of a gay Hispanic man, whose work incorporated references to both social issues and personal history, but who did not want to limit the definition of his work to a category solely defined by concern with multi-cultural issues. His subtle use of personally significant information is suggested by those stacks of candy where the ideal volume of the piece is based on the body weight of a specific individual, with that fact parenthetically indicated in titles that describe them as portraits. The use of the candy to stand in for the absent body is particularly charged in relation to the invitation to viewers to partake of those candies, implicating their own bodies in the process of consumption. In the 1990 *Untitled (USA Today)*, on the other hand, the pile of red, silver, and blue cellophane-wrapped candies with an ideal weight of 300 pounds presents a response to right-wing jingoism, playing with the idea of a "sugar rush" to suggest how calls for patriotism can create a euphoric high, "but then you come down."[71]

The cyclical depletion of these works can also be read in connection to the references to mortality that appear in guises as varied as the sheets of paper in the 1990 *Untitled (Death by Gun)*, covered with the faces and profiles of all the people shot down in the United States during a one-week period, or the two battery-operated clocks in the 1991 *Untitled (Perfect Lovers)*, which begin in a perfect synchronization bound at some point to fail. Other works make both direct and abstract reference to AIDS, the disease that killed Gonzalez-Torres's lover and then him, along with so many others. One of the most powerful of these works is also one of the most abstract. The 1990 *Untitled (The End)* consists of nothing more than sheets of white paper that are entirely blank except for a black rectangular border. At another moment, and in another configuration, it could have been taken as a prototypical example of minimalism. But here the black border turns into a funereal suggestion of the notices waiting to fill this potentially endless stack of blank pages.

Like the minimalist objects that they resemble, Gonzalez-Torres's stacks establish a relationship to the space of the gallery. Indeed the geometric form could be described as a serial structure since it is constituted by multiple, identical, mechanically produced units. But the fact that these units are endlessly replaceable pieces of paper, to be taken away by the viewer, with their dispersal sending them into a multitude of new contexts, adds further dimensions to the relationship between the work (wherever it is defined as residing) and the context. Gonzalez-Torres's method belongs to the particular type of production described as post-studio art, made only at the point of its exhibition. The continuing existence of the work is a product of Gonzalez-Torres's analysis of the system of ownership, particularly as it has been extended by works sold on the basis of certificates and instructions. Thus his relationship to context is articulated on multiple levels, including a self-

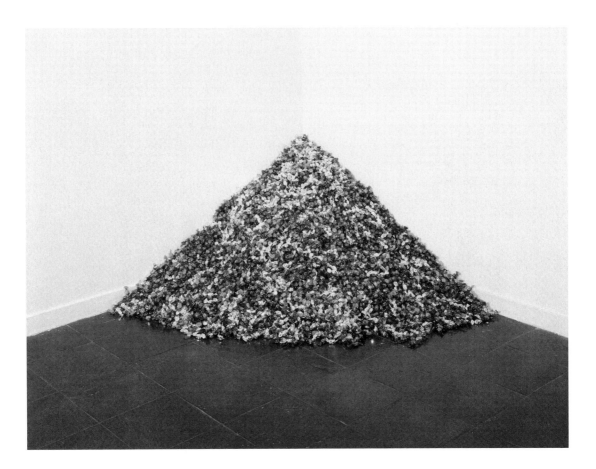

Felix Gonzalez-Torres, *Untitled
(USA Today)*, 1990. Candies, individ-
ually wrapped in red, silver, and
blue cellophane, endless supply, ideal
weight 300 pounds, dimensions
variable with installation. Courtesy
Andrea Rosen Gallery, New York,
in representation of the Estate of
Felix Gonzalez-Torres. Photo: Peter
Muscato.

Felix Gonzalez-Torres, *Untitled (The End)*, 1990. Offset print on paper, endless copies, 22" (ideal height) × 28" × 22". Courtesy Andrea Rosen Gallery, New York, in representation of the Estate of Felix Gonzalez-Torres. Photo: Peter Muscato.

conscious use of institutional conventions to ensure the continuity of his work that could be described as an aspect of his medium.

A stack of candy can be a portrait, a reference to politics, or a suggestion of mortality, yet still be a stack of candy. A portrait bust can be made of chocolate or soap, using those materials in the tradition of cast sculpture yet still deriving part of its impact from their specific cultural associations. And a painting of a single figure can be derived from a photograph yet also suggest the tradition of history painting. Gonzalez-Torres created his stacks of candy by using procedures from conceptual art to activate a version of the readymade and to establish a form of interaction with the viewer. Antoni's version of process in *Lick and Lather* involved her body in the making of a work, with additional references to the idea of self, in a sculpture made from materials that also open onto a series of other associations. Richter's dialogue with painting includes an intense exploration of the medium that is also mediated through other forms, including the photographs that he used to address both contemporary events and artistic traditions in his *October* series. What these disparate examples have in common with one another, and with a large number of contemporary works, is the tremendous specificity of each decision. The fracturing of materials, forms, and effects into increasingly separable elements means that none of these choices can be understood as simply given or customary. These multiple references to artistic traditions and a myriad of other sources remain individually evident even as they are also given a new unity in the context of the work that emerges from this process.

CONTEXT AS SUBJECT

Fred Wilson, *Mining the
Museum,* 1992 (detail). Installa-
tion at the Maryland Historical
Society, Baltimore. Courtesy
Metro Pictures, New York.

In 1992 Fred Wilson mounted the most popular exhibition in the history of Baltimore's Maryland Historical Society. Entering the institution as an artist, he created *Mining the Museum*, an installation that presented historic artifacts in new and unexpected combinations. Orchestrating objects and documents from the collection, some emerging from storage, others simply rearranged or otherwise highlighted, he both followed and subverted museum categorization to reveal an alternate history to the one traditionally on display. Yet one of the striking features of *Mining the Museum* is that this installation was understood as a work of art, despite the fact that it involved the arrangement rather than production of objects, and that it took place in a historical society, a type of collecting institution with an eclectic mix of art, furnishings, tools, artifacts, and documents. Using methods, or perhaps one could even say the medium, of institutional critique, in combination with an approach to the display of objects that employed text, lighting, and sound to engage viewers, he created a multipart installation work that addressed questions of history through telling juxtapositions.

Wilson drew upon his awareness of curatorial conventions to demonstrate how context frames the meaning of an object throughout the process of collecting and display. The convention of bringing together the furnishings and decorations typical of a particular period took an unexpected turn in a display labeled "Metalwork 1793–1880," where highly ornate silver vessels were shown together with brutally functional iron slave shackles. A section labeled "Modes of Transport 1770–1910," which included an eighteenth-century sedan chair and an early twentieth-century baby carriage, confronted viewers with a folded Klan robe and hood arranged inside the latter, with the implications of this startling juxtaposition further underscored by the appearance nearby of a photograph from around 1900 showing a group of white children posed with two black women who were obviously their

Fred Wilson, *Mining the Museum,* 1992 (detail). Installation at the Maryland Historical Society, Baltimore. Courtesy Metro Pictures, New York.

caretakers. Equally telling was the assembly, under the category "Cabinetmaking 1820–1960," of side chairs and armchairs arrayed audiencelike in front of a whipping post that had stood in front of the Baltimore city jail until 1938, was given by the Baltimore City Jail Board to the historical society in 1960, and remained in storage until Wilson brought it out of hiding.[1] Like a number of the objects in Wilson's installation, the whipping post had once been part of a highly visible system of discipline and control that was rendered largely invisible in the version of history that had been on display in the society.

One reason attendance for *Mining the Museum* was so high was that many of the visitors were there for the first time, coming to see how Wilson's arrangements had redirected the narrative told by a society founded with a very different mission into one that addressed the state's African American and Native American history. "I'm not trying to say that *this* is the history you should be paying attention to," Wilson has said of the arrangement he presented. "I'm just pointing out that, in an environment that supposedly has *the* history of Maryland, it's possible that there's another history that's not being talked about."[2]

When the society was incorporated as a foundation in 1844, the all-male and, needless to say, white founders had envisioned a collecting institution and club where exhibitions would be open to members only. During the intervening century and a half the admission and membership policies had been modified, but when Wilson began his research the displays still presented a history shaped by the perspective of the families who were the society's early donors. Little acknowledgment was given to their role as slaveholders, or to issues of the region's race relations in general, even though at its inception the mission of collecting objects and documents relating to the state's history included specific references to slavery and to Native American material.[3] What Wilson discovered in the society's holdings, interwoven with the usual commemorative portraits, period furnishings, and historical artifacts, were estate inventories, reward posters for runaway slaves, and other objects that afforded potent evidence of this side of the state's history. Over time the standing of these objects had shifted, from evidence of the status quo to documents of a system that the successors of the society's founders no longer wanted to emphasize. By the late twentieth century it was the other descendants of this history who had an interest in seeing it brought back to light in all its brutal details.

"What can you bring into a museum now that wouldn't belong in a museum?" asked Wilson in reference to his decision to focus on material already in the collection of the Maryland Historical Society.[4] Indeed, by the early 1990s, after more than three decades of challenges to the definition of the work of art, it might be hard to imagine what could not appear in the space of the art museum. The critique of institutional definitions and conventions that was an important aspect of conceptual work of the 1960s and 1970s helped establish the possibility that an ephemeral installation, made in response to specific conditions and incorporating elements that would not be treated as art beyond that moment, might be defined as a work. A fascination with the rhetoric of exhibition display, an analysis of the conditions established by different types of contexts, the transformation of the space, and even the decision to move outside such spaces are all aspects of this play with the nature of the presentation itself. The analysis of institutional practices has also found expression in the creation of works where the collecting process is part of the artist's method, or where there is an explicit focus on the history of the object. As part of this process the art museum has also become a forum for work with an explicit political agenda. In making the circumstances of the encounter part of their subject, artists have produced an increasingly large body of works (though not necessarily objects) that cannot be understood in isolation, because the context is indeed intrinsic to the work. And as the work has changed, so have the practices of the institutions to which artists have responded, with art

museums and an increasing number of other venues likely to allow or even invite contemporary artists to work within their domain.

In the early 1970s, however, while the work of art was still in the midst of this process of radical redefinition, Hans Haacke managed to find very clear limits on what might be brought into an art museum, when works he had been invited to exhibit were summarily rejected on several occasions. The now infamous cancellation of Haacke's Guggenheim exhibition at the beginning of April 1971, the very month it was due to open, hinged on three works in particular, all of which employed information in the articulation of what Haacke described as social systems. Two of these works presented photographic documents, charts, and lists based on information drawn from public records to delineate patterns of New York real estate ownership by corporations associated with a major real estate partnership and a family with extensive tenement holdings. A third piece consisted of a questionnaire for museum visitors that solicited demographic information as well as responses to social and political issues of the time. Thomas Messer, the Guggenheim's director, tellingly portrayed his decision to cancel the exhibition as a choice "between the acceptance of or the rejection of an alien substance that had entered the art museum organism."[5] Messer further characterized the two works that articulated systems of real estate ownership as "a muckraking venture under the auspices of The Solomon R. Guggenheim Foundation" that would contradict the museum's mission of "pursuing esthetic and educational objectives that are self-sufficient and without ulterior motive."[6] And Messer subsequently described the visitors' poll as an inappropriate imposition on "a public that by and large comes for other purposes than to divulge its income, its political convictions and its attitude toward extra-artistic issues."[7]

"On the basis of work that I had seen prior to any museum initiative," Messer later claimed, "I had no reason to doubt his *capacity* to be an artist when he chose to function as one."[8] Yet the exhibition proposal that had been approved by the board specified works that very obviously extended traditional definitions, listing different types of inorganic and organic systems as well as works described as "interactions between human organisms," and Haacke had already shown a visitors' poll at a New York gallery in 1969.[9] At this particular moment, then, a definition of artistic authorship initially supported by the Guggenheim had already expanded to encompass the hatching of chickens, the growth of grass, or the interactions among ants in an ant colony—all of which were part of the successful proposal. In fact it was the well-established division between the art museum and such other types of collecting and educational institutions as science museums or zoos that established the framework within which Haacke could present these demonstrations of organic processes as works of authorship—with their entry into the museum creating a context

where they could be understood as a response to more traditional aesthetic conventions. Yet the Guggenheim was brought up short by systems of information with social and political implications, which posed too great a threat to the rhetoric of disinterested aesthetic contemplation still prevalent in the discourse of the art museum.

Haacke did nonetheless succeed in exhibiting a visitors' poll as part of the Museum of Modern Art's 1970 "Information" exhibition that was far more explicitly directed at the museum's structure of governance than any of the works rejected by the Guggenheim. The *MOMA-Poll,* located at the exhibition's entrance, posed a question about Nelson Rockefeller's refusal to denounce Richard Nixon's Indochina policy, with the ballots cast by museum visitors visible in two clear acrylic boxes equipped with counters that provided an automatic tally. Rockefeller was at the time running for reelection as governor of New York State, and he was a member of MoMA's board of trustees as well as a past president and chair; other members of his family had also played extensive roles in the founding and governance of the museum. Haacke ascribed his success in exhibiting this very specifically targeted work not to a more open attitude on MoMA's part, but to his strategy of posting the actual text of the question only the night before the opening, when the museum did not have time to prepare a response, and to the controversy its abrupt removal would have caused in the politically charged aftermath of the shootings at Kent State University that May and the subsequent call among New York artists for a protest in the form of an art strike.[10]

Haacke's *MOMA-Poll* has to be understood in the context of both the "Information" show, with its emphasis on systems, documents, and instructions, and the role of the museum as a site for the articulation of the intense activism of the period. Actions in and around the museum were being mounted by artists who used the invitation to exhibit as an opportunity to create works with a critical relation to the institution; from outside, artists were also protesting museum policies and exclusions and using the museum as a visible site for demonstrations reflecting a broad political agenda. The Guerrilla Art Action Group had already issued its demand for the immediate resignation of all Rockefellers from the MoMA board in November 1969 in the form of a communiqué, followed by an unannounced GAAG action in the MoMA lobby when Jon Hendricks, Poppy Johnson, Silvianna, and Jean Toche entered the museum with sacks of beef blood concealed under their clothing, distributed copies of the call for resignation, and then staged a violent and bloody confrontation among themselves.[11] The Art Workers Coalition, which signed on in support of GAAG's resignation demand, provided a forum for political activism by artists, some of whom were not necessarily making art with explicitly political content. Women Artists in Revolution (WAR) and the Ad Hoc Women Artists' Group focused attention on the severe underrepresentation of women and minority artists in museum collections and

exhibitions, with picketing targeted particularly at the Whitney Museum's annual survey exhibitions to protest a version of art history that deployed a rhetoric of quality as a screen for its exclusionary selections.[12]

The call for greater access to institutions that had been closed to many artists thus intersected with a far broader political agenda. At the same time, the analysis of institutional structure and practices contributed to an increasing awareness that how a work is presented once it leaves the artist's hands will frame the meaning or interpretation of the work itself. This recognition motivated a desire to maintain control over the context of presentation, and to pay increasing attention to all aspects of institutional rhetoric and practice.

Certain kinds of information are significant tools for art history, yet are considered secondary to the object and to the experience of that object on display. A work's provenance is an important tool in confirming the authenticity of a work, even though it is often viewed as unconnected to a work's meaning except with respect to the initial circumstances of a commissioned piece, or when the physical contours of the work have been altered by its passage through different hands. With the increasing attention to all aspects of institutional practices, however, such art-historical tools have become the focus of a number of artists' works. John Baldessari made playful reference to the history usually treated as external to the object in *Painting That Is Its Own Documentation,* begun in 1968, by recording the conception and initial execution in text painted on the canvas, followed by a note, in slightly smaller letters: "FOR EACH SUBSEQUENT EXHIBITION OF THIS PAINTING, ADD DATE AND LOCATION BELOW. FOR EXTRA SPACE, USE AN ADDITIONAL CANVAS."[13] For Haacke, it was the political implications of provenance information that inspired him to focus attention on the ownership history of now canonical examples of modernist painting in his 1974 *Manet-PROJEKT '74* and 1975 *Seurat's "Les Poseuses" (small version), 1888–1975.*

Invited to participate in "PROJEKT '74," an exhibition planned for the Wallraf-Richartz-Museum in Cologne in the summer of 1974, Haacke made the following proposal: "Manet's *Bunch of Asparagus* of 1880, collection Wallraf-Richartz-Museum, is on a studio easel in an approx. 6 x 8 meter room of PROJEKT '74. Panels on the walls present the social and economic position of the persons who have owned the painting over the years and the prices paid for it."[14] But the provenance Haacke traced indicated a history of ownership that linked the work to Germany's Nazi past—which was not the history that the museum wanted to tell about that Manet painting, or about the role that art may play in general as an emblem of power. Although what Haacke proposed to include was basic art-historical and biographical information drawn from standard reference works, its presentation ran counter to the exhibition's theme, "Kunst bleibt Kunst" (art remains art).

Specifically Haacke's *Manet-PROJEKT '74* highlighted the role of banker Hermann Abs in the acquisition of the work while chair of the friends of the museum and included, in the biographical notes, references to his role in the Deutsche Reichsbank during the Nazi period. Horst Keller, the museum's director, asserted that "a museum knows nothing about economic power; it does indeed, however, know something about spiritual power," and he objected to Haacke's work on the grounds that "one should discuss the price of a work to be acquired only up to the point of its acquisition, and I believe that Haacke should have let this aspect of a museum's life alone."[15]

The degree to which a work of art's assumed autonomy is willed by the exclusion from consideration of certain types of information is made clear by the controversy created by Haacke's work. Its exclusion from the exhibition received even more attention after the museum rejected it a second time by effacing the small-scale reproductions of Haacke's panels that Daniel Buren incorporated into his own work—which the museum achieved by pasting over those portions of Buren's piece with white paper. Buren drove home the point by appending a poster with the text "Kunst bleibt Politik" (art remains politics) to his work, whereas Keller, despite his defense of the sanctity of the Manet painting, made the remarkable assertion that "it is a not uncommon practice for a museum to paste over an artist's work, when an artist has expressly disregarded an agreement previously reached with the museum."[16]

The real estate documentation rejected by the Guggenheim reflected outward, suggesting the impact of that system of ownership on the lives of people in New York. For the Manet piece it was a different kind of ownership history, one that reflected inward on the museum's collecting practices by raising questions about exactly how the objects in the museum get there, and the associations with wealth and power that lie behind the insistence on disinterested aesthetic contemplation. It is also significant that Haacke chose a work, even if in this particular case a seemingly uncontroversial still life, by the artist who had managed to scandalize the art establishment of his own time with the *Déjeuner sur l'herbe* in the 1863 Salon des Refusés and the notorious *Olympia* in the Salon of 1865. Yet just as Manet's painted scandal is now part of art history, understood in retrospect as the beginning of modernism, so is Haacke's conceptual attention to the history of ownership. Haacke's articulation of the history of an earlier work is now itself historically important as a significant example of a critical conceptual practice. And it is from that perspective that one has to understand the inclusion of the work in the 1997 "Deutschlandbilder" exhibition at the Martin-Gropius-Bau in Berlin. Whereas the version of *Manet-PROJEKT '74* that Haacke created after its initial rejection relied on a color photograph of the Manet still life, for the 1997 exhibition Haacke had the opportunity to present this now-historical work

Hans Haacke, *Manet-PROJEKT '74*,
1974, as installed in "Deutschland-
bilder," Martin-Gropius-Bau, Berlin,
1997. © 2002 Artists Rights Society
(ARS), New York / VG Bild-Kunst,
Bonn. Photo: Hans Haacke.

with the original painting, on this occasion willingly loaned by the Wallraf-Richartz-Museum and displayed on an easel in front of the text panels as he had initially proposed.

This approach to the object, involving both an interrogation of the circumstances of its presentation by the museum and the establishment of a new series of contexts—whether by providing additional information or by the physical relocation of the object—has to be understood as a circuitous version of the readymade. Once exhibitions began to be organized by inviting artists to work in a particular space, attention to the museum's permanent collection followed, increasingly in the form of temporary manifestations by artists who have incorporated both the physical space and other works of art into installations defined as a further work of authorship. Marcel Duchamp's own unrealized suggestion for a reciprocal readymade, from the notes collected for his *Green Box,* was "Use a Rembrandt as an ironing-board." In recent versions of the work of art as readymade, the original object, though physically undamaged by the ensuing attention, is given new significance through the maneuvers of subsequent generations of artists.

When Michael Asher was invited to participate in the Art Institute of Chicago's "73rd American Exhibition" in 1979, his contribution consisted of having the museum transport a statue of George Washington from its usual position at the museum's main entrance to a gallery devoted to late eighteenth-century European painting and decorative arts. "I was the author of the *situation,* not of the elements," Asher wrote of this work.[17] Asher in particular has established an approach specific to the site or context that leaves little other than documentation behind once the exhibition is over. Like many of his projects, the relocation of the statue followed a period of research and negotiation, with the realized project being the third proposal Asher made to the exhibition organizers. Yet his claim of authorship over this singular act of arrangement served to highlight particular qualities of the overall order of the Art Institute collection. Like Asher's earlier works, it incorporated a formal analysis of the site; but it also arose from an investigation of the relationship of this individual object to the historical structure established by the chronological arrangement of the collection.

Asher managed, with this act of recontextualization alone, to draw attention to the definition of a monument, the impact of categorization by period and author, the process of preservation and conservation, and distinctions between original and copy within the hierarchy of the museum. The relocation of the sculpture from its position outside, standing in front of the museum, to the European art galleries pointed out the different ways this sculpture might be read—as a sculpture *of* Washington, and therefore connected to United States history, or as a work *by* Jean-Antoine Houdon, a French sculptor, which, in the context of a history of art written according to artists' proper names, would be more

Michael Asher, installation,
"73rd American Exhibition," The
Art Institute of Chicago, 1979:
view of gallery 219 with statue by
Houdon after removal from Michi-
gan Avenue entrance. Courtesy
the artist. Photo: Rusty Culp.

appropriately contextualized according to the period and national origin of its maker. The move also brought into focus the sculpture's uneasy function as a monument, a role that it had been given by its placement in front of the building, even though the life-sized representation had not been designed for that purpose, particularly with respect to scale. Once inside the galleries, the contrast between its condition and that of the other objects there also drew attention to how the museum maintains the work of art through cleaning and conservation—and to the fact that one reason the sculpture had been outside in the first place was due to its secondary status as a twentieth-century bronze cast made after Houdon's 1788 marble original.

This type of institutional critique emerged from the intersection of conceptual procedures and a site-specific approach to the work, though it is by no means the only way artists have made reference to the museum. The degree to which work that takes the institution as its subject has become not just established but a significant part of the history of contemporary art was demonstrated by the Museum of Modern Art's 1999 "The Museum as Muse." This extensive compilation of works by artists who had turned their attention to the museum and its practices was assembled by Kynaston McShine, the same curator who had organized MoMA's 1970 "Information," an early and notable example of the procedure of issuing invitations to artists to submit proposals. One paradox of the 1999 exhibition, however, was that its organization was largely based on a more traditional curatorial approach to the selection of already extant works.

Numerous examples of museum constructs and responses could now be pulled from the archives. Versions of Duchamp's *Box in a Valise,* Marcel Broodthaers's *Museum of Modern Art, Department of Eagles,* and Claes Oldenburg's *Mouse Museum* had already been shown in conjunction with one another at the 1972 Documenta 5 in Kassel, Germany, and appeared again at the MoMA show as early exemplars of a now extensive history of both specific and general responses to museum environments and practices—with Broodthaers's museum assemblages represented by a few objects, and Oldenburg's eclectic collection displayed in its full-scale, mouse-shaped room. Also represented were several successive generations of artists, whose responses to the museum encompassed versions of institutional critique emerging from conceptual art, variations on reference and simulation identified particularly with a group of artists who came to prominence during the 1980s, and a number of other approaches to museums in general or MoMA in particular. Yet the exhibition as a whole was an eclectic affair, offering up works made from very different perspectives simply because they referred in some way to museums or museum practices. The appearance of photographs of revelers at gala openings in the same assembly as less celebratory examples had the effect of suggesting that works with a critical edge represented simply one

approach among many—with the difficulty they had initially presented safely understood as part of history.

A few artists were also invited to create projects, and Asher's proved that the process of invitation and negotiation can still put the institution in an uncomfortable position, if the history the artist wants to highlight is not one the institution wants to reveal. Asher's work appeared in the form of an 8½ x 11-inch stapled publication with a bright red cover and an interior of sixteen pages, some of which were blank. On the cover, the text read, in white type, *Painting and Sculpture from the Museum of Modern Art,* with an overlay in smaller gold type, *Catalog of Deaccessions 1929 through 1998 by Michael Asher.* In fact the catalogue of deaccessions was Asher's second project proposal. His first, rejected practically by return mail, proposed an exploration of authorship by means of the display of works from museum collections for which the attributions had changed or the authenticity had been questioned.[18] Yet the information about the collection modestly presented in the second, realized project was potentially far more eye-catching.

When Asher established the parameters for the work, he did not know exactly what the museum's compilation of this information would yield. What the publication contained was a listing of the works—numbering a total of 403—that had been removed from the museum's Department of Painting and Sculpture through sale or exchange since the museum's inception. The model for the cover and page layout was one of the museum's own publications, specifically the catalogue of works acquired between 1967 and 1977, *Painting and Sculpture in the Museum of Modern art, with Selected Works on Paper: Catalog of the Collection, January 1, 1977,* which was issued as a supplement to the earlier list of holdings, *Painting and Sculpture in the Museum of Modern Art, 1929–1967.* The other catalogues were, in their record of an expanding collection, demonstrations not just of holdings but of acquisitions. A list of deaccessions, however, had never been compiled, much less publicized in this manner.

The list, which includes works by a number of famous twentieth-century artists, cannot fail to catch the attention of the reader, as much for the questions left unanswered as for the information it does present. In particular, though the accession number indicates the date that the work entered the collection, the list does not indicate when or under what circumstances the work left. The museum's concern over how this listing might be received is evident in the statement by Kirk Varnedoe, Chief Curator of the Department of Painting and Sculpture, that the museum insisted on including in Asher's catalogue. "In principle I didn't want it because I don't believe a curator should modify the work of an artist," Asher later recounted to an interviewer. "But when I read it I realized it could be quite revealing."[19] Varnedoe's statement expanded upon the point already made in Asher's introduction—that the works in the list were sold or exchanged to make new acquisitions—and

concluded with the disclaimer that, due to time limitations, "we have not been able to assure ourselves that the present list meets the criteria of completeness or accuracy we would require in a Museum publication. Readers are thus cautioned to be aware of possible flaws and limitations in this listing of titles."[20]

Asher's analysis of how the museum records and disseminates collection information allowed him to use the museum's invitation as an opportunity to create a work that would have an existence beyond the duration of the show itself—with the plan for its distribution an equally important aspect of the conception. At his insistence the work was located in two sites, both within the galleries and in the bookstore, where it was available free with one's entrance receipt for those persistent enough to track it down.[21] Thus viewers were able to take away this object that is in one sense the work, complete in itself, yet is also linked to the particular circumstances of the exhibition for which it was generated. Asher's idea was that each of the ensuing venues would compile and publish its own list of deaccessions. The fact that the work was excluded from the traveling exhibition suggests both the contradiction of creating site-specific works in face of the convention of the traveling exhibition, and the potential for embarrassment inherent in this particular project. Yet one marker of the historical distance between this work and Haacke's rejected Manet project can be seen in the fact that it *was* realized for the show's initial venue and, further, that the compiling of the information, production of the publication, and distribution at the bookstore were all tasks realized by the museum, working under the instructions of Asher's proposal after having solicited his participation in the exhibition.

"It is no longer a matter of trying to subvert or intrude," says Louise Lawler of this general shift. "Those strategies are now recognized and invited."[22] Lawler's own photographs and projects, with their insistent probing of the many regions through which works of art move as they are on display or in transit, have played an important role in establishing such analysis as a central concern of contemporary art. Further evidence of the changing relations between the museum world and the contemporary artists who have challenged its institutional assumptions was provided when another exhibition that could be described as having the museum as its subject opened in 1996 at the Museum Boijmans Van Beuningen in Rotterdam. There a number of the same artists featured in "The Museum as Muse" appeared in an elaborate installation of the museum's holdings that included many paintings from its substantial collections of seventeenth-century portraits, examples of sculpture and decorative arts from a range of sources, and many works drawn from its collection of modern and contemporary art. In this case the artist responsible for the arrangement was Haacke, whose control over the assembly was specified by an agreement that guaranteed him complete freedom in his choice of works and their interpretation.[23]

Michael Asher, *Painting and Sculp-
ture from The Museum of Modern
Art: Catalog of Deaccessions 1929
through 1998*, 1999 (cover and page
eight). Stapled publication, 11" ×
8½". Courtesy the artist.

CÉZANNE, Paul.

CHOCQUET IN AN ARMCHAIR. (1877?). Oil on canvas, 17¾ x 14¼". 20.34

L'ESTAQUE. 1883–1885. Oil on canvas, 23⅞ x 27¾". 264.54

FRUIT AND WINE. (c. 1885–88). Oil on canvas, 20⅞ x 25⅜". 11.34

MAN IN BLUE CAP (UNCLE DOMINIC). 1865–66. Oil on canvas, 32¼ x 6⅜". 17.34

THE ROAD. 1871–72. Oil on canvas, 23½ x 28¾". 14.34

PEARS AND KNIFE. (c. 1878). Oil on canvas, 8⅛ x 12¼". 10.34

THE WATER CAN. (c. 1880–1882). Oil on canvas, 10⅝ x 13¾". 7.34

PORTRAIT OF MME. CÉZANNE. c. 1885–87. Oil on canvas, 18⅛ x 15⅛". 19.34

CHADWICK, Lynn.

THE JEWEL. Metal, glass, and plastic, 9⅜ x 10½ x 13⅜". 771.69

CHAGALL, Marc.

FLOWERS. 1925. Oil on canvas, 37¼ x 29⅝". 620.73

CHAMBERLAIN, John.

MAZ. 1960. Painted scrap metal, 44¼"h., at base 8⅛ x 9⅞". 1.61

NORMA JEAN RISING. 1967. Galvanized steel, 66 x 38 x 38". 627.73

CHARLOT, Jean.

BUILDER CARRYING STONE. 1930. Oil, 27½ x 27½". 178.35

THE DANCE (LA JARANA). (n.d.). Oil. 179.35

THE DRINKER. (n.d.). Oil. 180.35

DE CHIRICO, Giorgio.

DELIGHTERS OF THE POET. 1913. Oil on canvas, 27⅜ x 34". 525.41

EVANGELICAL STILL LIFE. 1916. Oil on canvas, (irreg.) 31¾ x 28⅛". 583.67

CONVERSATION. 1926 (?). Oil on wood, 13¼ x 10¼". 1.35

HORSES AND TEMPLE. (n.d.). Oil on canvas. 68.61

CIKOVSKY, Nicolai.

GIRL IN GREEN. 1937. Oil on canvas, 36 x 30". 295.38

COHEN, George.

IMAGO. 1955. Construction of varnished and painted wood, metal, string, sponge and cloth, 34¼ x 12⅜ x 2⅜". 16.61

COSGROVE, Stanley.

MEXICAN LANDSCAPE. 1942. Oil on composition board, 10⅛ x 18". 581.42

CROSS, Henri-Edmond.

WOODLAND IN PROVENCE. 1906–07. Oil on paper mounted on canvas, 21¾ x 17¼". 182.35

DALI, Salvador.

IMPERIAL VIOLETS. 1938. Oil on canvas, 39¼ x 56⅛". 527.41

DAUMIER, Honoré.

BUST OF GUIZOT. 1832, this cast 1930. Bronze. 6½" h., at base 3¾ x 5" (irreg.). 621.39

THE LAUNDRESS 1861(?). Oil on wood, 19⅝ x 13⅛". 27.34

THE REFUGEES. (n.d.). Oil on canvas, 15¼ x 27". 613.43

DAVIE, Alan.

STEPPING STONES OF THE DRAGON. 1962. Oil and gold paint on canvas, 18 x 22". 500.65

DAVIES, Arthur B.

ENERGIA. Oil on canvas, 42½ x 20½". 1.67

DAVIS, Stuart.

CARREFOUR. Oil. 837.63

PLACE DES VOSGES. 1929. Oil on canvas, 21 x 28". 183.35

SUMMER LANDSCAPE. 1930. Oil on canvas, 29 x 42". 30.40

DEGAS, Hilaire-Germain-Edgar.

ARABESQUE OVER RIGHT LEG, LEFT ARM IN LINE. (n.d.). Bronze, 11¼ x 17⅛ x 4", including bronze base ¼ x 4⅞ x 3¾". Separate marble base, ⅞ x 4¾ x 6½". 503.70

RACE HORSES 1884. Oil on canvas. 18¼ x 21⅜". 38.34

DELAUNAY-TERK, Sonia.

MARKET IN MINHO (STUDY 7). 1916. Distemper and encaustic on canvas, 12¼ x 17⅜". 151.55

DELVAUX, Paul.

THE ENCOUNTER (LA RENCONTRE). 1938. Oil on canvas, 35⅝ x 47½". 326.63

DERAIN, André.

MADAME DERAIN. 1920. Oil on canvas, 14¾ x 9¼". 44.34

THE FARM. 1922–24. Oil on canvas, 19¾ x 24". 46.34

LANDSCAPE SOUTHERN FRANCE. 1927–28. Oil on canvas, 31½ x 38". 45.34

GUITAR PLAYER. 1928. Oil on canvas, 32½ x 38⅜". 417.41

NIGHT PIECE WITH MUSICAL INSTRUMENTS. After 1930. Oil on canvas, 9⅛ x 15⅞". 679.54

DESPIAU, Charles.

LITTLE PEASANT GIRL. 1904. Original plaster. 15¾" h., including plaster base 5¾ x 5¼ x 5⅛". 619.39

A. MME OTHON FRIESZ.

B. LEDA AND THE SWAN. (1924). A. Original plaster, 20⅞" h. including plaster base 6 x 6¾ x 7½". h. B. Plaster relief, 6½ x 5". 616.39. A–B

MADAME HENRY WAROQUIER. 1927. Bronze, 15¾" h., on stone base 6 x 7⅞ x 6". 616.43

SEATED YOUTH: MONUMENT TO EMIL MAYRISCH. 1932. Bronze, 6' 5 15⁄16" x 3' 5⁄16" x 4' 7⅜". 623.39

ANNE MORROW LINDBERGH. 1939. Bronze, 15½" h., on wood base, 4½ x 8⅛ x 6¾". 657.39

MARIA LANI. (n.d.). Bronze, 14"h. 11.30

The strategy of inviting artists who have made collection and display practices the subject of their work into the museum, not just to create a site-specific installation in the space but to work with the collection itself, is one that became increasingly common in the 1980s and 1990s. Interventions by artists in art museum collections have included Lawler's focus on still life paintings and a thimble collection for a 1990 installation at Boston's Museum of Fine Arts, and Wilson's extensive reconfiguration of the Seattle Art Museum in 1993.[24] There were also certain earlier precedents, notably the 1969 "Raid the Icebox 1," for which Andy Warhol was invited into the storage vaults of the Museum of Art at the Rhode Island School of Design to apply his own taste to the many eclectic objects that were important enough to catalogue yet not generally to put on display, with the resulting exhibition intermixing paintings, sculptures, chairs, and framed wallpaper samples, along with entire cabinets from the costume collection filled with shoes or parasols and umbrellas.[25]

One feature that Haacke's reconfiguration of the Rotterdam collection shared with Warhol's much earlier installation was the attention to the way paintings and other relatively shallow works are stored in museum vaults on wire mesh grids, which in both cases the artists made into an element of the installation presented for public view. Haacke described his introduction to the basement storage at Rotterdam as a visit to a *Wunderkammer,* or curiosity cabinet, where he found an "indiscriminate accumulation of exhibition materials on gray steel grids, subject only to the rationale of efficient use of space."[26] Yet the degree to which artists' various plays on the idea of the museum have come to frame the apprehension of the collection is evident in the way the accumulation also made Haacke think of Broodthaers's 1972 installation of *The Eagle from the Oligocene to the Present* at the Düsseldorf Kunsthalle. And in turn, works by Broodthaers were among the many contemporary examples dealing with aspects of collecting and display that Haacke incorporated into his own work as constituted by his reinstallation.

An equally intriguing series of associations runs through the work that Haacke describes as the impetus for the invitation to create the exhibition. Edgar Degas's *Little Fourteen-Year-Old Dancer* had appeared in the sixth impressionist exhibition of 1881 in the form of a wax figure whose bodice was completed by a skirt made from layers of cotton fabric, and whose hair was tied with an actual satin ribbon. A posthumous bronze edition produced some four decades later used a similar combination of fabrics and sculpted form, which Haacke had commented upon during a visit to the Metropolitan Museum of Art published as part of a series of such discussions conducted by Michael Kimmelman.[27] Haacke's observations drew the attention of the newly appointed director of the Boijmans Van Beuningen, since the museum also owned a cast of the Degas sculpture that had been the focus of much attention, including research into the history of dance that resulted in the

sculpture being outfitted with a longer tutu. In his arrangement of the collection Haacke paired the Degas dancer with another cast, Auguste Rodin's 1905 *Walking Man* (an enlarged version of Rodin's 1877 half-life-size sculpture of the same subject that served as the basis for his 1878 *John the Baptist*), which belonged to the city of Rotterdam and was normally situated at an outdoor site not far from the museum. In Haacke's installation the Degas and Rodin faced one another—as much as a headless sculpture such as Rodin's can be said to face anything—in front of Warhol's 1965 *The Kiss (Bela Lugosi)*, a canvas made with a repeated photo silkscreen of a still from the 1931 film version of *Dracula*.

Why did Haacke choose this grouping? "I let myself be guided by the surrealist etiquette of the Comte de Lautréamont," was Haacke's own explanation. "Dracula and his victim have as little to do with an amputated baptist and a ballet rat from Montmartre as a sewing machine and an umbrella have to do with each other."[28] Yet one might well be tempted to draw connections between Warhol's title and one of Rodin's other famous sculptures. Even more suggestive is the attraction Degas's dancer has also held for Lawler, who has made a practice of photographing this multiple whenever she comes across an example. Whereas Haacke was glad to be able to show the work without a protective enclosure, the two photographs that, together with text, make up Lawler's 1991–1993 *Glass Cage* draw attention to the ways this sculpture is often framed by just such a setting. Not coincidentally, *Glass Cage* was one of several works by Lawler in the museum's collection that made its way into Haacke's installation.

"The production of meaning intrigues me as much as looking at who funds the institution and what they get in return," was Haacke's response to an interviewer's query about the connection between working within a collection and his earlier institutional critiques.[29] Many of the contemporary works that he chose already included a complex play of reference, so that Haacke's further intervention added another layer to their interpretation. Lawler had used the title of her 1984 *Pollock and Tureen, Arranged by Mr. and Mrs. Burton Tremaine, Connecticut,* to indicate to viewers the significance she placed on where she found this painting, which appears in her color photograph as a fragment above a shelf of elegant porcelains within the private collection thus indicated. Haacke in turn arranged Lawler's work next to another photograph of a painting, taken around 1938 of Dirk Hannema, an earlier director of the museum (then known as the Museum Boymans), contemplating a recent purchase, specifically one of the notorious Vermeer paintings of religious subjects forged by Hans van Meegeren during the 1930s and 1940s, which van Meegeren produced in part on the basis of information gleaned from his reading of a book on Netherlandish painting coauthored by Hannema.[30] In the publication devoted to the exhibition, Haacke established an echo of his own earlier work in an extended caption that

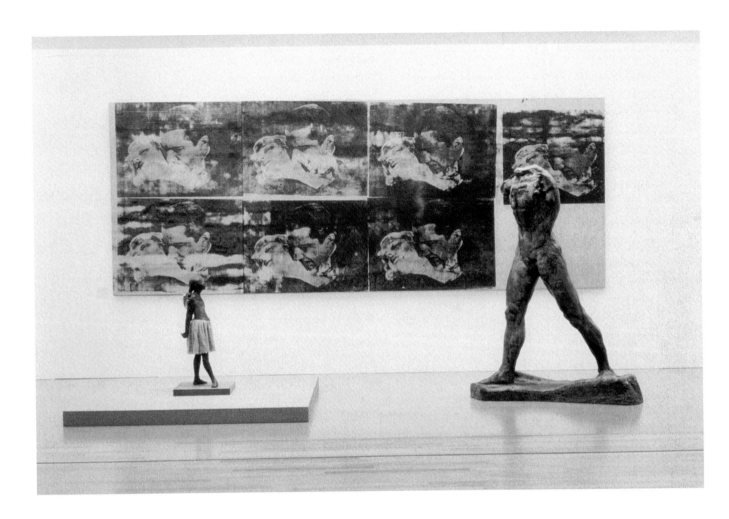

Hans Haacke, *ViewingMatters*, 1996
(details). Installation curated with
the collection of the Museum Boij-
mans Van Beuningen, Rotterdam.
© 2002 Artists Rights Society (ARS),
New York / VG Bild-Kunst, Bonn.
Photos: Hans Haacke.

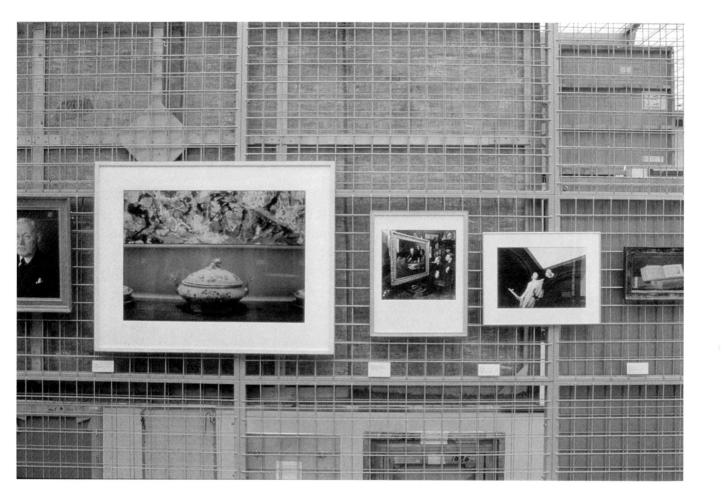

outlined the history of Hannema's collaboration under German occupation, followed by his dismissal and brief imprisonment after the end of the war.[31] Next was a photograph, Daan van Golden's 1978 *New York,* followed by Sebastian Stoskopff's 1625 *Still Life with Books,* each of which presented its own internal arrangement of art or objects. The importance of authorship and authenticity for the value accorded to the original object, and considerations of when and why certain works become highly sought after, already suggested in different ways by each of these works, become even more evident when they are brought together in this manner.

One effect of visible quotation is its retroactive impact on the earlier work. What Haacke's installation implicitly acknowledged was the way that anyone familiar with Lawler's series of photographs capturing the multiple appearances of Degas's dancer will be unable to see the sculpture without a far greater awareness of its presentation, encased, juxtaposed, or otherwise. And that was, of course, exactly Lawler's point—that such conditions had shaped her own appreciation of the work as she found it in differing circumstances. Thus her photographs highlight the arrangements created by the collectors who hung their Pollock over examples of highly refined porcelain, or by the unnamed staff members who brought together a grouping of works from Jeff Koons's 1988 "Banality Show" at the Sonnabend Gallery that is clearly not intended for public display.

The equal attention she gives to questions of presentation for her own images is evident in works where she has incorporated photographs into an objectlike series of paperweights. Their format transforms their orientation, as they appear not on the wall, in the vertical alignment typical of the photograph on display, but sitting on surfaces, whether on a pedestal in a gallery or perhaps in a private collection simply out on a table. Part of the encounter with this work is therefore the experience of finding the correct vantage point for viewing objects that can be approached quite literally from any direction—a process that may resolve itself fairly quickly for some of them, for example the 1989 *Untitled (Koons),* where the orientation of the sculptures in the photo is readily apparent, but less quickly for other images that, cropped to a circle, contain few internal clues regarding spatial alignment.

The intense engagement with context has created many intersections between artists, at times as actual collaborations, far more often involving the creation of works that incorporate a precise response to other works, both earlier and contemporary. Such works indicate both a thorough analysis of the circumstances of context and an equally careful consideration of the nature of authorship—paradoxically made that much more evident by the mechanisms of reference and quotation. The recontextualization can be as subtle as Sherrie Levine's photographs after other works of art, which contain within a seemingly

isolated and portable object traces of multiple contexts of both display and reproduction, or far more explicit in the many and varied ways artists have physically recontextualized nonart and art objects alike. The process of considering works of art that respond to and incorporate other works, which may themselves be created through acts of recontextualization such as copying or appropriation, implies a layering of authorship, or a chain of quotation and reference, that can create a disconcerting sense of vertigo.

A particularly sly example of this layering process appeared in *May I Help You?*—Andrea Fraser's 1991 performance by proxy at the American Fine Arts gallery. In her own thoroughly scripted appearances Fraser has presented herself in the guise of the docent, weaving together statements about art and culture lifted from a multitude of sources or, more recently, using a similar process of appropriation to perform the role of the artist. For the work at American Fine Arts, members of the gallery staff, performing a script crafted by Fraser, descended upon gallery visitors in a space hung with Allan McCollum's *Plaster Surrogates*. And just as the format used for the surrogates plays off found conventions, the text of the script consists of found statements, particularly published statements by dealers and collectors and the interviews with individuals representing different classes in French society that appear throughout Pierre Bourdieu's now-classic sociological study, *Distinction: A Social Critique of the Judgement of Taste*.[32] Fraser's authorship in this work was thus

reduced to the process of establishing a context for the individual quotations and their performance as a script.

The script performed by the gallery staff began with acclaim for the beauty of the work on display; as the performer moved around the room, she or he described or responded to the individual examples with varying degrees of enthusiasm, pomposity, incomprehension, and pathos. The objects by McCollum that were the ostensible subject of this puzzling soliloquy could already be described as highly enigmatic. The cast sculptures, approximately one hundred in all, hanging in a row around the gallery, were molded and painted to masquerade as framed images. From a distance their format would be instantly identifiable to anyone familiar with the conventions developed for displaying works on paper. But closer inspection reveals them to be a kind of painted relief, with the central rectangle where the image would normally reside rendered as monochrome black. In this attention to the appearance of art, the series is closely related to McCollum's *Perpetual Photographs,* and indeed some of the stills taken of television sets that served as the basis for that series of photographic abstractions also contained "surrogates on location," recognizable as framed and matted works with illegibly dark centers. The *Plaster Surrogates* also share with McCollum's other works a process of controlled variation that produces similar yet differentiated objects. For the *Plaster Surrogates,* the combinations made possible by approximately twenty different sizes for the object itself, 140 frame colors, and a dozen shades for the mats yielded thousands of unique if closely related works.[33] McCollum also minimized his physical touch with the help of studio assistants. He described his motivation for the *Plaster Surrogates* and the related *Surrogate Paintings,* where the entire object was painted in the same monochrome hue, as a desire "to represent the way a painting 'sits' in a system of objects . . . the goal was to make them function as props so that the gallery itself would become like a picture of a gallery by re-creating an art gallery as a stage set."[34]

McCollum began the *Surrogate Paintings* in 1978 and the *Plaster Surrogates* in 1982, and both were widely exhibited in the context of solo and group shows during the 1980s. So by 1991 viewers familiar with contemporary art were likely to recognize this play on gallery conventions as an example of work by McCollum. What they may or may not have been expecting, depending on how much prior knowledge they brought to their visit, was Fraser's activation of that stage set with her own play off art world conventions and rhetoric. The fact that McCollum's play with display conventions was so readily recognizable was an effect of his activation of a highly specialized set of practices for the presentation of art. In large part those practices are a product of the methods of collecting and display typical of the art museum, as they developed in the aftermath of the separation of museums into collections of different types. This division, largely solidified in the nineteenth century,

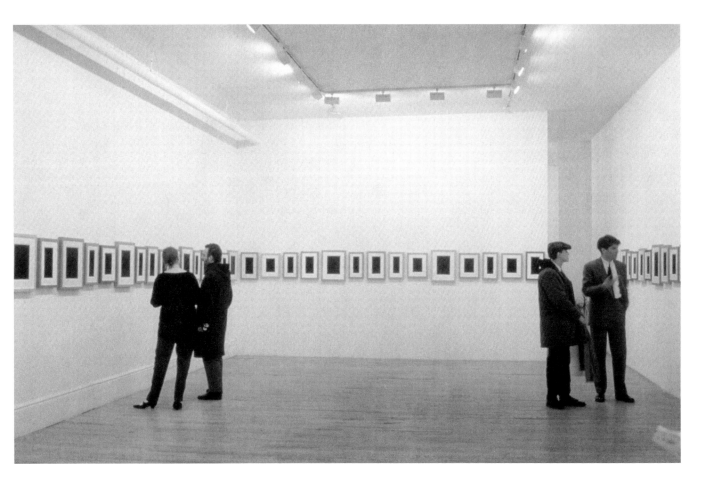

Andrea Fraser, *May I Help You?*,
1991. Performance by Andrea Fraser
at American Fine Arts, Co., New
York, produced in cooperation with
Allan McCollum. Courtesy the artist.

established the art museum as a specific kind of collection, in many ways distinguished by the attitude toward the object from such other collection types as historical societies and natural history museums. The art museum has also changed the relationship of art to its environment. Many early works were in a sense appropriated by their entry into the museum, with their original function at times drastically altered by their assimilation into a system of categorization based upon period, style, and, where possible, authorship. For contemporary artists, the museum and the related environment of the gallery are now the assumed space for art—with this condition evident in responses that range from extreme attention to particular aspects of such contexts to the explicit rejection articulated in work made expressly for other settings.

This attention to the circumstances of presentation has also been articulated in changes in artistic method, and in increased engagement with other kinds of collecting and display. Collecting, preservation, research, and display are no longer procedures that simply happen to works of art, but are transformed into processes that artists employ in their production. The amassing of objects, traditionally the province of the collector, and the assembly of photographic documentation that is likely to be part of the scholarly enterprise have both been taken up by artists, not just to accumulate materials to be made into works but with the collecting process constituting one of the methods by which the work is achieved. At the same time, artists have been exploring other types of museums or related attractions, with attention both to the different protocols for the objects and materials that may be collected and to the modes of display that might appear in such settings as natural history dioramas or the historic reconstructions found in wax museums. Yet the extent to which the exploration of such materials and methods is still defined as art indicates how the basis for the art museum's differentiation from other collections has been retained. Artistic authorship, even if in many ways based on the process of categorization associated with the earlier history of the art museum, still establishes the framework within which a variety of activities can be understood as art.

It is thus as an artist that Mark Dion went collecting insects in Venezuela, observed the wildlife in the rain forests of Brazil, embarked on a study of the endangered species of Belize, and excavated sites in Europe and the United States. Not only has he taken up various methods adapted from the history of scientific exploration, but those projects have yielded outcomes equally varied in both their form of expression and their context of display. The collecting tools and the insect specimens from Venezuela were brought together in a mixed-media assemblage. Lists of the different wildlife species he was observing in Brazil were faxed to the Museum of Natural History in Fribourg, Switzerland, where they were matched against the museum's holdings, with specimens that corresponded to his list

brought together in a special temporary display. In Belize his research appeared as a series of labels combining historical and conservation information about animals from the region that were appended to the displays in the Belize Zoo.[35] And to create his 2001 *New England Digs,* Dion conducted a series of excavations and then arranged the material in cabinets and display cases shown in a traveling art museum exhibition.

The various roles Dion has taken on—explorer, naturalist, archaeologist—consciously hark back to an earlier period in the history of scientific exploration, when areas of expertise were less narrowly defined and scientific inquiry might be conducted by the same wealthy amateurs who avidly collected its material evidence. For *New England Digs,* Dion gave these interests a site-specific spin by transforming the art museum staff, along with numerous volunteers, into teams that conducted a series of digs in the regions surrounding each of the institutions that were venues for the exhibition. In Brockton, Massachusetts, it was mounds of dirt that had been removed from other locations around the city to an area behind a local cemetery as part of a public works project that became his excavation site—reflecting Dion's careful avoidance, in his guise as artist taking on the role of archaeologist, of locations that might be of genuine archaeological interest.[36] Once the odd mix of the artifacts from each area had been cleaned and collected, his method of presentation echoed early cabinets of curiosities, where arrangements of natural and other artifacts often reflected visual as much as scientific criteria. The clearly aestheticized presentation also hints at the futility of trying to establish a consistent system of classification for such unlike objects as old glass bottles, ceramic shards, and plastic swizzle sticks.

One of the central factors in the division between the art museum and other display types was the emphasis on the aesthetic appreciation of the object. As artists have made both the art museum itself and its relation to other collection types a focus of attention, however, the activity of making art has increasingly come to incorporate materials or methods drawn from other disciplines. A response to the art museum's traditional relationship to the object is equally apparent in works where the artist pointedly attempts to negate a response based on aesthetic delectation. Conceptual art's emphasis on idea and, before that, Duchamp's antiretinal stance are both part of the history that may help account for how the small pile of gritty gray dust in Cornelia Parker's 1996 *Exhaled Cocaine* can be understood as a work of art. It is indeed, according to the caption, incinerated cocaine, with thanks given to HM Customs and Excise indicating her source for this substance.[37] One possible association is suggested by the art museum's collection of earlier religious artifacts, including relics that derived their power from the belief in an origin not necessarily evident in the object itself. Yet the work is also an example of how Parker has made the process of collecting a key element in the production of many of her works—sometimes as the beginning of a series of

Mark Dion, *New England Digs,* 2001
(Brockton cabinet and detail of
drawer). Installation, Fuller Mu-
seum of Art. Courtesy the artist and
the Fuller Museum of Art, Brockton,
Massachusetts.

Cornelia Parker, *Shared Fate*, 1998. Objects cut by the guillotine that beheaded Marie Antoinette (newspaper, loaf of bread, tie, gloves, and cards, with thanks to Madam Tussaud's). Dimensions variable. Courtesy the artist and Frith Street Gallery, London.

further transformations enacted with objects that already have a particular set of historical associations, or as a procedure for finding objects or substances ready-made as the result of processes that Parker has discovered rather than instigated.

Parker's materials and operations therefore evoke, under the guise of art production, the objects that appear in such other museum types as historical societies and historic house museums, which, like the religious artifacts that they resemble, achieve their significance from their connection to famous figures or events. Traces, whether physical or photographic, point back to a specific set of origins and procedures that nonetheless may not be evident without supplementary information. Thus a series of photograms of feathers from 1997 and 1998 were not made with just any old plumage. Their captions point to Freud's pillow, or Benjamin Franklin's attic, with acknowledgment of the appropriate historical societies providing support for these particular claims of origin. In her 1998 *Shared Fate*, all that is immediately apparent is that the objects in this somewhat disparate group—a rolled-up newspaper, loaf of bread, necktie, pair of gloves, and deck of cards—have been subjected to a process that has left them cut or severed. The description of these as "objects cut by the

guillotine that beheaded Marie Antoinette" thus adds far more exact information than could be determined from the internal evidence presented by the objects themselves.[38] In this respect they are part of Parker's self-conscious play with the relic, and with the trust or belief such origin stories demand of the viewer. It is therefore ironic that Parker found the guillotine used for *Shared Fate* in the midst of yet another kind of attraction, specifically Madame Tussaud's Chamber of Horrors in London, where this actual historical artifact, for Parker "the most chilling thing there," appeared in the midst of simulated horrors.[39]

A different but equally disturbing discovery in an obscure museum of medicine prompted Zoe Leonard's *Preserved Head of a Bearded Woman,* recorded in a group of five photographs from 1991. Leonard, much like Parker, has pursued an interest in collecting expressed both in accumulations of objects and through photographs that can play a double role as the basis for an imaginary assembly and as a means of drawing attention to the context in which an object was originally encountered. Yet this work demonstrates even more pointedly how documents and artifacts encountered outside the art museum, in other types of collections and displays, have proved a rich source for exploring how such institutions reflect cultural values. For Leonard the discovery of this seemingly forgotten exhibit opened up a whole series of questions about the intersection of collecting and assumptions about cultural norms. "How did her body end up in the hands of the people who decapitated her? And how did she end up in a back shelf on top of a file cabinet in the Musée Orfila?"[40] These are only a few of the unanswered questions Leonard had about this mysteriously fragmented and nameless head. The only information she could get, despite repeated inquiries, was that she had been a circus performer at the turn of the century. And there is a further decontextualization. As Leonard realized, "there is no proof of gender in the bell jar. That could be a man with earrings and a lace collar on."[41] Through her photographs Leonard draws attention to a historical intersection of entertainment and scientific claims, when human beings and their remains might also be displayed and collected on the basis of perceived difference—in this example based on signs of gender.

In 1987 some of these same issues were raised when an actual, living body appeared on display in the San Diego Museum of Man. The context for this exhibit was a museum of anthropology, with a collection that both intersects and diverges from that of the survey-type art museum. What might have been assimilated into the history of art in the context of a survey museum appears in this other type of collection as part of a history of different cultures and their developments. Here the Egyptian funerary objects, Native American pottery, and Mayan figurines are part of a story focused on human evolution told from a natural history perspective. Oddly enough, one exhibit that could definitely be defined as art was the human being who was temporarily on display, presented lying in a raised bed

Zoe Leonard, *Preserved Head of
a Bearded Woman, Musée Orfila,*
1991. From a set of five gelatin
silver prints, 37½" × 26" paper size.
Courtesy Paula Cooper Gallery,
New York.

of sand and identified as "James A. Luna, Born February 9, 1950, Luiseño Indian." Further labels directed the viewer's attention to "burns on the fore and upper arm . . . sustained during days of excessive drinking" as well as other less visible emotional scars, and nearby cases displayed such personal artifacts as music tapes, family pictures, certificates, and other mementos of his life.[42]

The installation, which involved Luna's own presence in an initial performance, and then traces through the imprint left by his body in the sand and photographic documentation, was created by an artist who, given the opportunity to work in this institution, chose to use performance and installation practices to address issues of cultural representation. What Luna's work interrupted was the museum's Kumeyaay exhibit, devoted to native Californians described in the museum's literature as "a thriving population, peaceful and hospitable," prior to Spanish conscription, and represented by "displays detailing food supplies, dress and adornment, games, and ceremonies," along with pottery and basketry.[43] By appearing at the San Diego Museum of Man rather than at an art museum, he used his own presence to address a history of collecting and display that has encompassed not only Native American artifacts but also human remains—and during certain periods also living human beings. At the same time, Luna's decidedly unromanticized self-presentation articulated a direct challenge to appropriations of Indian culture that ignore contemporary realities.[44] The work's disruptive power, generated through a process of institutional critique with roots in conceptual and performance practices, emanated from the intersection of contemporary evidence and the historical narrative from which it was extrapolated.

For three days in 1992, visitors to the Columbus Plaza in Madrid were also confronted with the unexpected sight of humans on display, in this instance a pair of them, sporting an abundance of familiar signs associated with images of the exotic or primitive and housed in a cage. A map in the guise of educational documentation accompanying the display identified their origin as Guatinau, a previously overlooked island in the Gulf of Mexico, and guards were on hand to interpret the actions of the duo, who purportedly spoke only their own native language. What was not necessarily evident to those who happened upon this display was that it was a work of art conceived and performed by Coco Fusco and Guillermo Gómez-Peña. The performance was one of a series of collaborative interventions that drew upon Fusco's background as a writer and curator and Gómez-Peña's work as a writer and artist involved with establishing a dialogue across the border between the United States and Mexico. This particular installation, *Two Undiscovered Amerindians Visit Madrid,* was part of the Edge '92 Biennial, timed to coincide with the five hundredth anniversary of Columbus's landing in the Americas. One indication that the history of putting non-Europeans on display as examples of exotic primitives was a conscious subject of

James Luna, *Artifact Piece,* 1987.
Installation and performance at the
San Diego Museum of Man. Cour-
tesy the artist. Image courtesy the
New Museum of Contemporary Art,
New York.

the work appeared in the chronology of just such occurrences presented on one of the display's information panels. The excess and inconsistency of their costume, and their performance of such "traditional tasks" as watching television, lifting weights, and working on a computer provided further clues to the status of the display. Yet Fusco reports varying responses of bafflement and hostility from the surprisingly large number of people who failed to grasp its fictional nature.[45]

A subsequent roster of appearances in England, the United States, Australia, and eventually Argentina included other similarly public sites and also installations in conjunction with museums of natural history, with the presentation ideally preceded by little advance warning. The failure of audience members to grasp the fiction had particularly acute implications when the work was shown under the auspices of a museum of natural history, where the misapprehension had ramifications for the other museum displays. "Their main concern was that we were inauthentic and did nothing to admit that. They thought we were damaging their institutions' reputations by suggesting that dissimulation takes place, not only in our cage, but in their exhibitions and their dioramas and their wall labels."[46] Or, as Fusco wrote of the work, "we were not the only ones who were lying; our lies simply told a different story."[47]

Like Wilson's orchestration of the Maryland Historical Society, the installation and performance works created by Luna and by Fusco and Gómez-Peña show how contemporary methods rooted in earlier conceptual and performance practices might be used in conjunction with an analysis of institutional practices to create work with a clearly critical edge. The works suggest a complex relationship to art institutions, in the fact that these appearances were understood as works of art regardless of the venue in which they were presented, and whether or not the viewers recognized them as such. Furthermore, the political agenda did not prevent the subsequent embrace of these and other works by the same artists in the context of museum exhibitions. These shifts indicate a transformation in the institutional response to challenging or difficult work, including art with an explicit political agenda. And by the late 1980s, it was institutional sponsorship of political or otherwise provocative work that was coming under attack by conservative politicians.[48]

Less than two decades separate the Guggenheim's 1971 rejection of Haacke's politically charged explorations of real estate ownership and the Hirshhorn Museum's 1988 sponsorship of a politically charged projection by Krzysztof Wodiczko, an artist with an established history of using temporary projections to create provocative anti-monuments. Wodiczko used the Hirshhorn invitation to turn the museum into the support for a projection that appeared on the exterior of the building facing the Mall in Washington, D.C.—timed to occur over three consecutive nights in the midst of the week before the presidential

Coco Fusco and Guillermo Gómez-
Peña, *Two Undiscovered Amerindians
Visit London,* May 1992 (installation
at Covent Garden). Courtesy Coco
Fusco. Photo: Peter Barker.

Krzysztof Wodiczko, Hirshhorn
Museum projection, 1988.
Courtesy the artist and Galerie
Lelong, New York.

election, when its symbolic allusions to the wielding of both weapons and rhetoric, juxtaposed with the more marked suggestion of one of the "thousand points of light" described by George Bush, Senior, during his presidential campaign, would have the maximum political impact.[49] Wodiczko's work has also been assimilated into art world distribution channels that the temporary nature of his projections might otherwise preclude through the backlit color transparencies he uses to present photographic documentation of his site-specific interventions.

Felix Gonzalez-Torres was equally adept in using the invitation to exhibit, which he combined with the mechanism of a work sold on the basis of instructions, to create a series of billboards that included pointed statements or information about health care policies and the AIDS epidemic as well as provocatively enigmatic texts and images. The procedure he established to ensure the long-term existence of these billboard works depended in two ways upon the precedent established by Sol LeWitt's wall drawings—both the process itself of using instructions to ensure the continuity of a work that does not have an uninterrupted physical existence, and the development of a market for works sold on the basis of a certificate and instructions. The negotiations for the public realization are set in motion as part of any plan to exhibit the work. Although the directions for the billboards do allow their individual owners to create a private installation, they specifically stipulate that anytime the work is borrowed for an exhibition it must be installed in at least one outdoor location as well.[50] Thus Gonzalez-Torres used this administrative procedure to ensure that these works will make periodic reappearances as public billboards, continuing the process of replacing the messages typical of this commercial space with such hauntingly ambiguous images as a black-and-white photograph of two pillows marked by the indentations left by absent heads or a small bird silhouetted against the clouds.

How is it that a work of art, whether or not it is recognized as such, can end up far removed from the galleries and museums devoted to the presentation of contemporary works? The move outside the gallery and museum context already has a long history, with particularly strong precedents in the manifold rejections of the traditional, portable, salable object during the 1960s and 1970s. Equally important was the exploration of new types of sites, both distant from the city and in its midst. The opportunities thus established to step outside the museum and gallery context have presented artists with the possibility of using highly varied strategies of intervention to interact with cultural situations. What is increasingly prevalent, however, is institutional sponsorship of the invitation for artists to intrude, not just within the gallery or museum space but in the context at large. At the same time, artists have investigated more ways to use the systems associated with exhibitions and other kinds of transactions as structures that they can incorporate into the process of achieving their work.

Felix Gonzalez-Torres, *Untitled (Strange Bird)*, 1993. Billboard, dimensions variable with installation. As installed for "Travelling," Museum of Contemporary Art, Los Angeles, April 24–June 19, 1994. Courtesy of Andrea Rosen Gallery, New York, in representation of the Estate of Felix Gonzalez-Torres. Photo: Alex Slade.

The artists who have created these temporary public works—widely varied in form, and sometimes presented with little or no specific identification as art—have in common their ability to use the exhibition system as it has developed to create works that can extend far beyond the traditional physical frame of the institution. Such interventions emerge from an ongoing process of analyzing the circumstances and customs that characterize these different types of spaces, and incorporating that analysis into the structure of the work. In many cases artists have taken advantage of settings that allow them to create works not immediately identifiable as art. At one extreme in this deployment of work outside the context of an established exhibition space is the presentation of readymades in their typical habitat, without the benefit of an obvious act of physical recontextualization to draw attention to their status as such. In this version of the play between the gallery or museum and the public presentation of their work, artists have taken up the conventions and publicity apparatus associated with gallery and museum exhibitions to declare authorship of objects and phenomena that anyone not armed with such knowledge would have little hope of identifying as art.

Given the intense theorization of the copy as well as the extended analyses of the rhetoric of representation that have been part of the discourse surrounding contemporary art, a work based on displaying actual objects made with rare jewels in precious metal settings in regular alternation with their photographic representation would seem to fit perfectly into these discussions. In fact Silvia Kolbowski took note of just such an intriguing possibility. Monday through Friday, as part of the normal process of closing up shop, employees of Harry Winston would remove the actual diamond jewelry from the display windows of their Manhattan store and replace it with a backlit photographic representation. Kolbowski, whose work has included a multifaceted examination of the circulation of both goods and information, decided to make the process of exchange her own during a four-week period in 1990. This act of appropriation was realized through an advertisement in *Artforum* and invitations sent to the Postmasters Gallery mailing list announcing this "example of recent work" and directing potential viewers to Harry Winston's Fifth Avenue address during the period each late afternoon when the displays would be reconfigured.

Part of Kolbowski's motivation was to create a public work of art that would explore divisions between public and private through the appropriation of an already accessible site. Given the fame of this exclusive jeweler, and the opulent examples on display each day, it was not a matter of having to draw attention to the one point where the general public can see goods otherwise viewed by appointment only. Kolbowski simply added a further layer to this play between public and private by directing another segment of the public to this same sidewalk to mix with those viewing the display without the benefit of Kolbowski's

silvia kolbowski

an example of recent work
may be seen in the windows of
Harry Winston Inc.
from approximately 4:47 p.m. to 5:04 p.m.
monday - saturday
november 19 - december 15, 1990

718 fifth avenue, at 56th street
new york, new york

there will be no reception

postmasters gallery new york

Silvia Kolbowski, *an example
of recent work may be seen in the
windows of Harry Winston, Inc., from
approximately 5:17 pm to 5:34 pm,*
1990 (invitation and installation
view). Courtesy the artist and Amer-
ican Fine Arts, New York.

mediating gesture. What the audience that came during the designated time to view the changing of the display as a work of art could not know from the invitation, however, was that this particular readymade had been alerted to their private reading. Kolbowski, upon discovering that her advertisement might run afoul of legal prohibitions against misappropriation of name, sought and received written consent from the company—which was granted on the condition that she make a change in the format of the invitation to avoid suggesting that the example of her work included the design of the jewelry itself. Another difficulty arose when Kolbowski discovered late in the process that the jeweler had changed its hours, with the consequence that the substitution over which she was asserting authorship would be taking place a half hour later than expected.[51] And because this process had a life of its own, Kolbowski's decision to limit the duration of her conceptual authorship to the four-week period typical of a gallery exhibition did not preclude further viewing of the substitution, even after her claim expired, with the experience inflected by the knowledge of this assertion of authorship.

The possibility that the readymade might take to the road, freed from the physical confines of the gallery space yet dependent for recognition on other kinds of pointing devices associated with such contexts, is one of the curious legacies of conceptual art. And a particularly tenacious example of a potentially invisible work of public art was presented by Asher's contribution to the 1997 "Skulptur" exhibition in Münster, Germany. This work, which took the form of a rented trailer that was moved to fourteen different locations in and around the city, and was identifiable as art only on the basis of leaflets available at the museum's front desk, appeared in the context of an exhibition that provided ample evidence of the extent to which the invitation to create works for such an occasion has been extended to include the surrounding territory. The vast majority of the works by more than seventy invited artists were realized in locations throughout the city, and while many consisted of configurations immediately identifiable as sculpture, or at least as art rather than something else, others were partially camouflaged by their resemblance to what was already there. The definition of sculpture was also extended to include such productions as a two-minute film by Charles Ray that was projected among the coming attractions in the local movie theaters, or an audio guide produced by Janet Cardiff that set viewers off on a prescribed walk through the city with the experience shaped by the voice and sound effects played through their headsets. In this context, visitors to the exhibition were undoubtedly mindful of the potential that any unexplained or ambiguous phenomenon might be art, even Asher's surreptitious and mobile contribution.

Another reason 1997 visitors would have been alert to Asher's work was that it already had a surprisingly long history. The 1997 "Skulptur" exhibition was the third in a series,

Michael Asher, Münster "Skulptur"
installation, 1997. Parking position,
12th week (September 8–15): church
square in Nienberge, in front of no.
6. Courtesy the artist.

organized at ten-year intervals, and Asher had been invited to participate in all three. His project for 1997 was actually a reprise of one he had shown in 1987 and 1977. The first "Skulptur" exhibition had been a two-part affair, one consisting of a historical survey of the evolution of abstraction in twentieth-century sculpture, and a second to which nine artists were invited to contribute temporary public works. In 1977 Asher's realized proposal—to have the museum rent a modest trailer for the duration of the nineteen-week exhibition and move it on a weekly basis to different sites Asher had selected in and around the city—followed upon a series of ideas that could not be executed for one reason or another.[52] When he was invited to contribute to the second "Skulptur" exhibition in 1987, the outline of the project was far more readily apparent. His instructions were to repeat the process, using the same make and model of trailer and taking it to the same locations. And for the third exhibition in 1997, his instructions were again the same.

The various sites included a mix of urban, suburban, residential, and commercial settings, where the temporary appearance of this vehicle might or might not be a likely occurrence, and where it was unmarked as art for those not alerted to its designation through the information at the museum. The trailer that Asher selected in 1977 was purposely unremarkable, and its provisional status was emphasized by its return to the rental agency at the conclusion of the exhibition. In submitting instructions for an exact repetition, Asher consciously activated one of the paradoxes that has emerged from the historicization of highly situation specific works—as the agenda of historical survey exhibitions can create pressure to remake examples of what had been understood as ephemeral work. In this case, however, the directive to remake the work as closely as possible ten years and then twenty years later arose from Asher's decision to use the consistency of the action to bring out the incremental changes in context. One challenge was the increasing difficulty of renting the original model of trailer ten and particularly twenty years later. Another difficulty was trying to pinpoint some of the original locations in the context of a changing environment. For locations where the earlier space was no longer available, Asher had the trailer placed in storage for that week. And because each of the exhibitions was shorter than the one before, the final positions used in 1977 were not reused.[53] In this respect, the instruction to repeat the work only served to emphasize its transformation as a result of the changes to both the exhibition schedule and the environment through which this readymade, let loose from the physical confines of the institution, was expected to move.

What might a trailer parked on the side of a road have in common with a performance in a museum of anthropology or a photograph of an arrangement of sculptures presented as a paperweight? In their nature of expression and context of presentation they are widely divergent. They nonetheless each emerge from a process of analysis, with the outcome

Michael Asher, Münster "Skulptur"
installation, 1987. Parking position,
12th week (August 24–31): church
square in Nienberge, in front of
bakery. Courtesy the artist.

Michael Asher, Münster "Skulptur"
installation, 1977. Parking position,
12th week (September 19–26):
church square in Nienberg, in front
of grocery store. Courtesy the artist.

inscribed in the work itself. The articulation of a relationship to context is part of an expanding definition of art that has enabled a hitherto unimaginable variety of often fleeting manifestations to be understood as art and presented as works of authorship. Even works made to appear exclusively outside the physical confines of the art museum, or those that may not be visibly distinguished as art, establish through their pointed negation a relation to the conventions associated with art institutions. As artists have incorporated the outcome of this process of analysis into the structure of their work, they have directed attention both to how art is interpreted and to the significance of other cultural formations. If it was conventions associated with museum and gallery display that initially allowed artists to point to everyday objects and identify them as art, an expanded definition of the work has now been taken up and used by artists to point outward in ways that heighten perception of the world at large.

CONTINGENT OBJECTS

Adrian Piper, *Catalysis III*, 1970.
Street performance, New York.
Courtesy the artist.

Sometime in 1970 Adrian Piper impregnated her clothing with a concoction of vinegar, eggs, milk, and cod liver oil and then spent a week moving around New York in her smelly regalia, subjecting other passengers on the rush hour subway or late-night browsers in a bookstore to an unannounced and open-ended performance that she called *Catalysis I*. Other works from the *Catalysis* series created an equally disconcerting presence, as she intersected with members of an urban public who had no idea that they were witnessing a work of art in action. For *Catalysis III* she "painted a set of clothing with sticky white paint with a sign attached saying 'WET PAINT,' then went shopping at Macy's for some gloves and sunglasses." *Catalysis IV* entailed stuffing her cheeks with a towel, part of which protruded from her mouth, and "riding the bus, subway, and Empire State Building elevator." She also went to the library with a concealed tape of loud belches (*Catalysis V*) and blew large chewing gum bubbles at inopportune times, letting the gum stick to her face (*Catalysis VII*). The point of these activities, as she described them, was to set up a confrontation "within oneself or between people," so that the artist "becomes the catalytic agent inducing change in the viewer."[1] Though this series of actions dealt less specifically with issues of racism than many of Piper's later works, it established her procedure of challenging beholders to respond to the perception of strangeness or difference in their midst. The goal of the work was not, Piper has indicated, to break down distinctions between art and life, since she assumed specific characters for the *Catalysis* series, and for later works as well. Yet she was clearly not a performer in the traditional sense, because her initial audience was not aware of its status as such, and had no warning that an art activity was taking place in its midst.

A few years earlier Piper had met another artist, Vito Acconci, whose self-described move from "I do art" to "I do" set him off on his own series of unusual actions and performances.[2] What he did most famously, for his 1972 *Seedbed*, was masturbate under a

Adrian Piper, *Catalysis IV*, 1970–
1971. Street performance, New York.
Courtesy the artist.

ramp built across the end of the Sonnabend Gallery in New York while giving voice to his fantasies about the viewers who happened into the gallery space. Between 1969 and 1973, after which he removed his direct presence in favor of an emphasis on video and installation, he used his own body to explore confrontations with others and with himself, engaging in a list of actions that included issuing invitations to meet him at the end of an abandoned New York pier over a series of nights when he would reveal embarrassing secrets, stepping up and down on a stool every day over several one-month periods, dressing his penis in doll's clothes and talking to it for three hours, and biting the portions of his own body he could reach hard enough to leave temporary indentations that he would then ink up and use to pull prints. Through these actions Acconci used his body to articulate procedures that included turning inward on himself, using his presence to set up a confrontation with others, and establishing situations where his own actions would be determined in response to other "agents."

Some of his actions were announced yet still disconcerting, while at the opposite extreme, for his *Following Piece* (where he chose people at random and then trailed them until they entered a private space), only he was aware of the action taking place. "In *Following Piece* my space and time are being controlled" was how he described the action to Liza Béar: "I'm following a person, but I'm certainly not a spy, I'm being dragged along."[3] In some cases these acts of following—one per day, between October 3 and 25, 1969, except for two days when he didn't follow anyone—were over in minutes and took Acconci only a short distance from where the following began, usually somewhere in the Greenwich Village area of Manhattan. Others went on for hours, requiring him to wait for an individual to finish a shift at work or watch a movie, or taking him on subway rides to points in Brooklyn, Queens, or the Bronx. *Following Piece* was a clandestine affair, since it did not involve the frame of the gallery or museum space or, seemingly, any awareness on the parts of the individuals Acconci selected for participation. By contrast, the *Proximity Piece,* conceived around the same time but realized for the 1970 "Software" exhibition at the Jewish Museum in New York, used the exhibition space to frame his transgressive confrontation. There, for the duration of the exhibition, Acconci challenged randomly selected museum visitors, "standing beside that person, or behind, closer than the expected distance—I crowd the person until he/she moves away or until he/she moves me out of the way."[4]

Acconci's *Following Piece* and Piper's *Catalysis* actions present a particular kind of hybrid: public yet private versions of performance with strong links to conceptual art and also to other ephemeral forms known only through documentation. They can be understood as offshoots of the mode of conceptual practice articulated by Sol LeWitt in his 1967 "Paragraphs on Conceptual Art." "The idea becomes a machine that makes the art" was his

Vito Acconci, *Following Piece*, October 3–25, 1969. Black-and-white photographs with text and chalk, text on index cards, mounted on cardboard, 30¼" × 40¼" (framed). Courtesy Barbara Gladstone, New York.

introduction to a process of working with a predetermined plan or set of rules that, regardless of how selected, should be followed to their conclusion, with "the fewer decisions made in the course of completing the work the better."[5] While the examples LeWitt gave of the move from idea to realization tended to highlight the simple geometric forms that characterized his own three-dimensional work of the time, the emphasis on plan had far broader applications. Nor is the connection to these conceptually oriented forms of performance fortuitous. Looking back at her early turn toward conceptual art, Piper described "LeWitt's work and writings" as offering her "the tools and encouragement to pursue this line."[6] Moreover, a second key statement by LeWitt, the 1969 "Sentences on Conceptual Art," first appeared in the poetry magazine *0–9* that Acconci coedited with Bernadette Mayer.[7] Several of Piper's early conceptual works also appeared in *0–9*, where Acconci's own changing interests were reflected in the increasing emphasis by 1969 on conceptually oriented projects and descriptions—which not coincidentally shared with the poetry that prevailed in early issues the potential to be expressed with nothing more than the typewriter and mimeograph machine that determined the format of this modestly produced publication.

So how do we know that Piper and Acconci engaged in these activities? First and foremost, we know because they have told us so. One of the striking features of both Piper's *Catalysis* actions and Acconci's *Following Piece* is the way both performances partake equally of absolute immediacy and significant delay. The immediacy is in the unscripted interactions between the artist and an unsuspecting public. The delay is in the dissemination of knowledge about the work to an audience that has access to the activity only through the accounts and documentation the artist decides to provide. All of the descriptions above of Piper's *Catalysis* series come from Piper's own statements in "An Ongoing Essay," published in *Art and Artists* in 1972, which constituted an initial and abbreviated version of her 1975 *Talking to Myself: The Ongoing Autobiography of an Art Object.*[8] Acconci's *Following Piece* was produced as part of "Street Works IV," one of a series of exhibitions sponsored by the Architectural League of New York, which provided a framework for activities to be carried out in public spaces throughout the city. Details about the following procedure were, however, distributed after the fact, with the record of each day's activities initially mailed only to a series of selected individuals.[9] Wider dissemination followed later still as Acconci's descriptions of his early actions appeared in various publications, including the 1972 issue of *Avalanche* devoted entirely to his work to that point. It was the dissemination of these descriptions that established the audience for the work (as opposed to those who happened to intersect with the action)—an audience that can only

experience the activities in retrospect, through the information provided by the artist, and therefore has to rely on the artist's claim that the described activities did indeed take place.

This is not to say, however, that even the experience of Acconci's announced actions was necessarily straightforward. Both *Proximity Piece* and *Seedbed* established "performance situations" where the activity was ambiguous, intermittent, and also required a certain degree of belief from its audience.[10] The *Proximity Piece* was performed both by Acconci and by substitutes during the 1970 "Software" exhibition's eight-week run, and a written description of the action was posted on a three-by-five-inch card within the exhibition. If the person chosen for the action did not happen to see the description, he or she might well fail to distinguish the crowding as a performance; and, conversely, someone aware of the planned activity would tend to find it even when it was absent. According to Acconci, "if a person who was looking at an exhibit had read the statement and someone happened to be close to him, he might quickly assume that the piece was being acted out. I know it worked out that way because I got calls from people I didn't know saying that they had seen me at the museum on days when neither I nor the substitute was there."[11]

Seedbed, by contrast, was in no danger of being lost in the cacophony of a group show. Visitors to this indubitably one-man exhibition at the Sonnabend Gallery were greeted with a ramp construction evocative of minimalism. The ramp's association with minimalism was, however, interrupted by a speaker in one corner and further redirected by a set of written statements about the piece posted on the wall leading up to the construction. Via the texts Acconci announced his activation of the room by his "presence underground, underfoot" and his goal of producing and scattering seed by means of "private sexual activity" while fantasizing about the gallery visitors.[12] One thing not indicated in the wall text, however, was that Acconci was there only part of the time. By his own description he was under the ramp two or three days per week for the duration of the exhibition.[13] Many visitors to the exhibition therefore heard only an ambiguous silence, and even those who did become the subject of verbalized fantasies could not see the artist. In the *Avalanche* interview published that same year he described *Seedbed* as his most important work because of the way it allowed him to be "with an audience . . . constantly physically present, in the sense of being audible." Yet he also acknowledged that his lack of visibility could lead a viewer to think he "wasn't really there, that it was just a tape."[14] Looking back at the piece some years later, from the vantage point of his move away from live performance, he emphasized this latter aspect of the work, describing the obvious question it raised as "If I'm not seen do I have to be there?"[15]

Of course another reason that we know, or think we know, that Piper and Acconci did the things they have claimed is because we have seen the pictures. The *Catalysis* works,

Following Piece, and *Seedbed* are familiar from small groups of by now often reproduced photographs. The *Catalysis* series comes into view in four enigmatic images, two from *Catalysis III,* showing Piper on a crowded sidewalk sporting her WET PAINT sign and attracting the attention of some but not all passersby, and two more from *Catalysis IV,* with her standing on a sidewalk under a bus stop sign that says "no standing" or on a bus in the middle of a row of seated passengers. *Seedbed* is usually shown in one or more of three often-reproduced images, two of a woman in black either standing or sitting on the ramp, and one of Acconci threaded through the support beams under the structure, seemingly in the midst of the act he claims to have performed. *Following Piece* is represented by a single photograph or a sequence showing Acconci in the act of following a man in a short-sleeved white shirt and dark pants.

The specific issues raised by these images intersect with the challenge posed by a wide range of performance and other ephemeral manifestations. All too many works from the 1960s and 1970s can be only faintly apprehended through published and oral history accounts that have circulated after the fact, supplemented by sparse documentation often produced because someone just happened to be on hand with a camera. Even works that are well known may be represented by a single image or a small set that can convey little of a long or complex activity. Carolee Schneemann's *Interior Scroll* is identified with the singular photograph of her speaking the text on the folded strip of paper that she is pulling in a dramatic curved line from inside her vagina, even though her description of the 1975 performance and the many additional stills reproduced in *More than Meat Joy* show this moment to be the culmination of a varied set of actions.[16] Or there are the photographs of the coyote interacting with the felt-enveloped Joseph Beuys in his 1974 *Coyote, I Like America and America Likes Me* at the René Block Gallery, capturing a few moments in a multiday action during which, for much of the time, the coyote slept off to the side. Or, from a different direction, while Chris Burden's 1971 *Shoot* is most often depicted with the single image of the shot itself, the sequence of still images that includes the process of taking aim as well as him walking away and then looking into the camera in apparent stunned surprise as the blood drips from the wound in his arm creates a much greater sense of duration than suggested by the film of the event, where the action is over almost as soon as it starts.[17]

Then there is the impact that the act of recording can have on the activity being recorded—a dilemma Allan Kaprow recognized early on in the response to his happenings. The problem Kaprow had with photographic documentation was twofold. Not only did the photograph reduce an event in time and space to a series of isolated, two-dimensional images, but participants would act for the camera, with its presence therefore mediating their experience. To counter the danger of happenings being transformed into media-driven

spectacles, Judith Rodenbeck recounts, "Kaprow banished both audience and photographers (but not photography) from his events," limiting those in attendance to participants and making sure that any photographs or other forms of recording or transmission were part of the action itself rather than documents produced by nonparticipants.[18] Kaprow's alternative to external documentation was to establish a tradition of having the participants meet to discuss their experiences after an event, and allowing stories about the happenings to serve as their record.[19] The opposite approach to the uneasy relationship between document and action was to transform the premise of the action so that its purpose was the making of a video. In fact Martha Rosler's consideration of the nature and impact of the document is part of the subject of her 1977 *Vital Statistics of a Citizen Simply Obtained,* where a tableau staged for the video camera explores the objectification of the female body as a series of absurdly detailed measurements are taken by and reported to individuals whose clipboards and white lab coats associate them with both scientific and medical examination.[20]

These issues circle back to the question of just what kind of evidence the photograph can provide. The image of Acconci under the ramp for *Seedbed* shows something that the initial audience for the work could not see taking place. In that respect the document is disconnected from the firsthand experience of the work in a manner similar to aerial views of certain installations or earthworks. Photographs taken from above of the 1972 *Maze* that Alice Aycock constructed on a farm in Pennsylvania, or Robert Morris's 1974 *Philadelphia Labyrinth* at the Philadelphia Institute of Contemporary Art, show the overall logic of the journey through those spaces not available to the ground-level viewers brave enough to enter them without knowledge of their layout. But the issues raised by photographs of the Acconci and Piper works under discussion become even more complex when one considers the relation of the photographs to the actions described by the artists. If one believes Acconci's descriptions of *Seedbed,* he was alone under the ramp, responding to footsteps above. He has not described being under the ramp with someone taking pictures of him masturbating, and in fact the paradox of a hidden exhibitionism is one of the striking features of the work. Likewise, in the artists' descriptions *Following Piece* and the *Catalysis* actions constitute particular kinds of performances, carried out without an audience, or at least without an audience that understood its role as such. The whole point is that the actions were unmarked, unannounced, unframed. The presence of a photographer would proclaim that something was happening, drawing attention to Acconci's covert operation, or framing the strangeness of Piper's confrontation as a planned and therefore less disconcertingly off-center activity.

Considered as evidence, the four published photographs of *Catalysis III* and *IV,* credited to Piper's friend Rosemary Mayer, suggest an interruption, however brief, in Piper's

solo engagement with the public. In the case of the photographs for Acconci's *Following Piece,* credited to Elizabeth Jackson, their status as document is even more dubious. The sequence of four images published in 1971 alongside Cindy Nemser's interview with Acconci in *Arts Magazine,* and again in Lucy Lippard's *Six Years: The Dematerialization of the Art Object,* presents strong internal indications that this particular instance has been staged for the photograph. The two views of Acconci's back that show him in the act of following the man in a white short-sleeved shirt and dark pants are preceded by two views of the man and Acconci approaching on the sidewalk—meaning that the photographer was positioned in advance of the trajectory of the following, taking pictures as both walked seemingly unaware toward the camera.[21] In fact none of the hand-written lists for the different days, eventually assembled in an array that also includes two of the photographs, describe this man. The lack of correspondence between described action and photographs suggests that these particular images are better understood as illustrations rather than evidence of these activities. Moreover, the sense of the work conveyed by the photographs and accompanying accounts is potentially far more interesting than what one might have encountered at the moment, without knowledge of the plan motivating the actions, had one accidentally intersected with Piper or Acconci as they moved around the city. Rather than serving as proof, then, the photographs unexpectedly confirm the status of these actions as essentially unverifiable, with part of their power lying in the challenge they pose about whether to believe the artists' claims to have done what they describe.

Yet even plausible photographs would hardly, in themselves, serve as definitive proof of an activity—as Sophie Calle's somewhat later following works make clear. Calle did her own following around Paris, using randomly chosen individuals to take her to parts of town to which she would not normally have gone. The activity became her 1981 *Suite vénitienne* when she accidentally met one of the people she had followed, found out that he was about to leave for Venice, and decided to pursue him there. For *The Shadow,* also 1981, she inverted the process of following by having her mother hire a private detective to follow her for a day and document her activities. In this way she turned her entire day into a performance for an audience of one. While the detective knew he had been hired to follow Calle, he was presumably not aware that he was being led, that he was a participant rather than a shadow. The subterfuge set up a reversal of the standard relationship between the followed and the observed, with Calle acting the process of being followed while also, in the documents thus produced, having the opportunity to see herself through someone else's eyes. Both works are documented in textual accounts and photographs, the *Suite vénitienne* with ambiguous black-and-white photographs taken by Calle over the course of her twelve days in Venice, and *The Shadow* with photographs of Calle taken by the detective. Though Calle thus accounts for how the photographs came into being, they could still be read as an

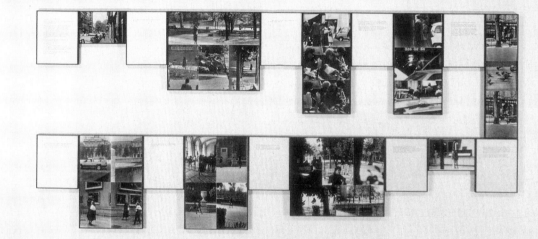

Sophie Calle, *The Shadow (Detective)*, 1981. Nine gelatin silver prints, one color photograph, and twelve panels of text, overall dimensions variable. Courtesy Paula Cooper Gallery, New York.

inversion of the proof they posit. Anyone familiar with her ongoing dialogue with the novelist Paul Auster might be tempted to wonder whether the photographs, presented along with Calle's first-person account and the reports about her various activities produced by the detective, could in fact be evidence of an elaborate fictional construction.

Does it matter whether a photograph actually documents the activity that it represents? Does it matter who took the photograph? In a sense it is not important whether these photographs are fact or fiction, actual documents or staged, because this is how each artist has decided to represent the work. "This is a portrait of Iris Clert if I say so," asserted Robert Rauschenberg in a 1961 telegram that constituted his submission to an exhibition in Paris. Perhaps that assertion should be expanded to encompass the possibility that photographs represent an artist's work if the artist says so. So we have works that are about immediacy of experience accomplished through the direct presence of the body, but an immediacy that has to be imagined through the mediation of accounts and documents. The more immediate, the more ephemeral, the more of-the-moment or of-the-place the work is, the more likely that it is known through images and accounts, the two sometimes working together, sometimes in isolation from one another. Thus there is a temporal gap built into the reception of work understood in retrospect, only through documents of inaccessible actions—unless, of course, the work is identified as standing not in the initial actions but in the documents themselves. There is in fact always a question of when, within a progression of choices, the document may be transformed from secondary object to something identical with the work itself, either because the emphasis has tipped toward the material realization or, at the other extreme, because the work itself is defined as a conceptual idea only partially and temporarily manifest in any specific physical embodiment. Thus the central role played by photography and video in the complex and fluid continuum linking performance and conceptual art of the 1960s and 1970s established a series of options that includes the document of the work, the document in the work, and the document as the work.

Amelia Jones points out a keen irony in a claim made by Ira Licht in the catalogue for a 1975 exhibition entitled "Bodyworks" at the Museum of Contemporary Art in Chicago. There Licht proclaimed bodyworks as a form that eliminates the traditional art object as intermediary and instead "delivers information directly through confrontation."[22] Against this, Jones quotes Laurie Anderson's description of "pieces of paper on a wall, photographs, notes, tapes. Artists putting their bodies on the line, on the shelf, dressing in drag, assuming alter egos, putting themselves through various exercises, contortions, exorcisms. . . . But in fact, no bodies were there. Only paper."[23] Furthermore, many of these pieces of paper could be disseminated through means more effective than the traditional gallery or museum format. Kathy O'Dell attaches particular significance to the circulation

of knowledge about performance work through published documents. Not only did this mode of dissemination activate alternative distribution systems, itself an important arena of exploration during this period, but it also brings out a different form of physicality, in what she describes as the combination of the "visual and haptic dynamics that one experiences in literally 'handling' the performance photographs."[24]

When the encounter with the work takes place at a remove, through documents or rumors, certainly the experience is transformed, but that does not necessarily mean that its significance is diminished. Thus Bruce Nauman recalled to an interviewer the importance during the 1960s of his awareness of what Merce Cunningham and John Cage were doing, but from the distance of the West Coast, where knowing about what was happening was formative for him even without the firsthand experience. He also described a series of interviews with Coosje van Bruggen in preparation for her 1988 monograph on his work: "I would tell her about something that had been very important to me, in terms of how to structure a performance or some art activity and she would say: 'Oh, but it wasn't like that.' I said: It's the way I remember it. So she calls what I did 'a creative misreading or a creative misunderstanding.'"[25] The resonance of the document or account can also come from what is left to the imagination to complete. Janine Antoni has spoken about the importance of how she came to know about works like Acconci's *Following Piece* or Schneemann's *Interior Scroll:* "I realized at a certain point that I know those works mostly through an oral tradition, and through some blurry black-and-white photographs that don't give me much information. I think I love this work so much because I've somehow elaborated on those stories and images in my imagination."[26]

The prospect that an activity might be understood through documents or accounts rather than firsthand experience has significant implications for contemporary practice. Photographic documents intersect with many other means by which artists make manifest the traces of the body and its actions. Thus the possibility that a manifestation need not be either permanent or accessible to be defined as a work has implications that extend far beyond the realm of performance practices. Photographic records may provide a particular kind of access to transitory or site-specific phenomena that, through this documentation, can be understood as continuous with an artist's work as a whole. In a sense, then, the potential disembodiment of the photograph functions not to eradicate the importance of time and place, or the highly distinct nature of the material an artist may decide to use, but instead to enable experimentation that would not be possible if the only way of considering a work was through an enduring physical object or, at the other extreme, the immediate experience of a singular ephemeral action. In the work of many contemporary artists, both still photographs and video operate in a complex intersection of document, medium

of expression, and component within multimedia or installation practices. There can be no doubt that the photograph has come to inhabit contemporary art across an incredible range of practices; but it would also be impossible to understand its many and varied roles without looking at precedents in earlier works emphasizing ephemeral actions, site-specific phenomena, and the relationship between document and event.

One important twist on the idea of the document occurs when the work is defined as the outcome of a procedure, emerging from within an activity rather than existing as an externally produced record. The possibility that the camera might be an integral component of an action has the power to transform the photograph or video from a partial and fragmentary record of a performance into a full and complete register of actions performed with a camera. In his 1969 *Stretch,* for example, Acconci took four photographs "stretching as far as I can over my head, out to my left, down to my feet, out to my right; taking a photograph from each position."[27] And shortly before the *Catalysis* actions Piper had produced another series of works under the title *Hypothesis* where the act of taking pictures was key to the process of marking and thereby increasing consciousness of a series of intervals within what would otherwise be everyday, unexceptional activities like watching television or walking down the street.

It is therefore telling that, in the account published in *Art and Artists* in 1972, Piper's text describing her *Catalysis* series was presented by Lippard in conjunction with a group of works by Eleanor Antin that focused exclusively on the role of the document within the art-making process.[28] Antin's "Proposal for a Film Festival Exhibition" presented images of a series of her *Movie Boxes,* each containing a combination of photographs and a single word arranged to evoke coming-attraction displays for movies. "I have directed and produced all seven of these movies," Antin claimed in an accompanying text proposing that they be brought together in a film festival. Yet they are also movies, she continued, that "exist only and exclusively in the set of stills (plus title) of which they consist." Although Antin would create close links between her performances and the manufacture of numerous fanciful documents to go with her assumed characters, this early work was comprised solely of the fictitious documentation, presented with the suggestion that, since any movie is simply "a handful of images offered to the mind," she had "only removed the padding."[29]

In the 144 photographs that both record and constitute Antin's *Carving: A Traditional Sculpture,* on the other hand, the link between performance and document is absolute. The photographs show, in daily front, back, left, and right side views, Antin's transformation as she lost ten pounds during the course of a 36-day diet designed to reconfigure her body in conformity with classical ideals. Had she included only the first and last images, they would have suggested the standard before-and-after photos familiar from advertisements

for diet plans. But the daily record, arranged in a horizontal grid, tracks the progress of a transformation that is barely discernible from one image to the next. "Documentation is not a neutral list of facts," Antin insisted in a discussion of her choice to employ this form of recording. "All 'description' is a form of creation. There is nothing more biased than scientific documentation."[30] In choosing this aggressively clinical recording method she was responding to the important role of a particular kind of consciously deaestheticized photography used in many versions of conceptual art, while also turning the play with the document to feminist ends by using her own body to perform this critique of the pressure to conform to an image of idealized female beauty.

It was indeed a particular kind of photograph, composed as if to suggest the lack of conscious composition emblematic of amateur snapshots, that Ed Ruscha modestly but insistently announced in a series of books, beginning with his *Twentysix Gasoline Stations* in 1963, that established important precedents for conceptual uses of photography. "My pictures are not that interesting, nor is the subject matter," Ruscha told John Coplans in 1965, using a series of negations to characterize photographs he describe as "simply a collection of 'facts,'" with the books into which they were assembled therefore "more like a collection of 'readymades.'"[31] Ruscha was also not particularly concerned with where the photographs originated, ascribing the decision of whether or not to take a photograph himself as merely a matter of convenience. Thus he took most of the pictures for *Various Small Fires* when he could not find suitable stock photos, whereas the views in *Thirtyfour Parking Lots in Los Angeles* were commissioned from an aerial photographer Ruscha instructed to take pictures of all the empty lots he found.[32] But the difficulty Ruscha had in finding stock pictures points to the exact qualities of the photograph he was after in his pursuit of images with the appearance of found facts.

The deliberately understated photographs help maintain the sense that the set of images comprises no more and no less than what is announced by titles that range from the absurd specificity of an exact number to the equally arbitrary vagueness of quantities like "various" or "some." It is, however, the ambitious term "every" that marks the tour de force of this series of projects, and the one where the title most insistently describes the plan for a systematic and predetermined course of photographic activity. In his 1966 *Every Building on the Sunset Strip* the disciplined execution of the title is evident in the layout of the book, 7 x 5⅝ inches in its folded state, but opening, accordion-style, to reveal a 299½-inch length of paper with the photographs of each building across the top and bottom, and the correspondence to the layout of the street further confirmed by the street numbers and names of cross streets printed in the white strip separating the horizontal rows of photographs. In this absolute adherence to the plan, followed to its conclusion, *Every Building on*

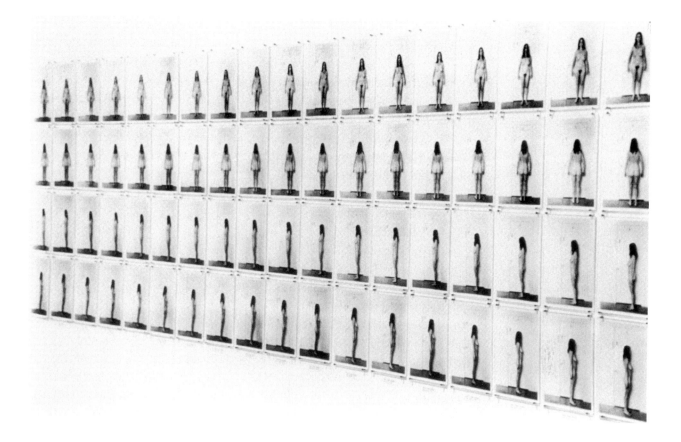

Eleanor Antin, *Carving: A Traditional Sculpture,* 1972. 144 black-and-white photographs, 7" × 5" each, and explanatory text. Collection of the Art Institute of Chicago. Courtesy Ronald Feldman Fine Arts, New York.

the Sunset Strip is consistent with the conceptually based mode of production LeWitt would articulate the following year in his "Paragraphs on Conceptual Art." Yet it is equally clear that the idea described by the title has been used to generate a work identified as the book itself. Thus the absolute consistency of the title with the material form in which it has been realized should not be taken to mean that the idea articulated in the title might itself be understood as the work.

The question of where the work might reside was far more pointedly activated by Lawrence Weiner. In a frequently repeated statement of intent, Weiner outlined a set of alternatives emanating from the emphasis on plan rather than object:

1. The artist may construct the piece
2. The piece may be fabricated
3. The piece need not be built
Each being equal and consistent with the intent of the artist the decision as to condition rests with the receiver upon the occasion of receivership[33]

One of Weiner's most often reproduced works from the late 1960s is his *A 36″ x 36″ REMOVAL TO THE LATHING OR SUPPORT WALL OF PLASTER OR WALLBOARD FROM A WALL.* Numerous published photographs show its realization in many and varied locations, a square cut or chiseled out of a wall, with the shape, scale, and position of the removal evoking painting's traditional presentation. There are also photographs documenting *THE RESIDUE OF A FLARE IGNITED UPON A BOUNDARY* that show Weiner igniting a flare on the Amsterdam city limit in conjunction with the 1969 "Op losse schroeven: Situaties en cryptostructuren" exhibition at Amsterdam's Stedelijk Museum. Within the exhibition, however, the work appeared as a statement on the wall of the museum and the same text printed on a small card.[34] It was also the statement itself that Giuseppe Panza purchased in 1970, along with *ONE KILOGRAM OF LACQUER POURED UPON A FLOOR* and *1000 GERMAN MARKS WORTH MEDIUM BULK MATERIAL TRANSFERED FROM ONE COUNTRY TO ANOTHER,* from the Konrad Fischer Gallery, with the transfer of the works effected in an exchange of correspondence, and the transfer of title duly registered with Weiner's attorney, Jerald Ordover.[35] The photographs that document actions or installations therefore show not just isolated instances of a physical action that can be realized in different locations, but also works consisting of descriptive statements that retain their identity as linguistic propositions.

What the statements share with Ruscha's books is the play between the general and the specific. Yet Weiner announced the primacy of the statement itself with his own mod-

estly produced book, his 1968 *Statements,* where twenty-four of his works were brought together, each isolated on its own page and presented in small blocks of type floating just below center within the vertical rectangle established by the format of the book. One of these works, *A FIELD CRATERED BY STRUCTURED SIMULTANEOUS TNT EXPLOSIONS,* represented a solution to the challenge posed by an earlier work made in California, his 1960 *Cratering Piece,* with the previous transformation of the landscape redirected into a far more open-ended linguistic declaration.[36] Nor did Weiner's own participation in the realization of the situation described in a statement give that particular realization priority. "*A SQUARE REMOVAL FROM A RUG IN USE* is a piece that was received by a person in Cologne," Weiner recounted to Willoughby Sharp. "I presented myself, and proceeded to remove a square from the rug in their living room. This is the construction of the piece. In the event that the piece is lent to an institution or the gentleman moves or so on, the rug itself has absolutely no value as art; the removal has no value as art."[37]

The only value Weiner would ascribe to the example was as "illustration" or "information," thus putting the physical manifestation secondary and incidental to the statement that actually constitutes the work—a reversal of the usual idea of the document. His resolutely conceptual approach nonetheless had much in common with a similar reorientation that is apparent in a number of contexts. The intersection of an engagement with material qualities or processes and works emphasizing concept over realization appears in the exhibition "When Attitudes Become Form" at the Kunsthalle Bern, with their convergence particularly evident in the catalogue's inclusion of works executed outside the space or manifest only in their documentation. In this respect the exhibition, and in particular the catalogue, echoed a far more modest presentation earlier that same year, Seth Siegelaub's "January 5–31, 1969," where the physical realization of works by Robert Barry, Douglas Huebler, Joseph Kosuth, and Weiner installed in a vacant New York office space were described by Siegelaub as secondary to the articulation of ideas in the catalogue. This shift in emphasis was even more apparent a couple of months later when Siegelaub organized "March 1–31, 1969," an exhibition that existed only in the form of a catalogue of verbal descriptions of works submitted by thirty-one artists who had each been assigned a day of the month. A second exhibition, "July, August, September, 1969," also a catalogue only, presented geographically dispersed examples encompassing site-specific as well as conceptual works.[38]

The role of information within conceptual practices generally was acknowledged by the title of the 1970 "Information" exhibition organized by Kynaston McShine for the Museum of Modern Art. The catalogue for the show, which proclaimed its allegiance to the modest production values of earlier conceptual publications with its Courier type and grainy black-and-white photographs, presented plans, documents, and statements of all

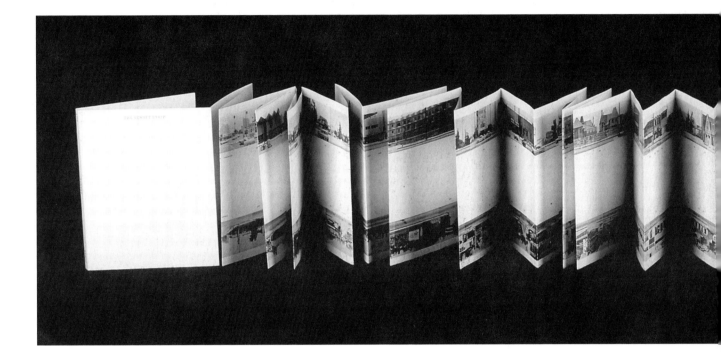

Ed Ruscha, *Every Building on the Sunset Strip*, 1966. Book, offset printing, 7" × 5⅝" × ⅛" closed, 299½" extended. Courtesy the artist. Photo: Paul Ruscha.

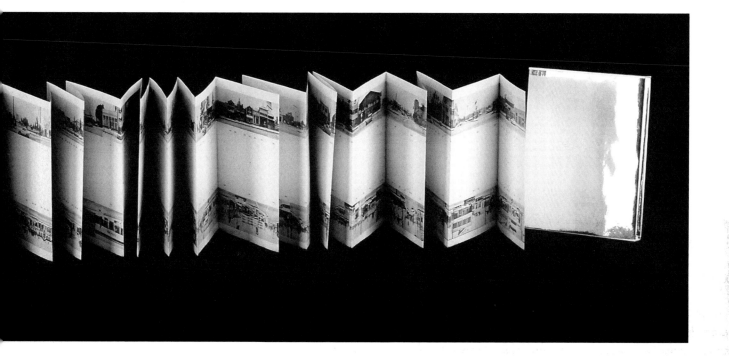

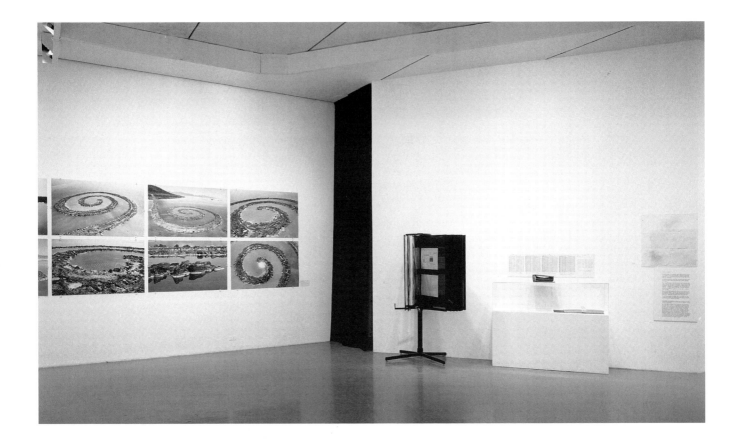

Installation view of "Information,"
Museum of Modern Art, New York,
July 2–September 20, 1970. Photo-
graph © 2001 The Museum of
Modern Art, New York.

kinds. In some cases the statement in the catalogue is itself identified as a work; in others, such as Acconci's plan for *Service Area* and Hans Haacke's proposal for his *MOMA-Poll,* the text describes a work realized specifically for the exhibition and subsequently known through descriptions and photographs. And, in a manner similar to Siegelaub's "July, August, September, 1969," the MoMA exhibition included photographs of physically imposing site-specific works that had been realized outside the confines of the museum and could not be relocated to it. In the context of "Information," Robert Smithson's distant earthworks (some of which were "exhibited" by Siegelaub as well) appeared in both the catalogue and the exhibition through documents, with a photograph and map relating to *Asphalt Rundown* in the catalogue and a group of photographs of *Spiral Jetty* in the exhibition.[39]

These photographs were exhibited in the midst of what Caroline Jones has described as the "one brief moment," extending for a year or so after its completion, when "*Spiral Jetty* could be described as a fifteen-hundred-foot jetty made from rock and compacted earth in the shallow, microbially polluted water of the Great Salt Lake."[40] Even then the encounter with the work itself was limited to the small group of intrepid individuals who made the trek to the remote site in Utah. It is through the series of documents that includes drawings, maps, written descriptions, and, most importantly, photographs and film that the rest of us can claim familiarity with this now-famous work. Most of the visitors to the "Information" exhibition, however, would have been familiar with neither. The work had been constructed in April of 1970, so the appearance of the photographs in the exhibition, which opened at the beginning of July, preceded the Dwan and Ace Gallery exhibitions of the documents and film later that year, and also scooped the art magazines, where coverage of the work only began appearing during the fall. The early appearance of photographs of *Spiral Jetty* in this particular exhibition is telling in light of later descriptions of the discursive or postmodern Smithson—the Smithson known through his anthologized writings, the publication of which occasioned Craig Owens's "Earthwords," or Smithson the author of what Jones has called "the cluster of works that Smithson titled *Spiral Jetty.*"[41] What these accounts emphasize is a decentered construction of meaning that makes manifest the extent to which direct experience of the earthworks has been supplemented and most often replaced by an encounter mediated by documents and descriptions.

Smithson's own statements hint at a complex relationship to photography. "Photographs steal away the spirit of the work" was his response to a question posed during the series of discussions that the editors of *Avalanche* conducted in December 1968 and January 1969 with Smithson, Michael Heizer, and Dennis Oppenheim (which appeared in *Avalanche* as part of an elegant layout accompanied by more than thirty photographs of the artists and their works).[42] But in another interview a few months later he described how

each of his mirror displacements "was dismantled after it was photographed," thus linking their existence to the act of taking the picture. "Photographs are the most extreme contradiction, because they reduce everything to a rectangle and shrink everything down. That fascinates me," he continued. "The photograph is a way of focusing on the site. Perhaps since the invention of the photograph we have seen the world through photographs and not the other way around."[43] Or, there is his response to a question about whether he recorded the process of constructing his 1971 *Broken Circle:* "While the piece was built, I was thinking about how this process could be captured on film and isolated in terms of the particular ideas I had in mind."[44] In addition to these statements, there is the evidence of the documents themselves—nowhere more apparent than in the photographs and film that record not only the final work but every stage in the construction of *Spiral Jetty.*

Robert Hobbs recounts how Smithson had begun selling photographs of his work around 1970, including some signed photographs of *Spiral Jetty* and three panels of stills from the film, only to change course away from that practice. "When his photographs began to be regarded as the art," Hobbs writes, "he decided not to sell any more, and the casual ambivalent status of gallery pieces that oscillated between being privileged objects and mere referents was again established."[45] It is also significant that the photographs of *Spiral Jetty*, when they were first exhibited in 1970, could still be understood as documents of an extant if remote original that might actually be experienced by anyone inspired enough to make the trip. It was not long, however, before the work was overtaken by the rising water of the lake. The spiral was submerged briefly in June and July of 1971, then reemerged in time for Smithson to see it that August, looking "like a kind of archipelago of white islands because of the heavy salt concentrations." Smithson's description presents a dramatic image of a work "affected by the contingencies of nature," as the structure that emerged covered with salt crystals was suddenly returned "back to naked rock" in the aftermath of a violent thunderstorm.[46] But by 1972 it was again under water, not destined to resurface until 1994.

Smithson's death in 1973—when the plane from which he was photographing the early stages of construction on his *Amarillo Ramp* crashed near the Texas site—deprived him of the opportunity to determine a response to the rising water that had engulfed the *Spiral Jetty.* It also left unresolved questions about the extensive archive of photographs that record both the large-scale earthworks and far more ephemeral interventions in the landscape. In an essay devoted to what she has designated the "Preconscious/Posthumous Smithson," Caroline Jones discusses what is in fact a double emergence since Smithson's death, both of his early collages and of certain later works that have been reconstructed or, in the case of the photographs, newly printed on the occasion of two major photographic exhibitions organized during the 1990s. These exhibitions interspersed Smithson's own

photographs, taken with a Kodak Instamatic (and in that sense consistent with conceptually based photographic practices), with those taken by others, including both friends and professional photographers. In their assembly Jones finds a second postmodern Smithson, not the discursive Smithson central to a critical analysis of the construction of authorship, but the "institutional and collector's Smithson," a version of the artist "gradually transformed from being a *user of photographs* to *a photographer,* full stop."[47] While the archive of images leaves no doubt about the central role photography played in Smithson's consideration of site and site-specific manifestations, these recent exhibitions also demonstrate, in the sometimes disconcerting plenitude of minor variants, the opportunity he lost to edit and define the presentation of his own work.

"Earth art and body art (with or without an audience) do not really have much existence as art without media transcription and distribution," wrote John Perreault in 1987. "The works are made inaccessible by geography or time. Although the program of the time was to escape the gallery system, this escape created another regime of dependencies: photography, film, written publicity, and then video. Photography in particular became the art object and the language of communication. Photography became the proof of art."[48] These words were also written on the occasion of the first retrospective of an artist whose early and unexpected death left to others the process of making sense of a trove of documentation related to site-specific and ephemeral manifestations—in many cases temporary and essentially private works where the only evidence was provided by documentation that the artist did not have the chance to organize for public presentation.

In this case the artist was Ana Mendieta, and the approach taken in the overview of her intensely personal and provocative use of her own body and of ephemeral manifestations, curated by Petra Barreras del Rio and Perreault for the New Museum of Contemporary Art in New York, was to catalogue the work by medium, listing color and black-and-white photographs, objects from performance works, drawings, and sculptures. With only a few exceptions the works listed as sculpture dated from the period 1983–1985, when Mendieta had a studio for the first time in her career, provided as part of her fellowship at the American Academy in Rome. Yet the catalogue also hints at the problem with this traditional subdivision by medium with another device, an asterisk used to indicate the works from "an extensive body of work entitled the 'Silueta' series."[49] Furthermore, the relatively small number of photographs relating to her *Silueta* series that Mendieta printed during her lifetime has been extensively supplemented since her death with photographic editions produced from her extensive collection of slides and the release of the films that she also made of her work, now transferred to video.[50] But paradoxically this increase in the number of still and moving images has had the effect of emphasizing not photography or film, but

site-specific sculpture and performance. It is largely on the basis of works recorded by Mendieta in slides and film that her fame as maker of site-specific body art and earthworks has continued to grow since her death in 1985.

Where the first retrospective focused on Mendieta's most recent work, which was also the work that most clearly existed at that time, subsequent examinations have drawn connections with her earlier performances, as she set up tableaus using her own body or bloody traces to create visceral confrontations around issues of violence against women. The *Silueta* works were initially known through a series of single images, but the performative aspect has been emphasized by the release of sequences of photographs showing the temporary body traces and outlines being transformed by natural forces, or subject to a more dramatic conflagration for those using gunpowder or fireworks. This instability in the status of the photograph is also a function of Mendieta's own emphasis, in her relatively small number of statements, on the event rather than the record. "In 1973 I did my first piece in an Aztec tomb that was covered with weeds and grasses," she would later tell Linda Montano about the inauguration of the *Silueta* series. "I bought flowers at the market, lay in the tomb and was covered with white flowers. The analogy was that I was covered by time and history."[51] Her desire to forge a connection to a site marked by the intersection of natural and cultural traces, and her use of materials found readily at hand, are both apparent in this passage. What she does not talk about is the process of recording her action. But photography was key to the portability of her practice—her ability to work wherever she might happen to be and then leave, often carrying away nothing more than a series of images. Since her own life was marked by a succession of moves starting with her exile from Cuba to Iowa at the age of thirteen, it seems telling that the *Silueta* series originated while she was on another journey, in this case a 1973 trip to Oaxaca, Mexico, with Hans Breder, who assisted her with the work by taking the pictures.[52]

The extensive literature that has developed around Mendieta since the New Museum retrospective is remarkably silent about how most of the photographs and films were made, or even the fact that we are looking at her works through such images in the first place. One exception is provided by Miwon Kwon, who has emphasized the sense of loss running through this work—the traces that stand in for the body in most of the *Silueta* series, and the role of documentary images as "delayed relays" that represent inaccessible events already marked by a profound sense of absence.[53] Nor is that sense of absence lessened by additional evidence. Her 1976 *Anima,* also realized in Oaxaca, is marked by three different forms of document or relic: both still photographs and film that show the burning firework silhouette in the shape of a body lit up against the faint outline of a hill under the night sky, and a physical trace in the armature made from bamboo and rope. The pre-

served armature from *Anima,* created for Mendieta by a fireworks maker in Oaxaca, has to be understood as an artifact of an event, not the work itself. Even with the fireworks attached, the form would have been meaningless if Mendieta had not lit it on fire. It was therefore photography and film that allowed her to retain potent traces of work incorporating processes of consumption or destruction.

What is the work, and what is the document? As various uses of photography have become interwoven into the practices of many different contemporary artists, the photograph may well play a double role, or it may slip between definitions. Not only have the forms of photography deployed by artists expanded exponentially; so too has the range of practices enabled by the possibility that the photograph might stand in, not just as a secondary document but as a substitute for direct access to a wide range of experiences that can, given the right combination of circumstances, be defined as works of art. In the case of Smithson's work, photographs as well as film provided a third element in his

Ana Mendieta, *Anima,* 1976 (from the *Silueta* series). Fireworks, Oaxaca, Mexico. Courtesy the Estate of Ana Mendieta and Galerie Lelong, New York.

combination of site and non-site works, and Mendieta's temporary incursions into the landscape are even more extensively framed by the documents through which they are received. Each in turn established important precedents for the artists who came after them, many of whom have accompanied their use of photography with far more explicit instructions and definitions regarding authorship.

A complex intersection of action, site, and document appears in many different guises in the work of contemporary artists who present photographs as part of their work while also relying on photographs to document works understood through, but not as, such images. Yet it is also clear that the establishment of a range of possible approaches, drawing upon earlier site-specific, performance, conceptual, and process-oriented work, often with reference to an equally wide set of options for forms and materials, forces a high degree of self-consciousness about authorship. The intersection of the photographic record and the engagement with specific materials or situations is part of an even more extensive set of options that brings with it an ongoing necessity to define exactly what constitutes the work, as it emerges from an array that includes photographs as objects, documents, or elements of a work and physical objects that may or may not be identified as permanent components of the work. Within this spectrum, the incursion of photography into the work of artists involved in a variety of procedures or practices, rather than promoting unity or uniformity, is likely to further enable experimentation with an increasing diversity of highly specific materials and forms.

In Cornelia Parker's case, her interest in the historical specificity of objects and materials, combined with systematic procedures for their collection and transformation, has yielded both sculptural and photographic works. But other photographs appear as secondary documents pertaining to works comprised by ephemeral actions or situations. It is photographs that record her 1992 *Words That Define Gravity,* when she took the series of words constituted by the title, cast them in lead, and threw them off the White Cliffs at Dover. And it is a photograph that documents the even earlier *Drowned Monuments* of 1985, a remarkably modest installation of souvenir models of famous buildings partially submerged in a drainage puddle. In an account of the origin of this early installation, Parker described her fascination with a series of children's encyclopedias from the early thirties that "always use famous buildings like the Empire State and St. Paul's Cathedral as measures of scale. Placed beside Everest or at the bottom of the deepest ocean, these familiar landmarks that everybody recognizes are used to describe the indescribable, taking the things you know to describe the things you don't." With her arrangement of the miniature buildings in *Drowned Monuments,* she was therefore "trying to measure how deep the gutter was."[54] The paradox suggested by this description lies in the fact that here, in the situa-

tion documented in the photograph, the suggestions of scale reside in the drainpipe and wall surrounding the puddle, not in the souvenir buildings, whose value as indications of scale is lost by their nonspecific miniaturization. The fugitive nature of the installation also raises questions about the mechanism that transformed this humble action into a work. The most obvious answer would be that it has this status because the artist has so designated it. But wider knowledge of its momentary existence depends on the dissemination of the photographic document.

"I like to see my work as the result or a byproduct or a leftover of specific situations," Gabriel Orozco has said of his subtle and often ephemeral manipulation of objects and sites. "That's probably why I cannot separate photography from my sculptural practice. I don't know in advance whether I will need to use the photograph or whether it will, at the end, become an object."[55] The work that inspired this series of observations was the *Yielding Stone*, a 132.2-pound ball of plasticine that Orozco rolled around Monterrey, Mexico,

Cornelia Parker, *Drowned Monuments*, 1985. Installation in a gutter, souvenirs of famous buildings. Courtesy the artist and Frith Street Gallery, London.

Gabriel Orozco, *Yielding Stone,*
1992. Plasticine and dust,
132.2 pounds. Courtesy Marian
Goodman Gallery, New York.

for a period of a little over a week during 1992. "Plasticine," Orozco wrote in his notebook, "a material often used for some sculptural processes, is hardly ever used for the definitive version of the work. . . . That is why it interests me: it is a material in a state of constant mutability, every time that it is touched it changes, it becomes 'upset.'"[56] The material was thus chosen for its malleability, its ability to evade permanence, as it remained soft and sticky, changing shape and picking up debris from its environment. Photographs of its progress show the *Yielding Stone* imprinted with numerous traces, including some recognizable as footprints or the grate by the edge of a road over which it has just been rolled. These images present a permanent record of a series of temporary situations, where vestiges of the object's earlier history were both erased and expanded upon by the marks and debris collected along the way. The work then entered the gallery as a sculptural object consisting of a somewhat irregular and dirt-encrusted sphere, still subject to the forces of its environment, with hints of its earlier history contained in the material it thus collected. In this case the work is defined as this object; but in many other situations the result has been a video or photograph.

"I saw it, I did it," Orozco wrote across the top of another notebook page from 1994, in a remarkably concise summation of the combination of found and lightly transformed situations recorded in his photographs.[57] Wet tire tracks left on the pavement by a bicycle ridden repeatedly in a circle that includes several puddles; an empty outdoor market ever so slightly transformed by the oranges distributed throughout the space, one on each table; some old pieces of wood and other debris in a little puddle, leaning against a cement barrier, echoing the seemingly far more permanent lower Manhattan skyline rising up in the background—all of these very temporary alterations were captured and became photographs bearing the titles *Extension of Reflection*, 1992, *Crazy Tourist*, 1991, and *Island within an Island*, 1993. And these are some of the more obvious transformations. In many images it is difficult to guess whether a slight oddity was made or found. In still others it is the photographic object itself that is altered, by being cut up and rearranged or subject to other alterations across the surface. And some found objects that became photographs have also made their way into the gallery as sculpture.

Elsewhere in his notebooks Orozco has described the Citroën DS that he altered in 1993 to form his sculpture *La DS* as a three-dimensional photograph, and indeed there are notebook pages that show the process of removal that transformed the actual car into a narrow, single-seat-wide, carlike object first taking place in a sequence of cut and pasted images.[58] The dramatic consequences that might follow upon a slight alteration of conditions are suggested by his unrealized proposal for the 1997 Münster "Skulptur" exhibition for a partially submerged Ferris wheel, half of whose circumference would move through

Gabriel Orozco, *Island within an
Island*, 1993. Cibachrome, 12½" ×
18¾". Courtesy Marian Goodman
Gallery, New York.

an underground trench. The magnitude of the transformation is determined not by the idea itself, but by the scale and medium of its realization. Yet for all the play back and forth between arrangement and photograph, Orozco's objects and installations also make specific references to traces of the body, as in the four yogurt lids that, for his first solo show in New York in 1994, he attached to the otherwise blank walls of the gallery at the height of his own mouth, or in the quantity of plasticine used in the *Yielding Stone,* equal to Orozco's own weight.

One marker of the heterogeneity of production increasingly prevalent in contemporary art can be found in the position occupied by photography within a continuum that has opened up between discrete objects and impermanent situations. Video, film, and particularly photographs play a key role at the intersection of performance, site-specific, process-based, and conceptual methods, with the images thus recorded performing a multitude of functions. Still and moving images both document and constitute works that range from portable objects to large-scale installations and are just as varied in their degree of physical permanence or impermanence. As part of this process, contemporary artists have drawn together elements that can be identified with movements of the 1960s and 1970s as divergent as minimalism, earthworks, performance, and conceptual art.

Equally important is the appearance of the body, not as a subject to be represented but as an absent instrument made evident in works of art through a mix of traces, documents, and objects that register the physical presence of the artist. As the traditional notion of the artist's hand has been deflected into a profusion of different kinds of manifestations, the works thus produced invite the viewer, whether literally or imaginatively, to occupy the positions vacated by the artist. And some of the most formally challenging and provocative contemporary artists combine all of these qualities in the creation of works where the relationship to the body articulated through a play of presence and absence is linked to an approach characterized by a tremendous diversity in the mode of presentation.

If Duchamp's readymades established a model of artistic authorship independent of formal unity, more immediate precedents appear in the work of certain hard-to-categorize artists who emerged after 1960. Although attempts to isolate the various forms associated with the 1960s and early 1970s into periods and movements reflect genuinely distinct tendencies, the complex intersections—evident particularly in some of the major exhibitions of 1969 where an expanding list of materials and forms included a mix of objects, process- and site-oriented works, and conceptual propositions—provide the most telling precedent for far-reaching contemporary practices. Indeed, a key precedent for the multifaceted exploration now so dramatically in evidence was announced in the works Bruce Nauman initiated in the second half of the 1960s. The use of forms related to the geometry of minimalism,

the interest in recording his own body in action, the play with language, the interest in the plan as a means of generating physical forms, and an activation of space that often amounts to a sense of confrontation for the viewer all intersect in the work he presented in several of the noteworthy exhibitions of 1969.

The group of works by Nauman that appeared in "When Attitudes Become Form" included two sculptures from 1966, *Collection of Various Flexible Materials Separated by Layers of Grease with Holes the Size of My Waist and Wrists* and *Neon Templates of the Left Half of My Body Taken at Ten-Inch Intervals,* that present a record of his own body while also pointing, in their significant material and procedural differences, to the many ways individual works intersect with what have subsequently been identified as divergent movements or tendencies. The orientation of Nauman's *Collection of Various Flexible Materials Separated by Layers of Grease with Holes the Size of My Waist and Wrists,* with its layers of foil, felt, plastic, and foam rubber spread out directly on the floor, links it to minimalism, and to the theatricality ascribed to the activation of real space, and in this respect it could be seen as an early exploration of the shift from hard-edged minimalism to the more flexible or malleable materials articulated a few years later in the idea of anti-form. Yet the work invokes the body in another way, through the one large and two small ovals cut into the material, identified in the title as direct measures or traces of the artist's body. *Neon Templates of the Left Half of My Body Taken at Ten-Inch Intervals* also presents a form of trace through neon arcs arranged to suggest the spatial orientation of the absent body from which they were taken. Yet there the title, with its indication of a predetermined plan that has been realized accordingly, points suggestively toward this aspect of conceptual art. Conceptual procedures are also suggested in the process of remaking established for exhibiting the neon works in the form of exhibition copies—with the instructions for this process (including the possibility of substituting another color if the original shade of uranium green is not available) presented in the catalogue for "When Attitudes Become Form."[59]

These examples are among the many ways of marking or recording the presence of the body that appear in Nauman's work during this period. The 1967 sculpture *From Hand to Mouth* began as a phrase that he first explored in drawings before deciding that the best way to realize the work would be to cast that portion of the body.[60] It was around this time that Nauman also began using photographs, at first, he told Willoughby Sharp, to record a series of temporary arrangements made from flour in his studio, and then to generate works in which he would "use the figure as an object."[61] Thus he turned the camera on himself to create a double-exposed black-and-white image suggesting an absurd activity, stretching this body between two folding chairs and partially collapsing on the ground, in the 1966 *Failing to Levitate in the Studio,* or spitting a stream of water in the air in *Self-Portrait as a*

Bruce Nauman, *Neon Templates of the Left Half of My Body Taken at Ten-Inch Intervals*, 1966. Neon tubing with clear glass tubing suspension frame, 70" × 9" × 6". Collection Philip Johnson. © 2002 Bruce Nauman / Artists Rights Society (ARS), New York. Photo courtesy Sperone Westwater, New York.

Fountain. This second work was one of a series of color photographs from 1966–1967 generated by wordplay or oddly literalized images. Another photograph from the series, *Bound to Fail,* showing a partial view of a back with arms bound behind, became the basis for a 1967 sculpture of the same motif, *Henry Moore Bound to Fail.* Such still images were quickly joined by films and videos also focused on activities performed in the studio, in many cases based on a play with everyday actions exaggerated or repeated to an extreme.

One of these video works from 1968, *Walk with Contrapposto,* which consisted of an hour-long record of him walking up and down a narrow corridor with an exaggerated side-to-side motion, hands clasped behind his neck, suggested to Nauman a way of bringing together his interests in sculpture and performance. When he made the corridor in his studio he had been thinking about it as a prop for the video, and a sequence of stills from *Walk with Contrapposto* was published in the catalogue for the Whitney Museum's 1969 "Anti-Illusion." Yet the construction itself appeared in the exhibition, under the title *Performance Corridor.* It was also during this exhibition that Nauman did his last live performance, a collaboration with Meredith Monk and Judy Nauman that involved the three of them bouncing in different corners of the galleries for an hour, generating both repetitive movement and sound.[62] The *Performance Corridor,* in its new identity as a sculptural object, was important for Nauman because it gave him "the idea that you could make a participation piece without the participants being able to alter your work."[63] In this way a construction originally conceived as a frame for a series of actions performed only for the video camera was transformed into a challenge posed to viewers about how to respond to the ambiguous invitation to enter the space thus set off.

Nauman's work of this period provides insights into the enduring importance of minimalism for subsequent art practices, even where the austere geometry associated with the movement may be little in evidence in a complex play between specific objects, actions, and photographs. If it was the elimination of anthropomorphism in favor of an obdurate objecthood or material presence that allowed minimalism and related sculptural work to activate the viewer's awareness of an experience unfolding in real space and real time, it is important to note how artists working since have reintroduced references to the body without negating the impact of the object on its physical environment. Certain objects may imply performance, whether it is the theatricality of the viewer's experience, unfolding in space and time, ascribed to minimalism, or the series of actions performed by the artist on or with materials associated with the slightly later emphasis on process (and there were, from early on, significant connections between minimalism and performance in the realm of dance). The body as object is suggested in numerous three-dimensional forms, particularly casts and fragments. And the body also appears, of course, in photographs and videos

Bruce Nauman, still from *Walk with Contrapposto*, 1968. Courtesy of Electronic Arts Intermix, New York.

that record the many and varied ways in which artists have presented themselves as object, conveying the idea of presence once the immediate moment is over and the body thus recorded has moved on to other pursuits. A crucial distinction lies in the difference between representation and trace. An object that retains evidence of the artist's physical presence in its form or scale opens up a space for the viewer in the identification of his or her own position in relation to the marks or imprints left by another, now-absent body.

A different but also significant model for the intersection of the body as object, recorded photographically, and the creation of objects through the actions or traces of the body appears in the work Hannah Wilke began developing in the early 1970s. In early sculptural works made from a roster of flexible materials that began with clay and then expanded to include gum, poured latex, and even laundry lint, Wilke, like Eva Hesse before her, played off of the seriality of minimalism while undermining the logic of its geometry. The folded or layered objects made from these materials presented suggestively sexual references to the female body at the same time that they bore the evident traces of process, and therefore the actions of the body on the material, in their form. Furthermore, Wilke's engagement with language in relation to objects and to the specifically female body is evident

Bruce Nauman, *Performance Corridor,* 1969 (Whitney Museum installation). Wallboard and wood, 96" × 240" × 20". Solomon R. Guggenheim Museum, New York, Panza Collection, 1992. © 2002 Bruce Nauman / Artists Rights Society (ARS), New York. Photo courtesy Sperone Westwater, New York.

in the playful title she gave to the small gum forms made out of kneaded erasers, the *Needed-Erase-Her* series from 1973–1975, or in the play on the construction of voyeurism in Duchamp's *Étant Donnés,* as well as his identity as *marchand du sel,* or salt seller, in the double color photograph of her nude body displayed suggestively over an outcropping of rocks in her 1977–1978 *I Object: Memories of a Sugar Giver.*[64]

The poses that Wilke took up in her *S. O. S. Starification Object Series* might be described as performances before the camera that present her nude body transformed by the disconcerting forms she proudly wears. The type of pose is readily apparent. The come-hither looks and her play with varying degrees of self-exposure in the display or coy hiding of her breasts suggest the glamour of the high-fashion pose as it intersects with more salacious modes of objectification. Yet the small chewing gum objects on it interrupt the allure of the nude body, with their abstracted suggestion of female genitalia transforming titillation into a dangerous surfeit of signs of female sexuality. These small sculptural forms carry a multitude of associations with the body. The material itself implicates the mouth in the way that it is processed, and the forms operate as references to another charged region of the female body while also functioning as objects applied to its surface. The play with different ways of registering the traces of the body, different suggestions of presence and absence, is made that much more complex in presentations of the work where the photographs are displayed together with the series of chewing gum objects in a row of small jewel-box-sized cases. Nor was this the last time she had recourse to the strategy of combining photographic documents with material traces of the body. In her 1992–1993 *Intra-Venus,* shown after Wilke's death from lymphoma in 1993, photographs of her body increasingly ravaged by her illness were shown in combination with knots of hair that fell out during treatment attempts. This final work underscores, in a particularly moving way, how the coupling of physical relic and photograph in both series actually emphasizes the absence of the body that seems so present for the lens of the camera but is present for the viewer only through the mediation of the photographic record.

The important role played by photography in the intersection of performance and sculpture has only increased in the work of artists who have built upon the precedents established during the 1960s and 1970s. The suggestion and simultaneous repudiation of the idea that the photograph might simply be an extension of vision appears in a particularly unexpected form in a series of photographs where Ann Hamilton used her own mouth as the enclosure for a pinhole camera. The two- or three-minute exposure time required to capture each image recalls the stillness required of the subject before the camera in the early history of the photographic portrait. Yet the taking of these works puts a similar demand on Hamilton herself, who must stand, open-mouthed, facing the subject of the

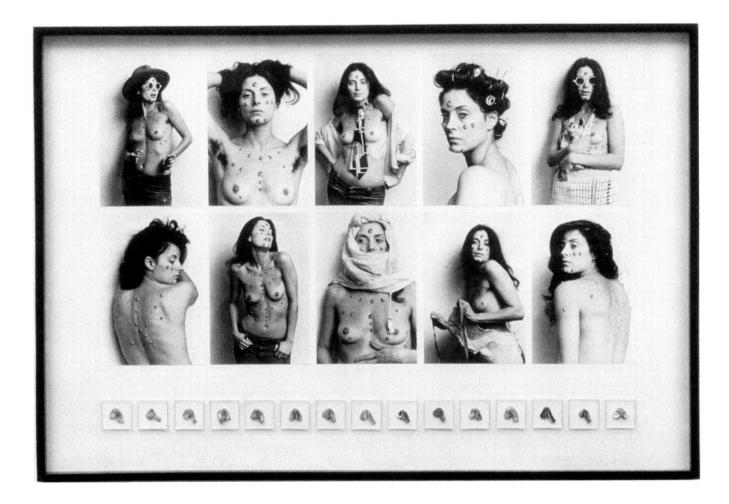

Hannah Wilke, *S.O.S. Starification Object Series,* 1974–1982. Mixed media, 40½" × 58" framed. © 2001 Marsie, Emanuelle, Damon and Andrew Scharlatt. Courtesy Ronald Feldman Fine Arts, New York. Photo: D. James Dee.

Ann Hamilton, *Face to Face · 5*, 2001. Pigment print in artist's frame, image 3½" × 10". Courtesy Sean Kelly, New York.

image for the duration of the exposure. She connected the experience to a much earlier performance at Franklin Furnace in 1985, where she wore the man's suit covered in tooth-picks, porcupinelike, that also appears in photographs from her *Body Object* series. That performance was, according to Hamilton, the last piece where she "actually stood and faced the audience," with the similarity to the series of photographs in the way the process required her "to register this time of standing quite still, face to face with another person, and to make oneself vulnerable, in fact, to another person."[65]

Thus one might speak about a fracturing of performance in Hamilton's work as well as the divergent intersections with the photograph. There are the early *Body Object* photo-graphs where she performed before the camera to create a series of absurdly literal juxta-positions between her own body and such objects as a shoe that extends from her face, or a door held so that it effaces all but her hands and feet. Performance plays a role in many of her installations, which may include the physical presence of the artist or others carry-ing out repetitive tasks as well as video elements focused on fragments of the body or the sound of her recorded voice. And while she will retain certain elements from an installa-tion once it is disassembled, photographic documentation provides the permanent record of the installation itself.[66] The photographs in the *Face to Face* series emerge not as external documents of a performance but as objects produced by the activity. Part of their discon-certing power comes from the way the aperture of the mouth mimics the shape of eye. Yet this is also one of the ways that they distinguish themselves from the experience of sight, which is no more framed by an eye-shaped aperture than it is by the rectangle far more typ-ical of the photographic image.

"I want to know the taste of his vision" is the text that Janine Antoni appended to the caption for *Mortar and Pestle,* a 1999 color photograph that shows, in an extreme close-up,

two faces locked in a form of embrace as a tongue extends from an open mouth to touch an exposed eyeball.[67] The photograph is one of a number of highly specific images interspersed throughout her work. Even as Antoni's artistic production has encompassed an ever wider range of materials and strategies as part of her intense exploration of activities experienced through the body, each work is also based on her careful consideration of the traditions and qualities particular to the form chosen for the individual work. Thus *Mortar and Pestle* was shot with a large-format camera and then blown up to a four-foot-square print, so the extremely detailed photographic record that is the result of this process captures a reality specific to the camera. "It's closer than intimate," Antoni has said in a description that encompasses both the effect of the photograph and the quality of trust that was a prerequisite for this encounter between her tongue and her husband's eye.[68]

She has also used photographs to document the labor-intensive process behind many of her sculptures and installations. But it would be a serious mistake to conflate the two realms of images, on the one hand the documents of activities, sometimes even performances, and on the other the photographs produced specifically as works of art. The connection to her other work is therefore not through the document, but through her use of qualities associated with photography to expand upon the exploration of presence and absence that runs through her work as a whole. In *Mortar and Pestle,* what she has chosen to represent is the insurmountable divide between self and other, the impossible desire to move outside one's own subject position and see oneself as one is perceived by another, articulated in this photograph by what she has described as her "willful misunderstanding of how to know something."[69]

"In a lot of your pieces the body is physically absent but implicitly present, or the body in question is really that of the viewer."[70] This comment could have been inspired by Antoni's sculptural work, but it is in fact part of an interview question Antoni directed to Mona Hatoum in a remarkable exchange between the two artists that touches upon the intersection of formal issues, the role of personal history, and the ways the work of art engages the audience. Hatoum's early work often involved performance; but her turn to sculptural and installation works represented a shift in her approach to the body. "By the late eighties I wanted to take my body, the body of the performer out of the work," she told Antoni. "I wanted the viewer's body to replace mine by interacting directly with the work."[71] Part of that interaction involves the sense of unease that Hatoum creates for the viewer, which is one she connects to the sense of dislocation in her own life, born to Palestinians living in exile in Lebanon and then herself relocating to London. But that is far from the only consideration reflected in the work.

Janine Antoni, *Mortar and Pestle*,
1999. C-print, 4' × 4'. Courtesy
the artist and Luhring Augustine,
New York.

"What makes one claim one history and not another?" Antoni asks Hatoum. "I am from the Bahamas but was educated in the U.S. as you were in London. Isn't Minimalism as much a part of our history as where we are from?"[72] Indeed references to the spatial logic of minimalism abound in the many works where Hatoum has deployed the geometry of the cube or horizontal forms that lie directly on the floor. But she adds new associations or specificity to minimalism's abstract framing of spatial experience when horizontal objects are recognized as a welcome mat or prayer rug, only to become further transformed by the realization that the dense texture in each is formed by the points of steel pins in place of the standard fibers. And the keen awareness that a viewer has of her or his own position in the space occupied by Hatoum's installations is sometimes provoked by a threat to the body that is actual as much as suggested, in works incorporating functioning heating elements or electrified metal objects. The importance of minimalism, both its initial hard-edged mode and Hesse's inversion of that logic, is equally evident in works that incorporate references to the body, as in the intestinelike pattern taken by the magnetized iron filings covering the large cube that is Hatoum's 1992–1993 *Socle du monde,* or spread out on the floor in silicone rubber for her 1995 *Entrails Carpet.* But her work is also permeated by photography and video, with one point of intersection between sculpture and image suggested by the similar patterns that appear in photographs obviously both staged and found, turning up in soapy swirls of body hair in a 1995 image entitled *Van Gogh's Back,* or in 1996 photographs from an East Jerusalem butcher's market capturing the pattern of veins in the hanging *Baid Ghanam (Sheep's Testicle)* and actual intestines in a tub of *Kroush (Tripe).*

The physical manipulation of space and photographic exploration of the body come together with particular power in her 1994 *Corps étranger.* The work creates a claustrophobic theater for the video projected onto the floor of a small circular room that viewers can enter. The video is also about entry, since what it captures is a minute examination of Hatoum's body, both outside and in. Hatoum has recounted how she had the initial idea for *Corps étranger* as early as 1980, when she was doing a series of works using video and performance focused on the idea of surveillance. At the time she recorded some of the sounds of the body that eventually became the audio part of the work, but it was not until more than a decade later that she found a doctor willing to do the endoscopic filming of her digestive and reproductive systems.[73] The references suggested by the title are multiple. The endoscopic camera used to photograph Hatoum's interior orifices is itself "an alien device introduced from outside." But she is also invoking the simultaneous familiarity and unfamiliarity presented by one's own body, "how we are closest to our body, and yet it is a foreign territory which could, for instance, be consumed by disease long before we become aware of it." And finally, the idea of cultural displacement appears in her indication that

Mona Hatoum, *Corps étranger*, 1994
(detail). Video installation with
cylindrical wooden structure, video
projector, amplifier, and four speak-
ers, 137¼" × 118" × 118". Courtesy
the artist and Alexander and Bonin,
New York. Photo: Philippe Migeat.

the "'foreign body' also refers literally to the body of a foreigner."[74] By projecting this scientific image of the body into the real space of the cylindrical room, Hatoum forces the viewer to assume the vantage point of the examining instrument itself. That such information can be reported out from the interior of the body is indeed remarkable; yet to anyone not used to reading this form of modern medical imaging, the intimate vantage thus presented appears alien, unfamiliar, and at times almost entirely abstract. The view of the body made possible by the mediation of this highly specialized camera, already strangely lacking any markers of context or scale, is further transformed by its projection, isolated and enlarged, into the space occupied by the viewer.

How might the traces of presence be marked? The idea of the touch, traditionally focused on a specific region of the body in the search for evidence of the artist's hand, has been fractured and displaced into the multitude of ways artists use their bodies to act upon materials and also turn the process of representation back upon themselves to record traces of their physical presence. Yet the artist is far more likely to have an ongoing connection to a work that incorporates a relationship to its surrounding environment than to a more traditional work where evidence of the hand is part of a self-contained object. The intersection of performance and installation, and the complex oscillation between presence and absence, in Antoni's *Slumber* might therefore serve as an appropriate conclusion to what is actually an open-ended inquiry. *Slumber* has been ongoing since 1993, and each time it is shown Antoni must renew her connection to the work by sleeping in the bed that is part of the installation while attached to an electroencephalograph machine that allows her to leave a record of her rapid eye movement, which is printed out on a long strip of paper. Then, over the course of many days or even weeks she weaves these abstract records of her dreams into a blanket, using strips torn from the nightgown she has worn during the night spent recording her dreams to delineate the REM pattern, in a process that continues until the garment is completely incorporated into the blanket. Thus the blanket grows longer each time the work is exhibited, carrying from site to site traces of each past exhibition woven quite literally into the fabric of the work.

When *Slumber* was shown in a 1994 exhibition at the Reina Sofía in Madrid, Hatoum's *Corps étranger* was installed nearby. As Antoni sat at the loom incorporating the record of her own body's rhythms into *Slumber* she could hear the sound from Hatoum's work, so she would weave through the day "listing to the pulse of her body."[75] While the specificity of such an experience may not be visible to viewers who encounter the work in each of its new contexts, the now lengthy blanket nonetheless presents powerful evidence of Antoni's continuous process of reengagement. Not only is the work always ongoing, but one of its particularly striking features is how precisely it transforms her presence into the

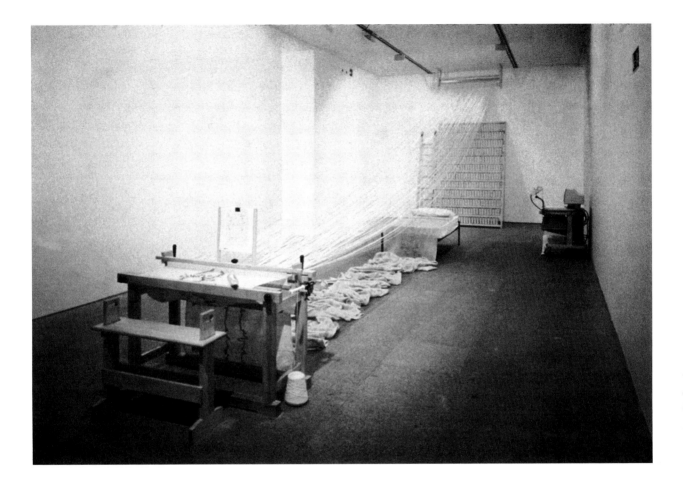

Janine Antoni, *Slumber,* 1993.
Loom, yard, bed, nightgown, EEG
machine, and artist's REM readings.
Courtesy the artist and Luhring
Augustine, New York.

recorded traces of her absent body. The technology employed within the work promises a far more intimate record than that afforded by photographic documentation of the action, even as the evidence thus collected about the content of her dreams takes form as a seemingly abstract set of lines. Once each section of the blanket is completed, and the installation returns to the state of uninhabited stillness that is the museum's far more customary condition, the installation invites the viewer to imagine the experience that has left these traces in its wake.

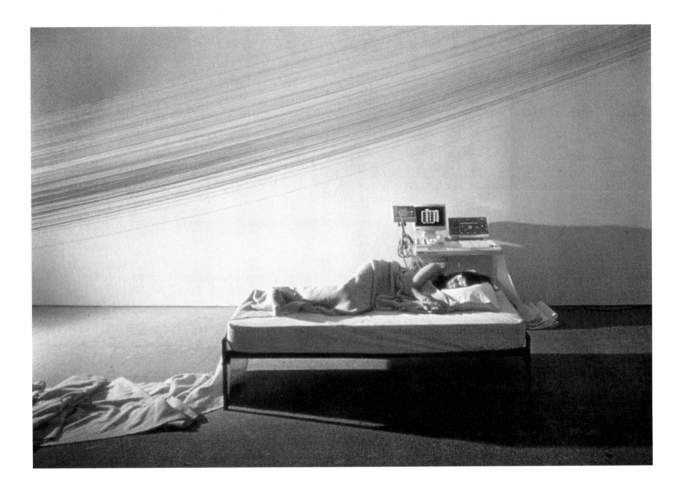

Janine Antoni, *Slumber*, 1993 (detail of the artist sleeping). Photo: Javier Campano.

NOTES

1 AUTHORSHIP AND AUTHORITY

1. See, for example, Rosalind Krauss's description of this experience in her 1985 hearing statement in support of *Tilted Arc,* reprinted in Clara Weyergraf-Serra and Martha Buskirk, eds., *The Destruction of Tilted Arc: Documents* (Cambridge: MIT Press, 1990), 81–82.

2. See Michael Fried, "Art and Objecthood" (1967), in Gregory Battcock, ed., *Minimal Art: A Critical Anthology* (New York: E. P. Dutton, 1968), 116–147, and Rosalind Krauss, *Passages in Modern Sculpture* (Cambridge: MIT Press, 1981).

3. Hal Foster, "The Crux of Minimalism," in *The Return of the Real: The Avant-Garde at the End of the Century* (Cambridge: MIT Press, 1996), 40.

4. Foster, *Return of the Real,* 50. Foster's reference is to Roland Barthes, "The Death of the Author" (1968), in *Image, Music, Text,* trans. Stephen Heath (New York: Hill and Wang, 1977).

5. Douglas Crimp, *On the Museum's Ruins* (Cambridge: MIT Press, 1993), 16.

6. Michel Foucault, "What Is an Author?" (1969), in *Language, Counter-Memory, Practice,* trans. Donald F. Bouchard and Sherry Simon (Ithaca: Cornell University Press, 1977), 113–138.

7. Robert Morris, "Notes on Sculpture, Part II" (1966), in Battcock, ed., *Minimal Art,* 235.

8. Donald Judd, "Specific Objects," *Arts Yearbook* 8 (1965), 82.

9. Fried, "Art and Objecthood," 116–117.

10. Craig Owens, "Earthwords" (1979), in *Beyond Recognition: Representation, Power, and Culture,* ed. Scott Bryson et al. (Berkeley: University of California Press, 1992), 40–51.

11. Thierry de Duve, especially "Archaeology of Pure Modernism," in *Kant after Duchamp* (Cambridge: MIT Press, 1996).

12. See James Meyer, "The Second Degree: *Working Drawings and Other Visible Things on Paper Not Necessarily Meant to Be Viewed as Art,*" in Lesley K. Baier, ed., *Mel Bochner: Thought Made Visible 1966–1973* (New Haven: Yale University Art Gallery, 1995), 95–106.

13. Benjamin H. D. Buchloh, "Conceptual Art 1962–1969: From the Aesthetics of Administration to the Critique of Institutions," *October* 55 (Winter 1990), 119.

14. See David Bourdon, "Carl Andre Protests Museological 'Mutilation,'" *Village Voice,* May 31, 1976, 117, and Carl R. Baldwin, "Whitney Flap: More on Artists' 'Moral Rights,'" *Art in America* 64 (September/October 1976), 10–11.

15. Reproduced in *Carl Andre, Sculptor 1996,* exh. cat., Haus Lange und Haus Esters Krefeld and Kunstmuseum Wolfsburg (Stuttgart: Oktagon, 1996), 258.

16. See Richard Marshall, *Immaterial Objects: Works from the Permanent Collection of the Whitney Museum of American Art, New York* (New York: Whitney Museum, 1989), 19–23.

17. See, for example, Colin Simpson, "The Tate Drops a Costly Brick," *Sunday Times* (London), February 15, 1976, 53.

18. See, for example, the listing for *Equivalents I–VIII* in Piet de Jonge, ed., *Carl Andre* (The Hague and Eindhoven: Haags Gemeentemuseum and Stedelijk Van Abbemuseum, 1987), 20, 22.

19. James Meyer, exhibition brochure for *Sand-Lime Instar,* Gagosian Gallery, January 10–February 11, 1995.

20. On the separation of the units, see Lucy Lippard, *Eva Hesse* (New York: New York University Press, 1976), 128–129. Lippard describes problems with the materials used for a number of works that were already fully evident by the mid-seventies. Regarding the ongoing conservation issues, see Elisabeth Sussman, ed., *Eva Hesse* (San Francisco: San Francisco Museum of Modern Art, 2002).

21. On the significance of Stella's use of this industrial paint, see Caroline A. Jones, *Machine in the Studio: Constructing the Postwar American Artist* (Chicago: University of Chicago Press, 1996), 165.

22. Judd, "Specific Objects," 74.

23. Jones, *Machine in the Studio,* p. 413, n. 142.

24. The decision in *Factor v. Stella* (1978) is reprinted in John Henry Merryman and

Albert E. Elsen, *Law, Ethics, and the Visual Arts,* 2d ed. (Philadelphia: University of Pennsylvania Press, 1987), vol. 2, 502–504.

25. Bruce Glaser, "Questions to Stella and Judd" (1964), in Battcock, ed., *Minimal Art,* 161.

26. Cheryl Bernstein, "The Fake as More," in Gregory Battcock, ed., *Idea Art* (New York: E. P. Dutton, 1973), 41–45. Carol Duncan later acknowledged the text as hers when she reprinted it in *The Aesthetics of Power: Essays in Critical Art History* (Cambridge: Cambridge University Press, 1993), 216–218.

27. The Giuseppe Panza Papers, 1956–1990, are in the Special Collections of the Getty Research Library at the Getty Research Institute. The material on Bruce Nauman appears in Series II, boxes 132–135. Material on each work owned by Panza is filed in a separate folder that includes originals and copies of the certificates for the work, along with correspondence and photographs relevant to the work, and there are also separate but sometimes overlapping correspondence files for each artist.

28. The certificate for Nauman's 1972 *Floating Room (Light Outside, Dark Inside)* is reproduced in Christopher Knight, *Art of the Sixties and Seventies: The Panza Collection* (New York: Rizzoli, 1988), 184. These certificates also appear throughout the Nauman files in the Panza Papers.

29. See Brenda Richardson, *Bruce Nauman: Neons* (Baltimore: Baltimore Museum of Art, 1983), 25–27.

30. These documents appear throughout the files for Judd's work in the Giuseppe Panza Papers, Series II, boxes 117–119. The first pages of several of these three-page certificates are also reproduced in Knight, *Art of the Sixties and Seventies,* 165.

31. Judd, "Una stanza per Panza," Part IV, *Kunst Intern,* November 1990, 7–8. This extended statement by Judd appeared in the May, July, September, and November 1990 issues of *Kunst Intern.* The English version of the text appeared as a separate four-part pamphlet, also published by *Kunst Intern.*

32. See the files for DJ 24 and DJ 31 in the Giuseppe Panza Papers, Series II, boxes 117–119.

33. See the entries for DSS 106 and 243 in Brydon Smith, *Donald Judd: Catalogue of the Exhibition at the National Gallery of Canada, Ottawa, 24 May–6 July, 1975, and Catalogue Raisonné of the Paintings, Objects, and Wood Blocks, 1960–1974* (Ottawa: National Gallery of Canada, 1975).

34. John Coplans, "An Interview with Donald Judd," *Artforum* 9 (June 1971), 47.

35. Sol LeWitt, "Paragraphs on Conceptual Art" (1967), in Alicia Legg, ed., *Sol LeWitt*

(New York: Museum of Modern Art, 1978), 166.

36. Coplans, "Interview with Donald Judd," 49.

37. Glaser, "Questions to Stella and Judd," 162.

38. James Dearing, letter to Giuseppe Panza, July 1, 1980, in the Giuseppe Panza Papers, Series II, box 19, folder 1.

39. Judd, "Una stanza per Panza," IV, 3–4.

40. Judd, "Una stanza per Panza," II (July 1990), 12.

41. Ibid., 13.

42. Quoted in Patricia Failing, "Judd and Panza Square Off," *Artnews* 89 (November 1990), 149.

43. Interview, Giuseppe Panza de Biumo with Suzanne Pagé and Juliette Laffon, in *Un choix d'Art Minimal dans la Collection Panza* (Paris: Musée d'Art Moderne de la Ville de Paris, 1990), 22.

44. Ibid., 23.

45. Failing, "Judd and Panza," 150.

46. Dan Flavin, letter to Giuseppe Panza, September 14, 1988, in the Giuseppe Panza Papers, Series II, box 110, folder 1. Quoted with the permission of the Research Library, Getty Research Institute, Los Angeles. © 2002 Estate of Dan Flavin / Artists Rights Society (ARS), New York.

47. Flavin, letter to Tomás Llorens Serra, Centro de Arte Reina Sofía, Madrid, October 16, 1988, in the Giuseppe Panza Papers, Series II, box 110, folder 1.

48. This certificate is reproduced in Knight, *Art of the Sixties and Seventies*, 184.

49. See the Giuseppe Panza Papers, Series II, box 95, folder 14.

50. Andre, letter to the editors, *Art in America* 78 (March 1990), 31. See also Susan Hapgood, "Remaking Art History," *Art in America* 78 (July 1990), 116.

51. LeWitt, in Andrea Miller-Keller, *Sol LeWitt Wall Drawings 1968–84* (Amsterdam: Stedelijk Museum, 1984), reprinted in *Sol LeWitt, Critical Texts,* ed. Adachiara Zevi (Rome: I Libri de AEIOU, 1994), 109.

52. LeWitt, excerpts from a correspondence with Andrea Miller-Keller, reprinted in *Sol LeWitt, Critical Texts,* 111.

53. LeWitt, "Doing Wall Drawings" (1971), reprinted in Legg, ed., *Sol LeWitt,* 169.

54. LeWitt, quoted in Kimberly Davenport, "Impossible Liberties: Contemporary Artists and the Life of Their Work over Time," *Art Journal* 54 (Summer 1995), 42–43.

55. This assurance was reaffirmed by Donald Thalacker, Director of the Art-in-Architecture Program, who wrote in a memo to William Diamond, Regional Director of the GSA, that "it was never our intention to convey anything other than the models and the drawings to the museum." See Weyergraf-Serra and Buskirk, eds., *Destruction of Tilted Arc,* 156. For other relevant statements, see also pages 4, 67–68, 145–146, 166–167.

56. Decision by Judge Jon O. Newman, in Weyergraf-Serra and Buskirk, eds., *Destruction of Tilted Arc,* 249.

57. Judd refers to taking away the metal in "Una stanza per Panza." The information that Judd paid Ace Gallery fifty cents on the dollar for the material as scrap metal comes from a February 19, 1990, letter from Douglas Chrismas to Giuseppe Panza thanking him for the loans for the exhibition. Giuseppe Panza Papers, Series IV, box 241, folder 1.

58. On the formation of the Art Workers Coalition, see Lucy R. Lippard, *A Different War: Vietnam in Art* (Seattle: Real Comet Press, 1990), 20, and Mary Anne Staniszewski, *The Power of Display: A History of Exhibition Installations at the Museum of Modern Art* (Cambridge: MIT Press, 1998), 263–268. On the activism of the period, see also Maurice Berger, "The Iron Triangle: Challenging the Institution," in *Labyrinths: Robert Morris, Minimalism, and the 1960s* (New York: Harper and Row, 1989), 107–127.

59. Sol LeWitt, "Some Points Bearing on the Relationship of Works of Art to Museums and Collectors," public hearing, Art Workers Coalition, School of Visual Arts, New York, April 10, 1969, reprinted in Legg, ed., *Sol LeWitt,* 172. See also Lucy Lippard, "The Art Workers' Coalition: Not a History," *Studio International* 180 (November 1970), 171–172.

60. For a brief discussion of the Projansky/Siegelaub model, see Franklin Feldman, Stephen E. Weil, and Susan Duke Biederman, *Art Law: Rights and Liabilities of Creators and Collectors,* 2 vols. (Boston: Little, Brown, 1986), 256–258; for the language of the agreement, see Leonard D. DuBoff, *The Deskbook of Art Law* (Washington, D.C.: Federal Publications, 1977), 1131–1133 and 1138–1139.

61. Copies of this contract are preserved in Michael Asher's own files and in the file on Asher in the Giuseppe Panza Papers, Series IV, box 174, folder 27.

2 ORIGINAL COPIES

1. See, for example, Richard Flood, "The Law of Indirections," in *Robert Gober: Sculpture and Drawing* (Minneapolis: Walker Art Center, 1999), 11–12.

2. For Levine's discussion of this connection, see Martha Buskirk, "Interviews with Sherrie Levine, Louise Lawler, and Fred Wilson," in Martha Buskirk and Mignon Nixon, eds., *The*

Duchamp Effect: Essays, Interviews, Round Table (Cambridge: MIT Press, 1996), 177–181.

3. Marcel Duchamp, "Apropos of 'Readymades'" (1961), reprinted in *The Writings of Marcel Duchamp*, ed. Michel Sanouillet and Elmer Peterson (1973; rpt. New York: Da Capo Press, 1989), 141.

4. Constance Lewallen, "Sherrie Levine" (interview), *Journal of Contemporary Art* 6 (Winter 1993), 59–83.

5. Paul Taylor, "Sherrie Levine Plays with Paul Taylor" (interview), *Flash Art* 135 (Summer 1987), 55.

6. Walter Benjamin, "The Work of Art in the Age of Mechanical Reproduction" (1936), in *Illuminations,* trans. Harry Zohn (New York: Schocken Books, 1969), 220.

7. See Levine interview in Buskirk, "Interviews."

8. Jasper Johns, in G. R. Swenson, "What Is Pop?" (1964), reprinted in *Jasper Johns: Writings, Sketchbook Notes, Interviews,* ed. Kirk Varnedoe (New York: Museum of Modern Art, 1996), 94.

9. Peter Bürger, *Theory of the Avant-Garde,* trans. Michael Shaw (Minneapolis: University of Minnesota Press, 1984), 58, 57.

10. Hal Foster, *The Return of the Real: The Avant-Garde at the End of the Century* (Cambridge: MIT Press, 1996), 21.

11. For a detailed account of the production of the *Box in a Valise,* see Ecke Bonk, *Duchamp: The Box in a Valise,* trans. David Britt (New York: Rizzoli, 1989).

12. Duchamp, "Apropos of 'Readymades,'" 141.

13. See Francis M. Naumann, *Marcel Duchamp: The Art of Making Art in the Age of Mechanical Reproduction* (Ghent and New York: Ludion Press and Harry N. Abrams, 1999), especially 245.

14. Arturo Schwarz, *The Complete Works of Marcel Duchamp* (New York: Abrams, 1969).

15. André Malraux, *Museum without Walls,* trans. Stuart Gilbert and Francis Price (Garden City, New York: Doubleday, 1967), 11–12. Malraux's *Le Musée imaginaire* (translated by Gilbert as *Museum without Walls*) was first published in 1947 as volume one of his three-volume *La Psychologie de l'art,* which Malraux revised and published in a single volume as *Les Voix du silence* in 1951. This translation is based on the final version of *Le Musée imaginaire,* which appeared as a separate volume in 1965.

16. Benjamin, "Work of Art in the Age of Mechanical Reproduction," 220–225.

17. See Albert Boime, "Le Musée des copies," *Gazette des Beaux-Arts* 64 (October 1964), 237–247.

18. See Alan Wallach, "The American Cast Museum: An Episode in the History of the Institutional Definition of Art," in *Exhibiting Contradiction: Essays on the Art Museum in the United States* (Amherst: University of Massachusetts Press, 1998), 38–56.

19. Rosalind E. Krauss, "The Originality of the Avant-Garde" (1981), in *The Originality of the Avant-Garde and Other Modernist Myths* (Cambridge: MIT Press, 1985), 151.

20. Ibid., 152.

21. See Susan Lambert, *The Image Multiplied: Five Centuries of Printed Reproductions of Paintings and Drawings* (London: Trefoil Publications, 1987), 33.

22. Quoted in ibid., 32.

23. Douglas Crimp, *On the Museum's Ruins* (Cambridge: MIT Press, 1993), 56–58.

24. Nathan Gluck, in Patrick S. Smith, *Warhol: Conversations about the Artist* (Ann Arbor: UMI Research Press, 1988), 56.

25. On Warhol's performance of authorship and its denial, see Caroline A. Jones, *Machine in the Studio: Constructing the Postwar American Artist* (Chicago: University of Chicago Press, 1996), especially 103–104 and 199–203. On the significance of ready-made imagery for Warhol, see Benjamin H. D. Buchloh, "Andy Warhol's One-Dimensional Art: 1956–1966," in Kynaston McShine, ed., *Andy Warhol: A Retrospective* (New York: Museum of Modern Art, 1989), 39–61.

26. Emile de Antonio, in Smith, *Warhol: Conversations about the Artist,* 187.

27. Ted Carey, in Smith, *Warhol: Conversations about the Artist,* 130.

28. De Antonio, in Smith, *Warhol: Conversations about the Artist,* 189.

29. Andy Warhol, in G. R. Swenson, "What Is Pop Art?," part I (interviews with Jim Dine, Robert Indiana, Roy Lichtenstein, and Andy Warhol), *Art News* 62 (November 1963), 26.

30. Henry Geldzahler, "Andy Warhol: Virginal Voyeur," in Henry Geldzahler and Robert Rosenblum, *Andy Warhol: Portraits of the Seventies and Eighties* (London: Anthony d'Offay Gallery and Thames and Hudson, 1993), 15.

31. David Bourdon, in Patrick S. Smith, *Andy Warhol's Art and Films* (Ann Arbor: UMI Research Press, 1986), 230.

32. Marco Livingston, "Do It Yourself: Notes on Warhol's Techniques," in McShine, ed., *Andy Warhol: A Retrospective,* 68.

33. Rainer Crone, *Andy Warhol* (New York: Praeger, 1970), 24, 30.

34. Andy Warhol and Pat Hackett, *Popism: The Warhol '60s* (New York: Harcourt Brace Jovanovich, 1980), 131–132.

35. Bob Colacello, *Holy Terror: Andy Warhol Close Up* (New York: HarperCollins, 1990), 208.

36. Constance W. Glenn, *The Great American Pop Art Store: Multiples of the Sixties* (Santa Monica: Smart Art Press, 1997), 40.

37. Colacello, *Holy Terror*, 170.

38. Gluck, in Smith, *Warhol: Conversations about the Artist*, 67.

39. See Christin J. Mamiya, *Pop Art and Consumer Culture: American Super Market* (Austin: University of Texas Press, 1992), 132.

40. U.S. Customs, "Notice of Action," and Walter Hopps, letter to Joseph D. Farrar, April 27, 1964, both quoted in Naumann, *Marcel Duchamp: The Art of Making Art*, 236.

41. Justice Waite, decision in *Brancusi v. United States*, November 26, 1928, quoted in Ann Temkin, "Brancusi and His American Collectors," in Friedrich Teja Bach, Margit Rowell, and Ann Temkin, *Constantin Brancusi, 1876–1957* (Philadelphia and Cambridge: Philadelphia Museum of Art and MIT Press, 1995), 62.

42. L. C., "Andy Warhol (Stable)," *Art News* 63 (Summer 1964), 16.

43. Smith, *Warhol: Conversations about the Artist*, 235.

44. Crone, *Andy Warhol*, 30.

45. Warhol, in Swenson, "What Is Pop Art?," part I, 26.

46. See Dan Cameron, "A Conversation: A Salon History of Appropriation with Leo Castelli and Elaine Sturtevant," *Flash Art* 143 (November/December 1988), 77, and "Bill Arning Interviews Sturtevant," in *Sturtevant* (Stuttgart: Württembergischer Kunstverein Stuttgart, 1992), 13.

47. See Jean Lipman and Richard Marshall, *Art about Art* (New York: E. P. Dutton, 1978), 152.

48. See Cheryl Bernstein, "The Fake as More," in Gregory Battcock, ed., *Idea Art* (New York: E. P. Dutton, 1973), 41–45, and Carol Duncan, *The Aesthetics of Power: Essays in Critical Art History* (Cambridge: Cambridge University Press, 1993).

49. Thomas Crow, "The Return of Hank Herron: Simulated Abstraction and the Service Economy of Art," in *Modern Art in the Common Culture* (New Haven: Yale University Press, 1996), 70. See also the original version of Crow's essay in *Endgame: Reference and Simulation in Recent Painting and Sculp-*

ture (Boston and Cambridge: Institute of Contemporary Art and MIT Press, 1986).

50. Joerg Bader, "Elaine Sturtevant: The Eternal Return of Masterpieces" (interview), *Art Press* 236 (June 1998), 34.

51. "Bill Arning Interviews Sturtevant," in *Sturtevant,* 13.

52. Thus, in 1970, when Warhol made a series of 250 print portfolios based on the image, Caulfield received eight and her attorney received four of the portfolios. See Gay Morris, "When Artists Use Photographs: Is It Fair Use, Legitimate Transformation or Rip-Off?," *Artnews* 80 (January 1981), 105.

53. Ivan Karp, in Smith, *Warhol: Conversations about the Artist,* 217 (emphasis in the original).

54. Crone, *Andy Warhol,* 30.

55. Eward Meyers, "It Works!!!!! Simple, Fast Color Prints at Home with Kodak's New Model II Processor," *Modern Photography* 28 (June 1964), 84–89, 102.

56. Patricia Caulfield, conversation with the author, March 15, 2002.

57. Quoted in Morris, "When Artists Use Photographs," 105.

58. Crow, "Saturday Disasters: Trace and Reference in Early Warhol," in *Modern Art in the Common Culture,* 49–65.

59. On both cases, see Morris, "When Artists Use Photographs," 105.

60. Barry Blinderman, "Modern 'Myths': Andy Warhol" (interview, 1981), reprinted in Jeanne Siegel, ed., *Art Talk: The Early 80s* (New York: Da Capo Press, 1988), 16.

61. See Morris, "When Artists Use Photographs," 103–104.

62. On Renaissance and baroque borrowing, see Leo Steinberg, "Introduction: The Glorious Company," in Lipman and Marshall, *Art about Art,* 8–31. On the impact of academic practices on Ingres's repeated self-borrowing, see Rosalind Krauss, "Originality as Repetition: Introduction," *October* 37 (Summer 1986), 35–40, and "You Irreplaceable You," in Rosalind E. Krauss, ed., *Retaining the Original: Multiple Originals, Copies, and Reproductions* (Washington: National Gallery of Art, 1989), 151–159.

63. *David Wojnarowicz v. American Family Association and Donald E. Wildmon,* decision by William C. Conner, United States District Court for the Southern District of New York, issued August 8, 1990.

64. Fredric Jameson, "Postmodernism and Consumer Society," in Hal Foster, ed., *The Anti-Aesthetic: Essays on Postmodern Culture* (Port Townsend, Washington: Bay Press, 1983), 114.

65. The information about advertisements is from the deposition of Jeff Koons taken by

John D. Parker, lawyer for United Feature Syndicate, July 2, 1990, pages 29–30. This deposition was taken in conjunction with the suit against Koons regarding his use of the character Odie from the Garfield comic strip in his 1988 *Wild Boy and Puppy* sculpture. Portions of the deposition were included as Exhibit B in United Feature Syndicate's January 15, 1991, Motion for Partial Summary Judgment in *United Feature Syndicate, Inc. v. Jeff Koons and Sonnabend Gallery, Inc.*

66. The case was initially heard in the U.S. District Court for the Southern District of New York on November 26, 1990, and judge Charles Haight issued his decision in favor of Art Rogers on the question of copyright infringement on December 10, 1990. The case was appealed by Koons's lawyer John Koegel to the U.S. Court of Appeals for the Second Circuit, where it was argued before judges Cardamone, Pierce, and Walker. The appeals court decision, which affirmed the district court finding, was written by judge Richard Cardamone and issued April 2, 1992.

67. See John Carlin, "Culture Vultures: Artistic Appropriation and Intellectual Property Law," *Columbia-VLA Journal of Law and the Arts* 13, no. 1 (1988), 139.

68. Leval makes this argument in the context of a discussion of the publication of stills from Zapruder's film of the Kennedy assassination. See Pierre N. Leval, "Toward a Fair Use Standard," *Harvard Law Review* 103 (March 1990), 1131–1132.

69. *Bleistein v. Donaldson Lithographing Co.* (1903).

70. Crimp, *On the Museum's Ruins,* 118.

71. Trevor Fairbrother, "James Welling" (interview), in Trevor Fairbrother, David Joselit, and Elisabeth Sussman, *The BiNational: American Art of the Late 80s* (Boston: Institute of Contemporary Art and Museum of Fine Arts, 1988), 219.

72. Ibid., 220.

73. William S. Bartman, ed., *Allan McCollum* (Los Angeles: A.R.T. Press, 1996), 45.

74. On Klein in relation to Rodchenko, see Benjamin H. D. Buchloh, "Primary Colors for the Second Time: A Paradigm Repetition of the Neo-Avant-Garde," *October* 37 (Summer 1986), 41–52. On Levine's monochromes, see Rosalind Krauss, "Sherrie Levine Makes a Monochrome," in *Das Bild nach dem letzten Bild / The Picture after the Last Picture* (Vienna: Galerie Metropol, 1991), 135–138.

75. Molly Nesbit gives a spirited account of the theft in "The Rat's Ass," *October* 56 (Spring 1991), 7–20.

3 MEDIUM AND MATERIALITY

1. Margit Rowell, *Objects of Desire: The Modern Still Life* (New York: Museum of Modern Art and Harry N. Abrams, 1997), 218.

2. See Klaus Ottmann, "The Solid and the Fluid: Perceiving Laib," in Ottmann, *Wolfgang Laib: A Retrospective* (New York and Ostfildern/Ruit, Germany: American Federation of Arts and Hatje Cantz Publishers), 14.

3. See Thomas Crow, *Patrons and Public Life in Eighteenth-Century Paris* (New Haven: Yale University Press, 1985).

4. Clement Greenberg, "Modernist Painting" (1960), in *The Collected Essays and Criticism,* vol. 4, ed. John O'Brian (Chicago: University of Chicago Press, 1993), 86, 85.

5. Thierry de Duve, *Kant after Duchamp* (Cambridge: MIT Press, 1996), 154. There is an obvious echo of Allan Kaprow's similar pronouncement at the end of his 1958 essay on Pollock (which de Duve later cites in an abbreviated form).

6. See Gerald Marzorati, "Imitation of Life," *Artnews* 82 (September 1983), 86.

7. Peter Bunnell to Ronald Feldman, in "Photographs and Professionals III," *Print Collector's Newsletter* (July–August 1983). This statement is quoted by Abigail Solomon-Godeau in her analysis of the dissolution of what she terms "art photography," in *Photography at the Dock: Essays on Photographic History, Institutions, and Practice* (Minneapolis: University of Minnesota Press, 1991), 113–114.

8. Els Barents, excerpts from an interview with Cindy Sherman, in *Cindy Sherman* (Munich: Schirmer und Mosel, 1982), reprinted in Kristine Stiles and Peter Selz, eds., *Theories and Documents of Contemporary Art: A Sourcebook of Artists' Writings* (Berkeley: University of California Press, 1996), 794.

9. George Howell, "Anatomy of an Artist" (interview), *Art Papers* 19 (July–August 1995), 6.

10. "Interview with Sabine Schütz," in Gerhard Richter, *The Daily Practice of Painting: Writings and Interviews 1962–1993,* ed. Hans-Ulrich Obrist, trans. David Britt (Cambridge and London: MIT Press and Anthony d'Offay Gallery, 1995), 216.

11. Thomas Crow, "The Simple Life: Pastoralism and the Persistence of Genre in Recent Art," in *Modern Art in the Common Culture* (New Haven: Yale University Press, 1996), 181.

12. See Crow, "Handmade Photographs and Homeless Representation," in *Modern Art in the Common Culture,* 97–110.

13. On the historical background as well as the paintings themselves, see Robert Storr, *Gerhard Richter: October 18, 1977* (New York: Museum of Modern Art, 2000).

14. Benjamin H. D. Buchloh, "A Note on Gerhard Richter's *October 18, 1977,*" *October* 48 (Spring 1989), 93.

15. Andreas Gursky, ". . . I Generally Let Things Develop Slowly," in *Andreas Gursky:*

Fotografien 1994–1998 (Wolfsburg: Kunstmuseum Wolfsburg, 1998), 9.

16. Robert Storr, "Interview with Chuck Close," in Storr, *Chuck Close* (New York: Museum of Modern Art, 1998), 87.

17. See Robert Storr, "Chuck Close: Angles of Refraction," in Storr, *Chuck Close,* 45.

18. Storr, "Interview with Chuck Close," 89.

19. Chuck Close, "A Progression by Chuck Close: Who's Afraid of Photography?," *Artforum* 22 (May 1984), 50.

20. John Coplans, "Talking with Roy Lichtenstein" (interview), *Artforum* 5 (May 1967), 34.

21. Carol Armstrong, "From Oil to Wax to Silver: Sugimoto's Portrait Gallery," in Tracey Bashkoff and Nancy Spector, *Sugimoto Portraits* (New York: Guggenheim Museum Publications, 2000), 47.

22. On the debate about the extent of Vermeer's reliance on the camera obscura, see Svetlana Alpers, *The Art of Describing: Dutch Art in the Seventeenth Century* (Chicago: University of Chicago Press, 1983), 30–32, and also Jonathan Crary, *Techniques of the Observer: On Vision and Modernity in the Nineteenth Century* (Cambridge: MIT Press, 1990), 43–47.

23. Tracey Bashkoff, "The Exactness of the World: A Conversation with Hiroshi Sugimoto," in Bashkoff and Spector, *Sugimoto Portraits,* 32.

24. Sugimoto in Bashkoff, "The Exactness of the World," 33–34.

25. Yve-Alain Bois, Douglas Crimp, and Rosalind Krauss, "A Conversation with Hans Haacke," *October* 30 (Fall 1984), 23.

26. See Brian Wallis, ed., *Hans Haacke: Unfinished Business* (New York and Cambridge: New Museum of Contemporary Art and MIT Press, 1986), 242.

27. Harold Rosenberg, "The American Action Painters" (1952), in *The Tradition of the New* (New York: Horizon Press, 1959), 25, 26.

28. Allan Kaprow, "The Legacy of Jackson Pollock" (1958), reprinted, with slight changes, in Kaprow, *Essays on the Blurring of Art and Life,* ed. Jeff Kelley (Berkeley: University of California Press, 1993), 2, 9.

29. Robert Rauschenberg, untitled statement, in Dorothy C. Miller, ed., *Sixteen Americans* (New York: Museum of Modern Art, 1959), reprinted in Stiles and Selz, eds., *Theories and Documents of Contemporary Art,* 321.

30. Robert Rauschenberg, in "Multi-Media: Painting, Sculpture, Sound" (transcription of a panel discussion conducted by Jeanne Siegel with Robert Rauschenberg, Larry Rivers, and Sven Lukin, broadcast November

21, 1966, on WBAI), in Jeanne Siegel, ed., *Artwords: Discourse on the 60s and 70s* (New York: Da Capo Press, 1992), 154, 155.

31. Robert Morris, "Anti Form" (1968), in *Continuous Project Altered Daily: The Writings of Robert Morris* (Cambridge: MIT Press, 1993), 43–46.

32. James Monte, in Marcia Tucker and James Monte, *Anti-Illusion: Procedures/Materials* (New York: Whitney Museum of American Art, 1969), 5.

33. Scott Burton, "Notes on the New," in Harald Szeemann, *When Attitudes Become Form: Works—Concepts—Processes—Situations—Information: Live in Your Head* (Bern: Kunsthalle Bern, 1969), n.p.

34. Richard Serra, "Verb List, 1967–68," in *Writings / Interviews* (Chicago: University of Chicago Press, 1994), 3–4.

35. For a detailed analysis of these transformations, see Elisabeth Sussman, ed., *Eva Hesse* (San Francisco: San Francisco Museum of Modern Art, 2002).

36. Emily Wasserman, "New York: Process, Whitney Museum; Theodoron Awards, Guggenheim," *Artforum* (September 1969), reprinted in Richard Armstrong and Richard Marshall, eds., *The New Sculpture 1965–75: Between Geometry and Gesture* (New York: Whitney Museum of American Art, 1990), 187.

37. See the entry on this work in Michael Asher, *Writings 1973–1983 on Works 1969–1979*, ed. Benjamin H. D. Buchloh (Halifax and Los Angeles: Nova Scotia College of Art and Design and Museum of Contemporary Art, 1983), 8.

38. Janine Antoni, conversation with the author, December 7, 2001.

39. Ibid.

40. Laura Cottingham, "Janine Antoni: Biting Sums Up My Relationship to Art History" (interview), *Flash Art* 171 (Summer 1993), 104.

41. Ibid.

42. Ewa Lajer-Burcharth, "Antoni's Difference," in *Janine Antoni* (Küsnacht, Switzerland: Ink Tree Edition, 2000), 63.

43. Antoni, conversation with the author, December 7, 2001.

44. Amy Jinkner-Lloyd, "Chewing the Fat with Janine Antoni" (interview), *Art Papers* 20 (March–April 1996), 3.

45. Ibid., 4.

46. Janine Antoni, conversation with the author, September 30, 1999.

47. Ibid. The three incidents occurred at the Venice Biennale Aperto, the Philadelphia

Institute of Contemporary Art, and the Irish Museum of Modern Art, Dublin.

48. Ibid.

49. Antoni, conversation with the author, December 7, 2001.

50. On the Philadelphia Museum purchase, see Ann Temkin, "Strange Fruit," in Miguel Angel Corzo, *Mortality Immortality? The Legacy of 20th-Century Art* (Los Angeles: Getty Conservation Institute, 1999), 45–50.

51. Anna Blume, "Zoe Leonard Interviewed by Anna Blume," in *Secession: Zoe Leonard* (Vienna: Wiener Secession, 1997), 18.

52. See ibid., 22–23.

53. Ibid., 18.

54. Stephan Götz, interview with Robert Gober, in Götz, *American Artists in Their New York Studios: Conversations about the Creation of Contemporary Art* (Cambridge and Stuttgart: Center for Conservation and Technical Studies, Harvard Art Museums, and Daco-Verlag Gunter Blase, 1992), 65.

55. Gober describes the process in Götz, *American Artists in Their New York Studios,* 65. The process, including the application of the cinnamon, was also described in a lecture: Christian M. Scheidemann, conservator of contemporary art, Hamburg, "How to Eat Art—A Conservator's View," Harvard University Art Museums, October 25, 2001.

56. Richard Flood, "The Law of Indirections," in *Robert Gober: Sculpture and Drawing* (Minneapolis: Walker Art Center, 1999), 17. Competing rumors of this now mythic incident include a trip to the hospital to have the man's stomach pumped, the threat of a lawsuit, and the bite as a critical act.

57. Gober in Götz, *American Artists in Their New York Studios,* 65–66.

58. Nayland Blake, conversation with the author, September 24, 1999.

59. Anne Barclay Morgan, "Art, Pleasure, and Community" (interview with Nayland Blake), *Art Papers* 19 (July–August 1995), 8.

60. On the rabbit theme in Blake's work, see Lynn M. Herbert's essay in *Nayland Blake: Hare Attitudes* (Houston: Contemporary Arts Museum, 1996).

61. Daniel Pinchbeck, "New York Artist Q & A: Nayland Blake" (interview), *Art Newspaper* 10 (October 1998), 57.

62. Rosalind Krauss, "Reinventing the Medium," *Critical Inquiry* 25 (Winter 1999), 296–297. See also her more extended analysis of Coleman's work in "'. . . And Then Turn Away?' An Essay on James Coleman," *October* 81 (Summer 1997), 5–33. Krauss's refer-

ence is to the description of the photo-novel in Roland Barthes, "The Third Meaning" (1970), in *Image, Music, Text,* trans. Stephen Heath (New York: Hill and Wang, 1977).

63. See David Galloway, "Beuys and Warhol: Aftershocks," *Art in America* 76 (July 1988), 113–122.

64. Jim Hodges, conversation with the author, October 1, 1999.

65. Ibid.

66. Tim Rollins, interview with Felix Gonzalez-Torres, in William S. Bartman, ed., *Felix Gonzalez-Torres* (Los Angeles: A.R.T. Press, 1993), 23.

67. See Nancy Spector, *Felix Gonzalez-Torres* (New York: Solomon R. Guggenheim Museum, 1995), 184, 191.

68. David Deitcher, "Contradictions and Containment," in Dietmar Elger, *Felix Gonzalez-Torres: Catalogue Raisonné* (Ostfildern-Ruit, Germany: Cantz, 1997), 107.

69. Robert Nickas, "Felix Gonzalez-Torres: All the Time in the World" (interview), *Flash Art* 161 (November–December 1991), 86.

70. Rollins, interview with Gonzalez-Torres, 21.

71. Nickas, "Felix Gonzalez-Torres," 89.

4 CONTEXT AS SUBJECT

1. On the exhibition as a whole as well as the individual objects, see Lisa G. Corrin, ed., *Mining the Museum: An Installation by Fred Wilson* (Baltimore and New York: The Contemporary and The New Press, 1994).

2. Fred Wilson, in Martha Buskirk, "Interviews with Sherrie Levine, Louise Lawler, and Fred Wilson," reprinted in Martha Buskirk and Mignon Nixon, eds., *The Duchamp Effect: Essays, Interviews, Round Table* (Cambridge: MIT Press, 1996), 187.

3. Corrin cites early annual reports in *Mining the Museum,* 11.

4. Wilson in Buskirk, "Interviews," 190.

5. Thomas M. Messer, "Guest Editorial," *Arts Magazine* 45 (Summer 1971), 5. According to Haacke, he was informed on April 1 of the cancellation of the exhibition due to open on April 30. See Haacke's April 3, 1971, statement in response to the cancellation, printed in "Gurgles around the Guggenheim," *Studio International* 181 (June 1971), 249.

6. Thomas M. Messer, letter to Hans Haacke, March 19, 1971, reprinted in "Gurgles around the Guggenheim," 248.

7. Thomas M. Messer, April 5 reply to Haacke's April 3, 1971, statement regarding the cancellation of the exhibition, printed

in "Gurgles around the Guggenheim," 249. For descriptions of all three of the works intended for the exhibition, see Brian Wallis, ed., *Hans Haacke: Unfinished Business* (New York and Cambridge: New Museum and MIT Press, 1986), 84, 88–97.

8. Messer, "Guest Editorial," 5 (emphasis in the original).

9. See the exhibition proposal, reprinted in Barbara Reise, "A Tail of Two Exhibitions: The Aborted Haacke and Robert Morris Shows," *Studio International* 182 (July–August 1971), 31. Edward Fry's statement that he took Messer to see Haacke's 1969 exhibition at the Howard Wise Gallery, which included a visitor's poll, appears on page 30.

10. See "Hans Haacke: What Makes Art Political" (interview), in Jeanne Siegel, ed., *Art Talk: The Early 80s* (New York: Da Capo Press, 1988), 65. See also the entry on the *MoMA Poll* in Wallis, ed., *Hans Haacke: Unfinished Business,* 86–87.

11. See Jon Hendricks and Jean Toche, *GAAG: The Guerrilla Art Action Group, 1969–1976, a Selection* (New York: Printed Matter, 1978), Number 3, November 10/18, 1969, "Demands for the resignation of the Rockefellers from the Museum of Modern Art and description of action: 'blood bath.'"

12. See "Nancy Spero: Woman as Protagonist" (interview), in Siegel, ed., *Art Talk: The Early 80s,* 257–266, and Norma Broude and Mary D. Garrard, eds., *The Power of Feminist Art: The American Movement of the 1970s, History and Impact* (New York: Harry N. Abrams, 1994).

13. A version of the painting, current as of June 1981, is reproduced in Coosje van Bruggen, *John Baldessari* (New York: Rizzoli, 1990), 43.

14. Reprinted in Wallis, ed., *Hans Haacke: Unfinished Business,* 118.

15. Quoted in Carl R. Baldwin, "Haacke Refusé in Cologne," *Art in America* 62 (November–December 1974), 37. See also Jack Burnham, "Meditations on a Bunch of Asparagus," *Arts Magazine* 49 (February 1975), 72–75.

16. Quoted in Baldwin, "Haacke Refusé," 37.

17. Michael Asher, *Writings 1973–1983 on Works 1969–1979,* ed. Benjamin H. D. Buchloh (Halifax and Los Angeles: Press of the Nova Scotia College of Art and Design and Museum of Contemporary Art, 1983), 209.

18. Asher's correspondence files indicate that he sent this proposal to McShine on June 2, 1998, and received a letter from McShine rejecting the idea dated June 9.

19. Stephen Pascher, "Cave Notes: Stephen Pascher and Michael Asher Examine Asher's Recent Work at the MOMA" (interview), *Merge* 5.

20. Kirk Varnedoe, "A Note on Deaccessioning at the Museum of Modern Art," in *Painting and Sculpture from the Museum of Modern Art: Catalog of Deaccessions 1929 through 1998 by Michael Asher* (New York: Michael Asher and the Museum of Modern Art, 1999), 5. The museum's demand that the statement be included was presented in a January 29, 1999, letter from McShine to Asher, in Asher's correspondence files.

21. Asher clarified the need for two sites in a August 2, 1998, letter responding to Kynaston McShine's acceptance of his proposal. In a January 27, 1999, letter to McShine, Asher expressed his surprise about a decision made the week before to show the catalogue only in the exhibition, and indicated that he would need to withdraw from the exhibition if the project was modified.

22. Louise Lawler, in Buskirk, "Interviews," 184.

23. Hans Haacke, *AnsichtsSachen / Viewing-Matters* (Düsseldorf: Richter Verlag, 1999), 13.

24. Lawler's arrangement of the Museum of Fine Arts collection was part of the series "Connections," organized by Trevor Fairbrother. On the Boston arrangement, see Francine A. Koslow, "Louise Lawler: Museum of Fine Arts," *Artforum* (March 1991), 133–134. Andrea Fraser also discusses a 1984 project by Lawler and Sol LeWitt for the Wadsworth Atheneum in "In and Out of Place," *Art in America* (June 1985), 122–128.

On Wilson's Seattle arrangement, see Buskirk, "Interviews," 187–190.

25. See *Raid the Icebox 1, with Andy Warhol: An Exhibition Selected from the Storage Vaults of the Museum of Art, Rhode Island School of Design* (Providence: Rhode Island School of Design, 1969). The 404 objects in the exhibition, including 194 pairs of shoes and 57 parasols and umbrellas, are all individually listed and described in the catalogue.

26. Haacke, *ViewingMatters*, 15.

27. The Kimmelman profile appeared in the *New York Times* of September 12, 1994, and was subsequently reprinted in Michael Kimmelman, *Portraits: Talking with Artists at the Met, the Modern, the Louvre and Elsewhere* (New York: Random House, 1998). According to Haacke, the invitation to work on the collection in Rotterdam arose when Chris Dercon, who was about to take over as director of the Museum Boijmans Van Beuningen, happened to come across his exchange with Kimmelman (Haacke, *ViewingMatters*, 11).

28. Haacke, *ViewingMatters*, 19. Haacke's reference is to Lautréamont's *Les Chants de Maldoror,* specifically the description taken up by the surrealists of the chance encounter of a sewing machine and an umbrella on a dissecting table.

29. Patricia Bickers, "Mixed Messages: Hans Haacke Interviewed by Patricia Bickers," *Art Monthly* 244 (March 2001), 3.

30. See Mark Jones, ed., *Fake? The Art of Deception* (Berkeley: University of California Press, 1990), 237–240.

31. Haacke, *ViewingMatters,* 53.

32. The individual sources used for the script were specified in a manuscript copy of the text provided by Andrea Fraser.

33. See the description of the *Plaster Surrogates* in William S. Bartman, ed., *Allan McCollum* (New York: Art Resources Transfer, 1995), 39.

34. Thomas Lawson, "Allan McCollum Interviewed by Thomas Lawson," in Bartman, ed., *Allan McCollum,* 2.

35. These works, *On Tropical Nature* (1991), *Nos Sciences Naturelles—Observations of Neotropical Vertebrates* (1992), and *Project for the Belize Zoo* (1990), are all discussed in Lisa Graziose Corrin, Miwon Kwon, and Norman Bryson, *Mark Dion* (London: Phaidon Press, 1997).

36. See Denise Markonish, interview with Mark Dion, in *Mark Dion: New England Digs* (Brockton, Massachusetts: Fuller Museum of Art, 2001), 26. The exhibition was instigated by Markonish, curator at the Fuller Museum, and expanded to include stops at the David Winton Bell Gallery of Brown University in Providence and the Dartmouth campus of the University of Massachusetts, with digs organized in the region of each institution.

37. See the information on materials in the checklist for Jessica Morgan, *Cornelia Parker* (Boston: Institute of Contemporary Art, 2000), 66–69.

38. See the checklist in Morgan, *Cornelia Parker,* 68

39. "Cornelia Parker Interviewed by Bruce Ferguson," in Morgan, *Cornelia Parker,* 57.

40. "Zoe Leonard Interviewed by Anna Blume," in *Secession: Zoe Leonard* (Vienna: Wiener Secession, 1997), 8. Elsewhere Leonard identifies the museum as part of the School of Medicine at the University of Paris.

41. Laura Cottingham, "Zoe Leonard" (interview), *Journal of Contemporary Art* 6 (Summer 1993), 64–77.

42. See the documentation published as part of Luna's photo essay, "James Luna, 'The Artifact Piece,' Kumeyaay Exhibit Area," *Fiction International* 18 (Spring 1988), 38–42. The work was shown again as part of the 1990 "Decade Show" organized by three New York art institutions. See Nilda Peraza et al., *The Decade Show: Frameworks of Identity in the 1980s* (New York: Museum of Contemporary Hispanic Art, New Museum of Contemporary Art, and the Studio Museum in Harlem, 1990).

43. "Kumeyaay: Native Californians," in the description of permanent exhibitions, San Diego Museum of Man website, www.museumofman.org, as of 2001.

44. See Steven Durland, "Call Me in '93: An Interview with James Luna," *High Performance* (Winter 1991), 39.

45. See Coco Fusco, "The Other History of Intercultural Performance," in *English Is Broken Here* (New York: New Press, 1995), 37–63.

46. Suzi Gablik, "Breaking Out of the Imperialist Cage: An Interview with Coco Fusco," *New Art Examiner* 21 (October 1993), 39.

47. Fusco, "Other History of Intercultural Performance," 50.

48. See Richard Bolton, ed., *Culture Wars: Documents from the Recent Controversies in the Arts* (New York: New Press, 1992), particularly Carole S. Vance, "The War on Culture" (106–114), originally published in *Art in America* (September 1989).

49. See Phil Freshman, ed., *Public Address: Krzysztof Wodiczko* (Minneapolis: Walker Art Center, 1992), 151.

50. See Dietmar Elger, *Felix Gonzalez-Torres: Catalogue Raisonné* (Ostfildern-Ruit, Germany: Cantz, 1997), 15.

51. See Kolbowski's description and documentation of the work in Silvia Kolbowski, *XI Projects* (New York: Border Editions, 1992), 90–99.

52. See Asher, *Writings 1973–1983*, 164–173.

53. These differences, exacerbated by inconsistencies in the positioning and photographic documentation in 1987, are evident in the grid of photographs covering all three exhibitions that appeared in the 1997 catalogue. See Klaus Bussmann, Kasper König, and Florian Matzner, eds., *Contemporary Sculpture: Projects in Münster 1997* (Ostfildern-Ruit, Germany: Verlag Gerd Hatje, 1997), 56–65.

5 CONTINGENT OBJECTS

1. Adrian Piper, "An Ongoing Essay," *Art and Artists* 6 (March 1972), 45–46.

2. Cindy Nemser, "An Interview with Vito Acconci," *Arts Magazine* 45 (March 1971), 20.

3. Vito Acconci in "Excerpts from Tapes with Liza Béar," *Avalanche* 6 (Fall 1972), 72.

4. Entry for *Proximity Piece* in Ann Goldstein and Anne Rorimer, *Reconsidering the Object of Art, 1965–1975* (Los Angeles and Cambridge: Museum of Contemporary Art and MIT Press, 1995), 43. See also the entry for *Proximity Piece* in *Avalanche* 6 (Fall 1972), 46, which is similar except for the use of only masculine pronouns. Acconci describes the conception in "Excerpts from Tapes with Liza Béar," 72.

5. Sol LeWitt, "Paragraphs on Conceptual Art," *Artforum* 5 (Summer 1967), 79–84, reprinted in Alexander Alberro and Blake Stimson, eds., *Conceptual Art: A Critical Anthology* (Cambridge: MIT Press, 1999), 12–16.

6. Adrian Piper, "Flying," in Jane Farver, *Adrian Piper: Reflections 1967–1987* (New York: Alternative Museum, 1987), 21. On this period in Piper's work see also Maurice Berger, *Adrian Piper: A Retrospective* (Baltimore: Fine Arts Gallery, University of Maryland Baltimore County, 1999), 15–19.

7. Sol LeWitt, "Sentences on Conceptual Art," *0–9*, no. 5 (January 1969), 3–5, reprinted in Alberro and Stimson, eds., *Conceptual Art,* 106–108.

8. See Adrian Piper, *Out of Order, Out of Sight,* 2 vols. (Cambridge: MIT Press, 1996), vol. 1, 29–53.

9. See Kate Linker, *Vito Acconci* (New York: Rizzoli, 1994), 20. On "Street Works IV," see Anne Rorimer, *New Art in the 60s and 70s: Redefining Reality* (London: Thames & Hudson, 2001), 211.

10. See the index for *Avalanche* 6 (Fall 1972), the special issue on Acconci, where the works are divided into activities, performances, performance situations, performance spaces, photograph pieces, films, audiotapes, and videotapes.

11. Nemser, "Interview with Vito Acconci," 20–21.

12. For the texts and also for a rarely reproduced photograph that shows the relation of the posted texts to the ramp, see Robert Pincus-Witten, "Vito Acconci and the Conceptual Performance," *Artforum* 10 (April 1972), 48.

13. The entry for *Seedbed* in *Avalanche* 6 (Fall 1972), 62, gives the dates of the exhibition as January 15–29 but gives the year as 1971 rather than 1972, and indicates that he was there twice a week for six hours each day. The entry for the work in Gloria Moure, ed., *Vito Acconci: Writings, Works, Projects* (Barcelona: Ediciones Polígrafa, 2001), 154, also indicates that his presence under the ramp was intermittent, but describes it as "9 days, 8 hours a day, during a 3-week exhibition."

14. Acconci in "Excerpts from Tapes with Liza Béar," 72.

15. Florence Gilbard, "An Interview with Vito Acconci: Video Works 1970–78," *Afterimage* 12 (November 1984), 11.

16. See Carolee Schneemann, *More than Meat Joy: Performance Works and Selected Writings* (Kingston, New York: Documentext/ McPherson and Company, 1997), 234–239.

17. See the series of thirteen photographs relating to *Shoot* in the book designed and published by the artist, *Chris Burden: 71–73* (Los Angeles: Chris Burden, 1974), 24–33.

18. Judith F. Rodenbeck, "Foil: Allan Kaprow before Photography," in Benjamin H. D. Buchloh and Judith F. Rodenbeck, *Experiments in the Everyday: Allan Kaprow and Robert Watts—Events, Objects, Documents*

(New York: Miriam and Ira D. Wallach Art Gallery, Columbia University, 1999), 56.

19. Allan Kaprow described this process at the 2000 Wasserman Forum at MIT. He gave as his example of the circulation of his work through stories his essay "Just Doing," *The Drama Review* 41 (Fall 1997), 101–106.

20. See Annette Michelson, "Solving the Puzzle," in Catherine de Zegher, ed., *Martha Rosler: Positions in the Life World* (Birmingham, England; Vienna, Austria; and Cambridge, Mass.: Ikon Gallery, Generali Foundation, and MIT Press, 1998), 186–188.

21. See Nemser, "Interview with Vito Acconci," 23, and Lucy Lippard, *Six Years: The Dematerialization of the Art Object from 1966 to 1972* (1973; rpt. Berkeley: University of California Press, 1997), 117. The photo sequence is credited to Elizabeth Jackson in *Avalanche* 6 (Fall 1972), 1.

22. Ira Licht, *Bodyworks* (Chicago: Museum of Contemporary Art, 1975), n.p.

23. Laurie Anderson, "A Note on Documentation: The Orange Dog," quoted in Amelia Jones, *Body Art: Performing the Subject* (Minneapolis: University of Minnesota Press, 1998), 32–33.

24. Kathy O'Dell, *Contract with the Skin: Masochism, Performance Art, and the 1970s* (Minneapolis: University of Minnesota Press, 1998), 14.

25. Chris Dercon, "Keep Taking It Apart: An Interview with Bruce Nauman," *Parkett* 10 (September 1986), reprinted in *Bruce Nauman* (London: Hayward Gallery, 1998), 100. Nauman's reference is to interviews conducted for Coosje van Bruggen, *Bruce Nauman* (New York: Rizzoli, 1988).

26. Janine Antoni, conversation with the author, December 7, 2001.

27. Entry for *Stretch* in *Avalanche* 6 (Fall 1972), 6.

28. Lucy Lippard, "Two Proposals," introducing Piper, "An Ongoing Essay," and Eleanor Antin, "Proposal for a Film Festival Exhibition," *Art and Artists* 6 (March 1972), 44–47.

29. Antin, "Proposal for a Film Festival Exhibition," 47.

30. Eleanor Antin, *Los Angeles Institute of Contemporary Art Journal* 2 (October 1974), 20. The catalogue for the 1999 retrospective of Antin's work gives the date as 1972, a year earlier than in previous sources. See Howard N. Fox, *Eleanor Antin* (Los Angeles: Los Angeles County Museum of Art, 1999), 47.

31. John Coplans, "Concerning 'Various Small Fires': Ed Ruscha Discusses His Perplexing Publications," *Artforum* 3 (February 1965), 25. On the books as a precedent for conceptual art, see Benjamin H. D. Buchloh, "Conceptual Art 1962–1969: From

the Aesthetics of Administration to the Critique of Institutions," *October* 55 (Winter 1990), 105–143. On the amateur qualities associated with what he describes as photo-conceptualism, see also Jeff Wall, "'Marks of Indifference': Aspects of Photography in, or as, Conceptual Art," in Goldstein and Rorimer, *Reconsidering the Object of Art,* 246–267.

32. See Clive Phillpot, "Sixteen Books and Then Some," in *Edward Ruscha Editions 1959–1999: Catalogue Raisonné* (Minneapolis: Walker Art Center, 1999), vol. 2, 63–64 and 67.

33. The first articulation of this statement appeared in the catalogue *January 5–31, 1969* (New York: Seth Siegelaub, 1969), and it has subsequently been restated by Weiner, with slight variations in wording, for numerous exhibitions and publications.

34. See Alexander Alberro and Alice Zimmerman, "NOT HOW IT SHOULD WERE IT TO BE BUILT BUT HOW IT COULD WERE IT TO BE BUILT," in Alexander Alberro, Alice Zimmerman, Benjamin H. D. Buchloh, and David Batchelor, *Lawrence Weiner* (London: Phaidon Press, 1998), 48–49.

35. Letters from Konrad Fischer, Lawrence Weiner, and Jerald Ordover confirming the purchase of the statements and the registration of the title appear in the Panza Papers, Special Collections, Getty Library, series IIA, box 152, in the folders for LW1, LW2, and LW3.

36. See "Lawrence Weiner at Amsterdam" (interview), *Avalanche* 4 (Spring 1972), 66, and also Alberro and Zimmerman, "NOT HOW IT SHOULD WERE IT TO BE BUILT BUT HOW IT COULD WERE IT TO BE BUILT," 46.

37. "Lawrence Weiner at Amsterdam," 66.

38. On these exhibitions generally, see Bruce Altshuler, *The Avant-Garde in Exhibition: New Art in the 20th Century* (New York: Harry N. Abrams, 1994), 236–255. On the Siegelaub catalogues, see Lippard, *Six Years,* 71–74, 79–80, 106.

39. See Seth Siegelaub, *July, August, September, 1969: Carl Andre, Robert Barry, Daniel Buren, Jan Dibbets, Douglas Huebler, Joseph Kosuth, Sol LeWitt, Richard Long, N. E. Thing Co. Ltd., Robert Smithson, Lawrence Weiner* (printed in the United States of America, 1 July 1969), and Kynaston McShine, *Information* (New York: Museum of Modern Art, 1970).

40. Caroline A. Jones, *Machine in the Studio: Constructing the Postwar American Artist* (Chicago: University of Chicago Press, 1996), 334.

41. Jones, *Machine in the Studio,* 277, and Craig Owens, "Earthwords," *October* 10 (Fall 1979), 120–130, reprinted in Craig Owens, *Beyond Recognition: Representation, Power, and Culture,* ed. Scott Bryson et al. (Berkeley: University of California Press, 1992).

42. Robert Smithson in "Discussions with Heizer, Oppenheim, Smithson," *Avalanche* 1 (Fall 1970), 67, reprinted in *The Writings of Robert Smithson,* ed. Nancy Holt (New York: New York University Press, 1979), 177.

43. Robert Smithson, "Fragments of an Interview with P. A. Norvell, April, 1969," in Lippard, *Six Years,* 87 and 89. The full, unedited transcript of this interview has now been published in Alexander Alberro and Patricia Norvell, *Recording Conceptual Art: Early Interviews with Barry, Huebler, Kaltenbach, LeWitt, Morris, Oppenheim, Siegelaub, Smithson and Weiner by Patricia Norvell* (Berkeley: University of California Press, 2001), 124–134.

44. Gregoire Muller, ". . . The Earth, Subject to Cataclysms, Is a Cruel Master" (interview), in *Writings of Robert Smithson,* 181.

45. Robert Hobbs, *Robert Smithson: Sculpture* (Ithaca: Cornell University Press, 1981), 197.

46. Muller, ". . . The Earth, Subject to Cataclysms," 183.

47. Caroline Jones, "Preconscious/Posthumous Smithson," *Res* 41 (Summer 2002). She is discussing Robert A. Sobieszek, *Robert Smithson: Photo Works* (Los Angeles and Albuquerque: Los Angeles County Museum of Art and University of New Mexico Press, 1993), and Guglielmo Bargellesi-Severi, ed., *Robert Smithson: Slideworks* (Milan: Carlo Frua, 1997).

48. John Perreault, "Earth and Fire: Mendieta's Body of Work," in Petra Barreras del Rio and John Perreault, *Ana Mendieta: A Retrospective* (New York: New Museum of Contemporary Art, 1987), 13.

49. See the checklist in del Rio and Perreault, *Ana Mendieta: A Retrospective,* 64–68. Mendieta died under still mysterious circumstances in a fall from the apartment of her husband Carl Andre, who was tried and acquitted on charges of second-degree murder.

50. See Mary Sabbatino, "Ana Mendieta: Identity and the *Silueta Series,*" in Gloria Moure, *Ana Mendieta* (Santiago de Compostela: Centro Galego de Arte Contemporánea, 1996), 136.

51. Linda Montano, "An Interview with Ana Mendieta," *Sulfur* 8, no. 1 (Spring 1988), 66, which is part of the section "'Earth from Cuba, Sand from Varadero': A Tribute to Ana Mendieta," 54–114. The interview is reprinted, with slight changes in wording, in Linda Montano, *Performance Artists Talking in the Eighties* (Berkeley: University of California Press, 2000), 395.

52. Hans Breder described the making of the work at a site he identifies as Yaagul, a Zapotec site, though he remembers the event as part of the 1976 trip to Oaxaca that generated *Anima,* which he also describes. See Hans Breder, "Ana Mendieta: Imprints / Student Years 1972–1977," *Sulfur* 8, no. 1 (Spring 1988), 74–76.

53. Miwon Kwon, "Bloody Valentines: After-images by Ana Mendieta," in Catherine de Zegher, ed., *Inside the Visible: An Elliptical Traverse of 20th Century Art* (Boston and Cambridge: Institute of Contemporary Art and MIT Press, 1996), 169.

54. Cornelia Parker, entry for *Drowned Monuments,* in *Cornelia Parker: Neither from nor Towards* (Berlin: Galerie Eigen + Art, 1992), n.p.

55. "Benjamin Buchloh Interviews Gabriel Orozco in New York," in *Gabriel Orozco* (Paris: Musée d'Art Moderne de la Ville de Paris, 1998), 31.

56. The notebook page is reproduced in Spanish, accompanied by an English translation, in Gabriel Orozco, *Photogravity,* ed. Morgen Cheshire (Philadelphia: Philadelphia Museum of Art, 1999), 100, 103.

57. Notebook page, reproduced and translated, in Orozco, *Photogravity,* 160–163.

58. See the images from the notebook, description, and translation, in Orozco, *Photogravity,* 78, 79, 90–91, 94–95.

59. Nauman entry in Harald Szeemann, *When Attitudes Become Form: Works—Concepts—Processes—Situations—Information: Live in Your Head* (Bern: Kunsthalle Bern, 1969), n.p.

60. Joan Simon, "Breaking the Silence: An Interview with Bruce Nauman," *Art in America* 76 (September 1988), reprinted in *Bruce Nauman* (Hayward Gallery), 110.

61. Willoughby Sharp, "Nauman Interview," *Arts Magazine* 44 (March 1970), 25.

62. See van Bruggen, *Bruce Nauman,* 236.

63. Sharp, "Nauman Interview," 23.

64. On the references to Duchamp in this and other works, see Joanna Frueh, *Hannah Wilke: A Retrospective,* ed. Thomas H. Kochheiser, with writings by Hannah Wilke (Columbia: University of Missouri Press, 1989).

65. "Pinhole Photography" (interview with Ann Hamilton), on the website for the PBS series "Art:21": http://www.pbs.org/art21/artists/hamilton/clip2.html.

66. See the list of objects, sounds, and videos derived from installations in *The Body and the Object: Ann Hamilton 1984–1996* (Columbus: Wexner Center for the Arts, 1996), 72–83.

67. The statement appears in *Janine Antoni* (Küsnacht, Switzerland: Ink Tree Edition, 2000), 98.

68. Antoni, conversation with the author, December 7, 2001.

69. Ibid.

70. Janine Antoni to Mona Hatoum, in Janine Antoni, "Mona Hatoum" (interview), *Bomb* 63 (Spring 1998), 59.

71. Hatoum to Antoni, in ibid., 59.

72. Antoni to Hatoum, in ibid., 57.

73. See Mona Hatoum's account in "Interview with Sara Diamond 1987," reprinted in Michael Archer, Guy Brett, and Catherine de Zegher, *Mona Hatoum* (London: Phaidon Press, 1997), 137–138.

74. Hatoum to Antoni, in Antoni, "Mona Hatoum," 60.

75. Antoni, introduction to "Mona Hatoum," 54.

SELECTED BIBLIOGRAPHY

Alberro, Alexander, and Patricia Norvell, eds. *Recording Conceptual Art: Early Interviews with Barry, Huebler, Kaltenbach, LeWitt, Morris, Oppenheim, Siegelaub, Smithson, and Weiner by Patricia Norvell.* Berkeley: University of California Press, 2001.

Alberro, Alexander, and Blake Stimson, eds. *Conceptual Art: A Critical Anthology.* Cambridge: MIT Press, 1999.

Alberro, Alexander, Alice Zimmerman, Benjamin H. D. Buchloh, and David Batchelor. *Lawrence Weiner.* London: Phaidon Press, 1998.

Altshuler, Bruce. *The Avant-Garde in Exhibition: New Art in the 20th Century.* New York: Abrams, 1994.

Archer, Michael, Guy Brett, and Catherine de Zegher. *Mona Hatoum.* London: Phaidon Press, 1997.

Armstrong, Richard, and Richard Marshall, eds. *The New Sculpture 1965–75: Between Geometry and Gesture.* New York: Whitney Museum of American Art, 1990.

Arning, Bill, et al. *Sturtevant.* Stuttgart: Württembergischer Kunstverein Stuttgart, 1992.

Asher, Michael. *Writings 1973–1983 on Works 1969–1979.* Ed. Benjamin H. D. Buchloh. Halifax and Los Angeles: Nova Scotia College of Art and Design and Museum of Contemporary Art, 1983.

Baier, Lesley K., ed. *Mel Bochner: Thought Made Visible 1966–1973.* New Haven: Yale University Art Gallery, 1995.

Barthes, Roland. *Image, Music, Text.* Trans. Stephen Heath. New York: Hill and Wang, 1977.

Bartman, William S., ed. *Allan McCollum.* Interview by Thomas Lawson. Los Angeles: A.R.T. Press, 1996.

Bartman, William S., ed. *Felix Gonzalez-Torres.* Los Angeles: A.R.T. Press, 1993.

Bashkoff, Tracy, and Nancy Spector. *Sugimoto Portraits.* New York: Guggenheim Museum Publications, 2000.

Battcock, Gregory, ed. *Idea Art.* New York: E. P. Dutton, 1973.

Battcock, Gregory, ed. *Minimal Art: A Critical Anthology.* New York: E. P. Dutton, 1968.

Benjamin, Walter. *Illuminations.* Trans. Harry Zohn. New York: Schocken Books, 1969.

Berger, Maurice. *Labyrinths: Robert Morris, Minimalism, and the 1960s.* New York: Harper and Row, 1989.

Blume, Anna. *Secession: Zoe Leonard.* Vienna: Wiener Secession, 1997.

Bois, Yve-Alain. *Donald Judd: New Sculpture.* New York: Pace Gallery, 1991.

Bolton, Richard, ed. *The Contest of Meaning: Critical Histories of Photography.* Cambridge: MIT Press, 1990.

Bolton, Richard, ed. *Culture Wars: Documents from the Recent Controversies in the Arts.* New York: New Press, 1992.

Bonk, Ecke. *Duchamp: The Box in a Valise.* Trans. David Britt. New York: Rizzoli, 1989.

Borja-Villel, Manuel J. *The End(s) of the Museum.* Barcelona: Fundació Antoni Tàpies, 1995.

Bourdieu, Pierre. *Distinction: A Social Critique of the Judgement of Taste.* Trans. Richard Niece. Cambridge: Harvard University Press, 1984.

Bourdon, David. *Carl Andre: Sculpture 1959–1977.* Foreword by Barbara Rose. New York: Jaap Rietman, 1978.

Bronson, A. A., and Peggy Gale, eds. *Museums by Artists.* Toronto: Art Metropole, 1983.

Broude, Norma, and Mary D. Garrard, eds. *The Power of Feminst Art: The American Movement of the 1970s, History and Impact.* New York: Harry N. Abrams, 1994.

Bruggen, Coosje van. *Bruce Nauman.* New York: Rizzoli, 1988.

Bruggen, Coosje van. *John Baldessari.* New York: Rizzoli, 1990.

Buchloh, Benjamin H. D. "Conceptual Art 1962–1969: From the Aesthetics of Administration to the Critique of Institutions." *October* 55 (Winter 1990), 105–143.

Buchloh, Benjamin H. D. *Gerhard Richter.* New York: Marian Goodman Gallery, 1993.

Buchloh, Benjamin H. D. *Neo-Avantgarde and Culture Industry: Essays on European and American Art from 1955 to 1975.* Cambridge: MIT Press, 2000.

Buchloh, Benjamin H. D., et al. *Gabriel Orozco.* Paris: Musée d'Art Moderne de la Ville de Paris, 1998.

Buchloh, Benjamin H. D., and Judith F. Rodenbeck. *Experiments in the Everyday: Allan Kaprow and Robert Watts—Events, Objects, Documents.* New York: Miriam and Ira D. Wallach Art Gallery, Columbia University, 1999.

Bürger, Peter. *Theory of the Avant-Garde.* Trans. Michael Shaw. Minneapolis: University of Minnesota Press, 1984.

Bürgi, Bernhard, ed. *Sherrie Levine.* Essay by David Deitcher. Zurich: Kunsthalle Zürich, 1991.

Buskirk, Martha, and Mignon Nixon, eds. *The Duchamp Effect: Essays, Interviews, Round Table.* Cambridge: MIT Press, 1996.

Bussmann, Klaus, Kasper König, and Florian Matzner, eds. *Contemporary Sculpture: Projects in Münster 1997.* Ostfildern-Ruit, Germany: Verlag Gerd Hatje, 1997.

Cabanne, Pierre. *Dialogues with Marcel Duchamp.* Trans. Ron Padgett. New York: Da Capo Press, 1979.

Cameron, Dan, et al. *Janine Antoni.* Küsnacht, Switzerland: Ink Tree Edition, 2000.

Camnitzer, Luis, Jane Farver, and Rachel Weiss. *Global Conceptualism: Points of Origin 1950s–1980s.* New York: Queens Museum, 1999.

Clifford, James. *The Predicament of Culture: Twentieth-Century Ethnography, Literature, and Art.* Cambridge: Harvard University Press, 1988.

Colacello, Bob. *Holy Terror: Andy Warhol Close Up.* New York: HarperCollins, 1990.

Corrin, Lisa G., ed. *Mining the Museum: An Installation by Fred Wilson.* Baltimore and New York: The Contemporary and The New Press, 1994.

Corrin, Lisa Graziose, Miwon Kwon, and Norman Bryson. *Mark Dion.* London: Phaidon Press, 1997.

Corzo, Miguel Angel. *Mortality Immortality? The Legacy of 20th-Century Art.* Los Angeles: Getty Conservation Institute, 1999.

Crimp, Douglas. *On the Museum's Ruins.* Cambridge: MIT Press, 1993.

Crone, Rainer. *Andy Warhol.* New York: Praeger, 1970.

Crow, Thomas. *Modern Art in the Common Culture.* New Haven: Yale University Press, 1996.

de Duve, Thierry, ed. *The Definitively Unfinished Marcel Duchamp.* Cambridge: MIT Press, 1991.

de Duve, Thierry. *Kant after Duchamp.* Cambridge: MIT Press, 1996.

del Rio, Petra Barreras, and John Perreault. *Ana Mendieta: A Retrospective.* New York: New Museum of Contemporary Art, 1987.

De Salvo, Donna. *Past Imperfect: A Museum Looks at Itself.* With essays by Maurice Berger and Alan Wallach. Southhampton and New York: Parrish Art Museum and New Press, 1993.

De Salvo, Donna, and Paul Schimmel. *Hand-Painted Pop: American Art in Transition 1955–62.* Los Angeles and New York: Museum of Contemporary Art and Rizzoli, 1993.

Deutsche, Rosalyn. *Evictions: Art and Spatial Politics.* Cambridge: MIT Press, 1996.

de Zegher, Catherine. *Inside the Visible: An Elliptical Traverse of 20th Century Art in, of, and from the Feminine.* Boston and Cambridge: Institute of Contemporary Art and MIT Press, 1996.

Duchamp, Marcel. *The Writings of Marcel Duchamp.* Ed. Michel Sanouillet and Elmer Peterson. 1973; rpt. New York: Da Capo Press, 1989.

Duncan, Carol. *The Aesthetics of Power: Essays in Critical Art History.* Cambridge: Cambridge University Press, 1993.

Elger, Dietmar. *Felix Gonzalez-Torres: Catalogue Raisonné.* Ostfildern-Ruit, Germany: Cantz, 1997.

Elger, Dietmar, and Thomas Weski. *Louise Lawler: For Sale*. Ostfildern, Germany: Cantz, 1994.

Elsner, John, and Roger Cardinal. *The Cultures of Collecting*. Cambridge: Harvard University Press, 1994.

Engberg, Siri, and Clive Phillpot. *Edward Ruscha Editions 1959–1999: Catalogue Raisonné*. Minneapolis: Walker Art Center, 1999.

Farver, Jane. *Adrian Piper: Reflections 1967–1987*. New York: Alternative Museum, 1987.

Feldman, Franklin, Stephen E. Weil, and Susan Duke Biederman. *Art Law: Rights and Liabilities of Creators and Collectors*. 2 vols. Boston: Little, Brown, 1986.

Fer, Briony. *On Abstract Art*. New Haven: Yale University Press, 1997.

Ferguson, Russell, Martha Gever, Trinh T. Minh-ha, and Cornel West, eds. *Out There: Marginalization and Contemporary Cultures*. New York and Cambridge: New Museum of Contemporary Art and MIT Press, 1990.

Flood, Richard, et al. *Robert Gober: Sculpture and Drawing*. Minneapolis: Walker Art Center, 1999.

Foster, Hal, ed. *The Anti-Aesthetic: Essays on Postmodern Culture*. Seattle: Bay Press, 1983.

Foster, Hal. *The Return of the Real: The Avant-Garde at the End of the Century*. Cambridge: MIT Press, 1996.

Foucault, Michel. *Language, Counter-Memory, Practice*. Trans. Donald F. Bouchard and Sherry Simon. Ithaca: Cornell University Press, 1977.

Fox, Howard N. *Eleanor Antin*. Los Angeles: Los Angeles County Museum of Art, 1999.

Freshman, Phil, ed. *Public Address: Krzysztof Wodiczko*. Minneapolis: Walker Art Center, 1992.

Frueh, Joanna. *Hannah Wilke: A Retrospective*. Ed. Thomas H. Kochheiser, with writings by Hannah Wilke. Columbia: University of Missouri Press, 1989.

Fusco, Coco. *English Is Broken Here*. New York: New Press, 1995.

Garrels, Gary. *Public Information: Desire, Disaster, Document*. Essays by Jim Lewis, Sandra S. Phillips, Christopher Phillips, Abigail Solomon-Godeau, and Robert R. Riley. San Francisco: San Francisco Museum of Modern Art, 1994.

Glenn, Constance W. *The Great American Pop Art Store: Multiples of the Sixties*. Santa Monica: Smart Art Press, 1997.

Goldstein, Ann, and Anne Rorimer. *Reconsidering the Object of Art, 1965–1975*. With essays by Lucy R. Lippard, Stephen Melville, and Jeff Wall. Los Angeles and Cambridge: Museum of Contemporary Art and MIT Press, 1995.

Götz, Stephan. *American Artists in Their New York Studios: Conversations about the Creation of Contemporary Art*. Cambridge and Stuttgart: Center for Conservation and Technical Studies, Harvard Art Museums, and Daco-Verlag Gunter Blase, 1992.

Greenberg, Clement. *The Collected Essays and Criticism*. Ed. John O'Brian. 4 vols. Chicago: University of Chicago Press, 1986–1993.

Greenberg, Reesa, Bruce W. Ferguson, and Sandy Nairne, eds. *Thinking about Exhibitions.* London: Routledge, 1996.

Guilbaut, Serge. *How New York Stole the Idea of Modern Art: Abstract Expressionism, Freedom, and the Cold War.* Chicago: University of Chicago Press, 1983.

Guilbaut, Serge, ed. *Reconstructing Modernism: Art in New York, Paris, and Montreal 1945–1964.* Cambridge: MIT Press, 1990.

Halbreich, Kathy, and Neal Benezra. *Bruce Nauman.* Minneapolis: Walker Art Center, 1994.

Hapgood, Susan. *Neo-Dada: Redefining Art, 1958–60.* New York: Universe and American Federation of Arts, 1994.

Haskell, Barbara. *Blam! The Explosion of Pop, Minimalism, and Performance 1958–64.* New York: Whitney Museum of American Art and W. W. Norton, 1984.

Hendricks, Jon, and Jean Toche. *GAAG: The Guerrilla Art Action Group, 1969–1976, a Selection.* New York: Printed Matter, 1978.

Johnson, Ellen H. *Modern Art and the Object.* New York: Harper and Row, 1976.

Jones, Amelia. *Body Art: Performing the Subject.* Minneapolis: University of Minnesota Press, 1998.

Jones, Caroline A. *Machine in the Studio: Constructing the Postwar American Artist.* Chicago: University of Chicago Press, 1996.

Jones, Mark, ed. *Fake? The Art of Deception.* Berkeley: University of California Press, 1990.

Joselit, David. *Infinite Regress: Marcel Duchamp, 1910–1941.* Cambridge: MIT Press, 1998.

Judd, Donald. *Complete Writings 1959–1975.* Halifax and New York: Press of the Nova Scotia College of Art and Design and New York University Press, 1975.

Judd, Donald. "Una stanza per Panza." *Kunst Intern* (May, July, September, and November 1990); issued in English as a separate four-part pamphlet.

Judovitz, Dalia. *Unpacking Duchamp: Art in Transit.* Berkeley: University of California Press, 1995.

Kaprow, Allan. *Essays on the Blurring of Art and Life.* Ed. Jeff Kelley. Berkeley: University of California Press, 1993.

Karp, Ivan, and Steven D. Lavine, eds. *Exhibiting Cultures: The Poetics and Politics of Museum Display.* Washington: Smithsonian Institution Press, 1991.

Knight, Christopher. *Art of the Sixties and Seventies: The Panza Collection.* Interview with Giuseppe Panza by Christopher Knight. Preface by Richard Koshaleck and Sherri Geldin. New York: Rizzoli, 1988. Rev. ed.: *Art of the Fifties, Sixties and Seventies.* Milan: Editoriale Jaca Book, 1999.

Kolbowski, Silvia. *XI Projects.* Texts by Johanne Lamoureux, Lynne Tillman, and Rainer Ganahl. New York: Border Editions, c. 1992.

Krauss, Rosalind E. *Bachelors.* Cambridge: MIT Press, 1999.

Krauss, Rosalind E. *The Originality of the Avant-Garde and Other Modernist Myths.* Cambridge: MIT Press, 1985.

Krauss, Rosalind E. *Passages in Modern Sculpture.* Cambridge: MIT Press, 1981.

Krauss, Rosalind E. "Reinventing the Medium." *Critical Inquiry* 25 (Winter 1999), 296–297.

Krauss, Rosalind E., ed. *Retaining the Original: Multiple Originals, Copies, and Reproductions.* Washington: National Gallery of Art, 1989.

Krauss, Rosalind E. *Richard Serra: Sculpture.* New York: Museum of Modern Art, 1986.

Krauss, Rosalind E. *"A Voyage on the North Sea": Art in the Age of the Post-Medium Condition.* London: Thames and Hudson, 2000.

Krauss, Rosalind E., and Thomas Krens. *Robert Morris: The Mind/Body Problem.* New York: Guggenheim Museum, 1994.

Kwon, Miwon. *One Place after Another: Site-Specific Art and Locational Identity.* Cambridge: MIT Press, 2002.

Legg, Alicia, ed. *Sol LeWitt.* With essays by Lucy Lippard, Robert Rosenblum, and Bernice Rose. New York: Museum of Modern Art, 1978.

Leval, Pierre N. "Toward a Fair Use Standard." *Harvard Law Review* 103 (March 1990), 1105–1136.

LeWitt, Sol. *Sol LeWitt: Critical Texts.* Ed. Adachiara Zevi. Rome: I Libri de AEIOU, 1994.

Linker, Kate. *Vito Acconci.* New York: Rizzoli, 1994.

Lipman, Jean, and Richard Marshall. *Art about Art.* New York: E. P. Dutton, 1978.

Lippard, Lucy. *Eva Hesse.* New York: New York University Press, 1976.

Lippard, Lucy. *Six Years: The Dematerialization of the Art Object from 1966 to 1972.* 1973; rpt. Berkeley and Los Angeles: University of California Press, 1997.

Malraux, André. *Museum without Walls.* Trans. Stuart Gilbert and Francis Price. Garden City, New York: Doubleday, 1967.

Mamiya, Christin J. *Pop Art and Consumer Culture: American Super Market.* Austin: University of Texas Press, 1992.

Markonish, Denise, et al. *Mark Dion: New England Digs.* Brockton, Massachusetts: Fuller Museum of Art, 2001.

Marshall, Richard. *Immaterial Objects: Works from the Permanent Collection of the Whitney Museum of American Art, New York.* New York: Whitney Museum, 1989.

McShine, Kynaston, ed. *Andy Warhol: A Retrospective.* Essays by Robert Rosenblum, Benjamin H. D. Buchloh, and Marco Livingstone. New York: Museum of Modern Art, 1989.

McShine, Kynaston. *Information.* New York: Museum of Modern Art, 1970.

Merryman, John Henry, and Albert E. Elsen. *Law, Ethics, and the Visual Arts.* 2d ed. 2 vols. Philadelphia: University of Pennsylvania Press, 1987.

Meyer, James. *Minimalism: Art and Polemics in the Sixties.* New Haven: Yale University Press, 2001.

Meyer, Ursula. *Conceptual Art.* New York: E. P. Dutton, 1972.

Miller-Keller, Andrea. *Sol LeWitt Wall Drawings 1968–84.* Amsterdam: Stedelijk Museum, 1984.

Montano, Linda. *Performance Artists Talking in the Eighties.* Berkeley: University of California Press, 2000.

Morgan, Jessica. *Cornelia Parker.* Boston: Institute of Contemporary Art, 2000.

Moure, Gloria, ed. *Vito Acconci: Writings, Works, Projects.* Barcelona: Ediciones Polígrafa, 2001.

Naumann, Francis M. *Marcel Duchamp: The Art of Making Art in the Age of Mechanical Reproduction.* Ghent and New York: Ludion Press and Harry N. Abrams, 1999.

O'Dell, Kathy. *Contract with the Skin: Masochism, Performance Art, and the 1970s.* Minneapolis: University of Minnesota Press, 1998.

O'Doherty, Brian. *Inside the White Cube: The Ideology of the Gallery Space.* Introduction by Thomas McEvilley. San Francisco: Lapis Press, 1986.

Ottmann, Klaus. *Wolfgang Laib: A Retrospective.* New York and Ostfildern/Ruit, Germany: American Federation of Arts and Hatje Cantz Publishers, 2000.

Owens, Craig. *Beyond Recognition: Representation, Power, and Culture.* Ed. Scott Bryson et al. Berkeley: University of California Press, 1992.

Pagé, Suzanne. *Un choix d'art minimal dans la Collection Panza.* Interview with Giuseppe Panza de Biumo by Suzanne Pagé and Juliette Laffon. Essay by Phyllis Tuchman. Paris: Musée d'Art Moderne de la Ville de Paris, 1990.

Peraza, Nilda, et al. *The Decade Show: Frameworks of Identity in the 1980s.* New York: Museum of Contemporary Hispanic Art, New Museum of Contemporary Art, and the Studio Museum in Harlem, 1990.

Piper, Adrian. *Out of Order, Out of Sight.* Cambridge: MIT Press, 1996.

Reise, Barbara. "A Tail of Two Exhibitions: The Aborted Haacke and Robert Morris Shows." *Studio International* 182 (July–August 1971), 30–37.

Reiss, Julie H. *From Margin to Center: The Spaces of Installation.* Cambridge: MIT Press, 1999.

Reitlinger, Gerald. *The Economics of Taste: The Rise and Fall of the Picture Market 1760–1960.* 3 vols. New York: Holt, Rinehart and Winston, 1961.

Richardson, Brenda. *Bruce Nauman: Neons.* Baltimore: Baltimore Museum of Art, 1983.

Richter, Gerhard. *The Daily Practice of Painting: Writings and Interviews 1962–1993.* Ed. Hans-Ulrich Obrist. Trans. David Britt. Cambridge and London: MIT Press and Anthony d'Offay Gallery, 1995.

Rogers, Sarah. *The Body and the Object: Ann Hamilton, 1984–1996.* Columbus: Wexner Center for the Arts, 1996.

Rogers-Lafferty, Sarah. *James Welling: Photographs, 1974–1999.* Columbus: Wexner Center for the Arts, 2000.

Rorimer, Anne. *New Art in the 60s and 70s: Redefining Reality.* London: Thames and Hudson, 2001.

Rowell, Margit. *Objects of Desire: The Modern Still Life.* New York: Museum of Modern Art and Harry N. Abrams, 1997.

Schaffner, Ingrid, and Matthias Winzen, ed. *Deep Storage: Collecting, Storing, and Archiving in Art.* Munich: Prestel, 1998.

Schneemann, Carolee. *More than Meat Joy: Performance Works and Selected Writings.* Kingston, New York: Documentext/McPherson and Company, 1997.

Scholder, Amy, ed. *Fever: The Art of David Wojnarowicz.* New York: New Museum and Rizzoli, 1999.

Schwander, Martin, ed. *Richard Serra: Intersection.* Basel: Christoph Merian Verlag, 1996.

Schwarz, Arturo. *The Complete Works of Marcel Duchamp.* New York: Abrams, 1969. Third rev. ed.: Delano Greenridge Editions, 1997.

Serra, Richard. *Writings/Interviews.* Chicago: University of Chicago Press, 1994.

Siegel, Jeanne, ed. *Art Talk: The Early 80s.* New York: Da Capo Press, 1988.

Siegel, Jeanne, ed. *Artwords: Discourse on the 60s and 70s.* New York: Da Capo Press, 1992.

Siegelaub, Seth. *January 5–31, 1969.* New York: Seth Siegelaub, 1969.

Singer, Susanna, ed. *Sol LeWitt: Drawings 1958–1992.* The Hague: Haags Gemeentemuseum, 1992.

Singerman, Howard. *Art Subjects: Making Artists in the American University.* Berkeley: University of California Press, 1999.

Smith, Brydon. *Donald Judd: Catalogue of the Exhibition at the National Gallery of Canada, Ottawa, 24 May–6 July, 1975, and Catalogue Raisonné of the Painting, Objects, and Wood Blocks, 1960–1974.* Ottawa: National Gallery of Canada, 1975.

Smithson, Robert. *The Writings of Robert Smithson.* Ed. Nancy Holt. New York: New York University Press, 1979.

Solomon-Godeau, Abigail. *Photography at the Dock: Essays on Photographic History, Institutions, and Practice.* Minneapolis: University of Minnesota Press, 1991.

Spector, Nancy. *Felix Gonzalez-Torres.* New York: Solomon R. Guggenheim Museum, 1995.

Staniszewski, Mary Anne. *The Power of Display: A History of Exhibition Installations at the Museum of Modern Art.* Cambridge: MIT Press, 1998.

Stewart, Susan. *On Longing: Narratives of the Miniature, the Gigantic, the Souvenir, the Collection.* Durham: Duke University Press, 1993.

Stiles, Kristine, and Peter Selz, ed. *Theories and Documents of Contemporary Art: A Sourcebook of Artists' Writings.* Berkeley: University of California Press, 1996.

Stoops, Susan L. *More than Minimal: Feminism and Abstraction in the '70s.* Waltham, Massachusetts: Rose Art Museum, 1996.

Storr, Robert. *Chuck Close.* New York: Museum of Modern Art, 1998.

Storr, Robert. *Dislocations.* New York: Museum of Modern Art and Harry N. Abrams, 1991.

Storr, Robert. *Gerhard Richter: October 18, 1977.* New York: Museum of Modern Art, 2000.

Sussman, Elisabeth, ed. *Eva Hesse.* San Francisco: San Francisco Museum of Modern Art, 2002.

Szeemann, Harald. *When Attitudes Become Form: Works—Concepts—Processes—Situations—Information: Live in Your Head.* Bern: Kunsthalle Bern, 1969.

Temkin, Ann, and Susan Rosenberg. *Gabriel Orozco: Photogravity.* Ed. Morgen Cheshire. Philadelphia: Philadelphia Museum of Art, 1999.

Tucker, Marcia, and James Monte. *Anti-Illusion: Procedures/Materials.* New York: Whitney Museum of American Art, 1969.

Vergo, Peter, ed. *The New Museology.* London: Reaktion Books, 1989.

Wallach, Alan. *Exhibiting Contradiction: Essays on the Art Museum in the United States.* Amherst: University of Massachusetts Press, 1998.

Wallis, Brian, ed. *Hans Haacke: Unfinished Business.* New York and Cambridge: New Museum of Contemporary Art and MIT Press, 1986.

Warhol, Andy. *The Philosophy of Andy Warhol. From A to B and Back Again.* New York: Harcourt Brace Jovanovich, 1975.

Warhol, Andy, and Pat Hackett. *Popism: The Warhol '60s.* New York: Harcourt Brace Jovanovich, 1980.

Weyergraf-Serra, Clara, and Martha Buskirk, eds. *The Destruction of Tilted Arc: Documents.* Cambridge: MIT Press, 1990.

Wright, Beryl J., ed. *Art at the Armory: Occupied Territory.* Essays by Robert Bruegmann, Anne Rorimer, and Beryl J. Wright. Chicago: Museum of Contemporary Art, 1992.

Zelevansky, Lynn. *Sense and Sensibility: Women Artists and Minimalism in the Nineties.* New York: Museum of Modern Art, 1994.

INDEX

Page numbers in boldface indicate illustrations.

Abstract expressionism, 66, 76, 80, 110, 118, 120–121

Abstraction, 7, 80, 110, 120, 155, 205
abstract forms and spatial experience, 23, 27, 137–139, 254
as a function of copying or transcription, 61, 97–98, 101, 184, 256–258
play between abstraction and representation, 12, 61, 117, 120, 149, 249

Acconci, Vito, 213, 215–221, 224–225, 233
Following Piece, 215–217, **216,** 219–221, 224
Proximity Piece, 215, 218
Seedbed, 213, 215, 218–220

Ace Gallery, 1–3, 35–37, 41, 45, 51, 233

Actions. *See* Performance

Ad Hoc Women Artists' Group, 167

AIDS, 63, 145, 155, 198

American Family Association, 88

Andre, Carl, 2–3, 23, 27–31, 45, 49
Equivalents I–VIII, **29,** 30–31
Fall, 2–3, 45, **47**
Twelfth Copper Corner, 27–30, **28**

"Anti-Illusion: Procedures, Materials" (Whitney Museum), 132–134, 136, 246

Antin, Eleanor, 115, 225–226
Carving: A Traditional Sculpture, 225–226, **227**

Antoni, Janine, 7–11, 137–143, 158, 224, 251–254, 256–258
Eureka, 142, **144**
Gnaw, 7–11, **9, 13,** 137–140, **138, 139,** 142
Lick and Lather, 140–142, **141,** 158
Mortar and Pestle, 251–252, **253**
Slumber, 256–258, **257, 259**

Appropriation, 65, 67, 76, 83–84, 87, 90–95, 102, 183, 186, 200

Armstrong, Carol, 123, 125

Arning, Bill, 84

Artifacts and relics, 43, 142, 187–193, 236–237, 249

Artists' Authorship Rights Act, New York, 90

Art Workers Coalition (AWC), 51, 167

Asher, Michael, 53, 134, 171–175, 203–207
installation at "73rd American Exhibition," Art Institute of Chicago, 171–173, **172**

Asher, Michael (cont.)
 *Painting and Sculpture from the Museum of
 Modern Art: Catalog of Deaccessions 1929
 through 1998 by Michael Asher,* 174–175,
 176–177
 "Skulptur" installation, 203–207, **204, 206,
 207**
Audience, 16, 195, 203, 213, 217–221, 235, 251
 audience or viewer participation, 139, 142,
 149, 152, 215, 218–219, 246
Auster, Paul, 223
Authenticity, 174, 182, 200. *See also* Author-
 ship
 as a function of the original, 71–72, 182
 internal versus external evidence of, 5, 26,
 34, 53, 56, 154, 168
Authorship. *See also* Authenticity; Copyright;
 Moral or integrity rights
 as an act of designation or arrangement, 1–
 3, 10, 15, 63, 105, 154, 171, 183, 200, 203,
 208, 243
 based on stylistic unity, 8–11, 129, 186
 as a classification system, 5–6, 8, 10, 15, 24,
 66, 102, 105, 114, 127, 171, 182, 186, 233,
 235
 internal versus external evidence of, 3–5, 8,
 15–16, 23–24, 26–27, 34, 77
 and issues of authority, 1–3, 6, 24–25, 27, 31,
 35–36, 38–42, 45, 49–53, 56, 70, 73
 layering of, 78, 82–84, 86, 89, 102, 105, 171,
 183
 and mass production, 78, 80, 91
 and property rights, 81, 84–85, 87–88, 91,
 93
 as a vehicle for heterogeneity, 8–11, 65, 90–
 91, 129, 166, 243
 withdrawal or failure of, 1–2, 25, 27, 30, 36,
 39
Avalanche, 217, 218, 233
Avant-garde, 62, 65, 67–68, 70, 73, 105, 111
Aycock, Alice, 220

Baldessari, John, 168
Ballantine, Peter, 41
Barry, Robert, 229
Barthes, Roland, 23
Battcock, Gregory, 34
Béar, Liza, 215
Beebe, Morton, 88
Benjamin, Walter, 65–66, 72
Berlin, Brigid, 74, 76, 78
Bernstein, Cheryl (Carol Duncan), 34, 83
Beuys, Joseph, 139–140, 152, 219
Bianchini Gallery, 78, 82
Blake, Nayland, 149–151
 Feeder 2, 149–151, **150**
 Gorge, 149–150, **151**
Blum, Anna, 145
Bochner, Mel, 26
Body
 in action or performance, 12, 134, 137, 140,
 191, 193, 215, 235–236, 244, 251
 fragmented, 62, 116, 147, 191, 246, 254
 mark or trace of, 7–8, 137–143, 193, 224,
 236, 243–258
 play between presence and absence, 139–
 142, 220, 223–226, 236, 243–258
 symbolic equivalent, 142, 155, 243
Bourdieu, Pierre, 183
Bourdon, David, 76
Brancusi, Constantin, 64, 80
Brand names and trademarks, 64, 67, 77–78,
 94, 137, 139
Breder, Hans, 236
Broodthaers, Marcel, 127, 173, 178
Bruggen, Coosje van, 224
Buchloh, Benjamin, 26, 35, 53, 118–119, 120
Bunnell, Peter, 114
Burden, Carter, 33
Burden, Chris, 219
Buren, Daniel, 169
Bürger, Peter, 67–68
Burton, Scott, 133

Cage, John, 224

Calle, Sophie, 221–223

 The Shadow (Detective), 221–223, **222**

Camfield, William, 64

Campbell, Barbara, 93

Cardiff, Janet, 203

Carey, Ted, 76

Castelli, Leo, 35, 66

 Gallery, 35, 37, 41, 81, 86, 132, 133, 134

Casts, 7–8, 61, 64, 66, 71–73, 80, 95, 97, 105,
 133–134, 140, 142, 158, 173, 178–179, 184,
 238, 244, 246. *See also* Copies

Caulfield, Patricia, 84–87, 94

 photograph of hibiscus flowers, 84–86, **85**

Certificates and contracts, 3, 4, 14–15, 24, 26,
 30, 34–38, 42, 43, 45–46, 48–49, 51, 53,
 56, 154–155, 198. *See also* Documentation

Cézanne, Paul, 65, 109, 110

Chocolate, 7–10, 137, 139, 140, 142, 149, 158

Christmas, Douglas, 35

Clert, Iris, 223

Close, Chuck, 121–123

 Robert/Fingerprint, 122, **124**

Colacello, Bob, 78

Coleman, James, 151

Collecting, 3–4, 6, 8, 12, 16, 25, 34–39, 42–43,
 45–46, 48, 152, 235

 by artists, 10, 173, 186–187, 190–191, 238

 by museums, 10, 11, 24–25, 27, 30, 63, 70–
 72, 129, 163–167, 184, 186

 through reproductions, 65, 68, 72, 186,
 190–191, 226

 as subject, 169–171, 175–184, 187, 191, 193

Commodities and commodification, 15, 64,
 67, 80–81, 87, 91–95

Conceptual art, 6, 11, 26, 34–36, 39, 45, 98, 129,
 133, 134, 136, 215, 217, 223, 238, 243–
 244

 as a basis for subsequent practices, 98, 115,
 137, 149, 152–154, 158, 187, 193–195, 203,
 238, 243

 and emphasis on idea or dematerialization,
 6, 26, 48, 56, 68, 136, 221, 223, 228–229

 and institutional critique, 165, 167, 173

 and minimal art, 6, 23, 26–27, 34–36, 38–
 42, 53, 56, 154

 and performance, 114, 215, 217, 223

 and photography, 114, 151–152, 166, 223,
 225–229, 235, 243

 and play with legal conventions, 1–2, 26, 53,
 228

 and role of plan or instructions, 6, 15, 26–27,
 34, 39–40, 45–46, 167, 175, 215, 228, 244

Connoisseurship, 5, 7, 72

Conservation and preservation, 5, 8, 10, 12,
 14–15, 24–25, 140, 143–149, 171–173,
 186–187

Context, 12, 15–16, 24–25, 113, 123, 143, 154–
 155, 163, 165, 179, 182–184, 205, 208

 of interpretation and reception, 5–6, 56,
 65–66, 68, 71, 105, 127

 of the museum, 10–11, 165–167, 171–173,
 186, 191, 198, 200, 203

Contracts. *See* Certificates and contracts

Copies, 3, 7, 31, 34, 64–67, 71–74, 77, 84, 88–
 95, 113, 200. *See also* Casts; Remaking
 and reconstructions; Reproduction

 as a basis for quotation and reference, 65,
 74, 88, 102, 105, 122, 183

 exhibition copies, 35, 37, 244

 hand-painted copies, 31, 33, 76, 120–121

 inherent in serial forms, 3, 23

 as mediation or transformation, 65, 95, 97–
 98, 101–102, 113, 117, 122

 and originals, 12, 72–73, 76, 171

Coplans, John, 226

Copyright, 12, 53, 64, 84–94

 fair use, 90–93

Crimp, Douglas, 23, 74, 95

Crone, Rainer, 77, 81, 86–87

Crow, Thomas, 83, 87, 110, 117–118, 120

Cunningham, Merce, 224

Dauman, Henri, 88, 94

De Antonio, Emile, 74, 76

Dearing, James, 40–41

Decay or deterioration, 8, 15, 25, 134, 140, 143, 145, 149, 152

Degas, Edgar, 178–179, 182

Deitcher, David, 154

De Kooning, Willem, 66

Del Balso, Dudley, 38

Del Rio, Petra Barreras, 235

Diagrams, 27, 33–34, 36, 42, 45–46. *See also* Documentation; Plans and instructions

Digital imaging, 97, 101, 120–121, 125

Dion, Mark, 186–187
 New England Digs, 187, **188–189**

Documenta, 117, 129, 173

Documentation. *See also* Certificates and contracts; Diagrams; Plans and instructions
 of ephemeral or site-specific works, 12, 14, 15, 115, 145, 152, 171, 193, 198, 215–217, 219–225, 228–229, 233–239, 243, 251–252, 258
 external to or in place of the object, 16, 24, 26, 34–35, 37, 42, 45, 53, 56, 70, 74
 as a form of delay, 217, 223, 236
 as indication of artistic intent, 16, 24, 43, 45, 56
 intrinsic to the work, 114, 163, 166–169, 186, 220–226, 237, 243, 249–251

Duchamp, Marcel, 1–2, 63–72, 78, 80, 101–102, 105, 111, 171, 173, 187, 243, 249. *See also* Readymades
 Box in a Valise, 68–71, **69,** 78, 102, 173
 Fountain, 63–64, 70, 78, 105
 Green Box, 1–2, 171
 L.H.O.O.Q., 78, 102, **104**

Duncan, Carol (pseudonym Cheryl Bernstein), 34, 83

Duve, Thierry de, 26, 111, 129

Dwan Gallery, 233

Earthworks, 11, 220, 233–236, 243

Editions, 31, 38, 70–71, 77, 235
 limited editions, 3, 12, 31, 65, 70–71, 73, 93

Fabrication, 1, 3, 6, 24, 26, 36–38, 40, 45, 48, 64, 70, 91, 105, 133, 149, 228. *See also* Minimal art; Post-studio art
 and delays between conception and realization, 6, 14–15, 35–36, 42
 and role of plans or instructions, 2, 6, 36–42
 or use of prefabricated components, 3, 23–24, 36, 64

Factor, Donald and Lynn, 31, 33

Fake or forgery, 34, 73–74, 83, 179

Ferus Gallery, 76

Film, 115, 219, 233–237, 243, 246

Fischer, Konrad, 45
 Gallery, 228

Flavin, Dan, 23, 36, 42–43, 53–56
 certificate for *Untitled 6B*, **55**
 Greens Crossing Greens (to Piet Mondrian who lacked green), 43, **44**
 Untitled 6B, **54**

Formal analysis, 72, 136–139, 143, 149, 154, 171, 243, 252

Foster, Hal, 23

Foucault, Michel, 24

Fraser, Andrea, 183–184
 May I Help You?, 183–184, **185**

Fried, Michael, 23, 26

Friedrich, Heiner, 53
 Gallery, 43, 53

Fusco, Coco, 193, 195
 Two Undiscovered Amerindians, 193, 195, **196**

Geldzahler, Henry, 76, 86

Gender, 8, 65, 87, 143, 191

General Services Administration (GSA), 48–49, 51

Genre categories, 109–111, 114, 117, 122–129, 136. *See also* History painting; Landscape; Portraiture; Still life

Glaser, Bruce, 33, 40

Gluck, Nathan, 74, 78

Gober, Robert, 62–63, 65, 143, 145, 147–149

 Bag of Donuts, 143, 145, 147–149, **148**

 Three Urinals, 62–63, **63**

Gómez-Peña, Guillermo, 193, 195

 Two Undiscovered Amerindians, 193, 195, **196**

Gonzalez-Torres, Felix, 154–155, 158, 198

 Untitled (The End), 155, **157**

 Untitled (Strange Bird), 198, **199**

 Untitled (USA Today), 155, **156**

Greenberg, Clement, 66, 110

Guerrilla Art Action Group (GAAG), 167

Guggenheim Museum (New York), 34, 45, 166–167, 169, 195

Gursky, Andreas, 120

 Rhein, 120, **121**

Haacke, Hans, 53, 127, 129, 166–171, 175, 178–182, 195, 233

 Manet-PROJEKT '74, 168–171, **170**

 Oelgemaelde, Hommage à Marcel Broodthaers, 127, **130–131**

 ViewingMatters, 175, 178–182, **180–181**

Hackett, Pat, 78

Hamilton, Ann, 249, 251

 Face to Face, 249, 251, **251**

Hammons, David, 61–62, 65

 Public Toilets, 61–62, **62**

Hand or touch of the artist, 1, 3, 7, 12, 16, 26, 31, 34, 49, 62, 73–76, 83, 120–122, 129, 147, 184, 243, 256. *See also* Signature

and mark or trace of the body, 7–8, 137–143, 158, 224, 236, 243–258

withdrawal of under minimalism, 3, 23–26

Hannema, Dirk, 179, 182

Harvey, James, 80–81

Hatoum, Mona, 252–256

 Corps étranger, 254–256, **255**

Heizer, Michael, 233

Hendricks, Jon, 167

Herron, Hank, 34

Hesse, Eva, 25, 31, 134, 145, 247

 Expanded Expansion, 134, **136**

 Sans II, 31, **32**

Heterogeneity

 in contemporary art, 8, 16, 114

 as a function of authorship, 8–11, 65, 90, 129, 166, 243

 as a function of the reproduction, 74, 117, 243

History painting, 110, 115–120, 158. *See also* Genre categories

Hodges, Jim, 152

 Not Here, 152, **153**

Hoepker, Thomas, 94

Holbein, Hans, the Younger, 125, 127

Holmes, Oliver Wendell, 94

Hobbs, Robert, 234

Hopps, Walter, 80

Houdon, Jean-Antoine, 171, 173

Huebler, Douglas, 229

Identity, 63, 115, 150, 155

Impermanence or ephemerality, 8, 12, 14–16, 113, 149, 152, 154, 165, 205, 215, 219, 223–225, 234–235, 238–239, 241, 243

 and contingency of object or experience, 15–16, 21–24, 88, 134, 234

Index, 101, 120, 125

"Information" (Museum of Modern Art), 167, 173, 229, **232,** 233

Installation, 2, 8, 14, 35–37, 41–43, 48, 53, 84, 129, 137, 152–154, 163–165, 171–173, 175, 178–182, 193–195, 198, 215, 220, 225, 228, 238–239, 243, 251–252, 254–258

Instructions. *See* Plans and instructions

Integrity rights. *See* Moral or integrity rights

Jackson, Elizabeth, 221

Jameson, Fredric, 90

Janis, Sidney, 70

Johns, Jasper, 66–68, 76, 83, 105
Painted Bronze, 66–68, **67**

Johnson, Poppy, 167

Johnson, Ray, 83

Jones, Amelia, 223

Jones, Caroline, 33, 233–235

Judd, Donald, 1–3, 5–6, 23, 25, 33, 36–43, 51, 152
Art in America advertisement, 1–2, **1,** 36
Untitled, 39, **40**
Untitled (galvanized iron wall), 2–3, **5,** 37, 41, 51
Untitled (straight single tube), 38, **39,** 40

Kaprow, Allan, 132, 219–220

Karp, Ivan, 86–87

Keller, Horst, 169

Kimmelman, Michael, 178

Kitsch, 79, 91, 118, 127

Klein, Yves, 101

Kolbowski, Silvia, 200–203
An example of recent work, 200–203, **201– 202**

Koons, Jeff, 91–94, 182
"Banality Show," 91–93, 182
String of Puppies, 91–93, **92**

Kosuth, Joseph, 229

Krauss, Rosalind, 23, 73, 151–152

Kruger, Barbara, 94

Kwon, Miwon, 236

Laib, Wolfgang, 109, 111
Milkstone, **108,** 109

Lajer-Burcharth, Ewa, 140

Landscape, 95, 97, 110, 117, 229, 234, 238. *See also* Earthworks; Genre categories

Lard, 7–10, 137, 139, 140, 142

Latow, Muriel, 76

Lawler, Louise, 175, 178–179, 182, 205
Untitled (Koons), 182, **183**

Lebel, Robert, 68

Leonard, Zoe, 143, 145, 147, 191
Preserved Head of a Bearded Woman, 191, **192**
Strange Fruit (for David), 143, 145, **146, 147**

Leonardo da Vinci, 102
Mona Lisa, 78, 102

Levine, Sherrie, 61, 63–68, 71, 84, 95, 101–102, 105, 182–183
Fountain (After Marcel Duchamp), **60,** 61, 63–67, 105
Meltdown, 101–102, **103**
Untitled (After Edward Weston), 95, **96**

LeWitt, Sol, 39–40, 45–46, 48, 52, 198, 215, 217
certificate and diagrams for *Wall Drawing no. 146,* **51**
Wall Drawing no. 146, **50**

Licht, Ira, 223

Lichtenstein, Roy, 123

Limited editions. *See* Editions

Lippard, Lucy, 221, 225

Lisson Gallery, 37, 41, 53

Longsdail, Nicholas, 53

Luna, James, 191, 194, 195, 205
Artifact Piece, 191, 193, **194**

Malraux, André, 71–72, 74

Manet, Édouard, 110, 118, 168–169, 175

Mass production, 14, 64, 66–68, 70–71, 76, 91, 94, 105

Materiality, 8, 10, 12, 14–15, 21, 23–24, 25–26, 38–43, 61, 64, 66–67, 72, 105, 113, 129, 132–151, 158, 186–187, 238. *See also* Medium

 material evidence of authenticity, 5, 34

 organic materials, 7–8, 109, 111, 140, 143, 147, 166 (*see also* Chocolate; Lard; Soap)

 and photographic information, 72, 97, 117, 127, 223–224

 and process, 7, 12, 23, 132–143, 229, 246–247, 249

 and scrap metal, 27, 30, 49, 51

 separation of idea and material expression, 23, 26–27, 30, 35, 48, 56, 65

 and shifts between materials, 38–39, 42, 61, 79, 95, 97, 101, 117, 125

 truth to materials, 7–8, 142–143, 147, 151

 unstable materials, 14–15, 134, 139, 142–149, 241 (*see also* Decay or deterioration)

Mayer, Bernadette, 217

Mayer, Rosemary, 220

McCollum, Allan, 98, 183–184

 Perpetual Photos, 98, **100,** 184

 Plaster Surrogates, 183–184

McShine, Kynaston, 173, 229

Medium, 12, 14, 77, 86, 88, 95, 101, 110–114, 116–117, 120–123, 125, 127, 129, 132, 133, 136, 143, 151–152, 158, 163, 224–225, 235, 243. *See also* Materiality

 as a series of separable conventions, 12, 14, 95, 112–113, 121, 123, 151, 158

Mendieta, Ana, 140, 235–238

 Anima, 236–237, **237**

Messer, Thomas, 166

Minimal art, 3, 6, 11, 15, 23–45, 56, 79, 97, 111, 133, 134, 139, 218, 243–244, 246–247

and activation of space, 3–4, 15, 23–27, 30, 36

as a basis for subsequent practices, 7, 12, 31, 137, 139, 149, 154–155, 254

and conceptual art, 6, 23, 26–27, 34–36, 38–42, 53, 56, 154

and industrial fabrication, 3, 23–24, 36

and temporal gap between plan and realization, 6, 14, 33, 35–36

and withdrawal of artist's hand, 3, 23–26

Modernism, 11–12, 14, 65–66, 109–111, 120, 168–169

Mona Lisa. *See* Leonardo da Vinci

Monk, Meredith, 246

Montano, Linda, 236

Monte, James, 133

Moore, Charles, 87, 94

Moral or integrity rights, 15, 48–49, 90

Morris, Robert, 1, 5–6, 23, 24, 38, 53, 132, 134, 220

 Litanies, 1–2, **4**

 "Nine at Leo Castelli" (warehouse show), 132, 133

 Statement of Esthetic Withdrawal, **x,** 1–2, 53

Multiples, 31, 35, 65, 73–74, 77, 80, 83, 86, 155, 179. *See also* Editions; Reproduction

"The Museum as Muse" (Museum of Modern Art), 173–175

Museum of Modern Art (MoMA), 10–11, 51, 102, 109–111, 114, 167, 173–174, 229, 233. *See also* "Information"; "The Museum as Muse"; "Objects of Desire"

Museums

 artists invited to create works specifically for, 133, 166, 168, 171, 173–175, 178, 195

 art museum classification systems, 8, 10–11, 72, 74, 105, 127, 171, 186

 and collection types, 8–10, 163, 166–167, 184, 186–187, 191, 193, 195

 and recontextualization, 10, 63, 66, 68, 80, 165, 175, 178, 186, 191

Museums (cont.)
 reproductions as an alternate form of, 68, 71–72, 127, 173
 subject to analysis by artists, 51, 163, 165–184, 186–187, 190–195

National Endowment for the Arts (NEA), 88
Nauman, Bruce, 34–36, 43, 45, 134, 224, 243–246
 Neon Templates of the Left Half of My Body Taken at Ten-Inch Intervals, 244, **245**
 Performance Corridor, 134, 246, **248**
 Walk with Contrapposto, 246, **247**
 Yellow Room (Triangular), 43, 45, **46**
Nauman, Judy, 246
Naumann, Francis, 70
Nemser, Cindy, 221

"Objects of Desire" (Museum of Modern Art), 109–111, 114, 115
O'Dell, Kathy, 223–224
Oldenburg, Claes, 83–84, 173
"Op losse schroeven" (Stedelijk Museum, Amsterdam), 133, 228
Oppenheim, Dennis, 233
Ordover, Jerald, 53, 228
Originals, 3, 12, 31, 35, 37, 64–68, 70–73, 80, 83, 88, 94–95, 98, 101, 102, 105, 171, 173, 179, 182, 200
 and copies, 12, 31, 64–66, 70–73, 77, 86–95, 102, 105, 171, 200
 as a function of external limits or evidence, 4–5, 30, 35, 37, 73
 and industrial fabrication, 3, 14, 30–31, 45, 64, 68
Orozco, Gabriel, 239–243
 Island within an Island, 241, **242**
 Yielding Stone, 239–241, **240**, 243
Owens, Craig, 26, 233

Painting, 25, 31, 33, 42, 65, 72, 77, 109–132, 136, 149–150, 158, 168–169, 184, 228
 and photography, 14, 74, 77, 80–88, 101–102, 111–112, 114–115, 117–127, 136, 158, 179
Panza, Giuseppe, 1–3, 34–48, 51, 53, 56, 228
 Varese installations, 2, **5,** 36, 40–41, 48, **50, 54**
Parker, Cornelia, 187, 190–191, 238–239
 Drowned Monuments, 238–239, **239**
 Shared Fate, 190–191, **190**
Performance, 8, 11–12, 14–15, 114–115, 134, 137, 139–140, 149, 183–184, 193–195, 205, 213–225, 236, 238, 243, 246, 249, 251–252, 254, 256
 and documentation, 12, 14–15, 114–115, 193, 215–217, 219, 221–225, 236, 243, 249, 251–252
 or repeated actions as process, 7–8, 12, 133, 137, 139, 142–143
 site-specific and ephemeral actions, 15, 113, 133, 167, 205, 213–225, 228, 236–239, 244, 246–249, 258
Permanence, 12, 30, 41, 49, 109, 137, 149, 152, 238, 241, 243, 251. *See also* Impermanence or ephemerality
Perreault, John, 235
Photography, 70–72, 95, 97, 112, 114–118, 120–123, 125–129, 136, 145, 151–152, 223, 246, 247, 249–254
 as documentation, 8, 35, 42–43, 70, 72–74, 114–115, 134, 193, 218–225, 233–239, 252
 and heterogeneity, 8, 74, 151–152, 243
 and mediation, 65–66, 74, 95, 98, 101, 200
 and painting, 14, 74, 77, 80–88, 101–102, 111–112, 114–115, 117–127, 136, 158, 179
 and play between document and work, 74, 175, 179, 182, 186, 190–191, 198, 225–228, 233–252
Piper, Adrian, 115, 213–215, 217–221, 225

Catalysis series, **212,** 213–215, **214,** 217–221, 225

Plans and instructions, 3, 6, 15–16, 24, 26–27, 33–37, 40, 42, 45–46, 48, 56, 134, 152, 154–155, 167, 175, 198, 205, 215, 217, 220–221, 226, 228, 238, 244. *See also* Diagrams; Documentation; Fabrication

Pollock, Jackson, 132, 179, 182

Pop art, 11–12, 26, 67, 73, 76, 110–111

Portraiture, 102, 110, 115–118, 122–123, 125, 127–129, 137, 140, 155, 158, 165, 175, 223, 244, 249. *See also* Genre categories

Postmodernism, 11–12, 66, 88, 90, 95, 110, 114, 117, 123, 233, 235

Post-studio art, 14–15, 133, 155. *See also* Fabrication

Preservation and conservation, 5, 8, 10, 12, 14–15, 24–25, 140, 143–149, 171–173, 186–187

Process. *See* Materiality

Projansky, Robert, 53

Provenance, 4, 34, 168–169

Quotation and reference, 14, 65, 78, 88, 90, 105, 110–114, 120, 123, 129, 136, 139, 142–143, 182–184

Rauschenberg, Robert, 33, 74, 83, 88, 132, 223
Short Circuit, 83, **84**
Tracer, **75**

Ray, Charles, 111, 203

Readymades, 2, 3, 6, 10, 12, 15, 26, 64–72, 78, 80, 94–95, 102, 105, 110–112, 117, 129, 147, 158, 171, 200, 203, 205, 226, 243. *See also* Duchamp; Remaking and reconstructions

Recontextualization, 10, 68, 79, 88, 90–91, 105
and authorship, 15, 63, 80, 83–84, 86, 182–183

and the museum, 10, 72, 171, 191
and the readymade, 10, 15, 95, 200

Reference and quotation, 14, 65, 78, 88, 90, 105, 110–114, 120, 123, 129, 136, 139, 142–143, 182–184

Relics and artifacts, 43, 142, 187–193, 236–237, 249

Remaking and reconstructions, 10, 14, 30–31, 35–38, 42–45, 53, 83–84, 102, 113, 142, 149, 151–152, 154, 205, 234, 244. *See also* Casts; Copies
remade readymades, 61, 63–64, 67–71, 77–79, 105

Representation, 12, 23, 70, 77, 127, 132, 134, 140, 143, 145, 147, 149, 151, 173, 184, 219, 223, 236, 243, 247, 256. *See also* Documentation
achieved through copies, 70, 77, 91, 101, 117–118, 120–123, 125, 140, 200
play between representation and abstraction, 12, 61, 117, 120, 149, 249

Reproduction, 3, 4, 12, 14, 16, 42, 65–66, 68, 71–74, 79, 88, 91, 94, 101–102, 122, 183
external limits on inherent reproducibility, 3, 4, 12, 31, 64–65, 73
mechanical reproduction, 12, 14, 31, 66, 74, 77, 79, 88, 95, 101, 105, 120, 122

Richter, Gerhard, 111, 114, 117–120, 158
October 18, 1977, 118–120, **119,** 158
Two Candles, 111, **112**

Rodenbeck, Judith, 220

Rodin, Auguste, 73, 179

Rogers, Art, 91–94

Rollins, Tim, 154

Rosenberg, Harold, 132

Rosler, Martha, 220

Roth, Dieter, 140

Rowell, Margit, 109

Ruscha, Ed, 226, 228
Every Building on the Sunset Strip, 226, **230–231**

Sandler, Irving, 81

Scheidemann, Christian, 145

Schneemann, Carolee, 219, 224

Schütz, Sabine, 117

Schwarz, Arturo, 70–71, 78

Sculpture, 8, 23–24, 27, 33, 49, 61, 97, 112, 132–134, 139–140, 158, 173, 179, 203, 241, 244–249, 252
 and photography, 235–236, 238–239, 241, 246, 249, 252, 254

Serial forms, 3, 23, 25–26, 74, 77, 79, 97, 155, 247. *See also* Minimal art

Serra, Richard, 21–24, 48–49, 51, 133–134
 Casting, 133, 134
 Splashing, 133, **135**
 Tilted Arc, 48–49, 51, **52**
 Torqued Ellipses, 21–24, **22**
 "Verb List," 133

Sharp, Willoughby, 229, 244

Sherman, Cindy, 111, 114–117
 Untitled Film Stills, 114–115
 Untitled #172, 111, **113,** 115–116
 Untitled #228, 115, **116**

Siegelaub, Seth, 53, 229, 233

Signature, 53, 73–74, 78. *See also* Hand or touch of the artist

Silvianna, 167

Site specificity, 14, 36, 41, 43, 48–49, 51, 53, 132–133, 171, 173–175, 178, 187, 198, 243
 and documentation, 14–15, 198, 224–225, 229, 233–238, 243

"Skulptur" (Münster), 203, 205, 241

Smith, Patrick, 81

Smithson, Robert, 233–235, 237
 Spiral Jetty, 233–234

Soap, 137, 140, 142, 158

"Software" (Jewish Museum), 215, 218

Sonnabend, Ileana, gallery, 77, 81–82, 182, 215, 218

Stable Gallery, 76, 80

Stella, Frank, 31–34, 83, 122
 Marquis de Portago, 31–34, **33**

Stieglitz, Alfred, 64

Still life, 109–111, 114–115, 117, 143, 149–150, 169, 178, 182. *See also* Genre categories
 vanitas, 111, 149

Storr, Robert, 122

"Street Works" (Architectural League of New York), 217

Sturtevant, 82–84, 86–87
 Warhol Flowers, 82, **82**, 84

Sugimoto, Hiroshi, 123, 125–127
 The Music Lesson, 125, **126**
 Portraits, 125, 127, **128**

Swenson, G. R., 82

Theatricality, 23, 26, 139, 244, 246. *See also* Minimal art

Toche, Jean, 167

Toselli Gallery, 53

Trace. *See* Body

Trademarks and brand names, 64, 67, 77–78, 94, 137, 139

Tucker, Marcia, 133

Varnedoe, Kirk, 174

Vassilakis, Takis, 51

Vermeer, Jan, 125

Video, 8, 133–134, 149–150, 215, 220, 223–225, 235, 241, 243, 246, 251, 254

Visual Artists Rights Act, 49

Wall, Jeff, 120

Wallach, Alan, 72

Ward, Eleanor, 76

Ward, Fred, 87

Warhol, Andy, 74, 76–89, 91, 94, 102, 105, 118, 120, 123, 178–179

Brillo boxes, 78–81, **79**

Flowers series, 77, 81–82, **81,** 84–87, 94

Jackie series, 87–88

Race Riot series, 87, **89,** 120

"Raid the Icebox 1" (Rhode Island School of
 Design), 178

Weil, Susan, 83

Weiner, Lawrence, 53, 149, 228–229

Welling, James, 95, 97

Untitled 2-29I-80, 95, 97, **98**

Weston, Edward, 65, 95

"When Attitudes Become Form: Works—
 Concepts—Processes—Situations—
 Information: Live in Your Head"
 (Kunsthalle, Bern), 133, 136, 244

Whiteread, Rachel, 95, 97

Untitled (One Hundred Spaces), 97, **99**

Whitney Museum of American Art, 27, 30,
 49, 94, 132–134, 168. *See also* "Anti-
 Illusion: Procedures, Materials"

Wildmon, Donald, 88, 90

Wilke, Hannah, 140, 247, 249

S. O. S. Starification Object Series, 249, **250**

Wilson, Fred, 163–165, 178, 195

Mining the Museum, **162,** 163–165, **164**

Winsor, Jackie, 53

Wodiczko, Krzysztof, 195, 198

Hirshhorn Museum projection, 195, **197,**
 198

Wojnarowicz, David, 88, 90, 145

Women Artists in Revolution (WAR), 167

0–9 (magazine), 217